China's
Thirty Years 見證改革開放三十年

China's Thirty Years

見證改革開放三十年

中國攝影師協會
Edited by CHINA PHOTOGRAPHERS' ASSOCIATION

OXFORD
UNIVERSITY PRESS

Oxford University Press is a department of the University of Oxford.
It furthers the University's objective of excellence in research, scholarship,
and education by publishing worldwide in

Oxford New York

Auckland Cape Town Dar es Salaam Hong Kong Karachi
Kuala Lumpur Madrid Melbourne Mexico City Nairobi
New Delhi Shanghai Taipei Toronto

With offices in

Argentina Austria Brazil Chile Czech Republic France Greece
Guatemala Hungary Italy Japan South Korea Poland Portugal
Singapore Switzerland Thailand Turkey Ukraine Vietnam

Oxford is a registered trade mark of Oxford University Press

© Oxford University Press and China Photographers' Association 2009

First published 2009

This impression (lowest digit)
10 9 8 7 6 5 4 3 2 1

British Library Cataloguing in Publication Data available

Library of Congress Cataloging in Publication Data available

CHINA'S THIRTY YEARS /editor, Wang Miao, Liu Yang

ISBN 978-0-19-800897-2

1. China—History—1976–. 2. China—Economic history—20th century.
3. China—Economic policy—1976–. 4. China—Politics and government.
5. Political leadership—China. 6. China—Reform and Opening Policy.

總策劃	秦曉　何迪　王波明
顧問	陳小魯　王文瀾　賀延光
主編	王苗　劉陽
撰稿	楊浪
圖文編輯	林道群　胡武功　石寶琇　潘科
圖文審校	袁曉露
英文編輯	Mary J. Child, John MacDonald, Mark Binnersley
英文譯者	左軍　滕晶　熊小麗
編輯助理	朱建輝　王小平
裝幀設計	李明元
監製	姜建
編製	中國攝影師協會
鳴謝	章百家　李小瓊　黃迪

畫冊裡有部分作品找不到作者姓名，如有作者發現該畫冊內有自己的作品，請速與本社聯繫

Coordinators:	Qin Xiao, He Di, Wang Boming
Advisors:	Chen Xiaolu, Wang Wenlan, He Yanguang
Chief Editors:	Wang Miao, Liu Yang
Head Writer:	Yang Lang
Picture Editors:	Lam To Kwan, Hu Wugong, Shi Baoxiu, Pan Ke
Picture Reviser:	Yuan Xiaolu
English Editors:	Mary J. Child, John MacDonald, Mark Binnersley
English Translators:	Zuo Jun, Teng Jing, Xiong Xiaoli
Assistant Editors:	Zhu Jianhui, Wang Xiaoping
Designer:	Li Mingyuan
Producer:	Jiang Jian
Compiler:	China Photographers' Association
Acknowledgements:	Zhang Baijia, Li Xiaoqiong, Huang Di

This book contains a few images, the photographers of which are unknown.
If you are such a photographer please contact this agency immediately.

Printed in Hong Kong by Elegance Printing & Book Binding Co., Ltd.
Published by Oxford University Press (China) Ltd
18th Floor, Warwick House East, Taikoo Place, 979 King's Road, Quarry Bay, Hong Kong

序

亨利 · A. 基辛格

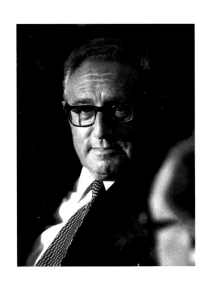

我1971年到中國時，若是有人把四十年後中國的情景繪成一幅畫，我當時也只會認定是幻想。我們那第一次到北京時，美國和中國已有二十五年沒有來往，中國尚未改革開放。我時常回憶起我們最初的經濟示好舉動僅限於在當時還很有爭議的一項決定，就是允許到香港的美國人購買一百美元價值的中國商品。

回顧以往這四十年的歷程，我不僅喜見中美關係的蓬勃發展，也讚嘆中國自身已取得的成就。中國的這些進展反映了鄧小平改革開放政策的兩個方面：一方面改革國內的經濟和政治體制；另一方面不斷擴大中國與世界的接觸。我很榮幸能在中國開放的歷史進程中扮演了一個角色。回想當年尼克松總統訪華時是一個美國總統去訪問一個美國不承認的國家的首都。就從這樣一個開端，中美關係竟發展到如今這般緊密膠着，這歸功於雙方領導人的遠見卓識和大略雄才。這裡包括了八位美國總統和四代中國領導人。這幾十年來我們看到了中美關係的巨大變遷。

中國的增長是驚人的。中國的經濟增長使三億多人脫離了赤貧，改變了幾乎每個中國人的生活。創造了新的機會，但也捎帶了隨現代化而來的各種挑戰。在改革期間，尤其是過去的十年，中國已崛起為國際舞台上重要的一員，這個過程仍在繼續。一個強大中國的崛起，意味着國際秩序將須作必要的調整，這調整需要謹慎和遠見。中美友好雖是兩國外交政策的基本事實，但歷史告訴我們，世界在歷史性的轉變過程中，這種友好關係必須加強和深化。

國際事務的重心，在許多方面正從大西洋移到太平洋以至印度洋。這使我們要重新審視以往的歐洲中心論；再者，伊斯蘭世界正處於與十七世紀歐洲宗教戰爭相當的動亂；最後，我們正在經歷的這場經濟危機，不僅影響着所有國家的國計民生，而且從根本上改變了經濟體系以往所依賴的基礎。

不僅如此，我們現在面臨的還有一系列以往未須處理的問題，例如，核擴散、氣候變化、環境問題等等。因此可以說，中美關係經過了以國家安全為主導的階段，經過了亞洲崛起的階段，現在須進入一個新階段。處理上述任何問題都有賴於中美雙方的密切合作。事實上，今天面臨的最大威脅不是古典意義上的大國衝突，而是由於不合作所造成的現代意義上的更微妙的危險。我們必須做到積極地、專注地合作，使之達到前所未有的深度。

紀念改革開放三十年有重要的意義。借此機會，我們回顧和思考這三十年所取得的史無前例的非凡成就。但當今美國仍在爭論應該將中國視為戰略競爭對手還是戰略夥伴。我認為我們這些在太平洋兩岸，無論在中國還是美國，關心中美關係的人有義務致力加強這跨太平洋的夥伴關係，並將此推進到一個新水平。如果確能如此（我認為能做到而且會做到），那麼未來三十年將會產生與過去三十年同樣驚人的演變。

在過去的三十年的動盪歲月裡，中美關係是世界的一個穩定因素。作為結束語，我希望在今後的三十年裡，中美關係能夠成為塑造這個世界的一個關鍵因素。

PREFACE By Henry A. Kissinger

When I arrived in China in 1971, if anyone had made a drawing of what the country would look like forty years later, I would have believed it to be fantasy. When we arrived in Beijing on that first visit, there had been no relationship between the United States and China for twenty-five years. The country had not yet begun its process of reform and opening. I often recall that our initial economic overtures were confined to a decision – then quite controversial – to allow Americans traveling in Hong Kong to purchase US$100 worth of Chinese-made goods.

But today, as I look at what has emerged over the past forty years, I am impressed not only by the extraordinary and growing ties between China and the United States, but also by what China has achieved, through her own efforts. What has happened in China during that time, of course, is a reflection of both elements of Deng's policy of "reform and opening", an approach that combined the restructuring of China's domestic economic and political system with ever-increasing Chinese engagement with the world. It has been a privilege to have had a role in the historic process of China's opening. When I think back to President Nixon's visit and reflect on the fact that here was an American President visiting the capital of a country we did not recognize, it is astounding and a great credit to leaders of both sides — eight U.S. presidents and four generations of Chinese leaders — that this relationship could evolve from such a beginning and develop the sense of coherence that it has. Over these decades, we have seen a stunning transformation of that relationship.

The growth of China is astonishing. The country has lifted more than 300 million from abject poverty, and the nature of economic growth in China has transformed the landscape of the lives of almost every Chinese, creating new opportunity but also delivering all of the challenges that come with modernization. During the reform period, and particularly in the past decade, China has emerged as one of the key actors on the international scene. This is a process that is still underway, and the necessary adjustment to the international system required by the emergence of a stronger China demands cautious and far-sighted management. The basis of friendship between the United States and China is a fundamental fact of the foreign policy of both nations, but history teaches us that such relationships must be strengthened and deepened at a time when the world is in a process of historic transformation.

The center of gravity of international affairs, for instance, is now moving in many respects from the Atlantic to the Pacific and to the Indian Ocean, and this brings about a need to reconsider some of the previous premises that were centered on Europe. Then, too, the Islamic part of the world is experiencing an upheaval comparable to the religious wars that Europe went through in the 17th century. Finally, we are living through an economic crisis which not only affects the wellbeing of all of our countries, but which fundamentally alters the very premises on which the economic system has been based.

All of this is taking place while a whole set of challenging issues has come onto the global agenda: nuclear proliferation, climate change, and environment are examples. Therefore, we can say that the Chinese-American relationship that has seen us through a period when security was a dominant concern, and then through a period of the emergence of Asia, now has to move into a new phase. Progress on any of these issues depends on close cooperation between the United States and China. In fact, the greatest threat we face today is not the classical threat of a collision between great powers, but rather the more subtle modern danger of a failure to cooperate. Active, engaged cooperation at unprecedented levels of depth is the imperative.

It is important to mark China's thirty years of reform and opening. It is a moment to reflect on the incredible accomplishments of the past three decades, accomplishments that are unprecedented in human history. But at the same time, we have in the United States the debate whether to treat China as a strategic competitor or as a strategic partner. I think that it is our responsibility, those of us who are concerned with Sino-American relations on both sides of the Pacific, in both China and the United States, to work for this trans-Pacific partnership and raise it to a new level. If that can be achieved, as I believe that it can and will, then we can see in the next thirty years the same dramatic evolution that has characterized the last thirty.

Let me conclude with this hope: We have gone through three decades now of a turbulent world, in which the relationship between China and the United States has been a stabilizing element. In the next thirty years, the relationship between China and the United States can be a key element that will help shape this world.

Henry A. Kissinger

序 杜潤生

參加革命的時候，我們沒有想過個人的未來。那時候是想着中國這樣下去不行，老百姓這樣苦下去不行，二十幾歲的我們要進步、要革命，就這麼投身到革命的洪流裡了。本來我們以為新中國建立起來了，問題就解決了。後來漸漸地明白，建立一個新中國與推翻一個舊政權一樣複雜，一樣地需要披荊斬棘。幾十年來，我們一直在摸索着怎麼走才能民富國強，難免走了一些彎路，這也是為甚麼建國30年後又要搞30年的改革開放。

這30年我們做的是甚麼？有人說做了兩件事，一個是解放生產力，一個是改變生產關係。我還有個意見，這30年就是「把老外請進來，把老鄉放出去」。「請老外」，進人，進技術，進資金，是改革也是開放。搞包產到戶，不僅是把糧食棉花搞多了，把農民和農村的生產力釋放出來，而且是給農民鬆綁，讓農民自由了。所以才會有以後的辦企業，進城，搞外貿。「把老鄉放出去」既是解放生產力，也是解放生產關係，這就促進了整個社會的變革，使城市改革有了堅實的依託。

要這樣一個歷史悠久幅員遼闊的國家強盛起來，讓老百姓過上富足自由的生活，這是一代一代仁人志士的理想。今天我們實現這個理想了嗎？我看是實現了一大部分，但是後面還有許多的事情要做。

我們已經是一個經濟上的大國，但算不算是一個真正意義上的強國呢？老百姓尤其是中國農民的生活富足，不等於他們必然地就當家作主了。我搞了一輩子農村工作，在中國這樣一個農業大國和人口大國，把幾億農民組織起來，使農民不但享受城市化發展的利益，還要真正享受到科技發展和社會發展的利益，這是我們過去在做，以後還要持之以恆做下去的事。我們總在說「制度建設」，「制度」就是要做好發展中不同群體穩定的利益安排，靠「制度」來抑制腐敗滋生，靠制度來保證整個國家的可持續發展。共產黨是為人民服務的，有一個保證人民當家作主的制度，才是一個真正意義上的強國。

我不懂攝影，但是我愛看優秀的攝影作品。記得在晉察冀解放區的時候，八路軍、解放軍裡就有一批攝影工作者，把我們的戰鬥、土改生活拍攝下來。今天看那已經是十分珍貴的歷史資料了。這本書的名字叫做《見證改革開放三十年》，我看「見證」這個意思很好。我算是革命戰爭的見證者之一，那時候留下來的照片雖然不多，卻使人們永遠記得那些硝煙中的歲月。

今天，我們都是中國發展進步的見證者，我已經96歲了，只有過來人才明白，改革開放也是不容易的！應該感謝這些攝影師們，有了這些照片，我們便看到了人民的昨天、今天和未來，也看到中國的昨天、今天和未來。

杜潤生

Du Runsheng

PREFACE By Du Runsheng

When joining the revolution, we didn't think of our personal futures. At the time, we thought only that China could not go on like this, that the ordinary people must not go on suffering like this. So at twenty-something, we demanded progress and revolution. Thus, we threw ourselves in the mighty torrent that was the Chinese Revolution. Originally we thought, once the New China was established, the problems would be solved. Later, we gradually realized that building a new China would be as difficult as overthrowing an old political order: both require overcoming many obstacles. For decades now, we have been exploring for a path to make our people prosperous and our county strong, and we've had our inevitable detours. This is why thirty years after the founding of the People's Republic, we still needed to do 30 years of reform and opening.

What have we been doing in these past thirty years? Some say that we have done two things: one is to liberate the forces of production, and the other is to change the relationships of production. I have another take: in these thirty years, we "invited the foreigners in" and "let the village folks out". "Inviting the foreigners in" meant bringing in people, technology and capital – this was reform as well as opening. Instituting the "household responsibility system" not only increased outputs in grains and cotton, freed up productivity of farmers and in the countryside generally, it also unshackled farmers and gave them freedom. This allowed them later to start enterprises, go into the cities and engage in foreign trade. "Letting the village folks out" not only liberated productive forces but also liberated the relations of production, thereby promoting the transformation of the entire society, and providing a firm support for urban reforms.

To raise this vast country with its long history to a position of power and greatness, and to provide its ordinary people with lives of abundance and freedom, have been the ideal of generation upon generation of high-minded men dedicated to noble callings. Have we realized this ideal? I think we have to a large extent, but there is still much left to do.

China is already a major economic power. But can she qualify as a great power in the real sense? Affluence among the common folk, especially farmers, does not imply that they have necessarily become "masters of their own house". I have worked on rural topics all my life. In this populous, agricultural country that is China, to organize hundreds of millions in rural populations so that they enjoy not only the benefits of urban development, but also fully partake in the benefits of technological advancement and social development, this has been our task in the past and will continue to require our sustained endeavors in the future. We are always talking about "systems building". The "systems" are about making appropriate, stable arrangements for the interests of different groups while the country is undergoing a process of development – to rely on systems to control corruption, and to rely on systems to ensure sustainable growth for the whole country. The Communist Party is about serving the people. To have a system for ensuring that the people are true masters, that would constitute a great power in the real sense.

I am no savant of photography, but I enjoy looking at quality photos. When I was in the liberated areas of JinChaJi (Shanxi-Chahar-Hebei), there were photographers in the Eighth Route Army and the People's Liberation Army who photographed us in our lives of combat and land reforms. Today those pictures have already become extremely precious historical materials. The Chinese title of this book is Witness 30 Years of Reform and Opening. I think the term "witness" is apt and fitting. I can be counted as a witness to the revolutionary wars. The few photographs that survive from those times will always remind people of those days of barrage fire.

Today we are all witnesses of China's development and progress. I am already 96 years old. Only those who have been through it will appreciate that Reform and Opening has also not been easy. We should thank these photographers, because with these images, we can see the people's yesterday, today and tomorrow, and also China's yesterday, today and tomorrow.

目錄

CONTENTS

文革大動亂
The Cultural Revolution (1966 – 1976)

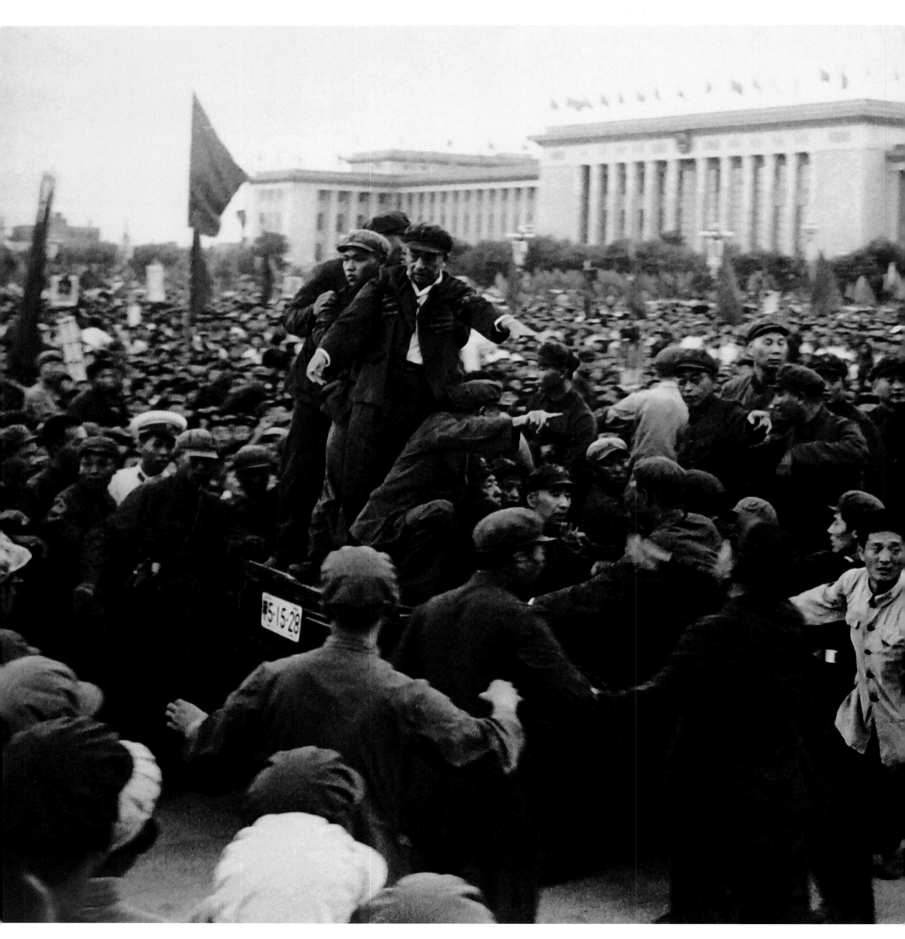

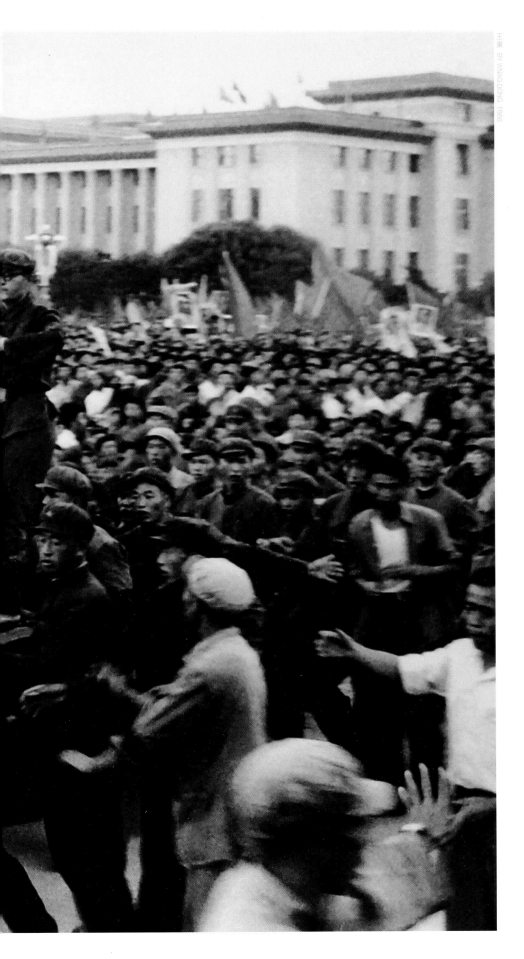

這是一個應當被人記取的頗有象徵意味的場景——領袖和他的汽車，被他發動起來的人群淤塞了！從歷史的角度看「文革」，毛澤東基於建構新的社會制度的理想，試圖通過發動民眾，打碎既有的制度結構來實現。結果，制度、秩序和文化都被打亂了。「全面內戰」，這是毛1970年對「文革」的形容；「只是不知道敵人在哪裡」，這是毛1967年說的，前者對斯諾，後者對阿爾巴尼亞人。其實，中國的「這輛車」從1966年駛出的時候就被堵塞了。在這個意義上，1978年以後發生的變革，不過是必然發生的對正常秩序的恢復。

The effects of the Cultural Revolution clearly continue to reverberate in China well beyond the turn of the century. The political campaign, which began in 1966 and lasted for a decade, was instigated by Chairman Mao Zedong in an attempt to thwart perceived "rightist" (broadly conceived as anything from more conservative elements within the Party to bourgeois tendencies or feudal remnants) influence among the Communist Party and society. The subject is still difficult to approach in modern-day China, but the official view is that the campaign was wrong. Indeed, it brought the country to its knees. The impact on the current leadership, who lived through the chaos, is obvious as social stability, perhaps even ahead of economic growth, is their number one priority. In the early days of the Cultural Revolution, millions of so-called Red Guards (youngsters from across the country) flocked to Beijing to do Mao's bidding. The Red Guards infamously turned on their teachers and academics or anyone else thought to be a rightist or conservative. But in the end, instead of purging capitalists, a small clique close to Mao seized power and made people's lives a misery, imposing major restrictions on art and anything else deemed "bourgeois". This clique was known as the Gang of Four and included Mao's own wife Jiang Qing. After Mao died in 1976, the Gang was arrested, officially marking the end of the Cultural Revolution.

領袖的車被堵住了

1966年8月31日晨，毛澤東第二次接見紅衛兵。當領袖的檢閱車剛剛駛出金水橋的時候，就被混亂的人群擋住了。可以看到，毛澤東、林彪、陶鑄、楊成武等人在當時一籌莫展的表情。

A surging crowd of supporters presses in on Mao Zedong's convertible, as it moves through Tiananmen Square on August 31, 1966. It was the second occasion on which Mao inspected Red Guards in Tiananmen Square.

毛澤東逝世
The Death of Mao Zedong

　　1976年9月9日，毛澤東逝世。在中國當代史上，這無論如何都是一件重大事件！一個締造並影響了這個國家命運27年的人逝去了。在這一刻，幾乎所有人都深淺不同地意識到，中國即將發生變化，只是不知道這變化對國家的未來和自己的生活將意味着甚麼？許多人的回憶都提到，那一瞬間，那種全民族的哀悼和慟哭承載着極其複雜的情感。或許中國再不會有那樣為了一個人的故去而舉國悲慟莫名的情感經歷了，因為，在不到一個月以後，毛澤東既定的中國的走向就被改寫了。

　　Mao Zedong (1893-1976) died on September 9, 1976 of heart and lung disease. Jiang Qing had been outside Beijing shortly before he passed away, but was called back when he took a turn for the worse. Along with doctors, she tried to nurse him but his condition was too serious. Following his death, a memorial service took place on Tiananmen Square on September 18 and his body was placed in the Mausoleum of Mao Zedong, where it lies today. Mao remains a controversial figure long after his death due to his various political campaigns, such as the Great Leap Forward and the Cultural Revolution, which are generally criticized as having caused great suffering on a nationwide scale and stunted the country's economic development. But to a great many Chinese he is a savior whose accomplishments must be considered before his mistakes. Mao is officially regarded by the Communist Party of China as a "great revolutionary leader" for his role in fighting the Japanese during the Second World War (referred to in China as the Anti-Japanese War) and most importantly for creating the modern-day People's Republic of China.

西安各界群眾設靈堂悼念毛澤東

1976年9月10日～18日，西安市各區縣都搭建起靈堂，供民眾悼念與緬懷毛主席。這項活動延續了9天，直到18日下午毛主席追悼會後結束。

Tearful crowds queue at a public memorial hall in Xi'an on September 10, 1976. All the districts and counties of Xi'an opened halls like this one, where people could pay their respects. When Mao Zedong died on September 9, 1976, all of China was plunged into nine days of official mourning.

火車司機拉響汽笛向毛主席告別

1976年9月18日15時，在北京天安門廣場舉行有百萬人參加的毛澤東追悼會。此時，中國大陸所有單位，無論是工廠、農村、醫院、學校；所有人，無論是在火車上或飛機上，都停止一切活動佇立，為領袖默哀3分鐘。圖為西安鐵路局機務段的司機拉響火車汽笛，向毛主席告別致哀。

Railway workers in Xi'an bowing their heads in respect as train whistles sound in salute to the departed leader. The state funeral was held in Tiananmen Square on September 18, 1976. A three-minute silence was observed across the country during the service.

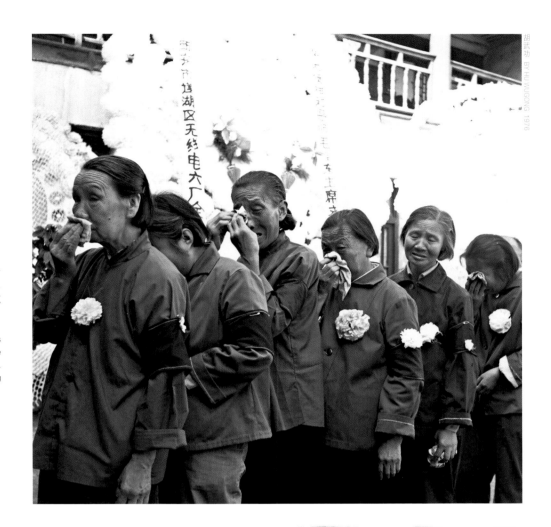

華國鋒接班
Hua Guofeng: Mao's Chosen Successor

　　1976年，中國的政治日曆旋轉得格外急迫：7月地震，8月批鄧，9月毛澤東逝世，10月，政治局勢更弦易轍。歷史會刻下華國鋒的名字──是他，與葉劍英、李先念、陳雲、汪東興等黨內元老在那個特殊的10月作出了大膽的決策，以非常手段解決「四人幫」問題。直至十五大，華國鋒依然高票當選中共中央委員；2007年，86歲的他仍是十七大特邀代表。可做歷史比較的是：去世時，訃告中對葉劍英和李先念的評價都是「偉大的無產階級革命家、政治家、軍事家」；華國鋒則是以「久經考驗的忠誠的共產主義戰士，無產階級革命家」來論定。

Mao's chosen successor Hua Guofeng became Chairman of the Communist Party of China in 1976 after the "Great Helmsman" died. Hua's most notable achievement was ousting the notorious Gang of Four, later jailed for crimes committed during the Cultural Revolution. But Hua's power waned within a couple of years, as he effectively retired from senior Party leadership.. Still, Comrade Hua, who died in 2008, is described by the Communist Party as an "outstanding CPC member, a long-tested and loyal Communist fighter and a proletarian revolutionary who once held important leading posts in the CPC and the government." Born in Jiaocheng, Shanxi province, in 1921, Hua joined the Communist Party of China (CPC) in 1938. He moved with the People's Liberation Army to Hunan in 1949 and remained there as a local official until 1971. Hua was called to Beijing to direct Zhou Enlai's State Council staff office in 1971, and when the latter died Hua was named Acting Premier. Less than a month after Mao's death, Hua arrested Jiang Qing and her followers. On the same day, he assumed the posts of Chairman of the CPC and the Military Affairs Commission. Hua was later denounced, however, for promoting the "Two Whatevers" policy, which called for adherence to the late Mao's instructions. He was replaced by Zhao Ziyang as Premier in 1980, and then by Hu Yaobang as Party Chairman in 1981. In early 2002, Hua officially lost his seat on the Central Committee of the CPC but he was invited to the 17th Party Congress in 2007 as a special delegate.

歡慶華國鋒擔任中共中央主席

1976年10月中旬，華國鋒任中共中央主席的消息傳到他曾經工作過的湖南省，引起全省轟動。省會長沙市率先冒雨遊行。人們在嚴密組織下舉着毛澤東和華國鋒二人的畫像，抬着毛澤東生前可能説過的「你辦事，我放心」和「毛主席無限信任華主席，全國人民熱烈擁護華主席」的巨幅標語，在雨中奔走。在華國鋒曾經任職的湘陰、汨羅、湘潭各地，遊行規模更大，人們情緒更為激昂。

People in Hunan Province marching through rainy streets in a show of support for Hua Guofeng, who assumed the posts of Chairman of the Communist Party of China and the Central Military Commission on October 6, 1976. They carried portraits of Hua and Mao, as well as banners reading, "With you in charge, my heart is at ease," words attributed to Mao as he lay on his death bed and believed to be his blessing of Hua's succession to leadership. Hua, a Shanxi native who worked in Hunan from 1949 to 1971, had risen from local official to provincial Party secretary.

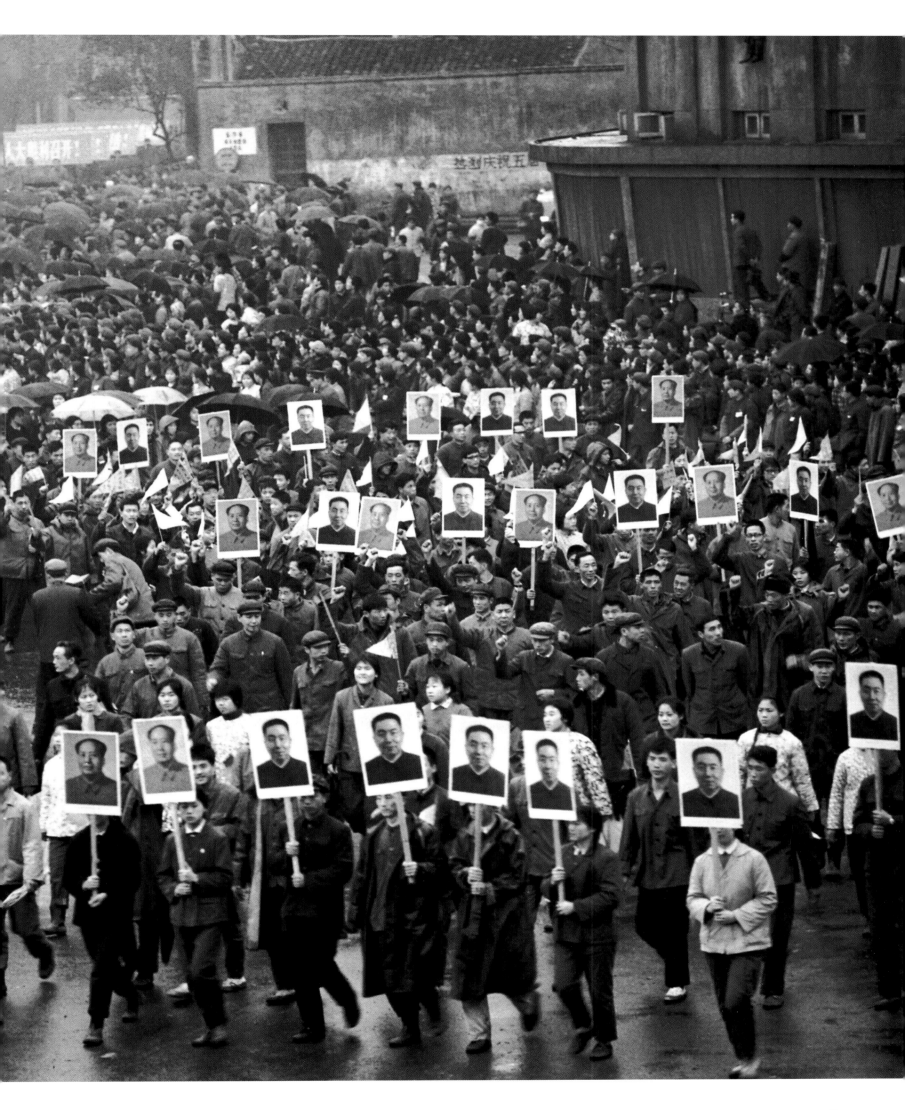

「四人幫」倒台
The Downfall of the Gang of Four

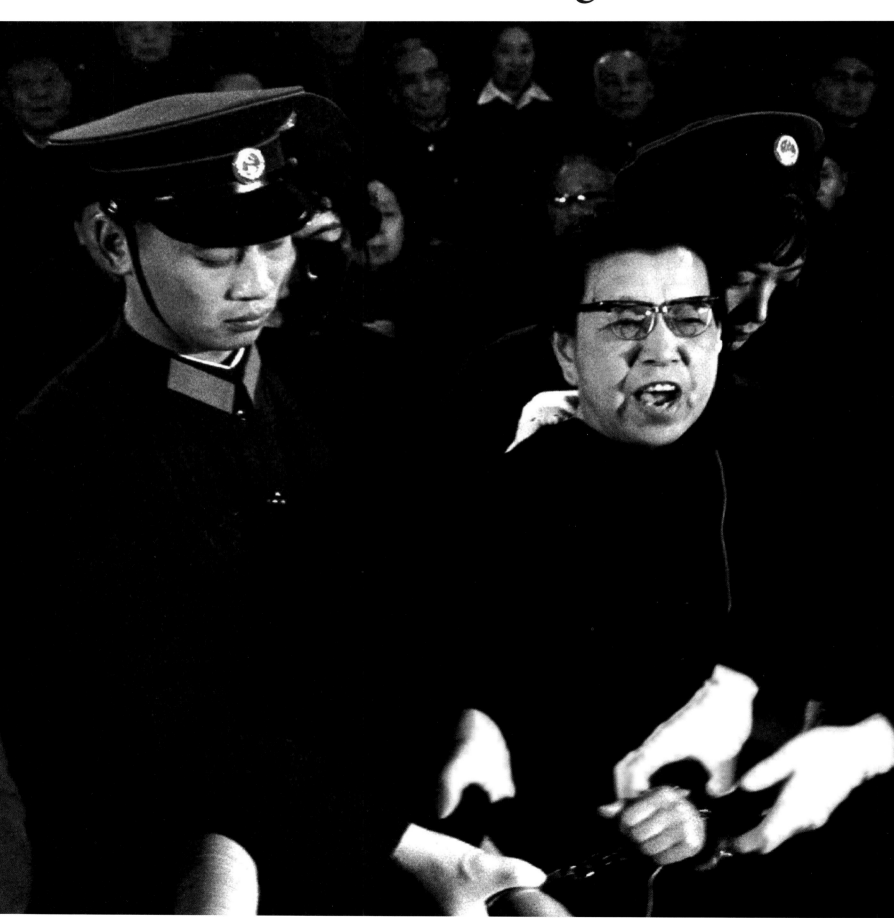

毛澤東主席去世不到一個月，以江青為首的中共黨內極左翼幫派被一舉剪除。全國民眾以可以想到的方式盡情表達歡欣，當時的話叫做「黨心民心所向」，今天看仍然一點都不誇張。如果説，沒有「四五運動」便沒有人民意願的大規模的公開表達，或許就沒有華國鋒們意志的決絕——這個説法還可以討論；而沒有粉碎「四人幫」就沒有道路的改弦易轍，沒有中國歷史新篇章的翻開——卻是毫無異議的。

The infamous Gang of Four, blamed for wreaking havoc on the nation during the Cultural Revolution, was made up of Mao Zedong's wife, Jiang Qing, former Vice Premier and Politburo member Zhang Chunqiao, former factory worker Wang Hongwen and Shanghai intellectual Yao Wenyuan. The four attempted to seize power after Mao's death on September 9, 1976, but less than a month later they were arrested on the orders of Mao's chosen successor Hua Guofeng. A massive media campaign was launched, blaming them for all the excesses of the Cultural Revolution. Jiang Qing is blamed for inciting the so-called Red Guards to attack the elite in society and imposing socialist themes on art. In 1981, the four were subjected to an emotionally charged show trial, in which Jiang Qing shouted out and burst into tears on occasion, and was convicted of anti-Party activities. Jiang Qing and Zhang Chunqiao received death sentences that were later commuted to life imprisonment, while Wang Hongwen and Yao Wenyuan were given life and 20 years in prison respectively. But they were all later released. All members of the Gang of Four have since died; Jiang Qing committed suicide in 1991, Wang Hongwen died in 1992, and Zhang Chunqiao and Yao Wenyuan died in 2005.

法庭公審江青

1980年11月20日，最高人民法院特別法庭開庭，公開審判以江青為首的「四人幫」反革命集團。

Mao's widow Jiang Qing, the leader of the Gang of Four, attempts to speak at her trial on November 20, 1980. The Supreme People's Court convened a special court to hold a public trial of Jiang on charges of conducting "counter-revolutionary crimes". She was sentenced to death, but this was suspended. Jiang Qing died in prison in 1991 in Beijing.

歡慶粉碎「四人幫」

1976年10月，歡慶粉碎「四人幫」的人們在遊行。這是中國革命歷史博物館的遊行隊伍在行進中。

People parade past Beijing's Tiananmen Gate to celebrate the arrests of the Gang of Four in October 1976.

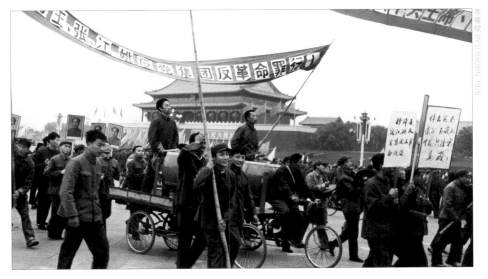

鄧小平復出
Deng Xiaoping Returns to Power

這是很難得的一張照片，「一代半」和「第二代」領導者們同在一幀畫面裡。今天的人們或許不大容易透徹理解當年的決策者作出抉擇時的複雜局面：舊有理論與現實需求的矛盾；歷史認知與現實呼聲的衝突；幹部和人才斷代至少有10年之距；國際環境的蹇促與國內經濟的困窘互為因果。但是，毛澤東去世與粉碎「四人幫」給予決策者難得的政治選擇空間；上下通同的變革呼聲給予決策者重大的變革基礎；再加上決策者明智地捕捉到國際格局演變的契機。終於，影響中國走向的決策得以形成。這一變，影響了這個偉大國家至少100年！

Deng Xiaoping (1904-1997) is the icon of the second generation of leadership in China since the founding of the People's Republic in 1949. He took power in 1978. Traditional Maoist theory ensured the focus of China's development was on the "construction of socialism" and class struggle. Deng's theory, however, emphasized economic construction and stability. His social and economic philosophy attempted to merge a market economic model with a socialist political system, in what became known as "socialism with Chinese characteristics". Deng opened China to the outside world following the closed period of the Mao years. He also oversaw the implementation of "one country, two systems" policy, which ensured the stable transition of European colonial territories back to Chinese sovereignty. Deng also uttered the phrase "seek truth from facts", advocating political and economic pragmatism. Controversially, perhaps more to the outside world than in China, Deng oversaw the decision to send in the troops to disperse Tiananmen Square protesters in June 1989. Some Chinese still contend that the sacrifice was worthwhile as it ensured stability, which they believe has enabled China to experience the levels of prosperity and well-being it enjoys today. If Chinese people think Mao Zedong pulled the nation together, it was Deng Xiaoping who pushed the country toward prosperity and modernity, setting it on the road to becoming one of the world's great powers.

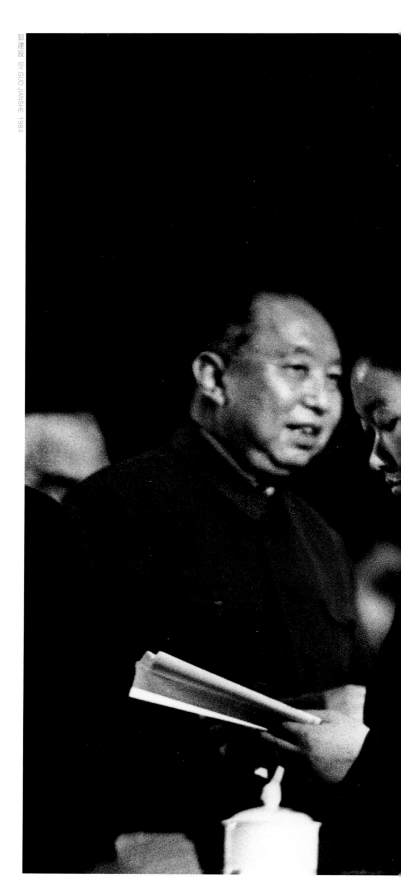

郭建設 BY GUO JIANSHE 1984

決策者

1984年全國人代會開幕式主席台上。

Deng Xiaoping at the opening ceremony of National People's Congress in 1984.

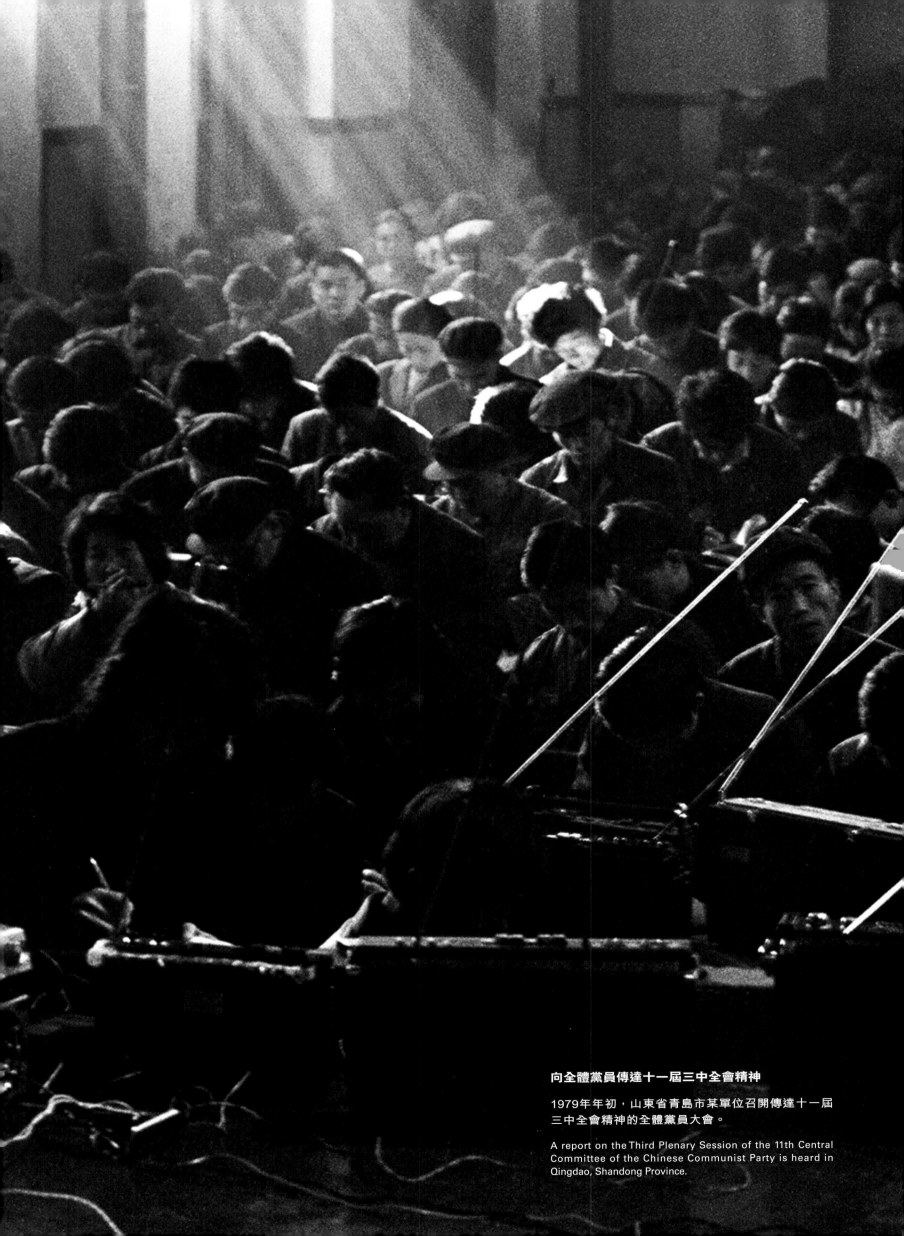

向全體黨員傳達十一屆三中全會精神

1979年年初，山東省青島市某單位召開傳達十一屆
三中全會精神的全體黨員大會。

A report on the Third Plenary Session of the 11th Central
Committee of the Chinese Communist Party is heard in
Qingdao, Shandong Province.

高考／競選
Back to School

　　1977年恢復高考是「文革」後關係千家萬戶也關係中國未來的一件天大的事！這正體現了教育於一個國家的意義：既聯繫着今天，又聯繫着未來。被「文革」耽誤的整整一代人，能夠通過考試而不是因為其身份走入高校大門，僅此便足以證明這個國家開始步入正軌。今天容易被人忽視的一件事是，1980年代初期，正值人民代表的換屆選舉，不少高校中掀起了一波競選人民代表的熱潮。這個幾十年後可以歸入「政治體制改革」的微小嘗試，最後無疾而終。不過，日後在中國政壇上留下重要痕迹的一些年輕政治家，已經在此時嶄露頭角。

　　College entrance examinations (gaokao) stopped in 1966, when the normal pace of the education system and other sectors of life in China were disrupted. In early 1970s, Mao Zedong realized that internal political struggle had taken too big a toll on the nation, and decided to resume the operation of universities. But the students were selected based on political and family backgrounds rather than academic achievements. This practice continued until the death of Mao in September, 1976. On May 24, 1977, Deng Xiaoping delivered a speech under the title, "Respect Knowledge, Respect Talent", in which he indicated the possible re-introduction of the national college entrance exam that had been stopped a decade before. Later that year, more than 5.7 million candidates, ranging from age 15 to 36, took the exam. Another 5.9 million sat for the exam in the summer of 1978. But with only 401,000 candidates from the two exams enrolled at universities, they had a one-in-29 chance of success. The gaokao was more than just an examination system; it was a symbol of social equality and justice.

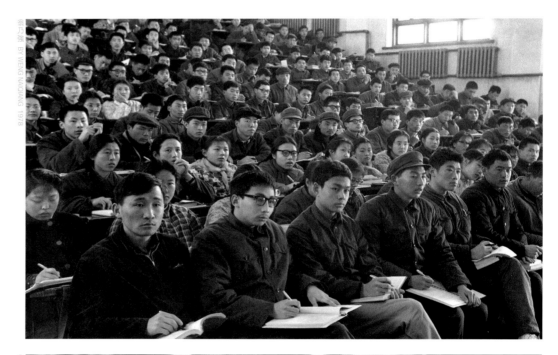

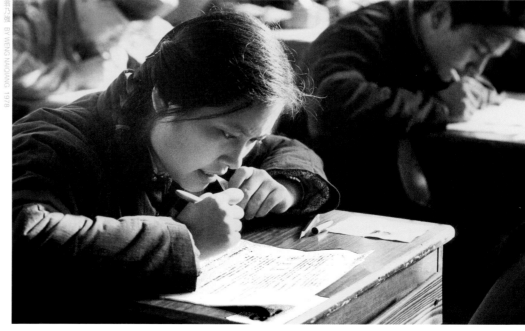

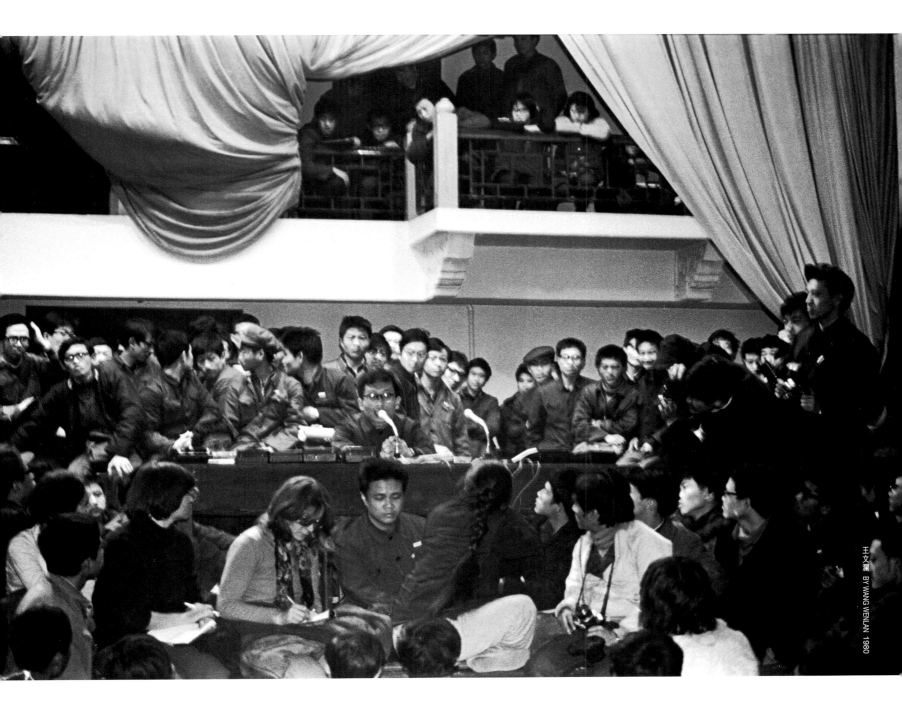

王文瀾 BY WANG WENLAN 1980

北京清華大學 1977 級新生在上課

1966年6月，中國高等院校停止招生，研究生招生和選派留學生的工作同時停止。1966～1977年，中國的大學教育幾近癱瘓，沒有經過統一正規考試的大學生在校學習。1977年8月，剛剛復出的鄧小平主持召開科學與教育工作座談會，決定恢復中斷10年之久的高考。1977年冬，570萬考生走進考場；1978年夏，又有590萬考生參考。兩季考生共1,160萬人，錄取新生40.10萬，平均考錄比例為29：1。1978年2月，恢復高考後的第一批大學生入校上課。圖為清華大學1977級學生在階梯教室上課。

Newly admitted students attending a lecture at Tsinghua University in Beijing in 1977.

文革後的第一批考生

1977年恢復高考，眾多考生參加了考試。

The first college hopefuls sit for exams after the reinstatement of national college entrance examinations in 1977.

北京大學掀起學生競選人大代表熱潮

1980年，北京大學學生競選活動現場。學者錢理群曾有長文《不能遺忘的思想》，記述了當年北京大學學生競選海淀區人大代表的活動。錢理群認為這次競選活動是1949年以來中國政治史上唯一的一次真正的民主選舉。這一勇敢的民間改革嘗試被塵封多年，至今不為社會公眾所知。

Students of Peking University holding an election for a deputy to the People's Congress of Beijing's Haidian District in 1981. It was said to be the first democratic election in Chinese political history since the founding of the People's Republic of China in 1949.

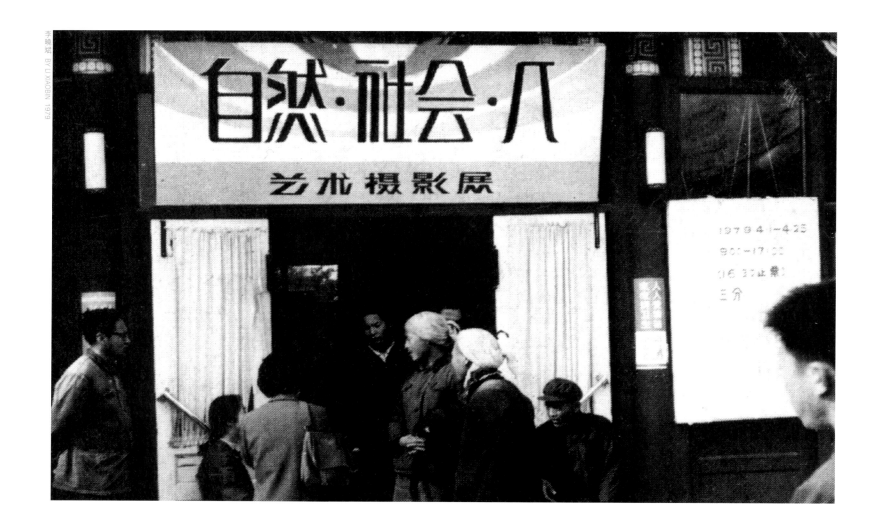

解凍
A Revolution in Art

　　1977～1978年，北京民間思想空前活躍。繼「自然・ 社會・人」影展公開展出以後，「星星畫展」在街頭的展出也引起人們的關注，還包括油印的《今天》、《沃土》等民間雜誌。一批年輕的文化人因為感受的痛切和思想的敏銳，成為試水「春江」的頭一批「鴨子」。當時，他們的遭遇是共同的，既招惹來尖銳的批評和非議，也得到體制內的默許和扶助。「解凍」，這是當時人們喜愛使用的詞語——確實，思想上的冰河的確開始融化了⋯⋯

　　The Chinese Communist Party has had an uneasy relationship with art ever since it took power. For many years throughout the Communist Revolution, artists and performers were suppressed as "bourgeois rightists" and thus seen as a threat. Before ruling the country, in 1942 Mao Zedong announced the official canon of Chinese Socialist Realism, a form of propagandistic art which has since become fashionable in the West for its romantic retro appeal. Mao declared that art was no longer meant for intellectuals and the refined literati, but for "the masses". His rules required artists to give up any form of individual self-expression. Later, during the Cultural Revolution (1966 – 76) many artists suffered criticism and were sentenced to periods of hard labor in the countryside. It wasn't until the end of the tumultuous period that was there any cultural thaw. In 1979 a momentous event took place in China's art world. After being stifled for more than 30 years, a group of experimental artists and photographers, who saw themselves as pinpoints of light in an endless night, organized two exhibitions that broke the stranglehold of Communist Party orthodoxy and set the stage for the future freedom of artistic expression in China.

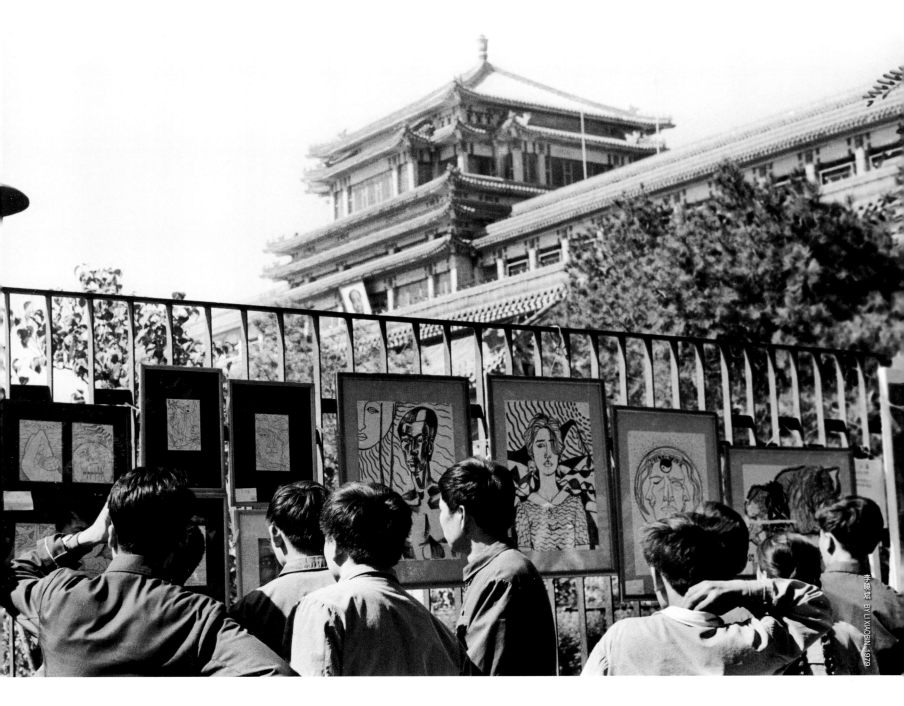

李曉斌 BY LI XIAOBIN 1979

「四月影會」首展盛況空前

1979年4月，一批業餘攝影人發起組織了「四月影會」，主辦的第1屆《自然·社會·人》影展在北京中山公園蘭室展出，當日參觀者近千。

The "April Photographers Group", the first photography organization independent of the government, held its first exhibition, "Nature, Society, People" in Beijing's Zhongshan Park in April 1979.

美術館外的美術展覽

1979年9月中國美術館外，來自民間的街頭美術展覽——《星星美展》同時開展。此展覽與同時期的「四月影會」、「無名畫會」迎春畫會展，文學作品的《班主任》（短篇小說，作者劉心武）等，共同構築了新時期文化藝術的回歸與覺醒。

The "Stars Painting Group", one of the first non-official collectives of artists, holds an exhibition outside the National Art Museum of China in Beijing in September 1979.

老幹部
Senior Cadres

　　「文革」結束的重要標誌之一，便是大批老幹部重新走上工作崗位。一場浩劫，使他們中的大多數人身心俱遭創痛。因此，當他們被重新起用之後，其意氣風發是可以想像也足堪觀瞻的。事實上，大批老幹部的解放，既是結束「文革」的政治舉措，也是進行經濟建設的必須——在「文革」中斷正常的高等教育以後，建設的需求使缺乏成熟管理幹部的現實一下子暴露出來。老幹部復出是1980年代初的一項政治景觀和經濟景觀，中國的幹部平均年齡一下子長了10歲。這也使年輕幹部的培養被提上議事日程。胡錦濤便是在當時作為「第三梯隊」進入以共青團為平台的中國政治舞台的。

　　Many senior cadres — that is, older experienced managerial personnel, government officials, and Party or PLA officials — including those who had helped establish the PRC, were removed from their posts and wronged or persecuted during the Cultural Revolution. The return of these senior cadres to their posts was a sign that the Cultural Revolution had truly come to an end. Not only were the reinstatements a proper righting of injustice, they were a downright necessity in a country newly rededicated to economic development and lacking managerial talent after the interruption of higher education. Their return raised the average age of China's corps of cadres by ten years, and focused attention on the need to cultivate young leaders for the future. It was in this context that Hu Jintao came to the leadership of the Communist Youth League, launching him onto the national political stage.

　　Some believe that Mao's suspicion of intellectuals and experts stemmed from severe paranoia, and fear that intellectuals were the greatest threat to his and the Communist Party's monopoly on power. The Hungarian Uprising in Eastern Europe — which Mao viewed as the doing of intellectuals, encouraged by Soviet leader Nikita Khruschev's moderate line – provided a cautionary example for China. It was in this atmosphere of suspicion and insecurity that many intellectuals were attacked or accused of treachery during the Cultural Revolution. It was not until after Mao died in 1976, that many were rehabilitated and returned to their positions.

老幹部平反解放把歌唱

1980年12月6日，一群老戰士、老幹部、老知識分子在首都的舞台上縱情高歌。「文革」結束兩年來，大批冤假錯案紛紛昭雪平反——在「文革」中遭受政治迫害的人們，稱其為第二次解放。

Veterans, senior intellectuals and elderly cadres singing in Beijing, December 6, 1980. During the Cultural Revolution many of them had been wrongfully attacked or accused. They were later rehabilitated and returned to their positions.

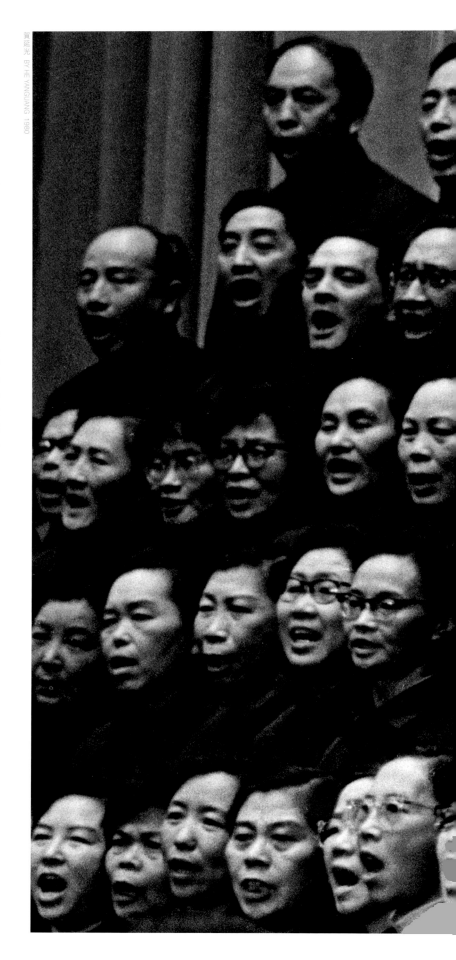

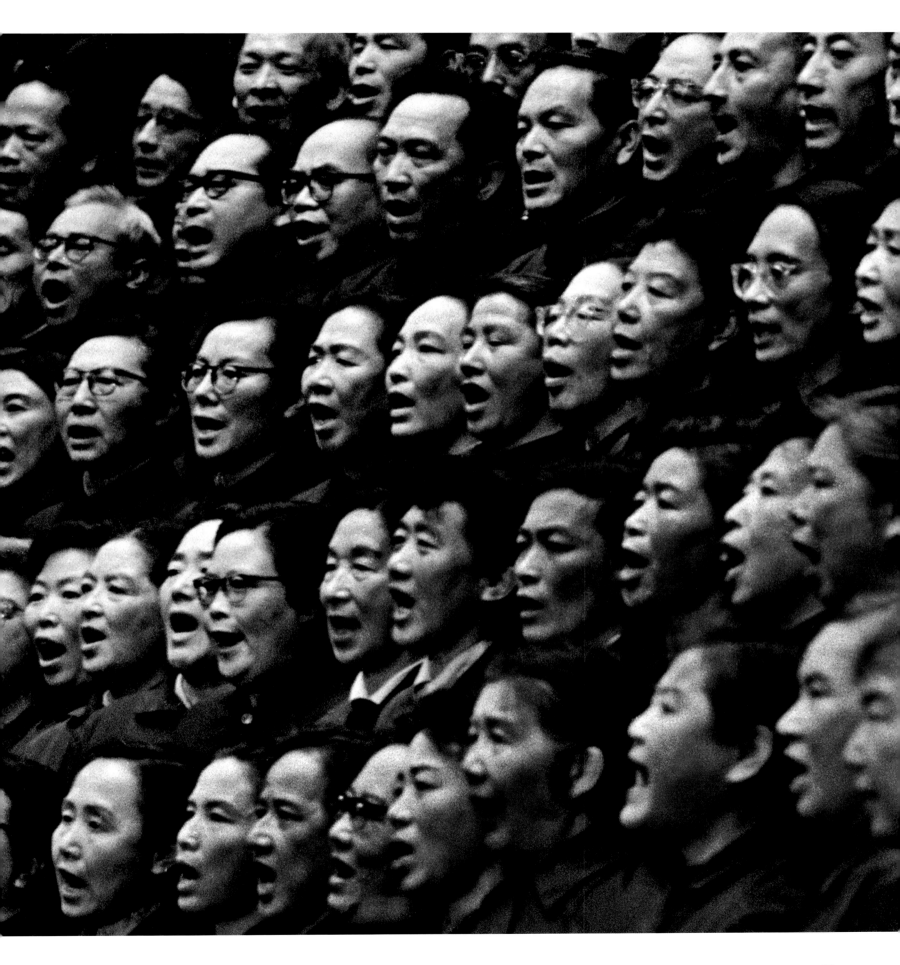

劉少奇
Liu Shaoqi Discredited, Then Rehabilitated

　　這是共和國歷史上黑暗的一頁：儘管他舉起《憲法》試圖申明自己起碼的權利，但依然被瘋狂的潮水淹沒了。劉少奇作為共和國主席，他的死被稱作「文革」中最大的冤案，由是，人們對國家的法治、公民的權利有了刻骨銘心的反思。

　　Liu Shaoqi died in shame in 1969, having been expelled from the Communist Party by Mao Zedong a year earlier. Liu was an ally of Deng Xiaoping and found himself at odds with Mao over his liberal economics. Before falling out of favor, though, Liu had progressed to a high position. He became First Vice Chairman and was picked as Mao's successor in 1961. He also announced the Great Leap Forward. His downfall came in 1966, having been displaced by Deputy Party Chairman and military chief Lin Biao, who later died in a plane crash as he fled China for Russia. Liu and his wife Wang Guangmei were placed under house arrest in Beijing in 1967 and he was stripped of all his positions.

　　But Liu was on the right side of history, as in 1980 he was posthumously rehabilitated by his comrade Deng and given a full, but belated, state funeral. Liu was born in Ningxiang, Hunan Province, in 1898. He joined the newly formed Communist Party of China in 1921 and worked mainly in Party organizational and theoretical affairs. An orthodox Soviet-style Communist, he favored state planning and the development of heavy industry. However, amid growing disenchantment with the Great Leap Forward, Deng and Liu gained influence and embarked on economic reforms that bolstered their prestige among the Party apparatus and the national populace.

淚別少奇

1980年5月19日，劉少奇骨灰海葬儀式在山東青島舉行，夫人王光美和子女們拋灑骨灰時悲痛萬分。

Liu's widow, Wang Guangmei, and his children spread his ashes at sea off the coast of Qingdao, Shandong Province, on May 19, 1980.

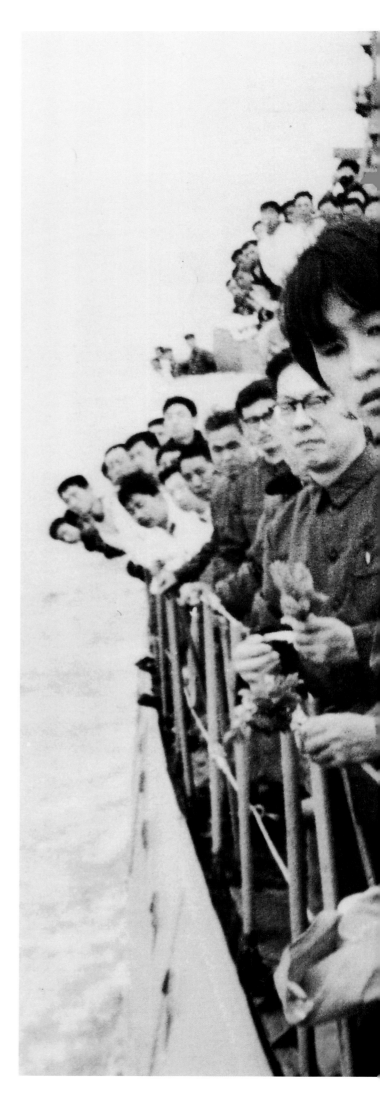

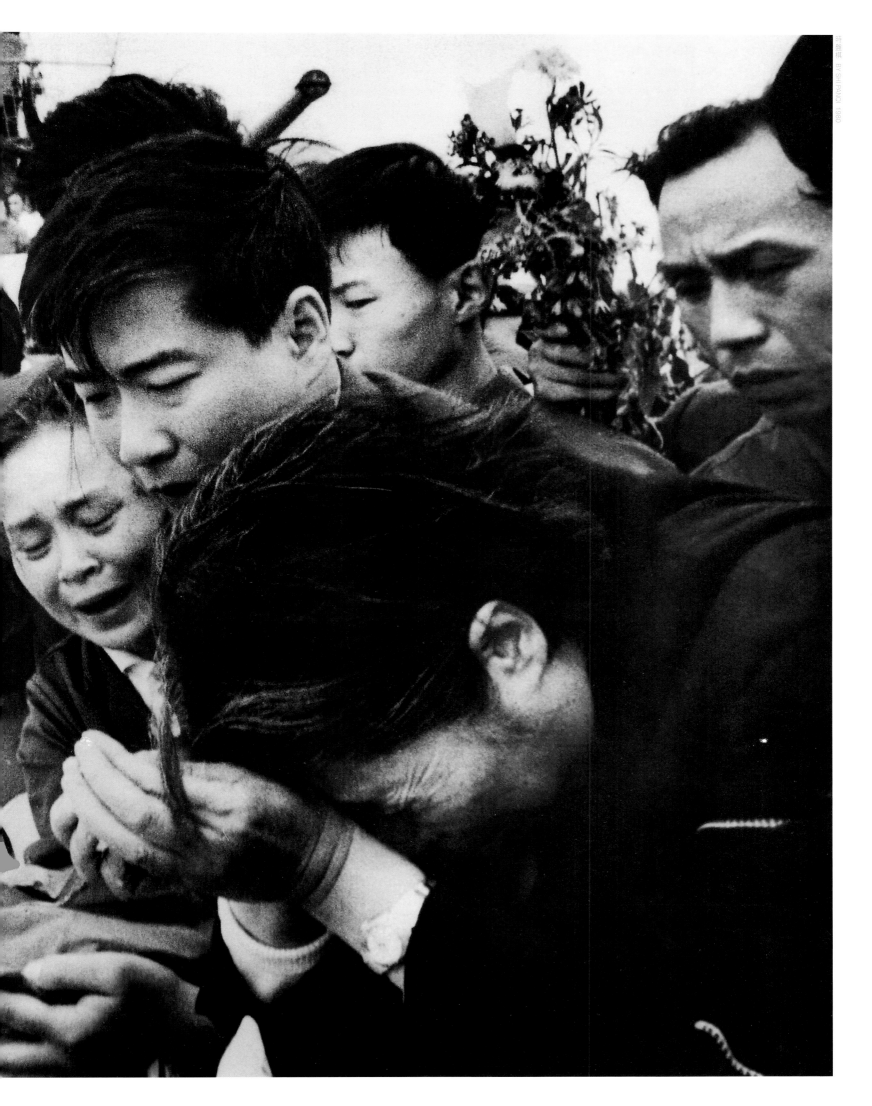

地震棋 BY SHI PANOI 1980

首次劃分責任田

1982年春，山東省青島嶗山刁龍嘴村村民正在村幹部的帶領下丈量土地。

Farmers in Diaolongzui village, Shandong Province, measuring their allotted land with village leaders in the spring of 1982.

再次調整責任田

1992年2月11日，陝西省志丹縣杏河鎮楊家嶺村在第一次責任田劃分的基礎上再次進行土地調整。

Farmers in Yangjialing village, Shaanxi Province, readjust their land measurements, February 11, 1992.

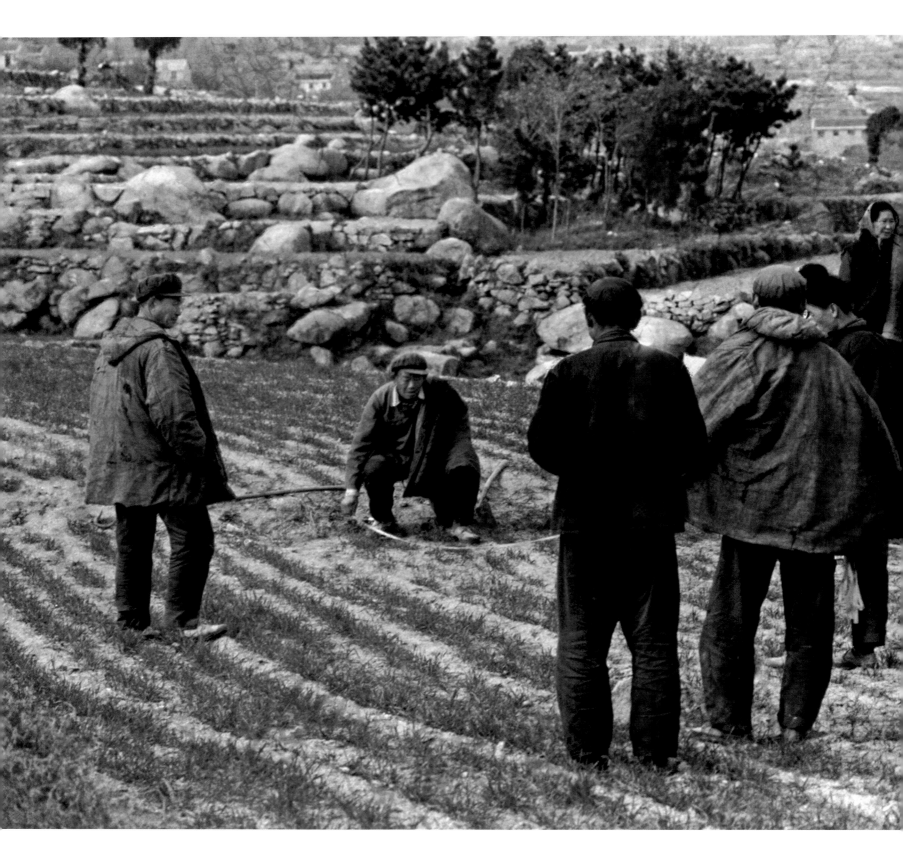

丈量
Getting a Measure of Things

　　1980年代初期，中共連續 3 年制定的 3 個「 1 號文件」都是關於農村政策的。中國的改革率先從農村開始，這也是這個農業大國步入發展的必由之路。無論聯產計酬還是土地承包，技術上總是從土地責任人的明晰責權開始的。有專家說，1949年的土地改革解放農民生產力，是從推翻封建性的地主土地所有制開始的；而1979年的解放農村生產力，則是從打碎大鍋飯式的土地所有制開始的。農民生產積極性的提高促使農業產量連年提高，為之後的城市改革提供了較為充足的物質基礎，也使農民成為中國改革的最初受益者。

　　Land reform has characterized rural China since the founding of the People's Republic in 1949. This took the form of three major farmland initiatives. First came the radical farmland revolution in the early 1950s, in which land was seized from landlords and distributed to landless peasants. China had finally achieved the goal of tillers working their own land — the dream of Chinese farmers for thousands of years. Like other socialist countries, China based its farmland policy on the Soviet Union model, characterized by collective ownership and unified collective operation. To reach this target, China carried out its second land reform, a campaign of collectivization in the mid-1950s. During the process individual farmers joined collectives. The collectivization finally developed an institution called the "People's Commune". But with centrally controlled property rights and a misapplied egalitarian principle of distribution, the communes destroyed farmers' operational freedom and, importantly, their enthusiasm for production. By the end of the 1970s, China had launched economic reforms led by rural reform. China ditched the Soviet model, introducing a family-based contract system, known as the "Household Contract Responsibility System". This system proved successful in generating incentives for production by giving farmers freedom of land use rights and decision-making, with rewards linked to performance. This dramatically revived China's agricultural sector, which in later years, however, began to face problems linked to development, such as shrinking arable land.

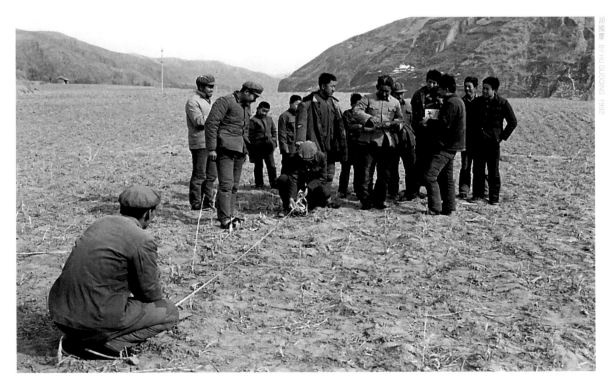

責任田裡播種忙

河南省宜陽縣董王莊鄉。一戶村民使用傳統的農具在收過小麥的地裡播種玉米。

Farmers using traditional methods to work their field after the harvest.

趕馬蹚河運煤去

當地資源也是「承包」的內容之一。雲南省昭通大水溝，不通公路的山裡，只能靠馬運送燃煤等生活物資。

Farmers journeying to the market to sell their produce.

聯產承包
Reasons to Work

　　「聯產承包」就是把原來人民公社「一大二公」的土地所有制關係,解構為以農民家庭為單位,鎖定上繳基數,餘糧歸己的生產制度。未來記述中國歷史的時候,在「一條鞭」、「租庸調」等等地畝田稅制度之後,一定會有「聯產承包」的地位。當年講「國家、集體和個人」,歷史地看,最終就是國家與農民之間的資源分配關係。好的制度,國富民強;壞的制度導致國貧民窮。但往往制度設立者的初衷與結果兩立——避免崩潰,國策的重大變動就在孕育之中了。1980年代國家的農業政策調動了農村和農民的積極性,極大活躍了農村經濟,使得農民有機會休養生息,這是歷史證明了的,只是這過程迄今還未有窮期。

Farming in China underwent a big change in the very early days of reform with the introduction in 1981 of the Household Contract Responsibility System. The dismantling of the commune system, and redistribution of land to farming households (with the chance to keep some of their produce to consume or sell) offered new work incentives for the rural population. Although this system, which served as a test balloon for reforms in other economic sectors, has been a great success in helping to revive China's agricultural economy, it also has had some limitations and weaknesses. For one, the distribution resulted in tiny and fragmented farm units, and large areas of cultivated land were wasted in the creation of the paths and boundaries separating the holdings. For another, a person was eligible for land based on their status as a villager (no matter when it was obtained), so villages had to readjust the distribution structure to accommodate more people as their populations grew. These problems have grown in areas where industrialization and urbanization have taken off, with people leaving the villages to find more lucrative work in factories. These issues have prompted the leadership to look toward finding new solutions through further reform.

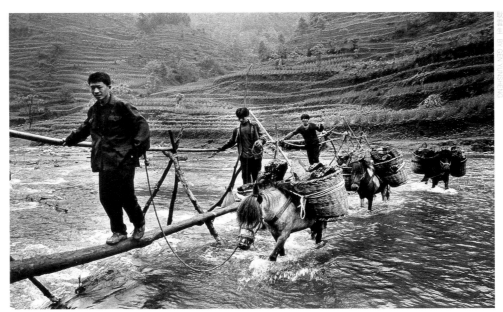

鄧小平訪美

1979年1月，時任國務院副總理的鄧小平抵達美國，進行正式訪問。30年後，據隨行的新華社攝影記者回憶，訪美時的鄧小平處處體現偉人風度，在接受外國記者採訪時非常自信，不看講稿，直接面對着攝像機發表演講。

Vice Premier Deng Xiaoping, touring Washington, D.C. during his official visit to the United States (from January 29 to February 4, 1979) at the invitation of President Jimmy Carter. Deng was the first Chinese leader to visit the United States since the founding of the People's Republic of China in 1949.

訪美

Deng Xiaoping Visits the United States

1979年1月，鄧小平訪美。比起1975年他去聯合國大會講話，這一次更有些不同凡響。1975年他是來講「三個世界」的理論，1979年他是來奠定兩個國家的未來關係；1975年他是政府副總理，1979年他是中國事實上的最高領導人。中國改革開放需要相對有利的國際環境，而此前的中國戰略一直是建立在「戰爭不可避免」、「要準備早打、大打」基礎上的。怎麼能夠在戰爭的陰影下進行一個國家整體上的大規模建設呢？現在看，1970年代末，鄧小平做了兩件重要的事。一件事是在理論上指出「現在看戰爭有可能打不起來」、「要爭取和平的國際環境」；一件事是走出了在新的戰略格局下恢復中美關係的決定性一步。

After Deng Xiaoping took power, relations with the capitalist West improved dramatically. Although Mao Zedong hosted President Richard Nixon in Beijing in 1972, no Communist Party chairman had ever traveled to the United States. This all changed when Deng became China's leader. Deng traveled to the United States in 1979 to meet with President Jimmy Carter at the White House. While in Texas on this tour, he was famously photographed in a large Stetson at a Houston rodeo. The visit came shortly after the United States had broken diplomatic relations with Taiwan and recognized the People's Republic of China (PRC) under the Communist Party as the sole Chinese government — eight years afterthe PRC had been recognized by the United Nations Security Council.

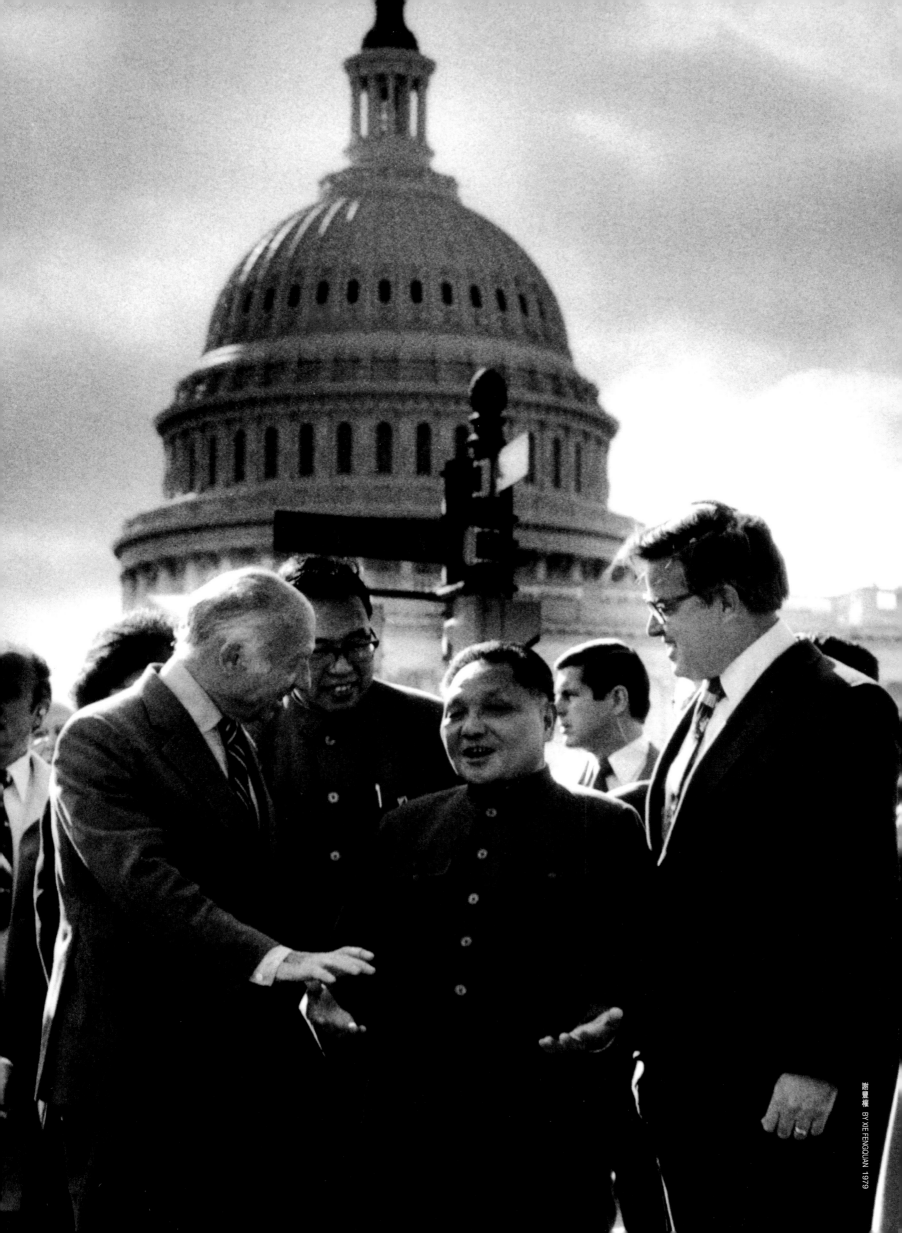

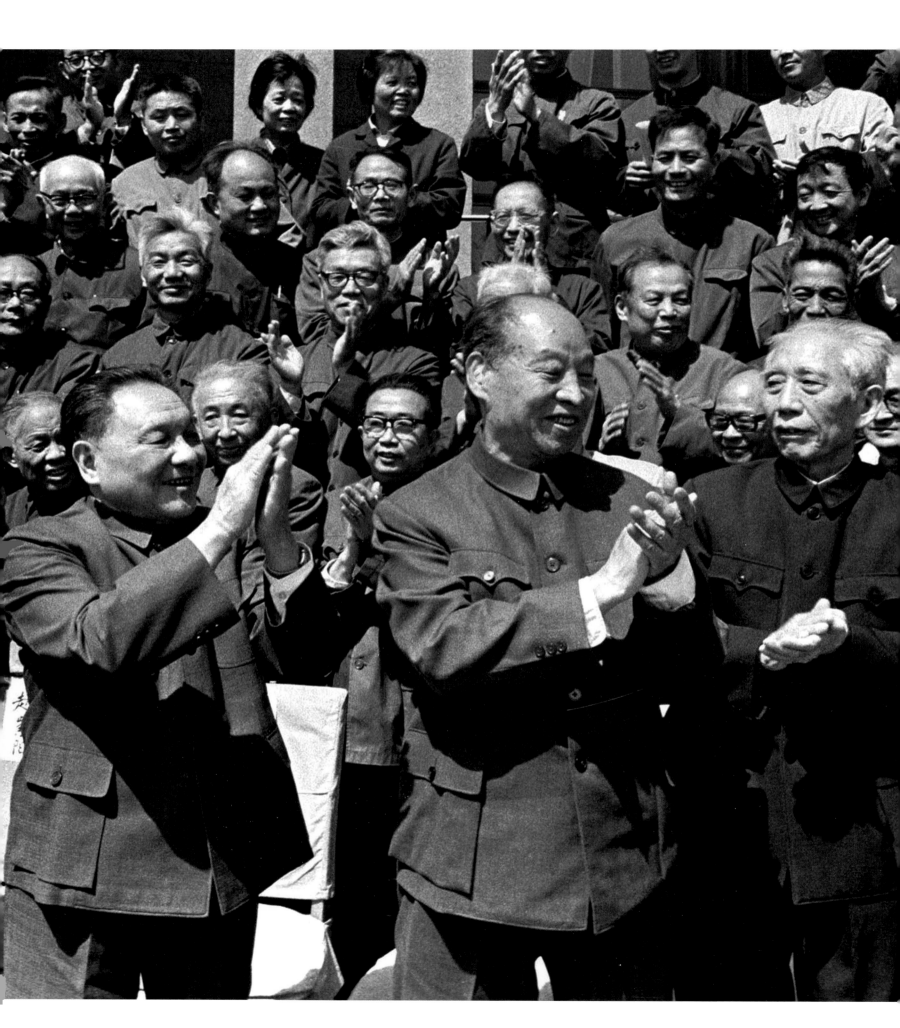

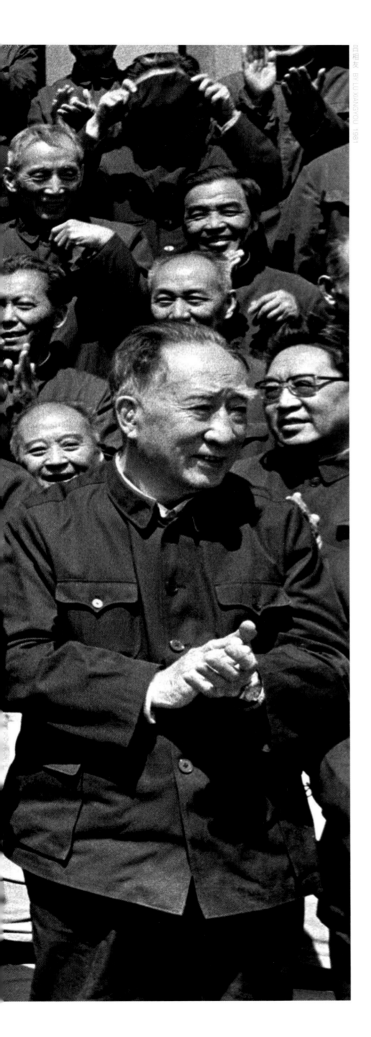

BY LU XIANGYOU 1981

老一輩
Capitalizing on Experience

　　被稱作「老一輩革命家」的一代人，在1980年代初期復出。這個以鄧小平為核心的群體又被稱作「中共第二代領導人」，繼毛澤東、劉少奇、周恩來之後執掌國家大脈。這一代領導人深知中國發展的肯綮所在，且對制度的顢頇有切身感受，於改革大政有共識，但在具體的尺度、時機以及經濟發展與意識形態發展的關係上，有孰輕孰重之把握——這些把握，或可成為解釋1980年代幾波意識形態之爭的鑰匙。無論如何，作為承上啟下的重要一代，他們開啟了中國新歷史的大門，而且使一批更年輕更開明的領導人登上中國政治舞台。

　　In the 11th Congress of the CPC Central Committee, Deng was surrounded by senior revolutionaries who had been instrumental in the founding of the People's Republic, and had been in leadership positions since 1949. Deng, at the center, was supported by talented officials such Chen Yun, Ye Jianying, Li Xiannian, Yang Shangkun, Bo Yibo, Song Ping and Peng Zhen. Most of these politicians had positions of authority during the Cultural Revolution, although as a rule those who held power after the 1980s had been purged during the upheaval that began in 1966. This "second generation of CPC leaders" turned the focus from class struggle and political ideology to economic reform and development. The dominant political ideology of the era was Deng Xiaoping Theory.

科學的春天來到了

1978年，在全國科學大會上，鄧小平提出科學技術是生產力、科學技術現代化是實現四個現代化的關鍵、知識分子是工人階級的一部分等重要論述。1981年，中國大陸恢復博士研究生制度。圖為鄧小平、彭真、薄一波、王震等在北京會見兩院院士。

In a speech at the opening of the National Conference on Science in 1978, Deng Xiaoping said that science and technology were key to China's modernization: "Intellectual workers who serve socialism belong to the working people." The system at universities for designating seniority and academic standing based on graduate degrees and doctorates was resumed in 1981. Deng Xiaoping (left), Peng Zhen, Bo Yibo and Wang Zhen greet academicians of the Chinese Academy of Sciences and Chinese Academy of Engineering.

論衡
The Distribution of Power

　　1980年代中國政治的最核心之處就在畫面上這10位領導人之間。具體說：以鄧小平、陳雲、李先念、葉劍英、彭真、聶榮臻、薄一波、楊尚昆8位壓陣的老人，與胡耀邦、趙紫陽兩個在前台的操作者。中國是一條大船，在現代化道路上的轉向，是一個艱難、複雜，既要加速又要保持平衡的非同尋常的操作過程。

　　While high-profile leaders like Mao Zedong and Deng Xiaoping are foremost in people's hearts, running a huge country like China requires much effort by unspoken actors backstage. The ten leaders pictured here made up China's political core in the 1980s.

胡耀邦匯報工作

時任中共總書記的胡耀邦在向8位老同志匯報工作。左起：趙紫陽、彭真、陳雲、聶榮臻、胡耀邦、葉劍英、薄一波、鄧小平、楊尚昆、李先念。

Hu Yaobang (center), who was made Party Chairman in 1981, adhered to the principles of collective leadership and decision-making. All important affairs were discussed among China's central leaders, the Standing Committee of the CPC Politburo. Hu was also appointed General Secretary of the Communist Party of China in 1980. (From left) Zhao Ziyang, Peng Zhen, Chen Yun, Nie Rongzhen, Hu Yaobang, Ye Jianying, Bo Yibo, Deng Xiaoping, Yang Shangkun and Li Xiannian.

萬里
Wan Li, a Pioneer of the Land

　　中國改革的最初推動，究竟是「自上而下」還是「自下而上」，學說不一。不過說是上下呼應，上下通同應不為過。安徽省鳳陽縣小崗村農民偷偷按手印搞分田到戶，沒有省委書記萬里的實際支持，恐怕真是要大禍臨頭的呢。在中國農業經濟幾乎崩潰，而政治高壓線使人動輒得咎的時刻，作為領導者敢於實事求是，以民為本，真是需要膽魄和智慧的！改革經年，啟動最難。萬里先在鐵道部後在政府及全國人大崗位上，多出急難險重之任。而今看去，應自難忘。

The pioneer of land reforms that guide China today, Wan Li, like many Chinese politicians in the last half century, had been purged and rehabilitated. He returned to positions of power in Beijing in 1973. He was named Minister of Railways in January 1975 and First Vice Minister of Light Industry in 1977. In May of that year, he took over as First Secretary of the Communist Party in Anhui Province, and it was here that he instituted the earliest post-Mao agrarian reforms. He introduced the contract responsibility system in which communal land was divided and assigned to individual farmers. Zhao Ziyang later adopted the initiative in Sichuan Province before it took off as national policy. The central government lauded the Anhui agricultural reforms as a brilliant innovation.

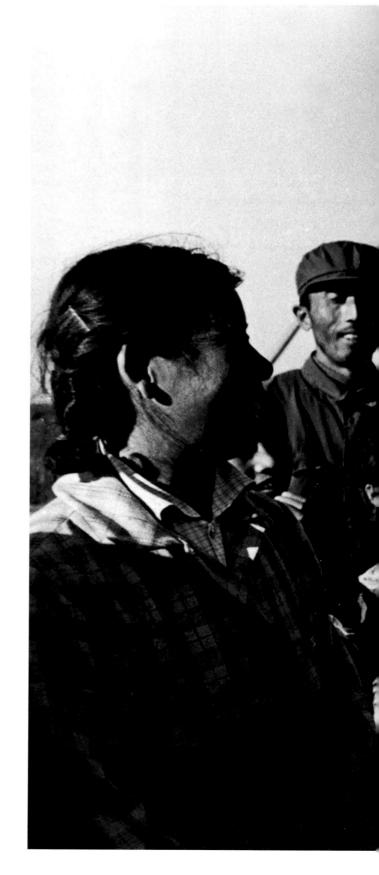

萬里在農村視察

1977～1980年，萬里在任中共安徽省委書記期間，數度深入農村視察調研。時至1990年代末，萬里對此仍記憶猶新：「原來農民的生活水平這麼低啊，吃不飽，穿不暖，家徒四壁。我真沒料到，解放幾十年了，不少農村還這麼窮！我不能不問自己，這是甚麼原因？這能算是社會主義嗎？」

Wan Li, on one of his many inspection tours to the villages during his tenure as Anhui Party Secretary from 1977 to 1980.

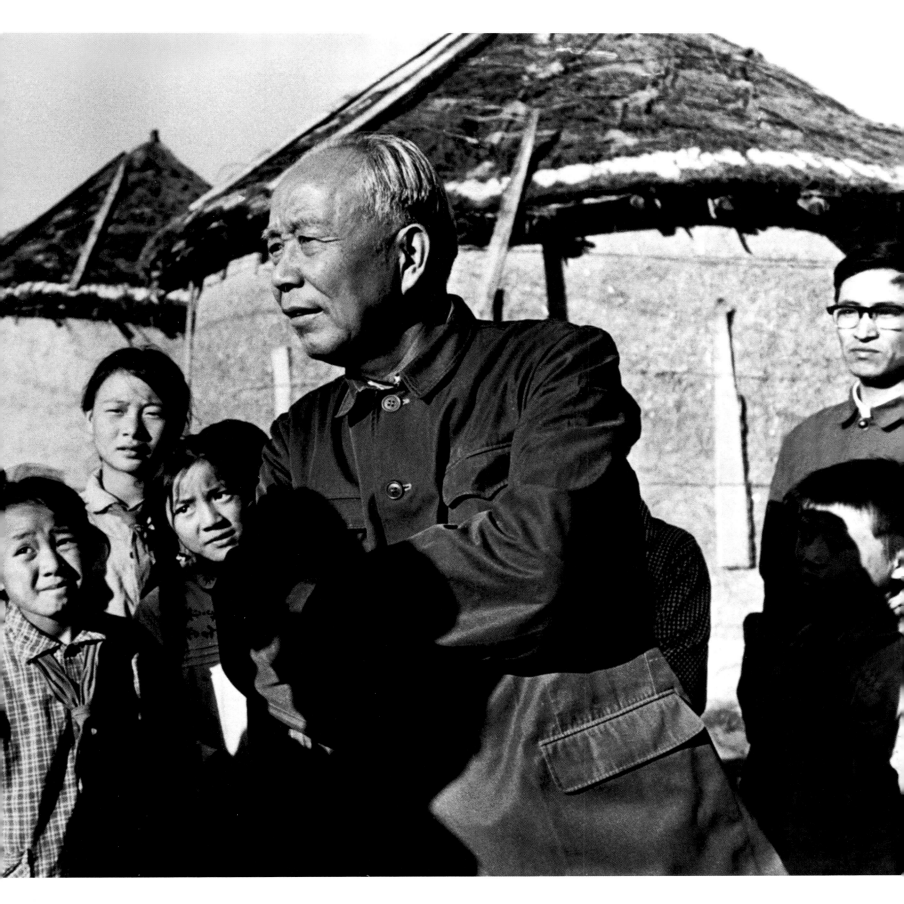

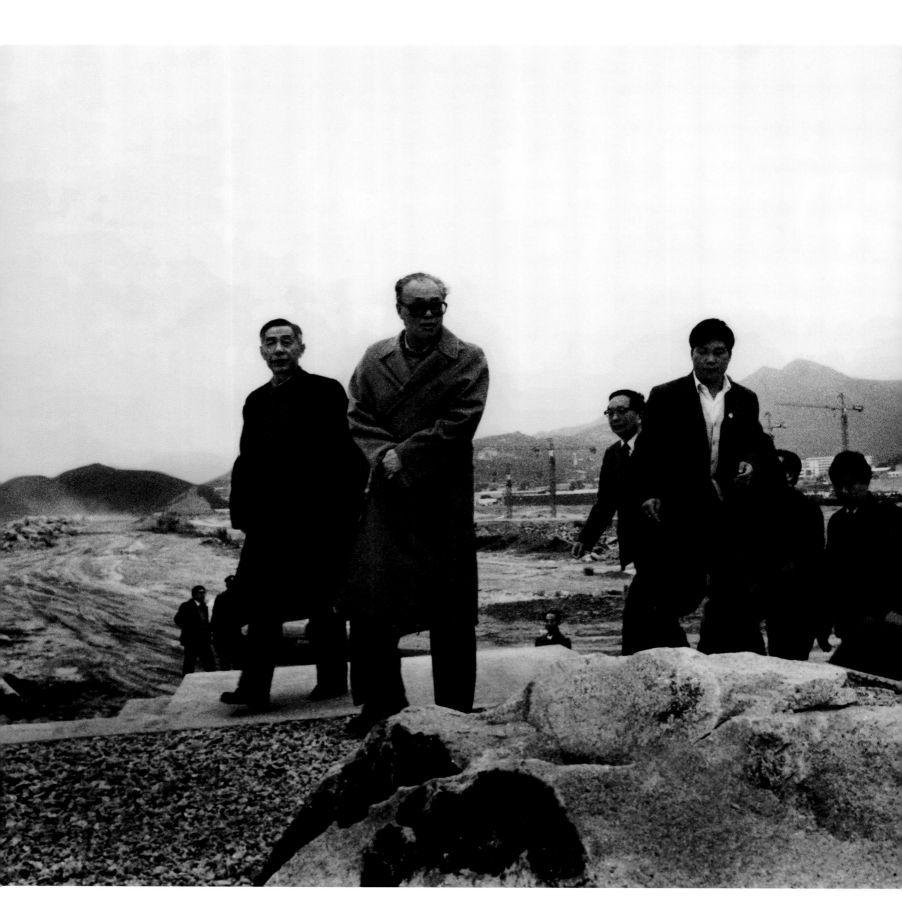

趙紫陽
Zhao Ziyang, Trials and Tribulations

在隱匿了17年之後，有關趙紫陽去世的消息中說明他「擔任過黨和國家的重要領導職務」。曾經，文革前，40多歲的趙就任職廣東省黨的領導；文革後，他在四川、廣東力行農業改革和經濟發展，因為成績斐然而躋身政府和中共的最高領導職務。這是一個在歷史上留下重要痕迹的領導人，在回顧中國30年發展歷程的時候，不能無視他的貢獻。1989年，因在「政治風波中犯了支持動亂和分裂黨的錯誤，對動亂的形成和發展負有不可推卸的責任」，趙去職。

Zhao Ziyang's "memory lives on today in the form of a controversial political diary that details his view of the decisions taken by the leadership during the Tiananmen protests in 1989. CPC General Secretary Zhao was dismissed toward the end of June 1989 for "his unshirkable responsibilities for the development of the turmoil" and of "the serious nature and consequences of his mistake". Having fallen out of favor with the political establishment, Zhao was placed under house arrest for 15 years. When he died of illness in 2005, he was buried without the funeral rites normally accorded to senior politicians in China. Zhao was famously pictured on Tiananmen Square with current Premier Wen Jiabao appealing to the student protesters. Born in Huaxian County, Henan Province, in 1919, Zhao joined the Communist Party in 1938. In 1955 he was transferred to Guangdong and became the first Party Secretary of Guangdong Province. Under his leadership, Guangdong was among the first provinces to return to guaranteed private plots, free rural markets, and contracting output to households. Later he was transferred to Sichuan, where he championed the household production responsibility system, which related peasants' performance with their remuneration. He was promoted to Vice Premier in April 1980 and Premier in September of the same year. Zhao replaced Hu Yaobang as CPC General Secretary in 1987. But due to his later untenable position, Zhao was replaced by Jiang Zemin, who went on to become President.

趙紫陽視察大亞灣核電站

1988年2月18日，時任中共中央總書記的趙紫陽在田紀雲陪同下來深圳，其間曾到大亞灣核電站工地現場視察。大亞灣核電站規劃之初，一度引起香港百萬人簽名、遊行反對興建大亞灣核電站。香港新華社社長許家屯給中央寫報告，說為確保香港平穩過渡，建議撤銷此項敏感計劃。時任總理的趙紫陽最後請示鄧小平，鄧批示「他反他的，我建我的」，一錘定音。

General Secretary of the CPC Zhao Ziyang (second from left) inspects construction of the Dayawan Nuclear Power Plant on February 18, 1988. The plant — China's first large commercial nuclear power plant — was built to the east of Shenzhen, Guangdong Province. Construction began on the plant, a joint venture with France, in August 1987 and its two generating units were put into operation in 1994. It provides 70 percent of its electricity to Hong Kong and 30 percent to Guangdong Province.

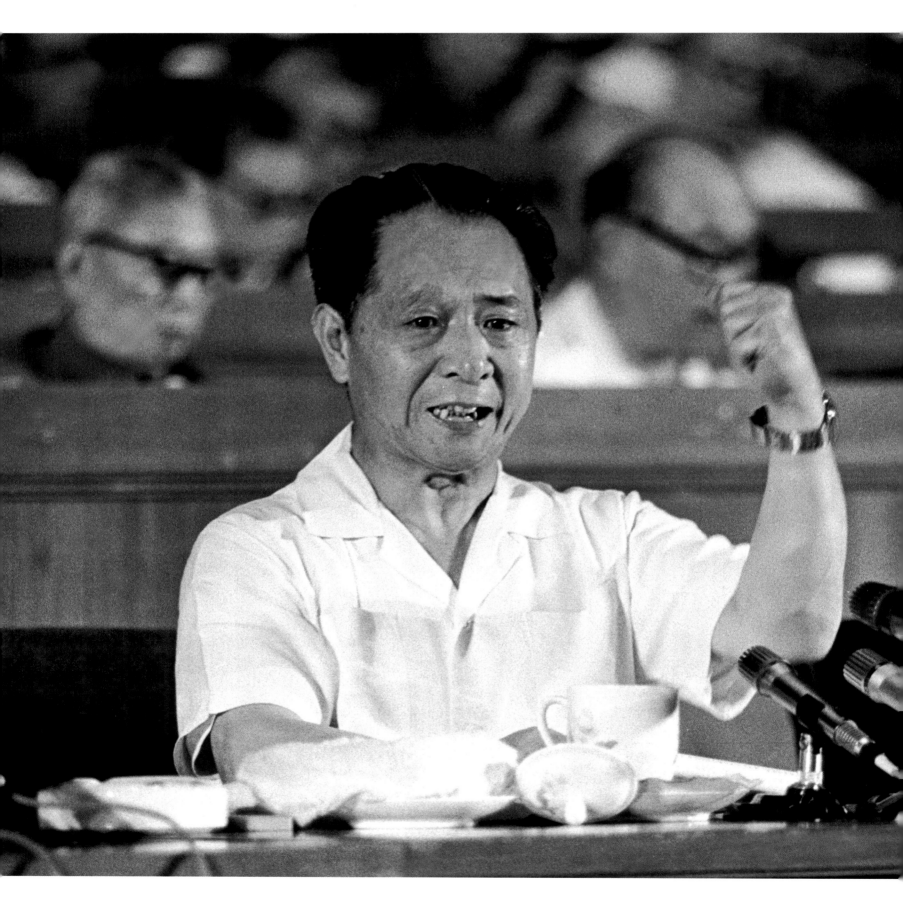

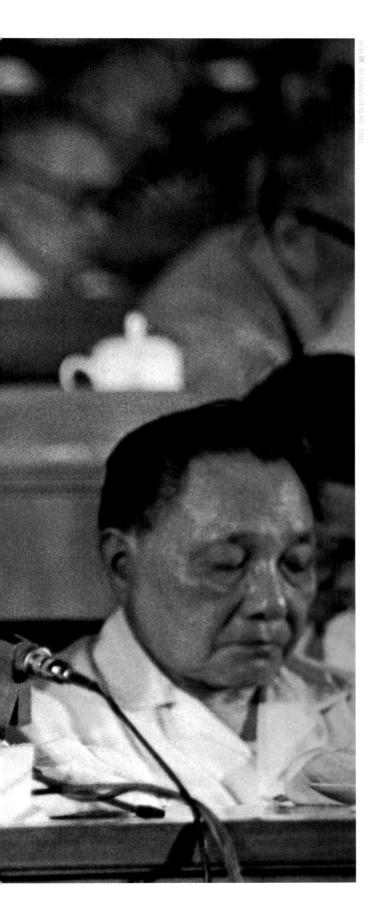

胡耀邦
Hu Yaobang, a People's Hero

　　一個參加過二萬五千里長征的「紅小鬼」；一個建國後多年掌管共青團的小個子；一位個性鮮明激情四射的高級幹部；一位被某些人愛戴也被某些人詬病的領導人——胡耀邦，在中國改革的歷史中是一定要留下重重一筆的，儘管他在中國政壇上位居要津的時間不過10年。實際上，對胡耀邦的評價濃縮了中國改革中最重大的兩個原則的關係：實事求是，解放思想和與資產階級自由化作鬥爭——胡失利於後者。1987年1月，他在一次黨內「民主生活會」後，「主動辭去」中共中央總書記職務。

Another controversial figure among the second-generation leadership is Hu Yaobang. Having been branded a "bourgeois liberalizer" by the establishment, his death in the spring of 1989 sparked the Tiananmen protests. Hardliners had forced reformer Hu to resign in 1987 for "mistakes on major issues of political policy". Born in 1915 in Hunan Province, Hu joined the CPC in 1933. Following the Cultural Revolution he became director of the Party's organization department, and soon afterward was made a member of the Political Bureau and Propaganda Chief. During his time in office, Hu exonerated more than 3 million purged cadres who had been persecuted during the Cultural Revolution. Many Chinese people think that this was his most important achievement. Although Hu had been forced to resign, he nevertheless remained a member of the Standing Committee of the Political Bureau. He died of a heart attack in April 1989. Despite his "mistakes", Hu was rehabilitated at a symposium in 2005 to commemorate the 90th anniversary of his birth. At the event, Vice President Zeng Qinghong said: "Comrade Hu Yaobang was a long-tested and staunch communist warrior, a great proletarian revolutionist and statesman, an outstanding political leader for the Chinese army, and a prominent leader who had long held crucial leading posts of the CPC."

胡耀邦在建黨60週年紀念大會上講話

1981年7月1日，慶祝中國共產黨成立60週年大會在北京舉行。胡耀邦發表講話。他在講話中回顧中共60年的歷史，指出：中國共產黨的歷史，是為民族解放和人民幸福而前仆後繼、英勇奮鬥的歷史，是馬克思列寧主義普遍原理同中國革命具體實際經過反覆實踐而愈益結合的歷史，是黨內正確糾正錯誤、光明面戰勝陰暗面的歷史。

To mark the 60th anniversary of the founding of the Communist Party of China on July 1, 1981, Hu Yaobang delivered a speech in Beijing's Great Hall of the People. In reviewing the history of the CPC, he said: "We can say that the 60 years since the founding of the Communist Party of China have been years of unflinching, heroic struggle for the liberation of the Chinese nation and the happiness of the Chinese people, years of ever-closer integration, through repeated application of the universal truth of Marxism-Leninism with the concrete practice of the Chinese revolution, and years when right prevailed over wrong, and positive aspects prevailed over negative aspects in the Party."

緊缺
Shortages Squeeze Diets

　　生活資料的緊缺，是1980年代初中國都市裡的普遍現象。農村率先改革的物質紅利首先要彌補對農民多年以來的物質虧欠，而城市的物資供應還有待逐步的經濟復甦。在全國各大中城市，取消副食品憑票證供應是1980年代中期的事——當年專門的「食品店」、「副食店」裡，人比商品多的景象並不罕見。而自帶容器排隊購買啤酒的情景，亦不惟北京獨有。在北京，1970年代居民生活的能源供應主要靠「蜂窩煤」，1980年代城市周邊建設了若干煤氣生產廠，還是供不應求；1990年代以後大力發展管道煤氣。直至2000年，西部天然氣幹線管道接入北京以後，居民生活的能源供應問題才算徹底解決。

　　Even as late as the early 1980s food was in short supply in China, so much so that the government rationed foodstuffs that Westerners could take for granted, such as cooking oil, pork, beef, mutton, chicken, duck, fish, eggs and sugar, as well as many kinds of vegetables. On weekends or at the end of the month, grain shops and vegetable markets were inundated with eager and hungry, customers, who formed long queues snaking down the street. In an attempt to tackle the shortages, China's Ministry of Agriculture during the late 1980s launched the Vegetable Baske" project, to bolster substantially the supply of non-staple foods such as poultry, eggs, milk, fruits and vegetables. The scheme, although it placed a heavy burden on the government, is credited with having stabilized food supply across the country. At the same time, due to economic reform in rural areas, China's grain output continually increased and more and more food items could be purchased without ration coupons. In 1993, the Chinese government abolished food coupons altogether and lifted price controls over grain. Through efforts over nearly a decade, supplies of non-staple foods were greatly improved, the market flourished, and prices stabilized.

郭建設 BY GUO JIANSHE 1984

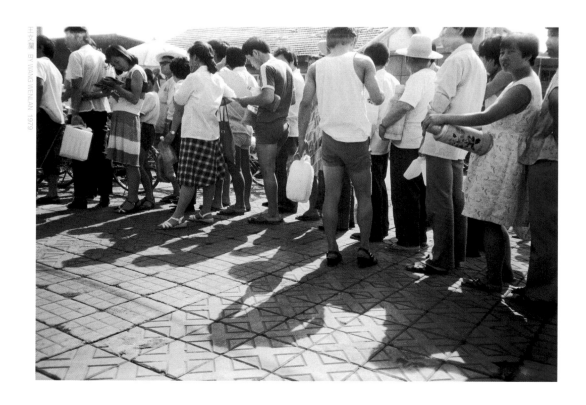
王文瀾 BY WANG WENLAN 1979

酒少人多

1979年，北京市民頂烈日排隊買生啤。

Beijing residents queue for draft beer in 1979.

供應匱乏

1984年，北京西單菜市場櫃檯空蕩蕩。

Shoppers survey empty counters at the Beijing Xidan Food Market in 1984.

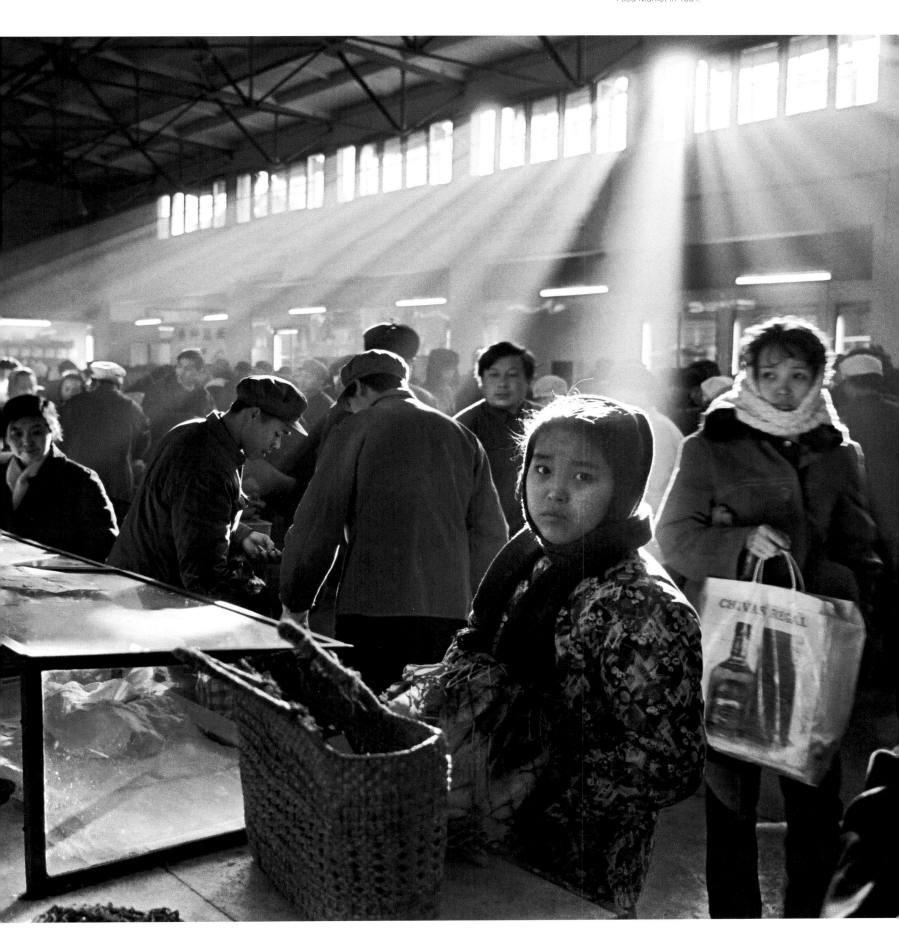

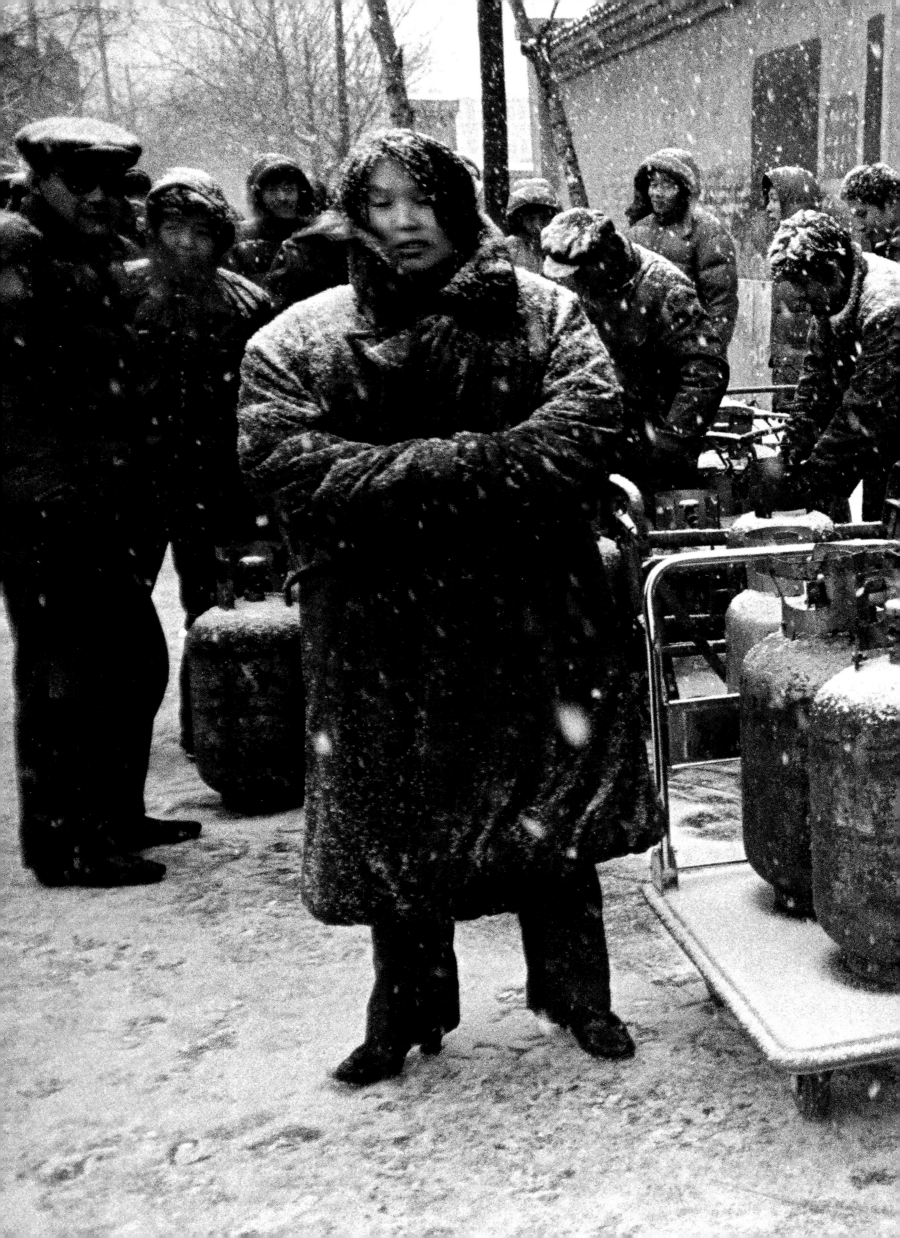

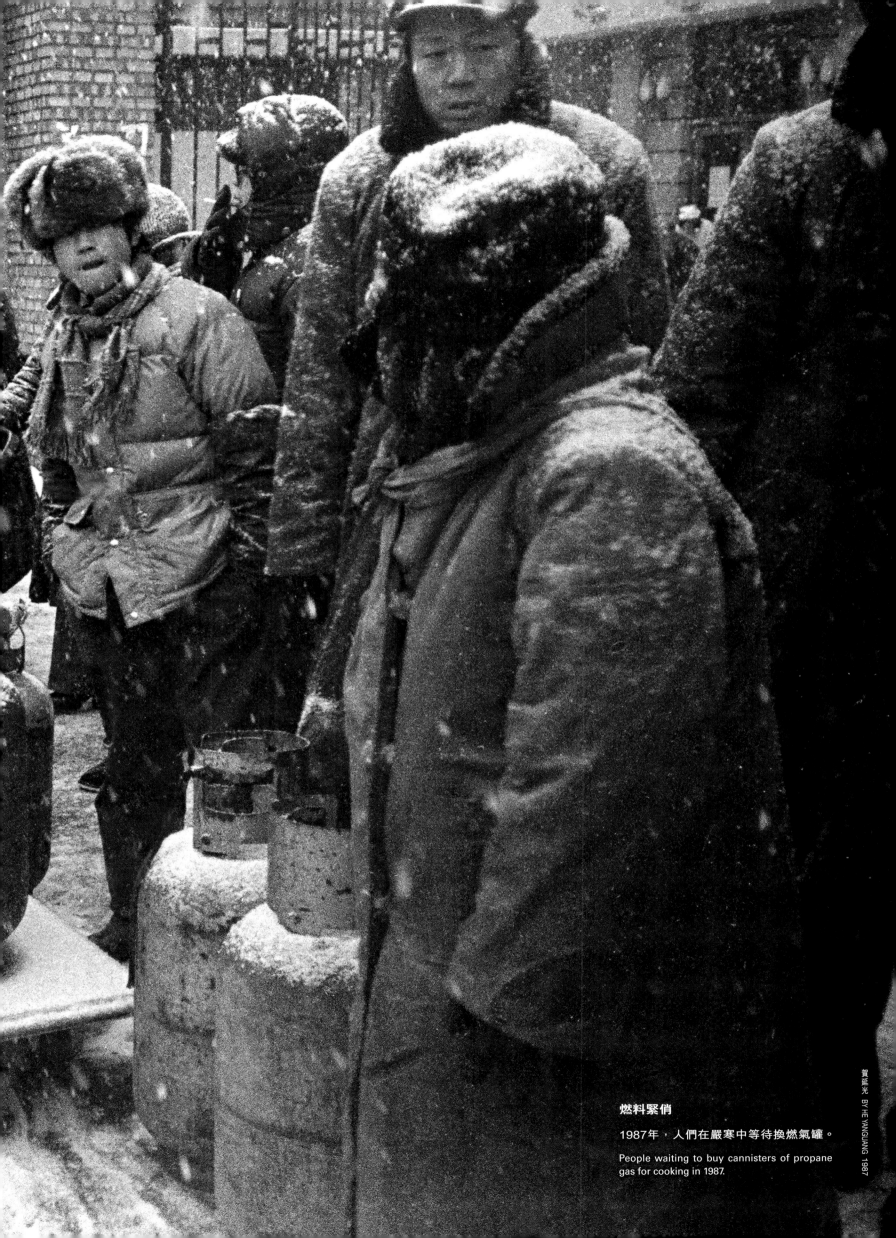

燃料緊俏

1987年，人們在嚴寒中等待換燃氣罐。

People waiting to buy cannisters of propane gas for cooking in 1987.

搶購
Stocking Up

　　人們的生活慾望提高以後，供應的不足和需求的旺盛形成反差。從服裝到大白菜，到處都可以看到搶購生活物資的人群。到1980年代中期，首先是農村生產力的解放為豐富供應提供了可能，然後是擴張的需求為城市商業活動提供了動力。瀰漫城鄉的第一波商業大潮由是興起。

　　One big impetus for reform in the early 1980s was the chronic problem of supply shortages and hoarding of everything from clothing to cabbage. Long queues, empty shelves, and ration coupons were a major consumer frustration. But agricultural reforms boosted the supply and diversity of farm products in the mid-1980s, and provided the initial push for the first wave of merchandizing. The transformation of China's consumer markets was to become one of the great success stories of the era. Chinese supermarkets now boast fresh meat and dairy counters as big as any found in the West. The variety is staggering. Snacks and sweets counters are also bountiful, another indication of the country's growing wealth.

北京居民貯存冬菜

1985年，北京街頭，居民在購買冬貯大白菜。

Beijing people stockpile Chinese cabbages for the winter in 1985.

重慶市民搶購服裝

1985年，在重慶的一家商場，民眾在搶購服裝。

A press of shoppers at a Chongqing clothing market in 1985.

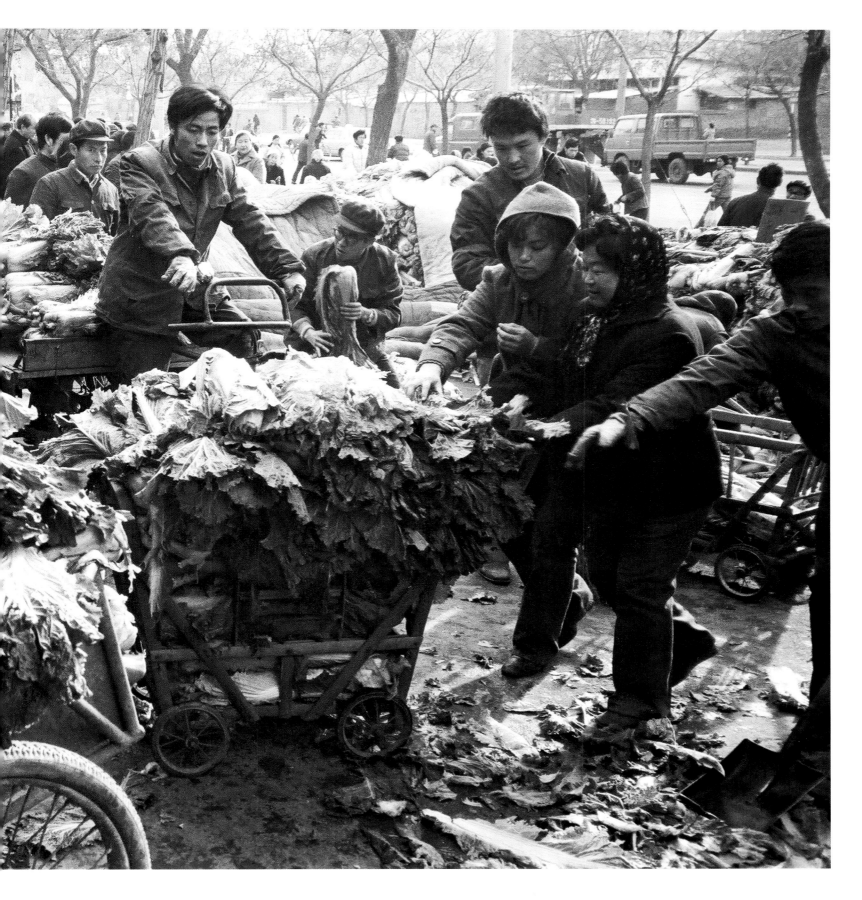

交通
Get a Move On

　　1970年代末至1980年代初，經常聽到的一句話叫做「百廢待興」。開始活躍了的經濟活動，使城市交通落後凸顯。道路破敗，車輛不足，居民日常需要的公共交通嚴重擁擠。「把人擠成相片兒了」的調侃，就是這時候從相聲作品裡傳出的。按説，當年的攝影記者對此已經見怪不怪了，所以反映這種城市現象的圖片今天很難看見——以至於我們對北京飯店排隊等出租汽車的這張照片，覺得很稀罕！新的農村政策可以立即使農民得到實惠，被束縛的生產力迅速得到釋放，但是落後的鄉村交通條件卻不是立時三刻就能改善的。30年前的這類場景，在許多圖片中都可以看到，一方面説明當時農村交通落後現象的普遍，也説明當時的攝影師或憂心忡忡或興致盎然，在觀察和記錄着這類視覺景觀。

China's transportation system lagged behind the needs of the country's reawakening economy in the early years of reform — slowing the movement of people, of goods to market, and the delivery of raw materials for manufacturing from one part of the country to another. Dilapidated roads and a lack of vehicles created bottlenecks; overcrowded trains and buses made travel a hassle. With the understanding that economic development and efficient transportation go hand-in-hand, the nation set about overhauling its roads system. Between 1978 and 2008, China tripled the extent of its roads network — a vast improvement over the pre-reform years. Yet more work remains to be done. In 2008, 30,000 villages in poor regions still had unpaved roads. The government has worked to solve this deficiency by 2010 with plans to connect all of China's villages to modern-standard asphalt highways.

「打的」不易

1984年，北京飯店門口等車人心焦。

Queuing for a taxi outside the Beijing Hotel in 1984.

超載嚴重

1985年，貴州省黎平縣公交運力緊張。

Travelers scramble to find any free space on a bus in Liping County, Guizhou Province, 1985. A shortage of vehicles meant that there was constant high demand for any form of transport, no matter how uncomfortable.

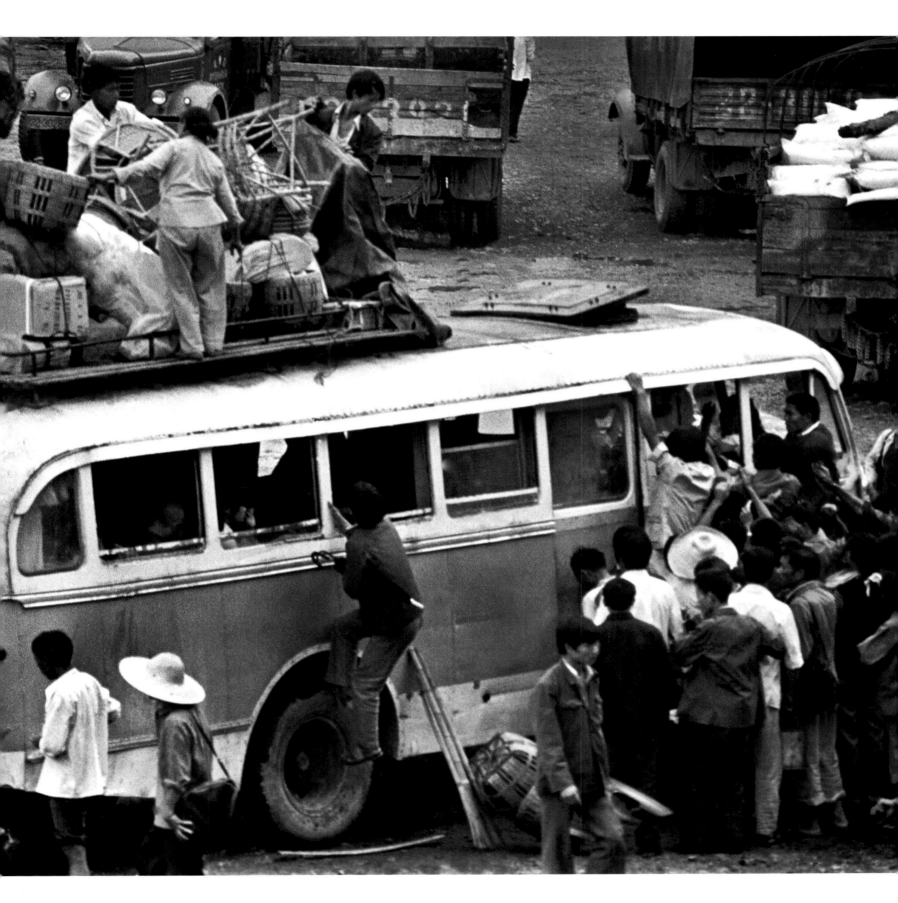

「打的」不易

1984年，北京飯店門口等車人心焦。

Queuing for a taxi outside the Beijing Hotel in 1984.

超載嚴重

1985年，貴州省黎平縣公交運力緊張。

55

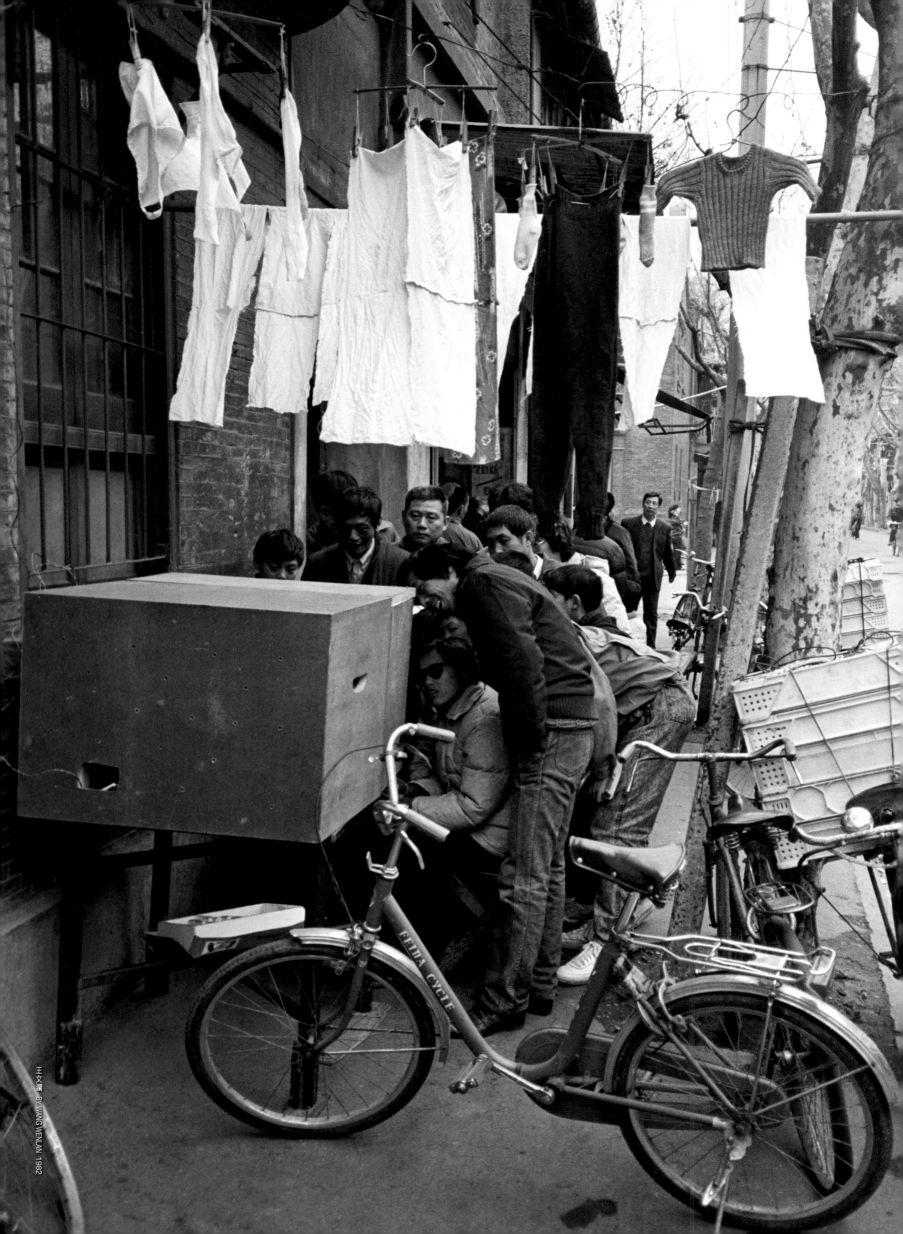

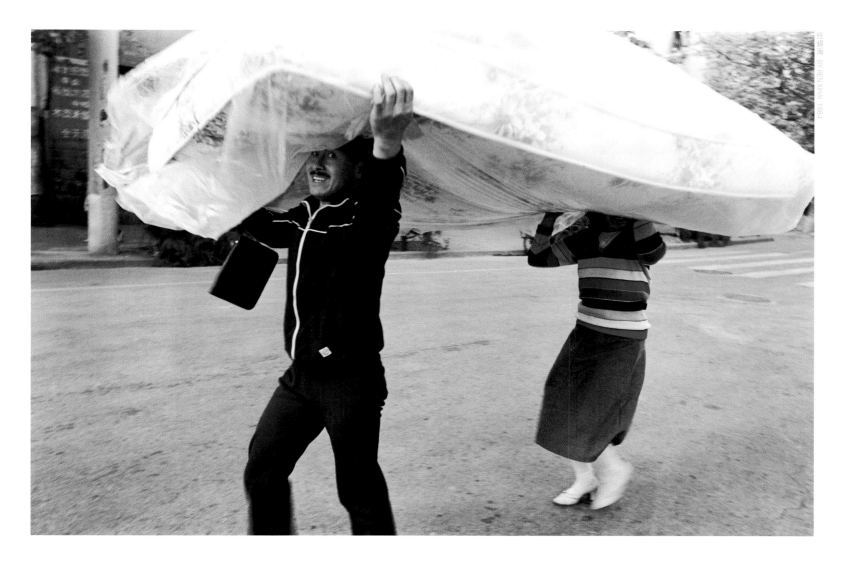

▶ 有電視大家看

1982年上海老城區的普通市民家裡，電視機還未普及。時常可見有人把自家電視機搬出來，讓里弄居民聚在一起觀看的情景。

Neighbors gather around a television in Shanghai in 1982, when owning a TV set was still out of reach for most families.

▶ 把席夢思扛回家

1980年代初許多洋名詞進入大眾生活，「席夢思（SIMMONS，美國著名的彈簧牀品牌）」即是一例。這對夫妻喜洋洋地用頭頂着「席夢思」回家時的歡快心情，絕不亞於今天的人買了一輛汽車時的心情。

In the 1980s, buying a "Simmons" was a sure sign of rising status. The name of the U.S. bedding firm became a byword for any inner-sprung mattress, and was one of many foreign terms to enter the Chinese lexicon at the time.

見微知著
Luxuries for All

　　民眾改善生活的慾求是無法阻擋的，在任何社會都是這樣。考量一個社會是否健康，完全可以從它通過甚麼途徑以及是否能為這種慾求提供滿足來觀察。1980年代初期，一張席夢思牀墊，一台電視機就能為城鎮居民帶來莫大的欣喜。如果說「見微知著」的話，這種改善生活的不竭慾求，正是推動經濟發展的務實政策和改革成功的來自底層的動力。

　　Instead of worrying about where the next meal is coming from, many Chinese people nowadays are concerned with having the latest iPod or Lenovo laptop computer. This trend is a far cry from just a couple of decades ago, when a TV set was a major luxury. Many people can still recall which family was the first in their midst to own a TV and the crowds of neighbors who flocked to watch. Now most urban households own a television and DVD player. Items such as refrigerators and air conditioners have also replaced larders and fans for keeping food and people cool under China's scorching summer sun.

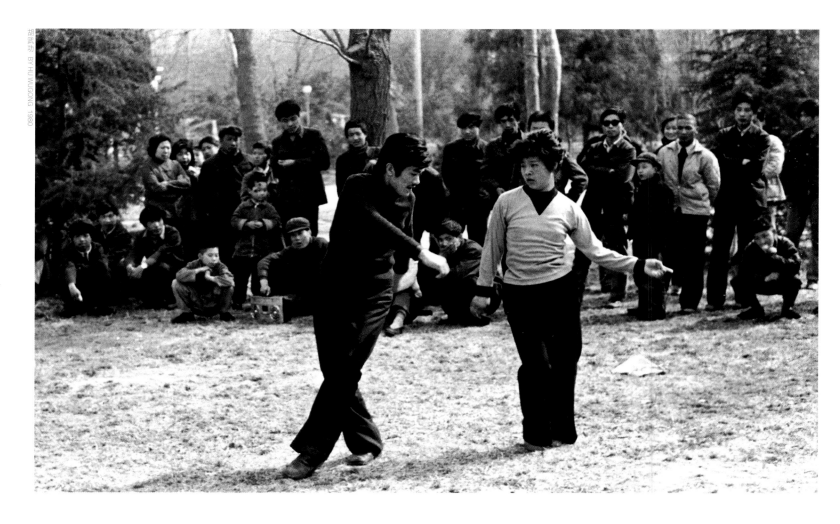

△ **公園迪斯科**

1970年代末，伴隨鄧麗君的歌聲，許多青年人跳起迪斯科、交際舞。他們手提收錄機，身穿喇叭褲，在公園或街頭隨心所欲，也被當時的父輩斥為「傷風敗俗」、「垮掉的一代」。

Outdoor disco and ballroom dancing became a new fad in China in the 1980s.

▷ **路邊撲克檔**

廣州濱江路很久以來一直就是市民的戶外公共活動空間，工作之餘，人們經常會聚集在這裡休閒、娛樂。這大概也算得上是他們難得的社交活動了。1988年拍攝的照片上的這位身上夾滿了木夾的男士，顯然是這場撲克戰鬥中的輸家。

A clothes peg on the ear was the penalty for losing at cards in Guangzhou's Binjiang Road, where many people gathered in the 1980s to while away their free time.

嬉戲
Leisure

　　被「文革」緊繃了10年的社會生活開始鬆弛下來，流行音樂和交誼舞成為城市時尚的同時，各類民間娛樂悄然復興。民間娛樂的復興是人民精神愉悦的象徵，也是文化需求提高的表現。儘管商業性的文化活動還要過幾年才開始時興，但是看到這些情景，也就看到了此後文化市場繁榮的前兆。

　　With the decompression after the Cultural Revolution, popular music, social dancing and other forms of popular entertainment revived, signaling a growth in general cultural demands. Although commercialized culture was still a few years away, these early developments were a harbinger of the vibrant cultural market place to come.

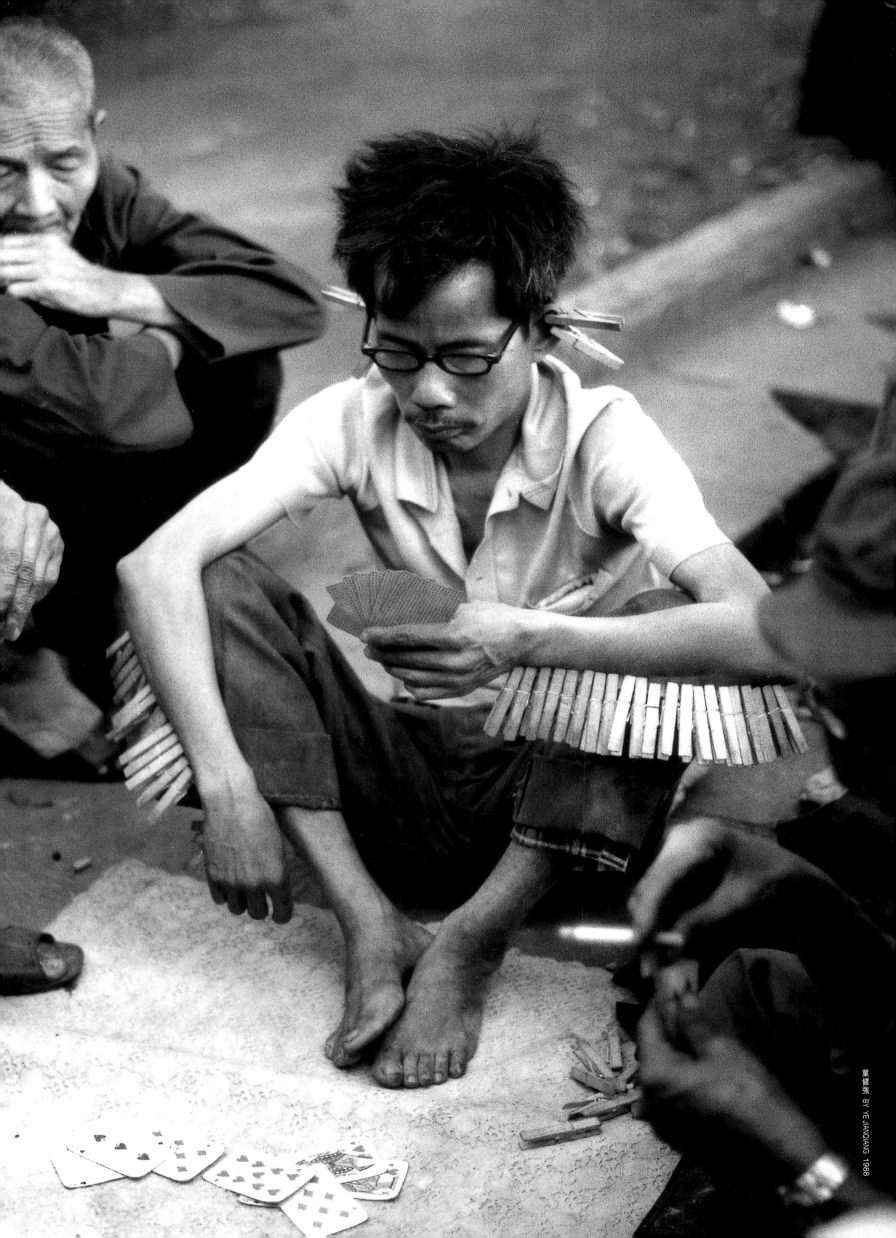

葉健強 BY YE JIANQIANG 1988

遊玩
On Holiday

在旅遊業成為一個新興產業之前，我們寧肯把這種出行的娛樂叫做「遊玩」。儘管那出行多是本地，遊樂的設施也是簡陋的，這種遊玩的前提也必須是在有錢和有閒的基礎上。有趣的是，視野打開以後，感受「新鮮」的閾值是不一樣的。比如圍觀海灘上一個外國兒童這樣的景象，今天看來不免荒誕，當年卻是司空見慣。先有大驚小怪，方有見怪不怪，才會出現自我搞怪，人們的心智也才在這些見聞中拓展和成熟起來。

Before the tourist industry has become an emerging industry, pleasure trips were limited to the locality, and the facilities were crude. Even so, people had to have money and leisure before they could have pleasure trips. Today, the horizons of the Chinese have been broadened and the knowledge widen. The things they find interesting are greatly different from before, such as a foreign girl on the beach.

任錫海 BY REN XIHAI 1983

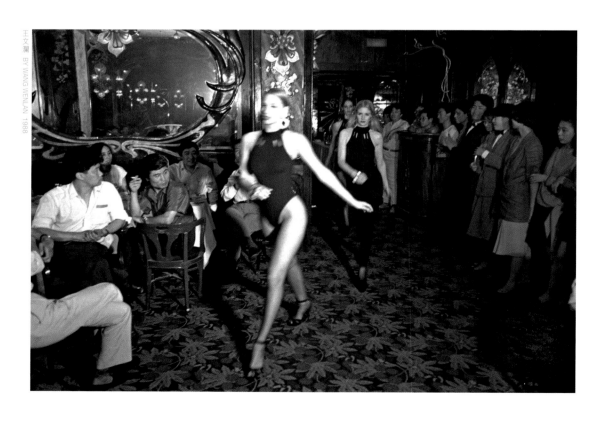

王文瀾 BY WANG WENLAN 1988

合資餐廳裡的「時裝秀」

1988年，北京，巴黎以外第一家馬克西姆餐廳。

The "fashion show" in the first Maxim's outside Paris.

眾人圍觀外國小丫

「文革」期間你如果有親屬在國外那就麻煩了，更不用說與外國人交往。那些年，我們與外國人的交往很少。改革開放初年，開始有少量的外國人來到中國，由於感到新鮮和好奇，於是便有了幾十個人圍觀這位外國小姑娘的不禮貌的場景。照片1983年攝於青島第一海水浴場的沙灘上。

A foreign girl is a focus of curiosity on the beach in Qingdao, 1983. Due to China's isolation in the decades before the reform and opening in the early 1980s, many Chinese people had never encountered foreigners.

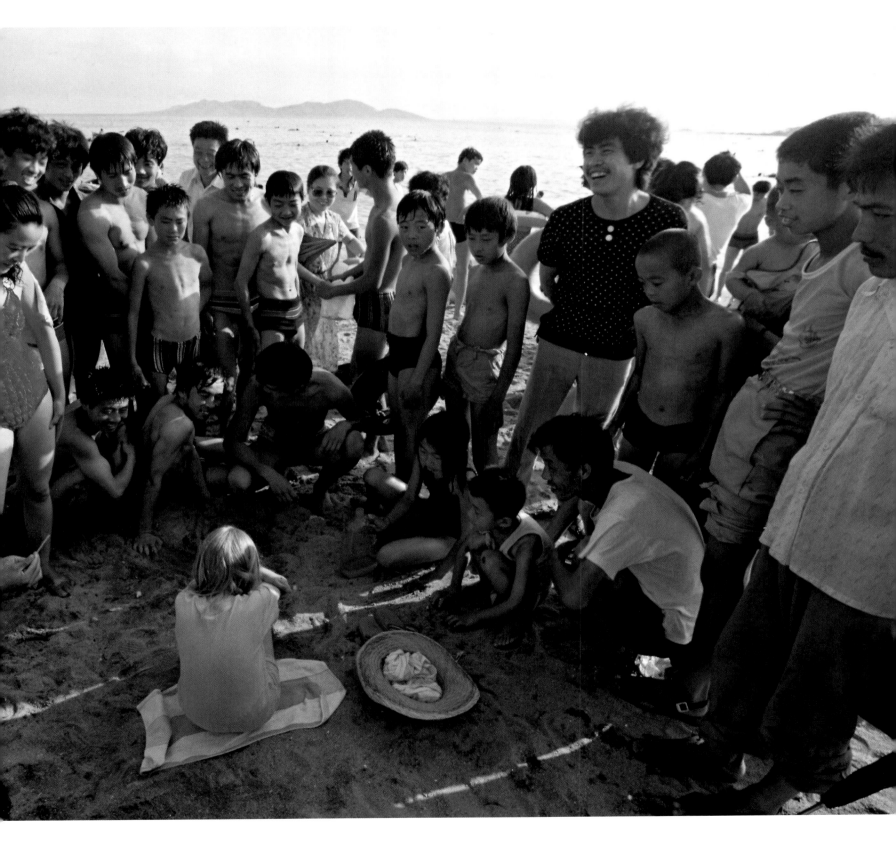

合資餐廳裡的「時裝秀」

「文革」期間你如果有親屬在國外那就麻煩了，更不

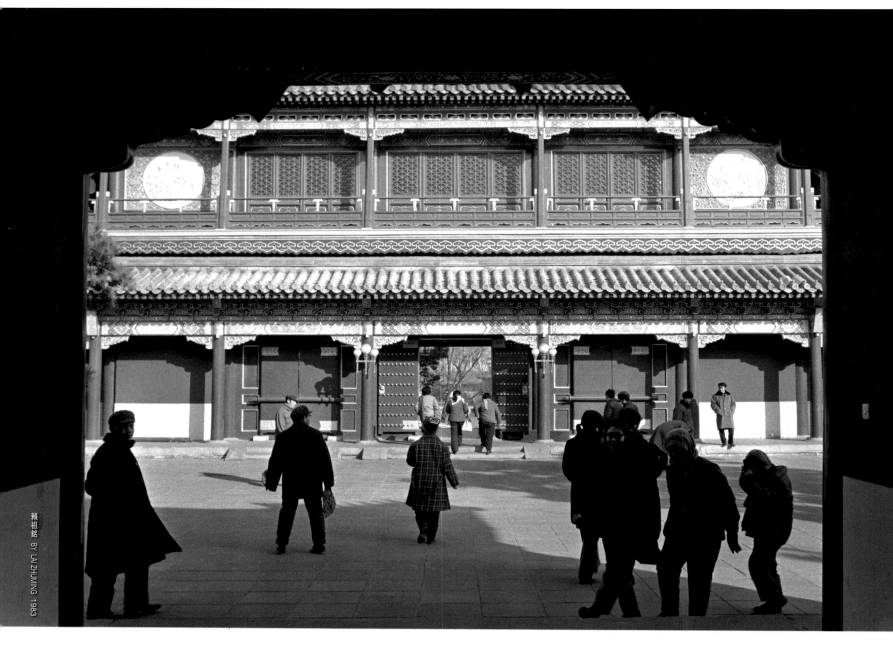

賴祖銘 BY LAI ZHUMING 1983

△ **中南海對公眾開放**

1983年，北京最神秘的中南海開放，讓市民參觀。這裡是毛澤東和中央主要領導人工作、生活、居住的地方。

In 1983, visitors could stroll at the once-mysterious Zhongnanhai, now open to the public.

▷ **看飛機啟航**

1983年，為了適應歸國華僑和來往客商的需要，廣東梅縣山區將一個簡易軍用機場改為民航機場。四鄉百姓聞訊後紛紛扶老攜幼，結伴前來看真飛機。

On the opening day of the civil aviation airport, people came together to have a look at the aircraft in Mei xian, Guangdong, 1983.

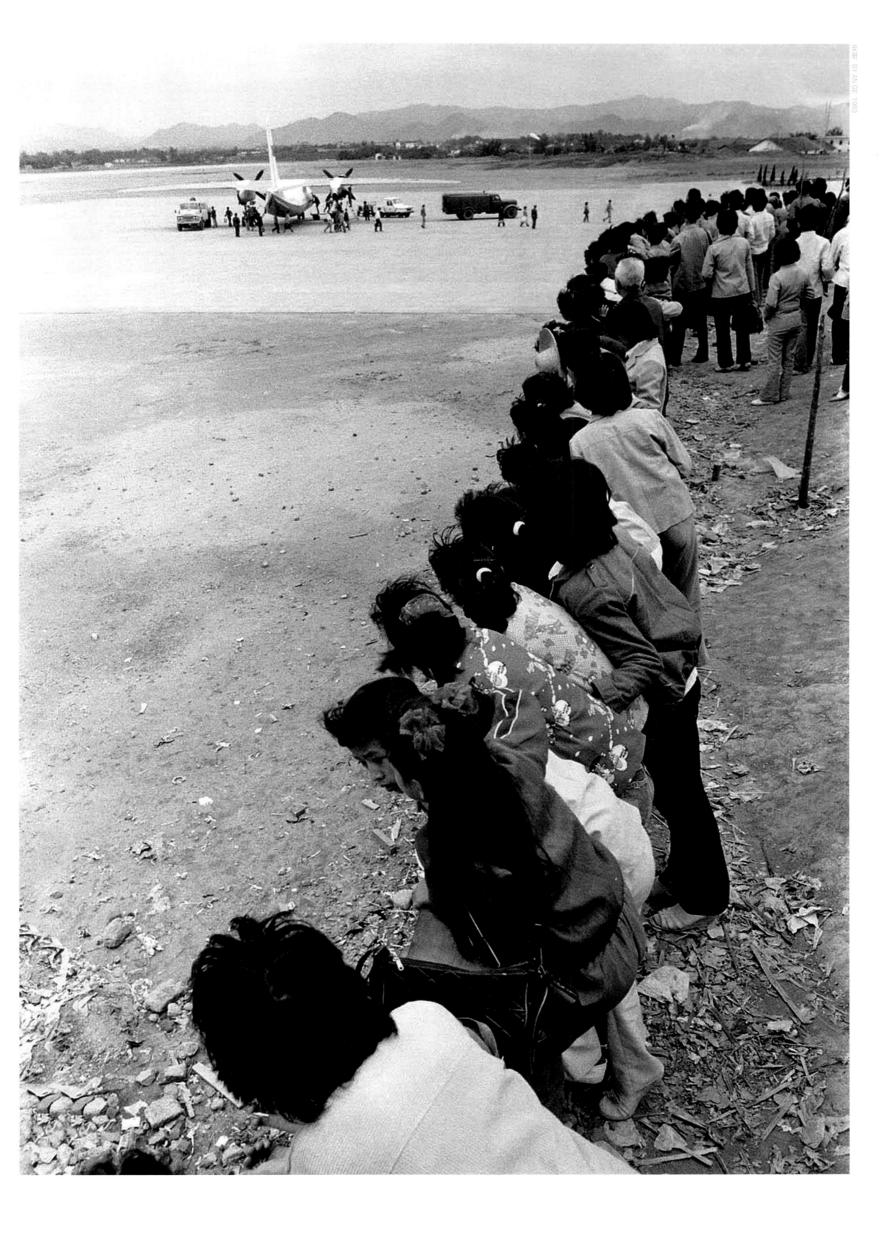

金水橋變 T 台

1986年北京天安門金水橋上的北歐裘皮時裝表演。

Models pose in a fashion show outside central Beijing's Tiananmen Gate in 1986.

開放伊始上海人學繫領帶

1983年初夏，開放之初的滬上青年嚮往西方文明，流行西裝革履。上海閘北區某單位員工，為參加一個集體活動，許多人第一次學習打領帶。

Learning to knot a tie in Shanghai in 1983.

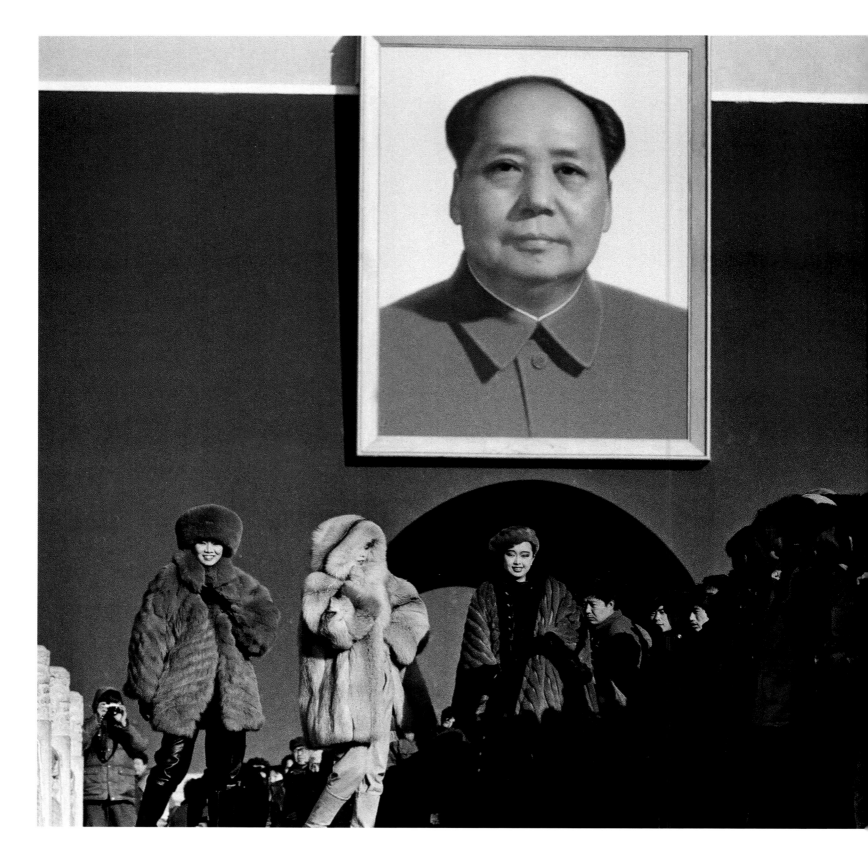

金水橋變 T 台

1986年北京天安門金水橋上的北歐裘皮時裝表演。

服 飾
A Fashion Comeback

　　1970年代的中國色彩是灰藍色的。被外國記者譽為「藍螞蟻」的人群，因為其服裝色調的驚人一致性而著稱於世。在「國際化」成為經濟趨勢之前，人民對「開放」的實踐主要還是在外在觀瞻上，當時的服飾變化被攝影記者們記錄下來當作新聞，又像今日的服裝廣告一樣，推動了中國的服裝革命。中國的色彩，就這樣豐富生動起來。

　　The Cultural Revolution was a dark time for fashion in China. People were forced to abolish "antiquated"concepts, culture and dress, and anything associated with "the bourgeoisie". As a result, people wore neither traditional Chinese costumes nor Western-style suits, and China became renowned for its uniform dress code of blue or green "Mao suits". Those who wore jewelry or make-up faced serious consequences. The Mao suit — fashioned from sturdy blue serge — and green army uniforms were the only attire available to most of the population for decades until the end of the Cultural Revolution. Dress in China underwent a drastic change after the turbulence. In 1979, French designer Pierre Cardin staged a fashion show in Beijing, and his bold and futuristic designs excited Chinese audiences, most of whom were still wearing simple cotton-padded jackets. China's youth rediscovered the joy of dressing up as a result of Deng's "open door" policy, and modern fashions began to reappear on the streets. Today, China's young are among the most fashion-conscious in the world and her cities' clothes shops are jam-packed at weekends with consumers eager to dress to impress.

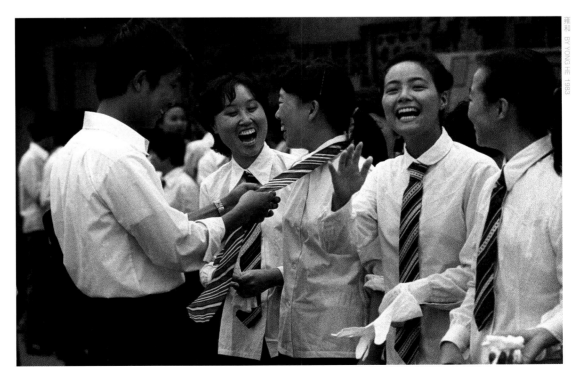

舞動
Moving to a New Beat

　　作為一種身體律動的舞蹈，源於人類歡愉時情緒的表達。不過，在「文革」中它僅被允許成為對領袖忠誠和政治認同的儀式。在普通民眾，新時期國策中「開放」的意義主要不是對外的，而是在公共行為上的。比如1980年代初期中國城鄉的各個角落突然湧現出大批舞蹈着的人群！今天看來，它或許因為公眾娛樂設施普遍缺乏；因為「時尚」蔓延的流行規律；因為密切人際交往宣洩壓抑情緒的社會需求。怎麼看，一個自然舞動着的中國總比單純為政治而舞動要健康、美麗！

　　After the reform and opening, gone was the need to dance to a political beat. Although pop music took time to evolve and public spaces were often improvised, people could now dance to modern music. This healthy pastime has become a common activity in China, and parks and other public spaces in the cities are often the scene of groups of dancers grooving to all kinds of beats. Dance pervades all parts of society with enthusiasts ranging from soldiers to students and the elderly.

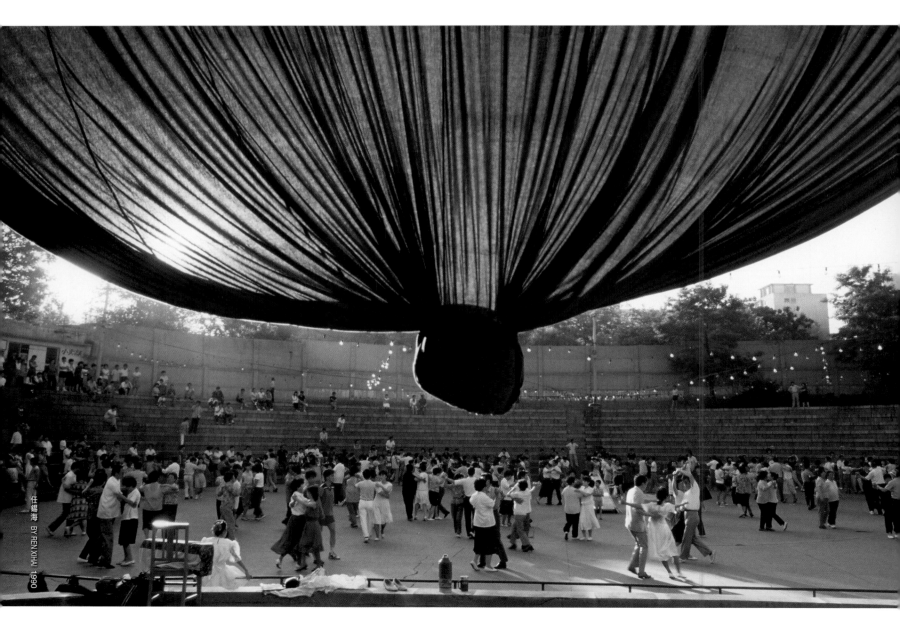

任錫海 BY REN XIHAI 1990

露天交誼舞

1990年，改革開放給人們帶來寬鬆的生活環境和
交流平台，1980年代興起的「交誼舞」熱便是一
個例證。圖為人們在青島某廣場跳舞。

Dancing in the open air in Qingdao, 1990.

烈士陵園裡練現代舞

1988年，廣州舞蹈學校現代舞班的學員在十九路
軍烈士陵園練習現代舞。

Students of Guangdong Dance School practice a modern
dance performance in the Guangzhou's Cemetery of
Revolutionary Martyrs in 1988.

初入舞廳的現役軍人

1978年，初入舞場的軍人，流露出怯生生的
神情。

Soldiers practicing their dance moves, 1978.

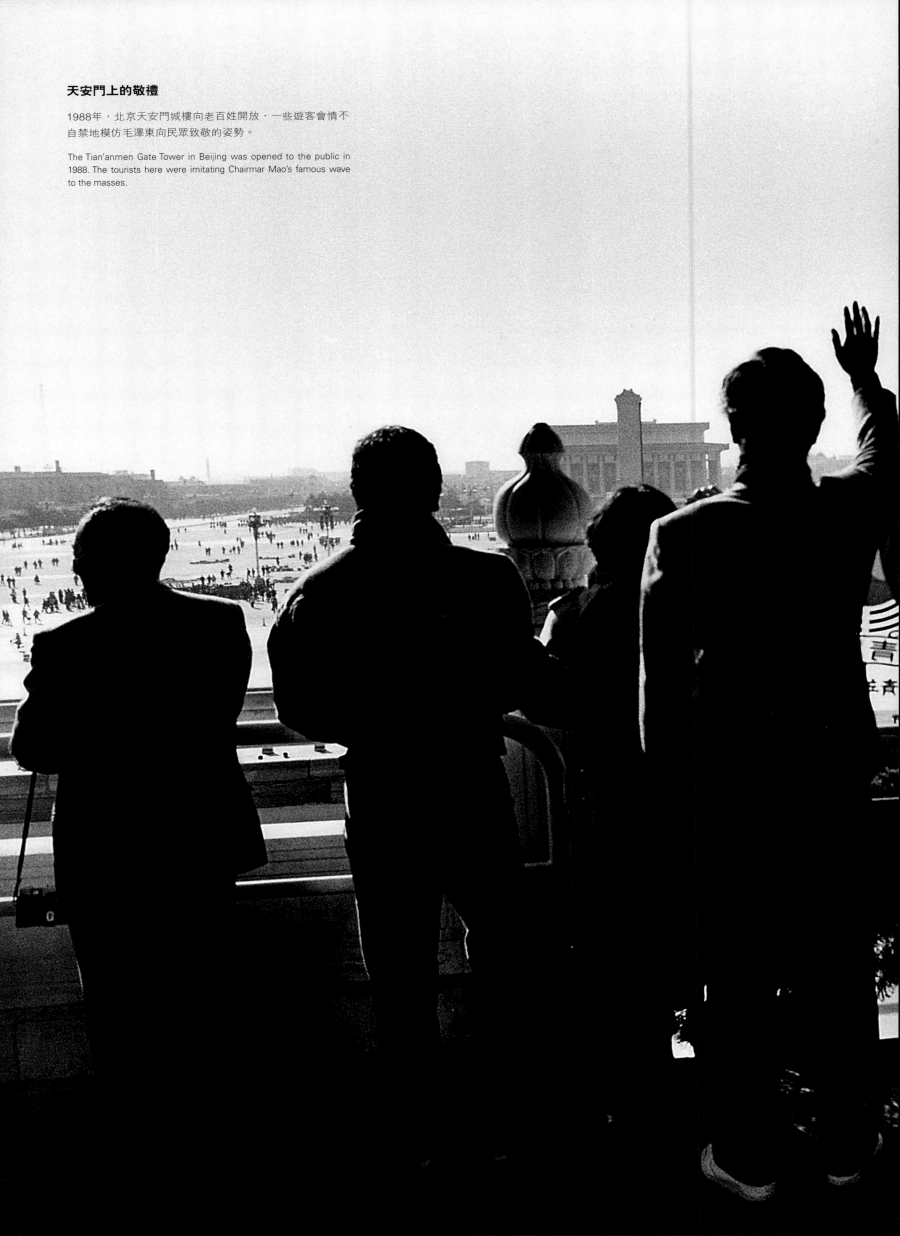

天安門上的敬禮

1988年，北京天安門城樓向老百姓開放，一些遊客會情不
自禁地模仿毛澤東向民眾致敬的姿勢。

The Tian'anmen Gate Tower in Beijing was opened to the public in
1988. The tourists here were imitating Chairmar Mao's famous wave
to the masses.

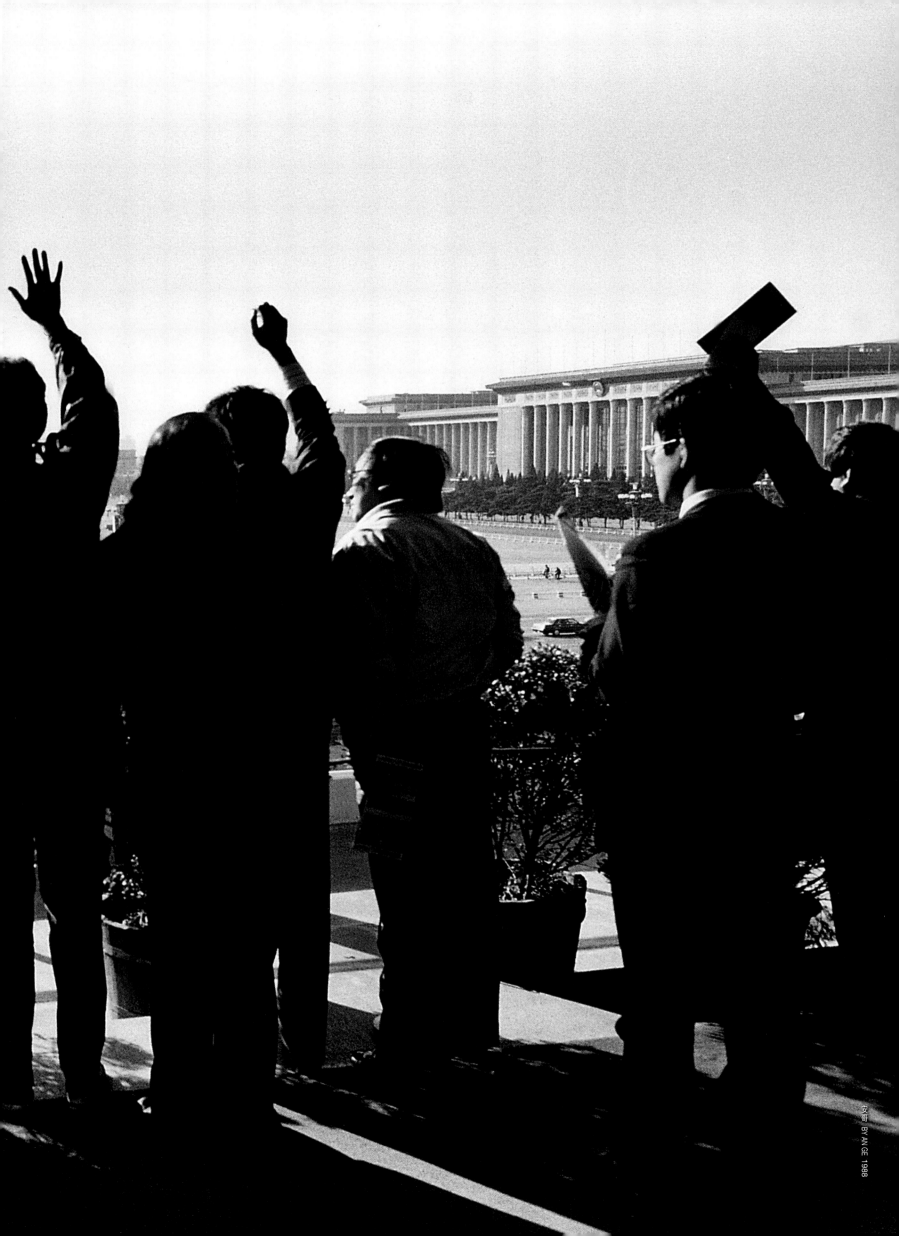

服務
Serving the People

在當年的教科書上，社會主義的生產目的是「滿足人民群眾日益增長的生活和文化需求」，然而在實際生活中，長期以來這種「增長的需求」與供給不足，成為隨處可見的現象。於是，出現這樣「分配服務」的場景。在普遍緊缺的環境下，30年前社會為公眾提供的某些公共服務，今天看來頗有些滑稽，但它的確些微地彌補了居民生活中的某些需求。

Since reform and opening, the concept of "serving the people" has shifted from revolutionary ideology to customer service or service to the public. Increases in both leisure time and tourists have created huge markets for hospitality services. But the phrase "Serve the people" was first thrust into the public arena in a speech by Mao Zedong in 1944. The idea has stuck with the Communist Party throughout its time in power, along with other slogans such as "Never benefit oneself, always benefit others" and "Tirelessly struggle". Today, the phrase can be heard at ceremonial events when leaders address members of the armed forces. The inspecting official will say: "Comrades, you have worked hard." To which the soldiers will reply: "*Wei renmin fuwu*" (To serve the people).

王文波 BY WANG WENBO 1981

「北京可樂」

暢飲北京大碗茶，解渴賽過可口可樂。1981年，天安門金水橋前，兩名外國遊客在品嚐大碗茶。

Foreign tourists sample *dawancha* in front of the Tiananmen Gate, 1981. *Dawancha*, the drinking of tea from a large, roughly fashioned china bowl, is a custom in northern regions. The informal bowl encourages the drinker to relax, which accounts for its continued popularity.

老工人在臨潼溫泉療養院洗浴

陝西西安的驪山北麓，分佈着眾多溫泉。其中最有名的當數《長恨歌》中描寫的華清池。圖中老者是身患關節炎痼疾的鐵路老工人和勞動模範，他們正在臨潼鐵路工人療養院的溫泉浴池洗浴。改革開放以後的華清池浴館，每年可接待50萬人次沐浴，普通百姓也可以花錢買票來此享受「天子之樂」。

Enjoying the waters at the Huaqing Hot Spring (Huaqing Chi), 26km east of Xi'an at the foot of Mount Lishan. The springs, 43 degrees Celsius (109 degrees Fahrenheit) and rich in minerals, have been a popular attraction for more than 3,000 years.

石寶琇 BY SHI BAOXIU 1980

李曉斌 BY LI XIAOBIN 1980

公園提供暗箱服務

1980年，北京北海公園換膠卷的年輕人。

Dark boxes in Beijing's Beihai Park allowed visitors to change their camera film in 1980.

71

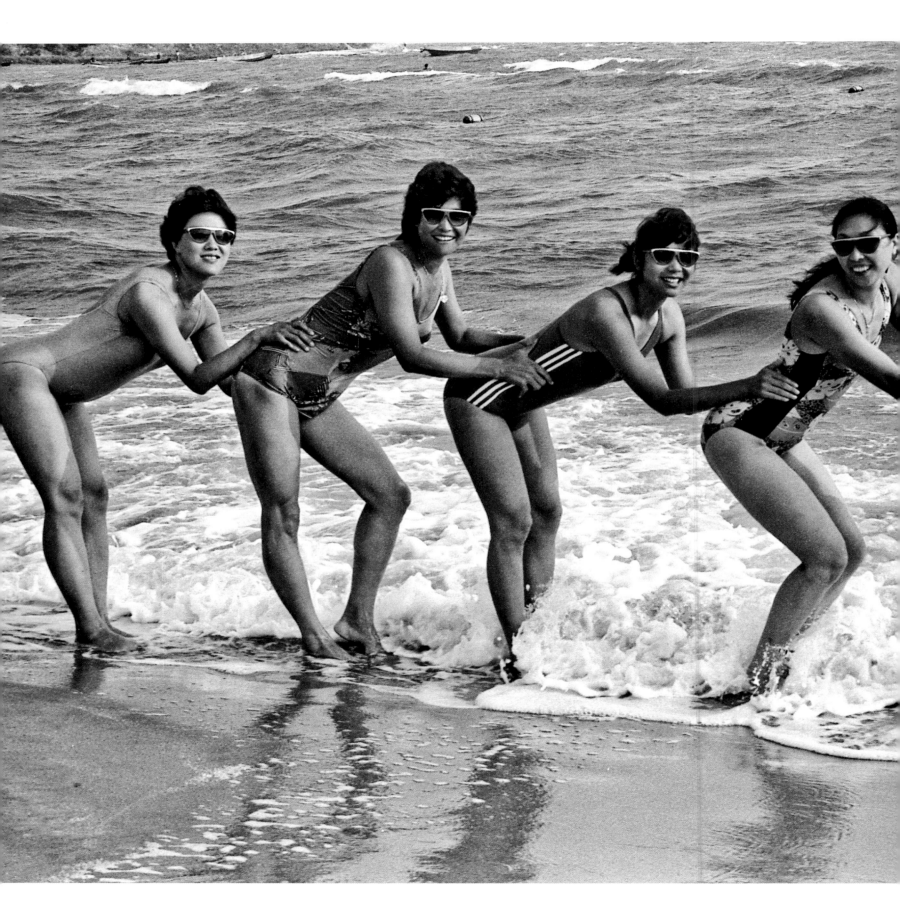

明星
The Birth of Celebrity

　　最早的明星是電影演員和運動成績優異的運動員們，這與所有國家的追星趨勢一致。不過中國女排稍有特殊，1980年代初，她們率先在所謂「大球」上獲得集體項目的世界冠軍，時有京城大報專門為此發表社論，題為《振奮革命精神的典範》。在這「精神典範」之後，1980年代的中國體育確實成績驕人，更有人寫出「國運」、「球運」一類的文章。不過女排裡的隊員都是年輕姑娘，她們也愛美，也趨時。這張圖片當時沒有發表，今天看，也是一種「精神」。

In December 1981, China's women's volleyball team won the World Cup tournament in Japan. Having endured the Cultural Revolution, the Chinese people were eager to experience a little joy brought by this rare sporting victory, and that night the whole country celebrated. The team then went on to win gold at the 1984 Los Angeles Olympic Games, in addition to dominating two other international tournaments and a World Cup title. These five successive victories won the team many fans and they became sporting role models among young people in China. The "combative spirit" of China's women's volleyball team is still remembered by the nation and the success is perhaps the birth of celebrity worship in modern China.

女排姑娘在海邊

1985年夏，河北省秦皇島市。中國女子排球隊隊員在海邊嬉戲。

Members of the Chinese women's volleyball team posing for a photo at Qinhuangdao beach in 1985.

蛤蟆鏡

The Future's So Bright

　　那種鏡片寬大一般由塑膠壓製的遮陽鏡是1980年代都市裡的流行，被叫做「蛤蟆鏡」大概是因為其形狀酷似漫畫裡的蛙眼。此前，遮陽鏡是電影中反面角色的典型妝扮，在社會生活中，其也多與「小流氓」相關。「蛤蟆鏡」的流行印證了社會審美的遷延，它的實用、廉價、微觀，或許也透露出流行因素蔓延的某種規律呢。

　　In the 1980s, as opposed to its old negative screen image, wearing sunglasses became a fashion in China, which also reflected the winds of change blowing through the society.

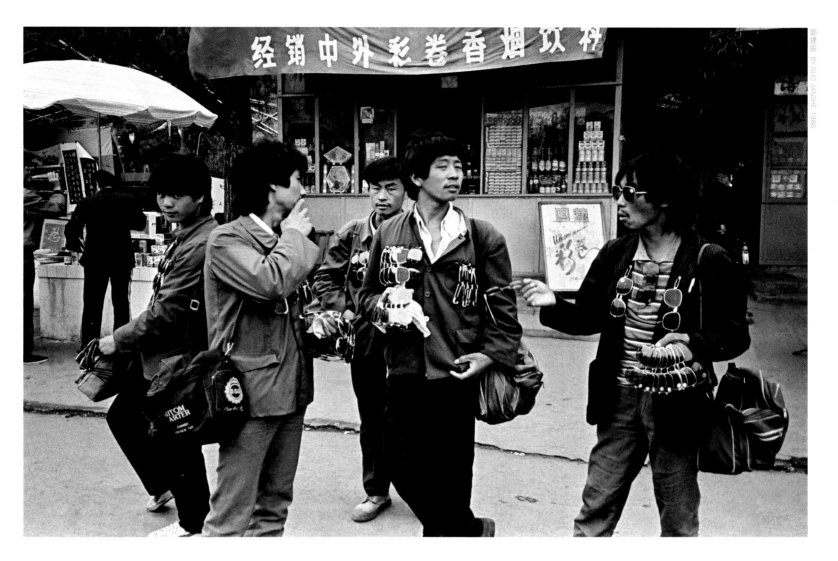

郭建設 BY GUO JIANSHE 1986

戴墨鏡的時尚女青年

1980年夏，在北京香山公園，5個戴墨鏡的女子在遊玩留影。

Sunglasses became a popular fashion statement in the 1980s.

街頭小販熱銷「蛤蟆鏡」

1980年代中期，廣東、香港等地產的塑膠遮陽鏡（俗稱「蛤蟆鏡」）在北方很是流行。圖為北京街頭出沒流動的小商販正在向行人兜售「蛤蟆鏡」。

Street peddlers in Beijing hawking sunglasses made in Hong Kong and Guangdong, 1980.

模特
On the Catwalk

1980年代以前，「模特」這個詞兒與中國人的生活絕少聯繫，但在1980年代服裝服飾激變的潮流中卻成為推波助瀾的一個角色。在商業化專業性的服裝模特隊伍興起前，這種展示時尚的工作先是由企業自發組織的，因此多具有企業產品推介的意義。在受到媒體關注、社會歡迎並取得商業利益之後，服裝模特更發展為一門新興行業。中國的不少新興行業大多經歷了這樣一個需求——嘗試——成長——專業化的過程，「第三產業」於是走向成熟。

With the reemergence of fashion in China came a new model army. Beijing put together its first fashion model team after the launch of reform and opening in 1987. By the turn of the century, photographs of models both Chinese and foreign strutting their stuff on the catwalk had become a common sight in Chinese newspapers. Today Chinese models are growing in popularity around the world, with stars such as Liu Wen and Du Juan working with international designers like Jean-Paul Gaultier and Karl Lagerfeld.

葉健強 BY YE JIANQIANG 2001

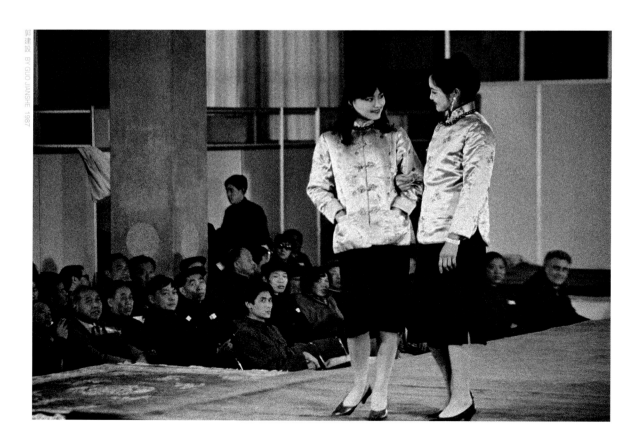
郭建設 BY GUO JIANSHE 1987

北京飯店模特隊

北京最早的時裝模特隊是在1987年組成的，最初僅在當時只接待境外客人的北京飯店登台表演。

Beijing's first team of fashion models was formed in 1987, but they performed only for foreign tourists in the Beijing Hotel.

廣州街頭內衣秀

五四青年節的廣州街頭，十幾位身着內衣的模特施施然走在人流如潮的廣州農林下路，引來不少路人觀看。這一頗不尋常的景觀，是一家內衣廠為宣傳其產品而推出的「大膽策劃」。

Models parading down Nonglinxialu street in Guangzhou to promote a new line of lingerie, 2001.

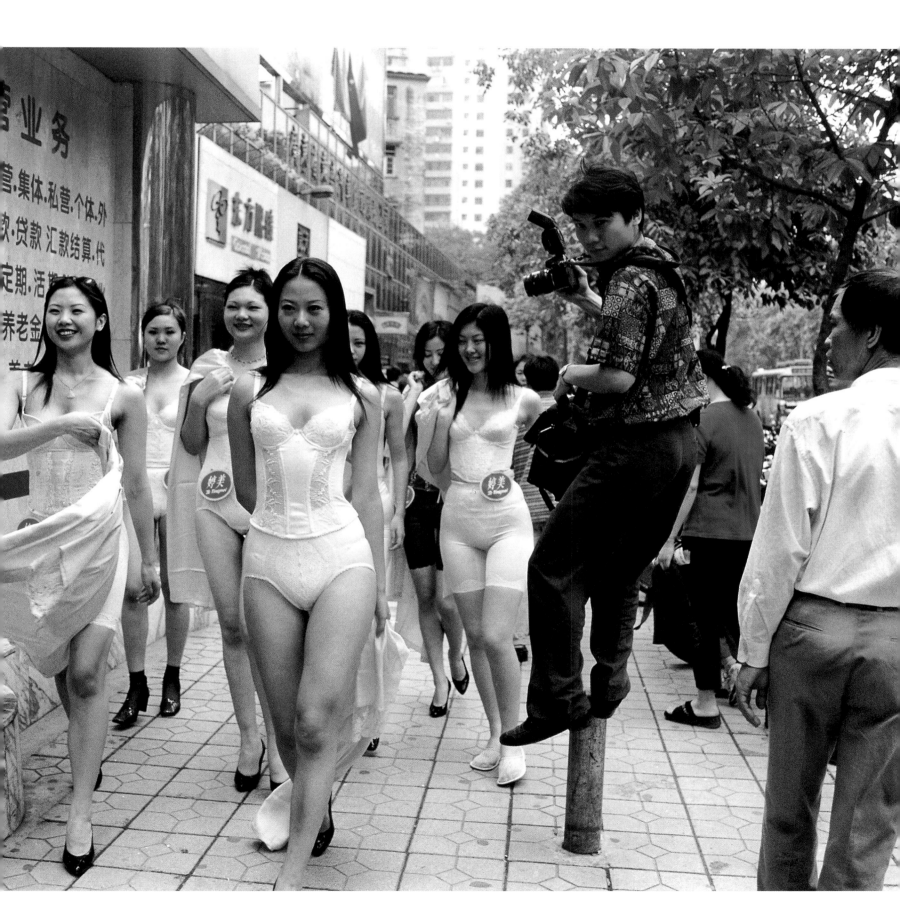

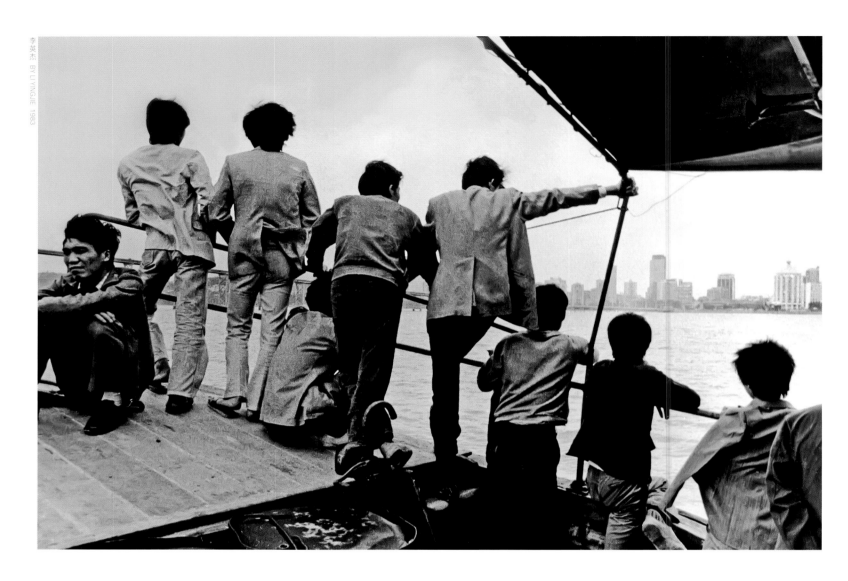

李英杰 BY LI YINGJIE 1983

△ 從海上看澳門

1983年，乘着小船在海上轉一圈看澳門，成為當時一件新奇之事。

In 1983, a trip around Macao on a boat was novelty to people.

▷ 沙頭角「中英街」上的購物人潮

80年代，能開個證明到香港與深圳特區之間的沙頭角中英街走一走，也感覺好像到了香港。

In the 80s, a walk in Chung Ying Street of Sha Tau Kok, an area between Hong Kong and Shenzhen, felt like being in Hong Kong.

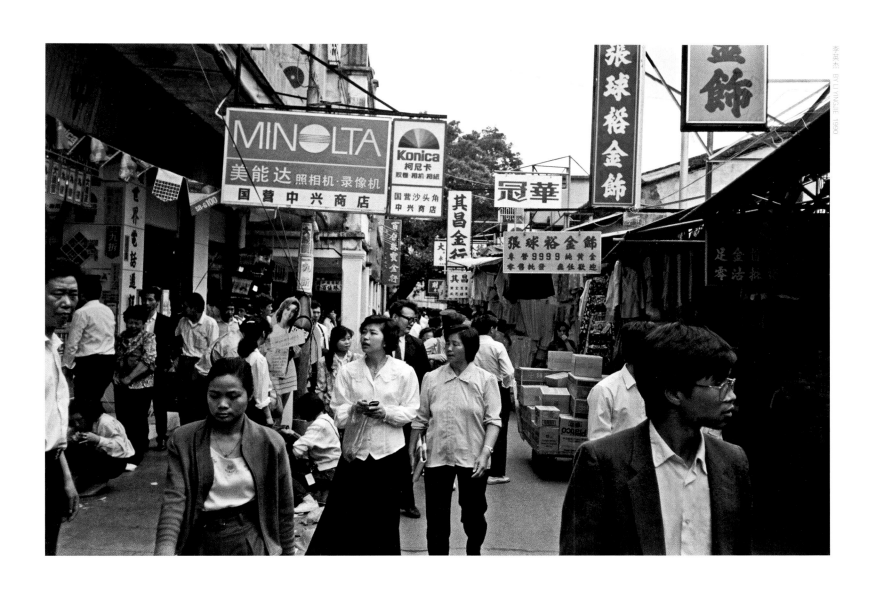

沿海工業
Coastal Industry

　　珠江三角洲因為地理上的便利最早吸納了大量境外投資，使「三來一補」的出口加工工業繁榮起來。電子業、加工業、紡織業……這種輕型工業都以勞動密集為特徵，在吸納投資的同時吸納了大量農村勞動力。投資、就業、外向型經濟三管齊下，迅速帶動了沿海地區的經濟成長，也為1980年代中國經濟持續成長作出巨大貢獻。

　　Coastal manufacturing industries took off after Deng Xiaoping led the decision, in 1980, to allow certain areas to experiment with market reforms and opening and "get rich first" – and coastal economies have been booming ever since. It began with the establishment of four special economic zones (SEZs) — in Shenzhen, Zhuhai, Shantou (in Guangdong Province) and Xiamen — designed to attract foreign investment to develop export-oriented industries through foreign joint ventures. The idea was to import advanced foreign technology and management expertise, and export to the world.

　　After this experiment was deemed successful (and it was proven to skeptics that the zones could serve socialism after all), an additional 14 port cities were opened to foreign investment and development. This was followed by the opening of other areas, such as the Yangtze River Delta, southeast Fujian Province and the Bohai Sea Rim. Hainan Island most joined the list of special economic zones in 1988.

　　Manufacturing industries in these areas have created millions of jobs and attracted workers from other parts of the country. The development of the coastal areas, which had a collective population of about 200 million boosted the nationwide reform and opening and economic construction.

▷ 深圳外資企業的工人宿舍

1985年，深圳打工妹宿舍外景。一片琳瑯滿目，呈現的是活力也是生活。

A residence for women workers in Shenzhen, 1985.

◁ 為港商加工電吹風線圈

1982年，原廣東省寶安縣石岩公社上屋村線圈廠的生產流水線，是深圳（當時是寶安縣）第一家牽扯外資的來料加工小工場。香港怡高實業公司於1978年12月18日與上屋村簽訂「三來一補」（來料加工／來樣加工／來件裝配補償貿易）合同，隨即合辦了一間200平方米，60多名工人的「線圈廠」。年加工費收入30萬港元。所謂「發熱線圈」，不過是電吹風的發熱絲而已。此舉開始時曾引起很大爭議和強烈反對，認為這是為境外資本家充當廉價勞動力。

Women at work on the production line for Shiyan Commune in Shenzhen, Guangdong Province. The commune, based in Shangwucun village, of Bao'an County, established Shenzhen's first joint-venture processing plant with an overseas company when it signed an agreement with a Hong Kong firm on December 18, 1978.

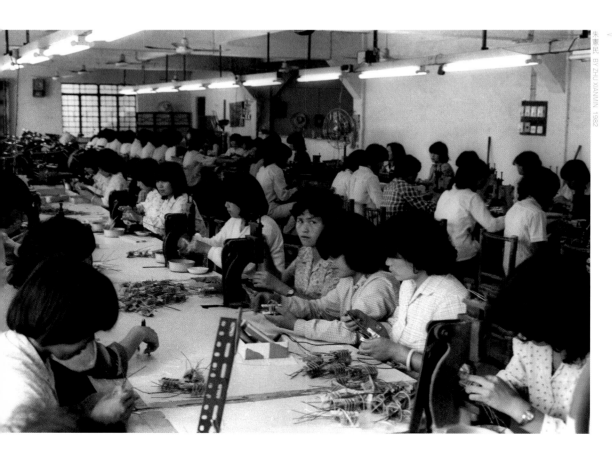

朱憲民 BY ZHU XIANMIN 1982

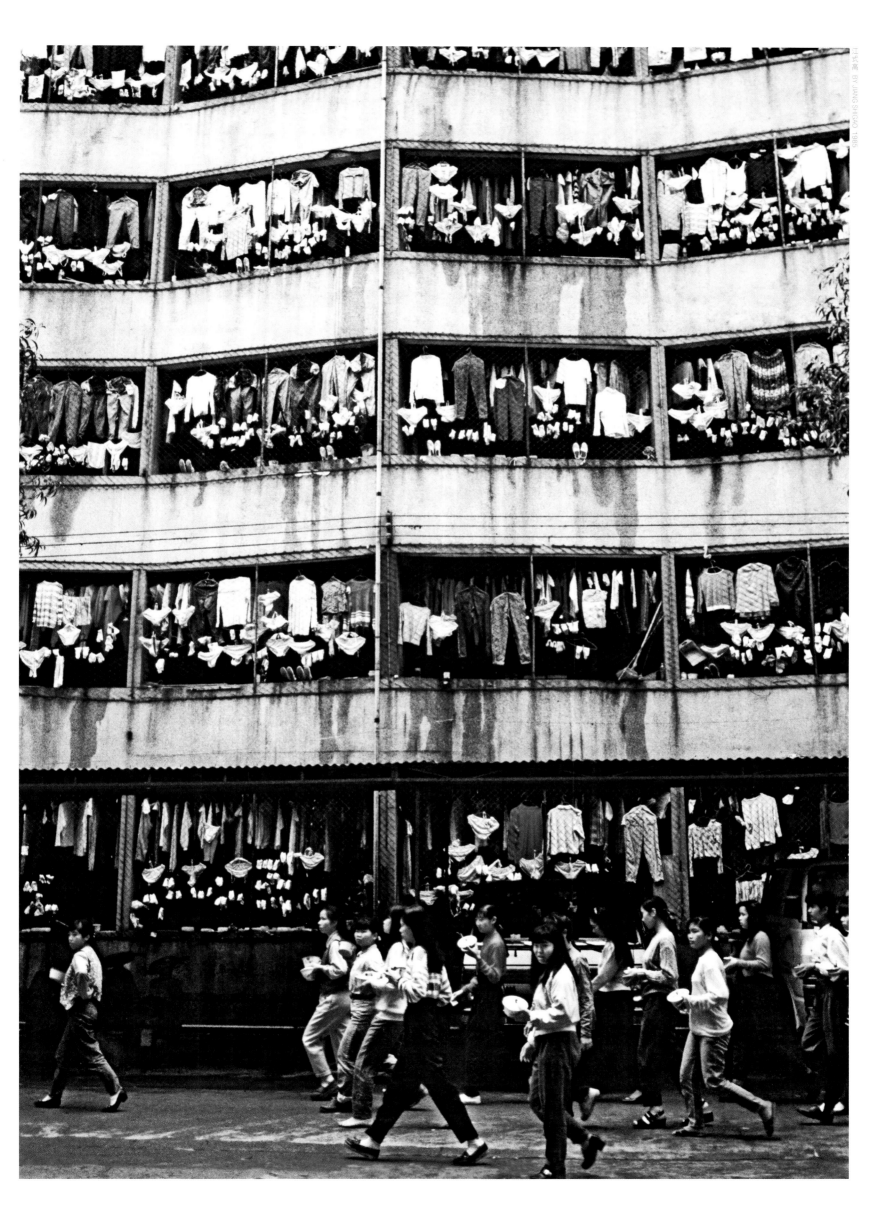

拍賣產權

Auction of Property Rights

　　中國式的產權革命靜悄悄地推行着。最初的拍賣是對經營不善的企業前途進行處置，摸着這塊石頭過河，卻撈出了產權問題。社會經濟活躍後，舊的管理模式低效率低收益的弊端越來越突出，原因出在產權名義上的公有制事實上的無人負責。改革開放以前，所有企業都是國有的或「集體」的。1980年代中期，隨着「第三產業」的發展，先是在商業企業普遍進行了管理方式的改革，繼而在中小企業進行了同樣的推行。一大批鄉鎮企業、民營企業由是產生。

　　Auction of property rights of badly-run enterprises in fact showed the failure of the state-own and local enterprises, which were the only available business models prior to the reforms in China. Since the middle of 1980s, the development of service tertiary industry sent waves of reform in business management in China, and many local and private enterprises were then found.

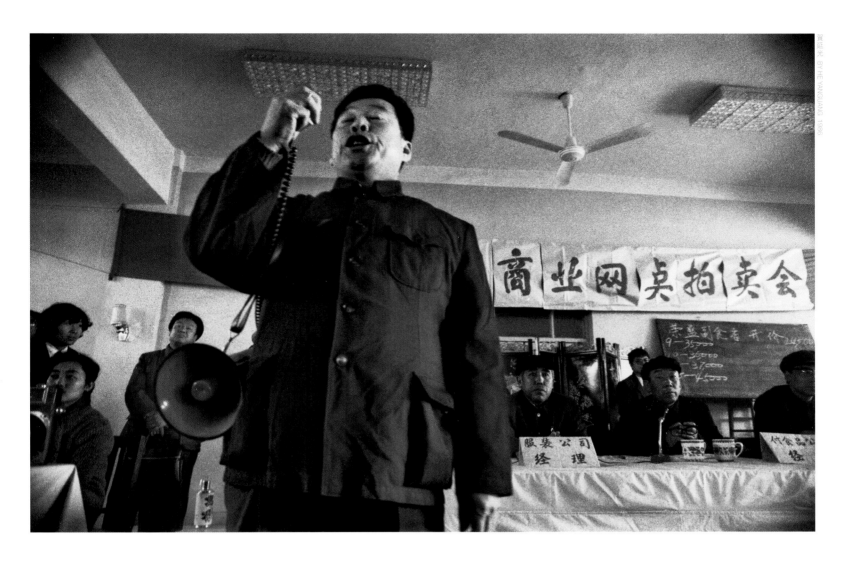

賀延光 BY HE YANGUANG, 1986

深圳政府拍賣土地使用權

1987年12月1日，中國大陸首次土地使用權公開拍賣會在深圳會堂舉行。深圳市房地產公司以525萬元的最高價擊敗另外33家角逐者，從市政府手中購得一塊面積為8,588平方米的商品住宅土地50年的使用權。時任中共中央政治局委員、國家體改委主任的李鐵映觀看了這次拍賣會。1988年3月，中國七屆人大一次會議通過《中華人民共和國憲法修正草案》，把禁止出租土地的「出租」二字刪去，規定：「土地的使用權可以依照法律的規定轉讓。」

At China's first auction of land use rights in Shenzhen on December 1, 1987, the Shenzhen Special Zone Housing Development Company successfully bid 5.25 million yuan for the 50-year land use rights of a block measuring 8,588 square meters. Nine overseas investors were among the 43 competing bidders.

北京國營店舖易主私人

1986年11月28日，北京市朝陽區服務公司下屬的4家長期虧損的店舖，經估價後公開向私人拍賣。據稱可使國營單位走出困境亦可為個體戶搭建平台的這一舉措，引發經濟界的激烈爭辯。

An auctioneer, selling off four unprofitable state-owned shops in Beijing, November 28, 1986. The sale went to a private bidder.

「市場經濟」
The Market Economy

同樣叫「市場經濟」，30年裡，它的內涵經歷了不動聲色的變化。一開始，這個詞兒意味着消費市場可以由普通人進入買賣、經營，這是中文中「經濟」的本來語義。到今天，它意味着生產要素按照社會需求進行市場配置的經濟制度。無論如何，在中國的政治辭典裡，這個詞語的引用和推行意義重大。

China's socialist market economy, the brainchild of the late leader Deng Xiaoping, has generated huge amounts of wealth in China, lifting millions out of poverty. Nevertheless, in addition to benefits, the system has presented the government with major challenges, such as how to ensure effective tax collection from so many entrepreneurs and how to regulate the quality of goods and services on sale in such a large country. According to the People's Daily in 2005, the private sector generates up to 70 percent of China's gross domestic product. Since the beginning of Deng's reforms, GDP rose from around US$150 billion to more than US$1.6 trillion by 2005.

武漢街頭催繳稅

1988年9月15日，武漢市青山區稅務局稅務專管員吳彧年在青山區紅鋼城十一街要求漏稅的個體商販補交稅款。改革開放後，多種經濟成分十分活躍，偷稅漏稅現象也相應多了起來，促使全國各地稅務部門加強了收繳與管理。

A tax collector for Wuhan's Qinshan District presents a tax demand to a street stall holder on September 15, 1988. Tax evasion became rife as the economy diversified, and the government was forced to tighten tax regulations.

領袖身邊的賣肉攤

1987年山西省晉城市，春節前的下雪天。領袖像近旁是個體戶的賣肉攤。

Butchers set out their stalls below Mao Zedong's statue in Yuncheng, Shanxi Province, 1987.

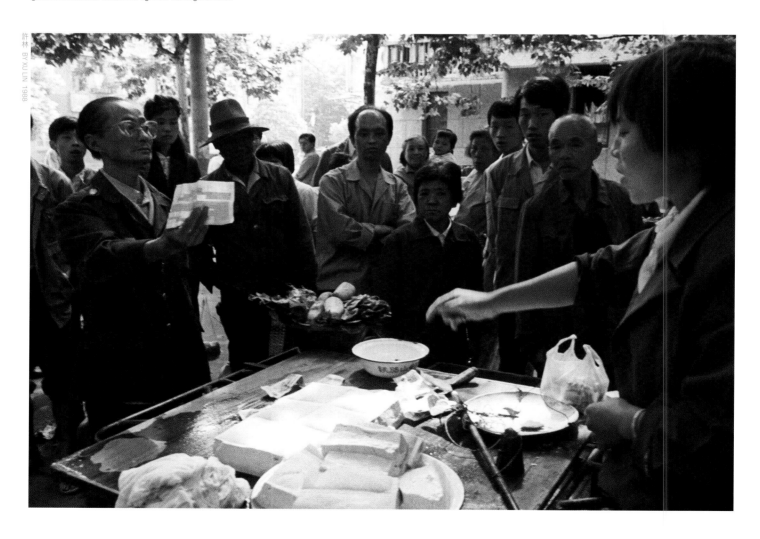

攝林 BY XU LIN 1988

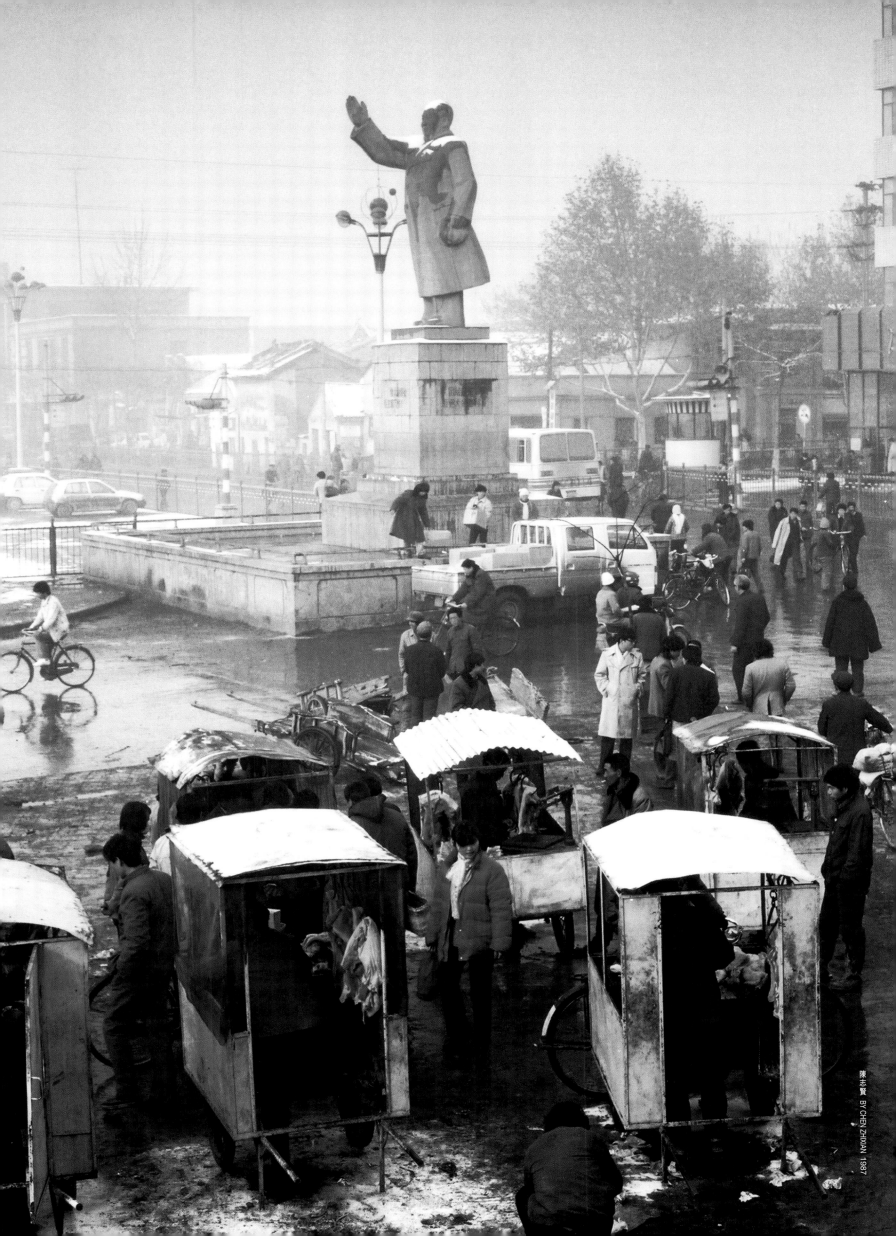

陳志賢 BY CHEN ZHIXIAN 1987

瀆職者的窘境

圖為憂心忡忡的漠河縣長高保興（右1）。1987年5月13日上午，漠河縣西林吉火車站橋頭臨時停機坪，半小時後，時任副總理的李鵬的專機就要在此降落，他將如何面對？那年的5月6日，一場森林大火燒毀了漠河縣城，燒毀了百萬公頃的森林。

Gao Baoxin (right) waits pensively for the arrival of Vice Premier Li Peng's helicopter amid the scorched terrain left by a massive blaze on May 13, 1987. Gao was head of Mohe county, Heilongjiang Province, the site of the fire that started on May 6 and burned for three weeks. The fire laid waste to 2.5 million acres and claimed 193 lives. Around 50,000 people lost their homes and hundreds more were injured. When the fire finally burned out on May 27, Forestry Minister Yang Zhong was held responsible for the initial failure to contain the blaze and was sacked.

住院之前

1990年，安徽蚌埠一家醫院門口，一農家兄弟幾個在湊錢，身後的拖拉機上躺着的是他們生病的母親，如果不先交付一筆費用，病人是住不進醫院的。

Three brothers pool their cash to get medical treatment for their elderly mother, who lies on a tractor behind them. The sick are required to pay a deposit before they can be treated at hospitals.

蔡天富 BY QIAO TIANFU 1987

困窘
Anxiety and Frustration

　　總有一些人在困窘。大興安嶺火災以後的當地官員會困窘；醫院裡交不起醫療費的農民也會困窘；改革進程中總有問題需要靠深化改革才能解決。比如，大興安嶺的官員們其實有點冤枉，那個地區長期分屬三個省級機構管轄，難免有責任和資源上的扯皮和推諉。農村醫療制度的建立更是難題，資金、醫藥供應、專業人才、財務系統……處處都是障礙。有人說「深化改革，深化改革，越深化問題越多」。事實上，改革越到深處碰到的問題越是棘手：好改的都改了，剩下的都是難度大的深層問題。

Anxiety and frustration seem ubiquitous in times of economic reform, as outdated systems are replaced (sometimes slowly) by news ones, while nature continues to exact its toll on the environment and on people's health. But when a fire rages over a forest under the jurisdiction of three different provincial authorities, each facing scarce resources, one hardly knows where justly to put the blame. Establishing a rural health care system is even more challenging, with problems of funding, accounting, and the daunting needs for medical supplies, facilities and professional personnel. Some problems may be addressed through reform; but just as often, reforms engender new and often more intractable problems.

雍和 BY YONG HE 1990

企業家
Entrepreneurs, from Hero to Zero

在整個1980年代的中國工商註冊中，企業註冊呈幾何級數放大。在企業的迅速成長中，企業家群體也在形成。企業家控制基層經濟細胞，擁有民間財富，影響着就業和地區經濟。更重要的是，企業家是經濟增長的發動機，社會穩定的制衡器，政策調整的推動者。企業家階層的形成是經過市場選擇的，興焉衰焉此焉彼焉，優勝劣汰。好的是，這裡市場的選擇必然勝於非市場的選擇。進步了！

Since the launch of reform and opening, entrepreneurship has exploded in China. From slick fashion boutiques selling the latest designs, to street hawkers peddling sweet potatoes, the country boasts a diverse array of small, medium and large-scale enterprises. It's difficult to imagine what Mao would make of this transformation, but it has undoubtedly helped improve the lot of hundreds of millions of people. Since President Jiang Zemin's "Three Represents" policy, many businessmen have joined the Party and many Party members have become businessmen, but sadly not all to good effect. One staggering example is Yu Zuomin, who transformed his impoverished village into an enterprise hotspot with an output worth 4.5 billion yuan a year. Things all went wrong for Yu, though, when he was jailed for 20 years for covering up murders in 1993. The temptations for a local official during a time of exploding wealth were, for some, too much to resist. Many have fallen from grace after converting power into cash by taking bribes for land development rights.

企業停工以後

上海景福針織廠，工人們得知停工消息後，指着牆上照片中的老總痛罵。該廠生產「飛馬」牌針織服裝，是全國針織行業著名創匯大戶。後來被令兼併兩家針織廠，由此揹上了近1億元的債務，再加上經營不善，兩年後景福廠破產，「飛馬」商標被拍賣。

Workers jeer at a photo of their boss after hearing they are to be laid off from the Jingfu Shanghai Company factory, which went bankrupt in 1997.

「最佳農民企業家」

天津大邱莊的農民企業家禹作敏，是1980年代帶領農民致富的典型。1993年，他因牽涉一樁命案入獄。

Yu Zuomin, Communist Party secretary of Daqiuzhuang village, poses amid the trappings of success. In the 1980s, Yu transformed the impoverished community, 45 kilometers from Tianjin, into an industrial powerhouse. By 1992, the village's collectively owned enterprises were churning out 4.5 billion yuan in output and generating an astonishing 50 million yuan in profits. In 1993, he was convicted of covering up murders carried out by his close subordinates and was sentenced to 20 years in prison.

法律諮詢到鄉鎮

1978年，街頭法律諮詢。

People queue for legal assistance in 1978. Such consultations were held in villages and towns around the country.

「嚴厲打擊犯罪」

1983年，「嚴打」期間，湖北十堰法院門前的佈告欄。

Rulings are posted on the walls outside Shiyan People's Court, Hubei Province, during a crackdown on serious crime in 1983.

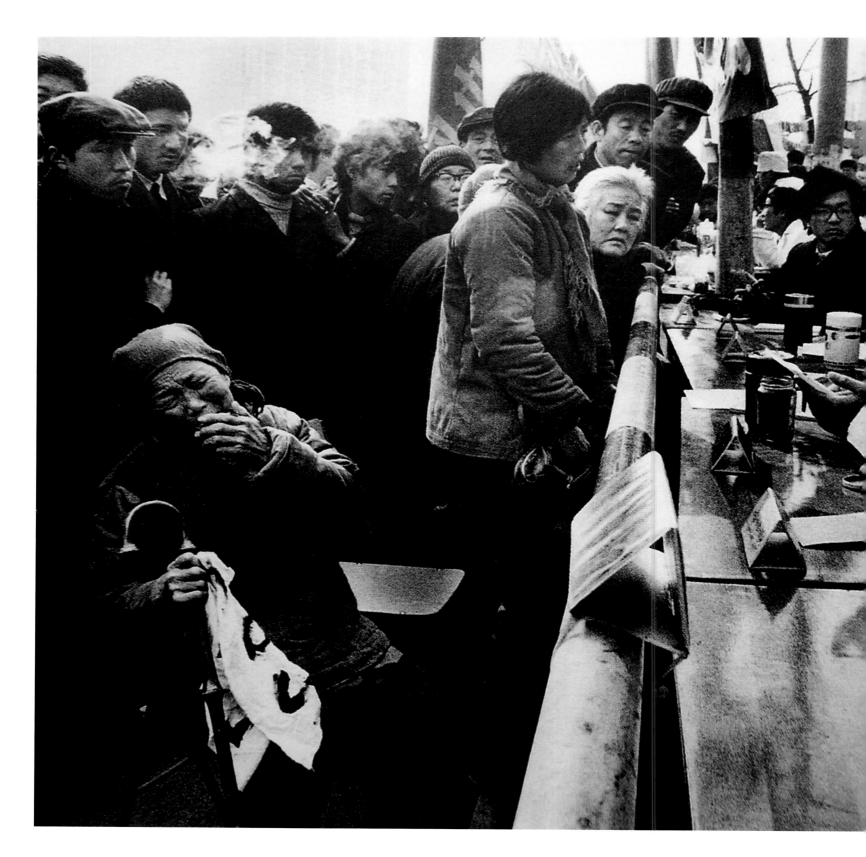

法治
Living with the Law

　　「文革」中，國家主席劉少奇在被批鬥前手裡捏着一本《憲法》，但最終依然慘死於「無法無天」。「文革」後，國家的最高領導人屢聲疾呼「依法治國」，這在剛剛結束個人權力至高無上的年代，社會發展又面臨空前活躍的時候，不啻乾綱命脈。在一個具有悠久「人治」傳統並且現代法律意識淡漠的國家，建立健全法律制度，是力行改革始終的過程。1980年代人們經常談論的話題，不外「人大還是法大？」和「法制還是法治」——前者涉及法律權威與官員權力孰輕孰重，後者關乎國家制度與社會治理。1983年前後，中國曾有一次嚴厲打擊犯罪的社會運動，針對社會秩序的整飭。此期間，各種形式的法律普及、法律服務開始深入城鄉。

　　In 1983, China launched a series of "strike hard" anti-crime campaigns, with criminals being dealt with "severely, heavily and with no delay". The policy was aimed at countering a sudden surge in crime which came about shortly after China began its reform and opening up policy. While the campaigns did help to maintain public order and social stability, the rapid police interrogations and hasty court judgments led to widespread torture and unjust punishment of innocent people. Many people were given penalties harsher than they deserved. After the turn of the century, the authorities began to take a more enlightened approach to tackling crime, and in October 2006 a policy of "balancing severe punishment with leniency" was introduced with the aim of building a more harmonious society. The use of the death penalty has also been curbed, with power to review and ratify death penalty cases handed back to China's Supreme People's Court on January 1, 2007. This ended a 26-year period in which lower courts had the power to decide who got the death penalty. The new policy meant law and order authorities could continue to crackdown on organized crime and severe violence, as well as offenses related to national security, while imposing lighter sentences for more minor matters. Even though severe punishments, including the death penalty, are still part of the new approach, the shift is a major step forward in China's judicial reform, which aims to increase the protection of human rights.

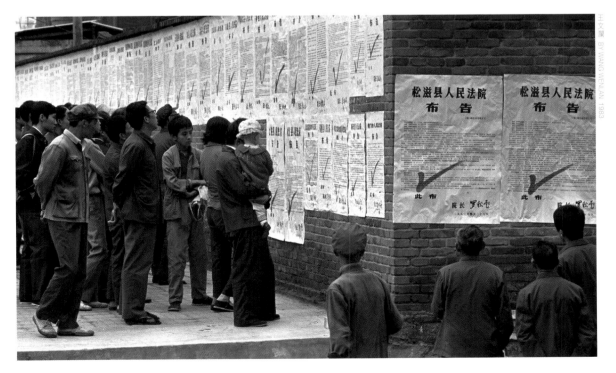

親情
Building Bridges

　　現在人們愛說「相逢一笑泯恩仇」，而剛剛開放兩岸親人探望的時候卻到處是抱頭慟哭訴親情的場面。1949年以後的兩岸隔絕延續了30年。又30年前，這個局面因為大陸政策與對岸政策的互動而呈現變局：台灣同胞到大陸探親成為現實。近30年間，兩岸關係風雲流轉起伏跌宕，其中文化、親情和經濟發展愈來愈成為割不斷的紐帶。放大看，過去100年的中國主題就是「中國現代化」，不同政治力量對其實現路徑持有不同的立場，故而連橫、搏殺，並釀成彌天之血肉悲劇。近30年來之中國改革開放，對彌合兩岸溝壑共鑄民族大義，實在是前進了很多很多。

The resolution of the Taiwan issue and realization of the complete reunification of China is a key policy of the Mainland Chinese government. Beijing has worked persistently toward this goal in the past 50 years, and since 1979 the Chinese government has sought peaceful reunification of China in the form of "one country, two systems", currently in operation in Hong Kong and Macau. But there is a significant movement on Taiwan that is fearful of coming under the control of Beijing, largely due to differences between the two sides' political systems. The pro-independence movement's bubble was burst, however, after losing the election, Taiwan's anti-Beijing leader Chen Shuibian, who has since been jailed for corruption. As a result of these developments contact between Beijing and Taipei has increased and tensions have been eased. Current Taiwan leader Ma Ying-jeou has dramatically improved relations with Beijing since taking office. And there are now more economic and cultural exchanges than at any point since 1949.

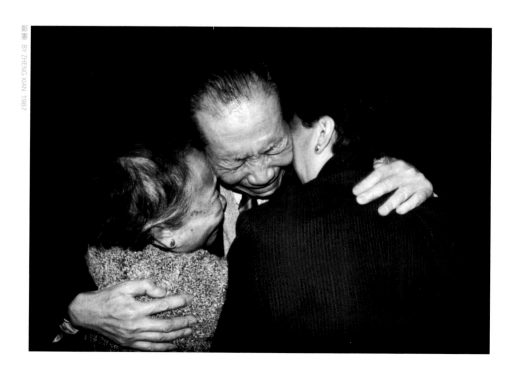

攝影 BY ZHENG XIAN 1987

兩岸親人相聚

從1987年11月開始，台灣同胞首次返鄉探親。年過七旬的台胞蔡先生與分別50年的老姐姐蔡秀珍在廈門和平碼頭相聚，悲喜交集抱頭痛哭。

A man from Taiwan embraces his sisters at their first meeting in 50 years in Xiamen, Fujian Province. In November 1987, for the first time since 1949, Taiwan people were allowed to return to the mainland to visit relatives.

台灣老兵

1988年1月21日，台灣國民黨退伍老兵衝破重重阻力，終於踏上家鄉的土地。他們多年來呼籲返鄉探親，如今，站在萬里長城上，台灣老兵們感慨萬千。

Veterans of the Kuomintang from Taiwan celebrate their return to the mainland atop the Great Wall.

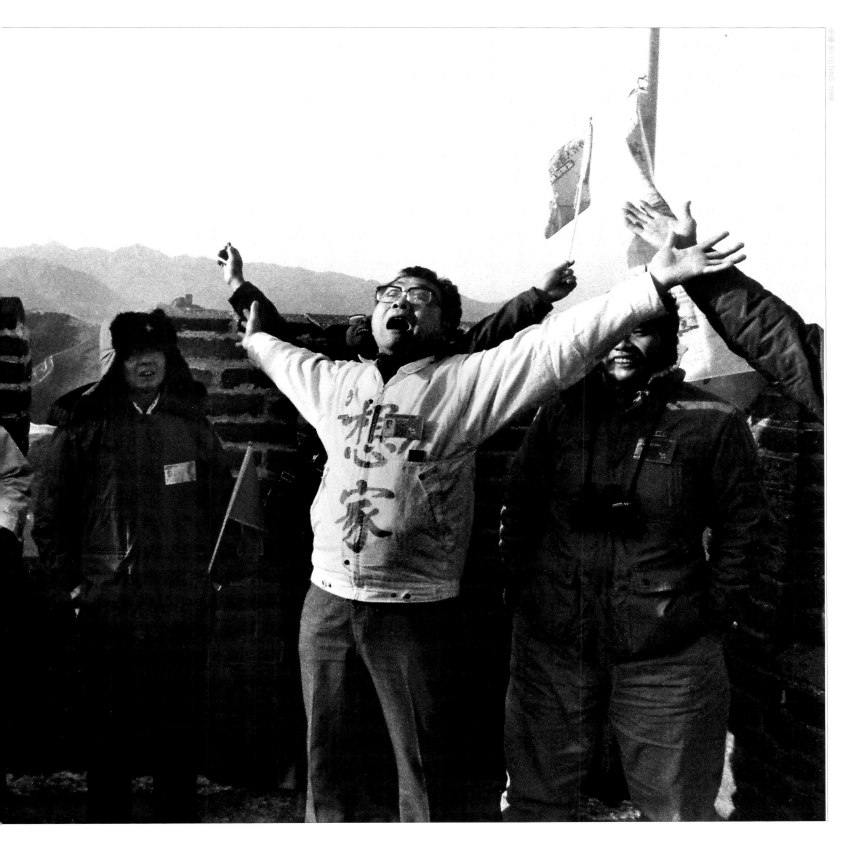

攝影 BY YU NING 1988

留學
Overseas Students

　　上世紀八十年代前後，大陸從公費選派到打開自費留學大門，這項政策的變化對於中國的現代化建設意義極其深遠。30年裡，數以百萬計的青年分赴國外留學，到本世紀初，已經形成了極其可觀的被稱作「海歸」的一支隊伍，成為各領域推動和實踐現代化的中堅。

　　其實，中國的現代化過程在人力資源上就是一個持續地「請進來」和「走出去」的過程。沒有「洋為中用」，「古為今用」就只是文化和體制的複製；改革的不可逆轉，就是人類文明經驗和先進科學技術比照下的中國的必由之路。

After the 1980s, Mainland Chinese students who wanted to study abroad were granted the right to fund their own studies in a policy change which had far-reaching effects and deep meaning for China's modernization. Students previously had to rely on public funding. And during the past 30 years millions of young people have gone abroad to study. By the turn of the century, this large group in society had become objectively known as the "returnees", and they became the backbone in pushing forward modernization in all fields. In fact, China's process of modernization, as far as people power is concerned, is a continual process of "inviting people in" and "sending people out" to explore. If China does not implement means to have "foreign things serving China", its effort to have "the past serving the present" would only result in copying and reproducing cultures and systems from previous generations.

留學生們在美國紐約的生日聚會

1988年5月，一群在紐約的中國留學生，其中有的人已經完成學業，打入了華爾街。這是一次生日聚會，也是為王波明（後排右八）、高西慶（後排右一）回國送行，他們要回去打造中國的華爾街。

May 1988, New York City. A birthday party, as well as a farewell party for Wang Boming (eighth from right back row) and Gao Xiqing (first from right back row) — they were going back to China to build the Chinese Wall Street.

宗教
Choosing Religion

　　民間思想活躍的一個角落是宗教的悄然復興。中國本來是一個文化多元、教派豐富的國家，「文革」中，在「破四舊」的旗號下，傳統宗教受到極大摧殘，個人崇拜成為新的宗教。改革既然是全方位的，那麼思想禁錮被打破之後，宗教也必然會在民間信仰中「復燃」。有人對此不以為然，不過沒辦法，該滋生的就會滋生，民間要有信仰遵從，國家要講信仰自由，宗教就在這個夾縫中攀緣生長。

　　With its huge land area and population, it is no surprise that China is a country with diverse religious beliefs. The main religions are Buddhism, Taoism, Islam, Catholicism and Protestantism. Religious freedom has greatly improved since the days of the Cultural Revolution, although activities are subject to strict scrutiny from the government, which is officially atheist. The period of turmoil from 1966 to 1976 had a disastrous effect on all aspects of society in China, particularly religion. But since then, major efforts have been made to right some of the wrongs inflicted on the followers of faith. Massive investment has been made in repairing temples damaged or destroyed during the chaos. Still, this area of society poses challenges for the government. Lately much importance has been attached to combating religious fanaticism linked to disquiet over policy in the country's western territories. The government states that it "resolutely opposes attempts to split the country along ethnic lines", or "divide the people". But despite its strict stance, government leaders including President Hu Jintao have publicly recognized the contribution religion makes to society.

外國兵士與嶗山道士

1984年，青島嶗山風景區，一隊加拿大士兵正圍着一位道士在交談。「道士」和「戰士」，配在一起本身就耐人尋味，何況又是來自「資本主義國家」的戰士。也是在這次訪問中，3位加拿大士兵夜間在青島棧橋邊救起一位落水女青年，為這次友好訪問加上浪漫一筆。

Visiting Canadian naval personnel, talking with a Taoist priest at Qingdao, Shandong Province, 1984.

龍華寺裡摸銅佛

1989年，農曆二月初八，除了到處都一樣的拜神、表演、交易外，摸銅佛算是雲南姚安龍華寺廟會上最重要的內容了。銅佛有名有姓，叫高映，據說是古時雲南的一位太守。人們相信只要能在二月初八這天，哪兒有病痛就去摸佛身的哪兒，準能治病祛痛。

Villagers in Yunnan Province touch a bronze Buddha, believing it will bring them good health.

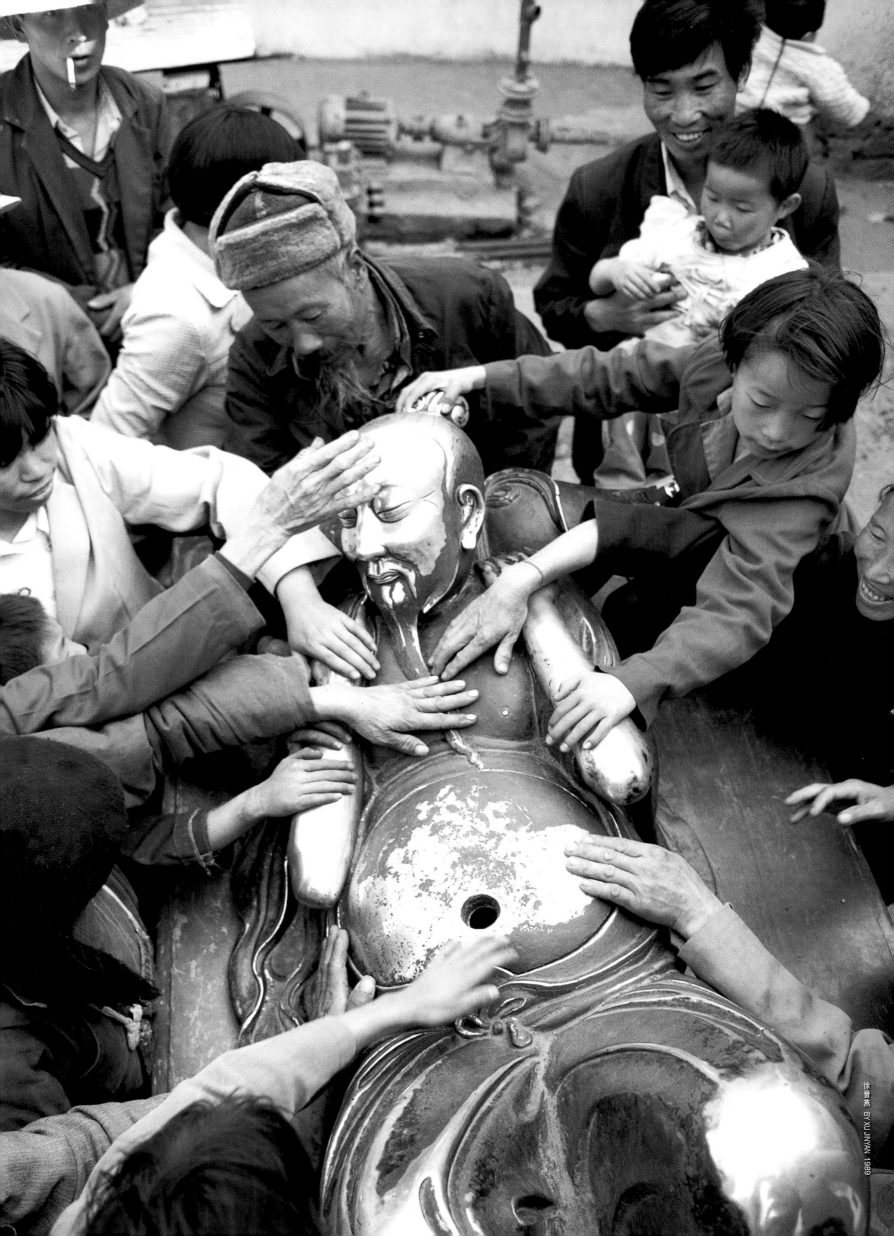

徐晋燕 BY XU JINYAN 1989

變
Transcendence

　　道教是產生於中國的獨特的宗教。氣功是道教文化中一脈奇特的養生倫理和方法，在民間深入人心。不管信不信那個教派，道教及《易經》中的很多意思是貫透在中國人的精神裡的。「天不變，道亦不變。」、「天行健，君子以自強不息」，等等。中國在發生着巨大的變化，這些變化為民眾的生活帶來改善，使這個民族對未來充滿自信與期待。還得變！

　　For a healthy lifestyle, one needs more than good diet and plenty of exercise. In China meditating is an important way of taking care of one's wellbeing. People do this through the practice of *qigong*. *Qigong* incorporates controlled breathing and graceful movements to improve the circulation *of qi* (Chinese for air) within the body. The practice is popular among more mature members of society, who can often be seen in gardens and parks early in the morning practicing their skill. While some believe *qigong* has metaphysical qualities, health practitioners from both East and West have acknowledged its stress reduction potential.

潘科 BY PAN KE 1987

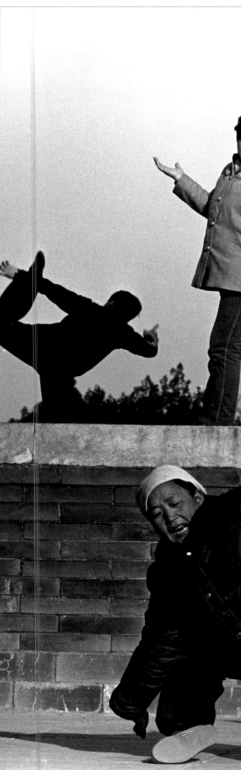

黃小兵 BY HUANG XIAOBING 1992

全民氣功熱

古城西安，全城大興練氣功。圖為1987年西安航空發動機集團公司的職工在練功。

Staff at Xi'an Aviation Group practice breathing exercises for the ancient physical discipline of *qigong*, 1987.

氣功熱風靡一時

1992年4月12日，北京物資禮堂，氣功授課。

Qigong was once the rage, 1992.

地壇公園練功人

1980～1990年代，中國興起氣功熱。圖為1988年在北京地壇公園練羅漢功的人們。

Beijingers practicing qigong in Ditan Park in 1988. The exercise of *qigong* flourished across the country in the 1980s and 1990s.

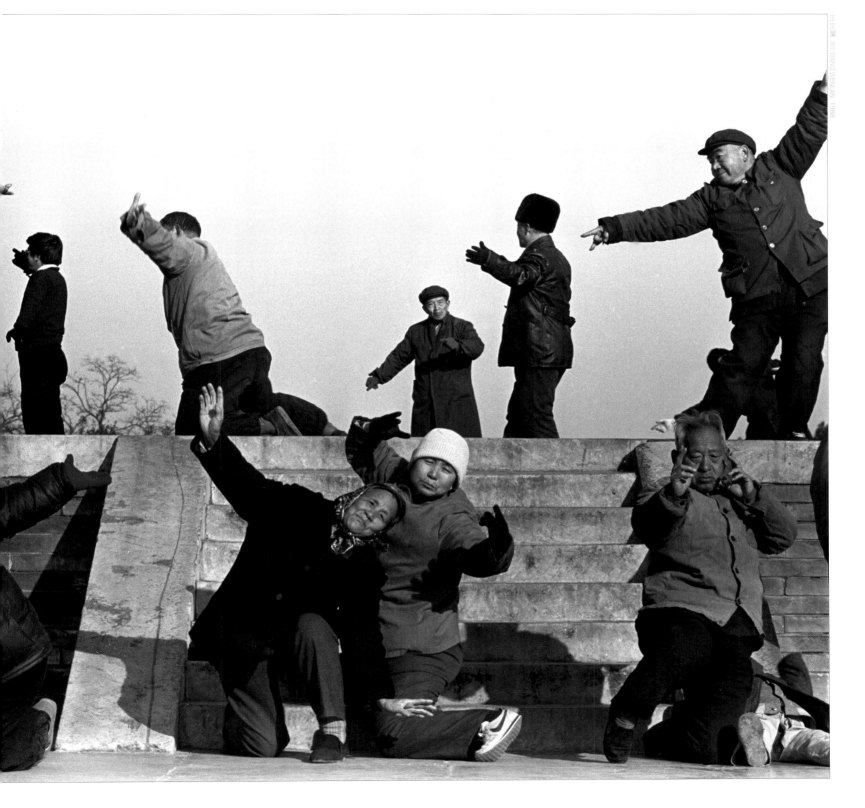

軍隊
The People's Liberation Army

中國軍隊在國家整體改革開放中的作用是值得關注的。作為國家最重要的實力集團之一,軍隊總會在國家政策的重要變動之中起着舉足輕重的作用,各國皆然。改革開放之初,中國軍隊曾以不同形式介入經濟活動,這既是因為軍隊借資源之重,也與當年國家資源分配中「軍隊要忍耐」有關。不過到1990年代初期,軍隊全面退出商業活動,這個過程是值得記錄的。總體而論,中國軍隊對改革開放始終表示堅決支持,曾有口號叫做「保駕護航」,軍隊為開放的國策提供有效的安全屏護,並在改革實現的國力提升中得到軍力提升的巨大資源保證。所有這些,皆源於中共對軍隊的絕對領導。

With an estimated 3 million members, the People's Liberation Army (PLA) is the world's largest military force. Formed by the Communist Party in 1927 as the Red Army, it became the national armed forces in 1949, after the establishment of the People's Republic. China's President Hu Jintao, the leader of the Communist Party, is also the Chairman of the Central Military Commission. The military leadership is comprised of Party members and run by Party committees. The Chinese military, during the latter reform years, has made reductions in personnel in the hundreds of thousands as part of an effort to become a leaner, more efficient and up-to-date defense force. In addition to its core role of safeguarding China's sovereignty, territorial integrity and national security, the also in rescue and relief operations after major natural disasters, most recently the Sichuan earthquake and snow storms in southeast China in 2008.

將士依舊在戰場

1985年,人民大會堂,將領齊聚紀念抗戰勝利40週年。

Senior PLA officers at the Great Hall of the People in 1985, at an event to mark the 40th anniversary of the victory in the war against the Japanese invasion.

郭建設 BY GUO JIANSHE 1985

邊境戰爭
Indochina, a Conflict Erupts

　　1980年代上半葉，南部邊境的小規模戰爭持續不斷。戰爭的原因與鄰國在國際關係中的立場有關，也與地緣經濟和地緣政治中利益的爭奪有關。中國軍隊在戰爭中得到了鍛煉，儘管這不是戰爭的直接目的，卻是戰爭的重要結果。下面的照片在當年曾引起爭論，爭論焦點是關於軍事宣傳的立場和傾向的。攝影領域新舊觀念的交鋒，是當時思想文化領域觀念交鋒的縮影。結果是照片中真實的人性展示得到普遍肯定。

　　The Sino-Vietnamese War, which is also known as the Third Indochina War, erupted in 1979 and claimed tens of thousands of lives. The conflict arose most immediately from geo-political differences in the region, although there had been territorial disputes, including disagreement over the Spratly Islands. Since then both sides have pursued peace. In 1999 the two countries signed the *Treaty on the Land Boundary between China and Vietnam* and the following year they exchanged the treaty's instruments of ratification in Beijing. On December 25, 2000, the two countries officially signed in Beijing the *Agreement on the Demarcation of the Beibu Gulf Territorial Waters, Exclusive Economic Zones and Continental Shelf*, and *Agreement on Fishing Cooperation in the Beibu Gulf*. On February 23, 2009, China and Vietnam marked the final demarcation of their land border at the Youyiguan border gate in Pingxiang City in south China's Guangxi Zhuang Autonomous Region. The completion of the demarcation is aimed at promoting peace and stability in the border area, promoting trade and exchanges and pushing forward the strategic partnership between the two countries. Meanwhile, negotiations over the Spratly Islands are ongoing.

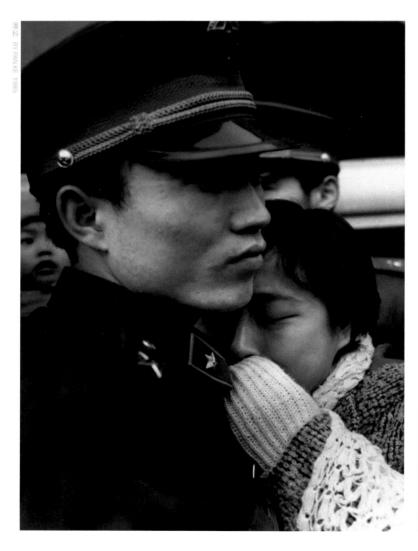

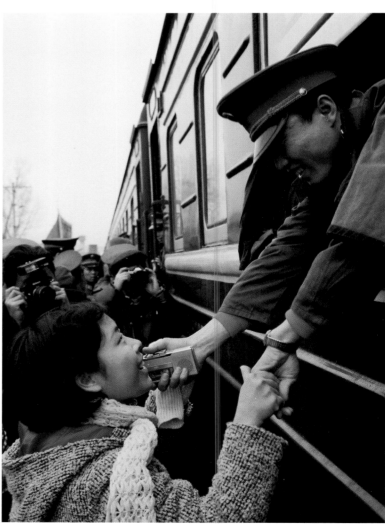

潘科 BY PAN KE 1985

侯登科 BY HOU DENG KE 1985

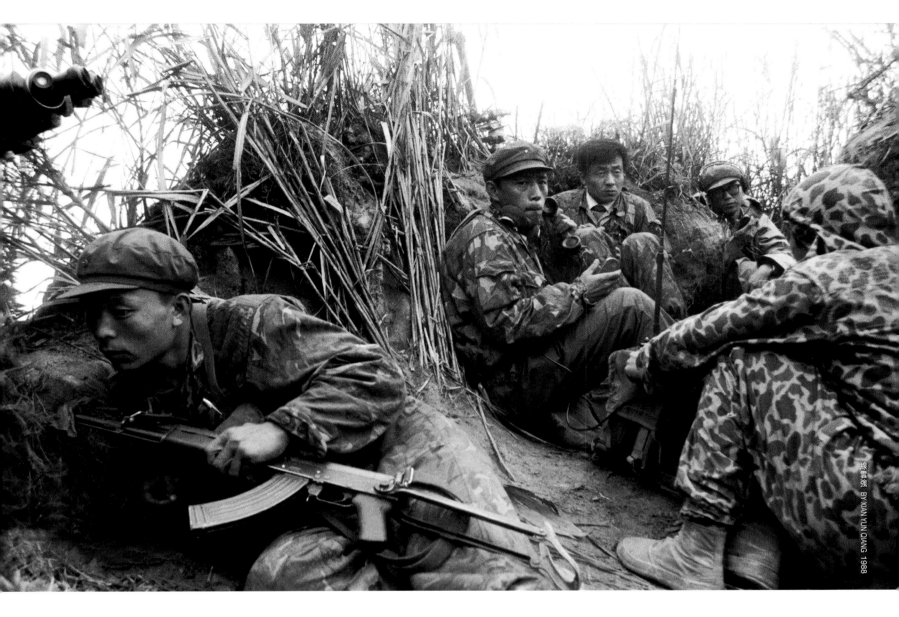

鮮韻強 BY XIAN YUN QIANG 1988

▌鐵血男兒也惜別

1985年12月19日，解放軍某部開赴對越自衛反擊戰前線，軍人楊越朝和他的未婚妻盧俏梅依依惜別。

A tearful goodbye, as soldiers return to the front, December 19, 1985.

▌老山前線

1988年雲南省老山前線的一個戰地指揮所。

A frontline command post in Laoshan, Yunnan Province, 1988.

NBC 天安門廣場直播採訪

1987年，美國全國廣播公司（NBC）經過一年的申請
與準備，派遣150人的報道團隊來到中國，展開題為
《變化中的中國》特別報道。1987年9月30日下午，
NBC在天安門廣場架起衛星天線，直播由其名主持布
賴恩特·岡貝爾（Bryant Gumbel）採訪當時能用英語
直接對話的中國農牧漁業部部長何康。

Chinese Agriculture Minister He Kang (left) gives a live interview
to U.S. NBC broadcaster Bryant Gumbel in Tiananmen Square on
September 30, 1987.

遊人駐足看廣場

1979年，遊人們站在天安門前的觀禮台前，並不是有
甚麼特別的事情發生，只是為了看新鮮。

Sightseers take in Tiananmen Square from the Tiananmen Gate
in 1979.

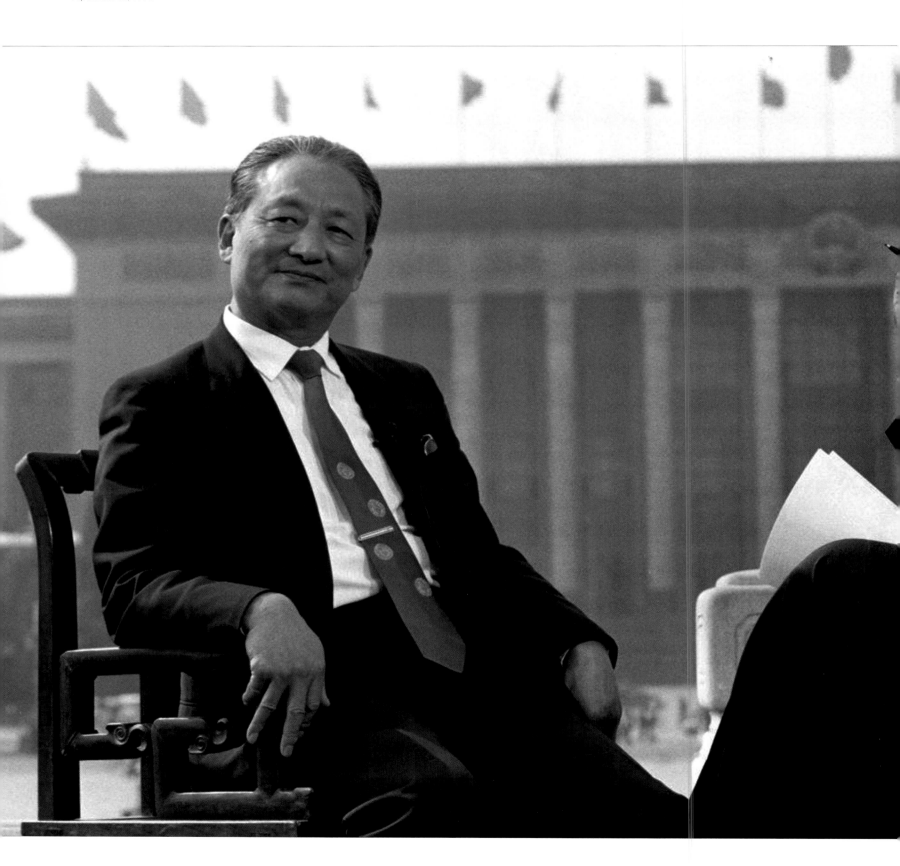

廣場
A Square to Define a Nation

外國人到中國一定要來天安門廣場，外地人到北京也一定要看天安門廣場。這裡是凝聚着國徽圖案的地方，現實，也是象徵。1980年代初，站在天安門觀禮台的台階上看，所有的都會是新鮮的，人、車、景，就像今天我們看他們。不過也確有今天難得一見的場景：外國記者搬兩把椅子，就坐在天安門廣場上採訪官員。今天，如果奧巴馬或布朗坐在白宮或白金漢宮的院門外接受採訪，一定是發生了不同尋常的事情——還有甚麼更象徵着「開放」的採訪位置呢？

Tiananmen Square has been the site of numerous historic political events over the past century. These include the anti-imperialist May Fourth Movement in 1919; the proclamation of the People's Republic of China by Mao Zedong on October 1, 1949; the annual mass military displays on all subsequent National Days until October 1, 1959; Mao Zedong's greeting of the Red Guards and mass rallies during the Cultural Revolution; the 1984 military parade for the 35th anniversary of the People's Republic of China and the 50th anniversary in 1999. There were also protests on the square in 1976 after the death of Premier Zhou Enlai, and of course by student activists in 1989.

「聯辦」 機構
The Stock Exchange Executive Council

　　1989年3月15日下午，在北京香格里拉飯店的牡丹廳，證券交易所研究設計聯合辦公室成立（1992年改名為中國證券市場研究設計中心），這家被業界稱為「聯辦」的機構，先後參與了上海證券交易所和深圳證券交易所的籌備建立以及中國證券監管體系的建立。以後又培育了包括和訊網、《財經》雜誌和《證券市場週刊》等一系列知名財經媒體。

　　The China Securities Market Research and Design Center was formally established on March 15, 1989, as part of the reform and opening policy. The center (also known as The Stock Exchange Executive Council) participated in the design and launch of the Shanghai and Shenzhen stock exchanges the following year as well as the establishment of China's securities regulatory structures.

「聯辦」機構成立

「聯辦」成立儀式前，參加簽約的代表們對相關文件進行最後的核對。

On March 15, 1989, China Securities Market Research and Design Center was set up in Beijing.

從「蘇聯」到「俄羅斯」
The Bear and Dragon Make Up

　　中蘇關係是中國對外關係中最重要的關係之一。經過重大的政策折轉，以戈爾巴喬夫訪華為標誌，中蘇關係完成了正常化的進程。戈氏訪華正值中國改革歷程中最複雜嚴峻的時候，他回國後不到兩年，在蘇聯乃至東歐發生巨變，蘇聯解體易幟「俄羅斯」，共產黨失去執政地位。「蘇、東事變」之後，許多人擔憂中國的改革是否會停滯？事實上，恰於此後，中國興起新一輪改革開放的熱潮。這期間，鄧公執掌國運樞紐。1989～1992年間之中國命運及鄧氏作用，足可為史家咀嚼經年！

　　Despite their shared Communist brotherhood, Sino-Soviet relations began to worsen in the late 1950s due to ideological differences between China's Mao Zedong and Russia's Joseph Stalin. In 1964, the Chinese and Soviet Communist parties broke relations, and the Warsaw Pact Communist parties followed suit. Relations remained frozen until the early 1980s. On March 24, 1982, Soviet leader Leonid Brezhnev announced the intention to improve ties with China. The normalization of Sino-Soviet ties arrived under Deng Xiaoping, based on the precondition that the Soviet Union eliminate the so-called "three barriers". These were: to withdraw troops from the China – Soviet border areas and from Mongolia; to withdraw troops from Afghanistan; and to persuade Vietnam to withdraw from Cambodia. China and Russia later exchanged a series of visits between high-ranking officials. Tensions simmered, however, due to the Soviet Union's slow progress in removing the three barriers. These obstacles were eventually removed before Gorbachev paid an official visit to China from May 15 to 18, 1989. The theme of the meeting, devised by Deng, was to "Put an end to the past and open new prospects for the future". Following the disintegration of the Soviet Union and its Communist Party's loss of its governing role in Russia, Sino-Russian relations agreed developed rapidly on the basis of principles for guiding inter-state relations at the Deng – Gorbachev summit. Since then, the two countries have surmounted ideological obstacles and established ˙ strategic cooperative partnership aimed at facing the 21st century. Nowadays, the Sino-Russian relationship has created one of the most influential forces in global politics.

鄧小平會見戈爾巴喬夫

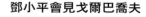

1989年5月15日～18日，蘇共中央總書記、蘇聯最高蘇維埃主席團主席戈爾巴喬夫對中國進行了正式訪問。鄧小平與他舉行的會見，宣告了中蘇關係正常化的最終實現，這是20世紀最具影響力的事件之一。

Deng Xiaoping greets Soviet President General Secretary Mikhail Gorbachev and his wife, Raisa, in Beijing in May 1989. The historic meeting came about with the formal restoration of relations that was expedited when the Soviet leader came to power in 1985.

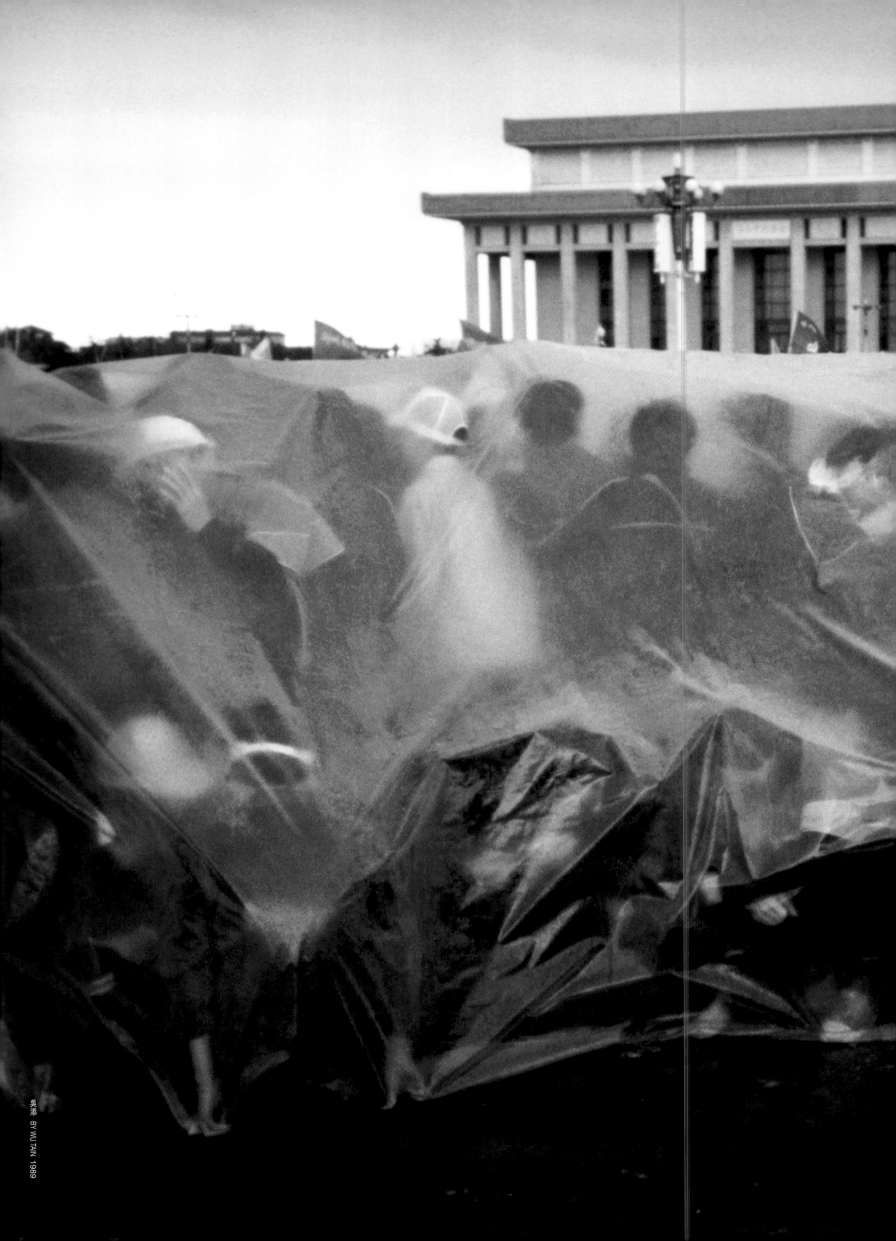

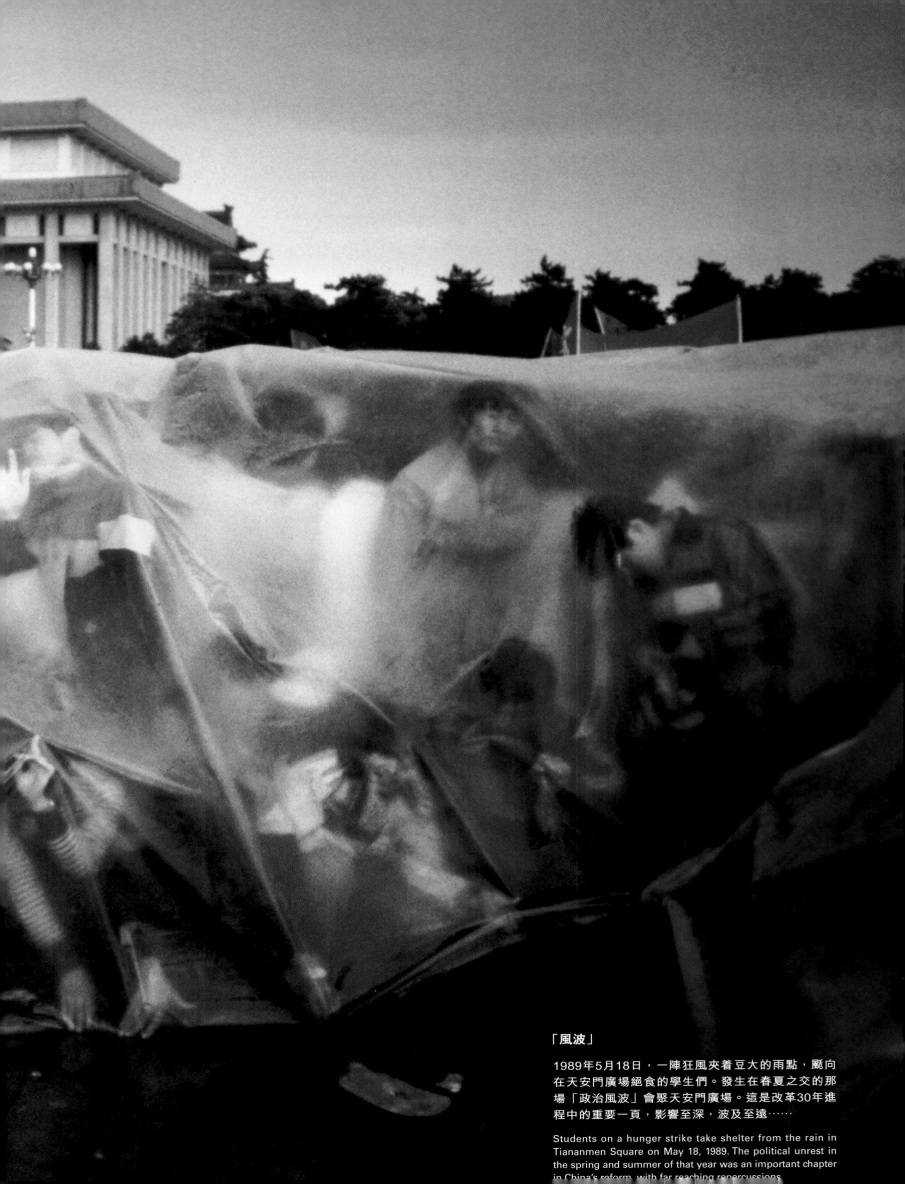

「風波」

1989年5月18日，一陣狂風夾着豆大的雨點，颳向在天安門廣場絕食的學生們。發生在春夏之交的那場「政治風波」會聚天安門廣場。這是改革30年進程中的重要一頁，影響至深，波及至遠……

Students on a hunger strike take shelter from the rain in Tiananmen Square on May 18, 1989. The political unrest in the spring and summer of that year was an important chapter in China's reform, with far reaching repercussions.

字坐標

影像是用來「看」的，「說」的越少越好。文字作為一個符號系統存在了三千年，圖像存在歷史遠遠長於文字，圖像的信息含量遠較文字豐富，而且不同的讀者也會有不同的解讀，比如，「站在」拍攝的當時看取景框裡的情景，與「站在」此刻觀望並不遙遠的當年。

歷史是一個坐標系。我們每一個人是那個坐標系中的「子坐標」。

20年前的1987年10月，《人民日報》一版發表過一篇當時引起轟動的文章《中國改革的歷史方位》。3位當時尚且年輕的記者前瞻後望，說：「生活在變，觀念在變，人在變，一切都在變。興奮、驚愕、困惑、期待……襲擾着每一個人」，然後問：「我們從哪裡來？我們向何處去？」

30年來，這類哈姆雷特式的問題無時不在拷問着我們。

是啊，這是一個縱向的歷史演進和橫向的社會變革的過程……當年在河灘上丈量責任田的鄉親們（第32頁）知道他們以後可能票選村幹部（第178頁）嗎？在物質匱乏的年代搶購服裝的市民（第52頁）可會想到私家車市場火暴的時候（第327頁）？曾幾何時我們還在為打上一條領帶而欣喜（第65頁），為一牀席夢思而辛勞（第57頁），現在卻要為「拉動消費」而鼓噪。當然，貪官一直在湧現，他們聚斂財富的瘋狂在放大，他們的官階和數量級也在放大。

微觀地看，社會發展和歷史演進就是一些相互聯繫着的細節構成的鏈條，所有的宏大敘事沒有這些鏈條的支撐，便是乾癟、空洞的。至於進退的歷史方位，只有退開去看那些坐標點的位置，是在印證着進步還是倒退。把影像當成一個信息鏈，這樣的坐標系比比皆是：縱着看，變了——時間推動財富積纍改變着人們的生活；橫着看，變與不變——數量級的放大並不代替基因的變化，制度變革是緩慢的，但在進行中。「我們從哪裡來？」已經清晰；「我們向何處去？」；「石頭」是摸着了，還在「過河」。

還是那篇文章中引用了當年32歲的王滬寧「副教授」的話：「政治形式、民主形式是在一定的社會、歷史、經濟、文化中生長出來的，是一個生態生長過程，不能搞移花接木，也不能搞揠苗助長。」他認為「高度民主當然是社會的發展方向」，「但民主本身是一個發展過程，只有與一定的社會、經濟、文化相適應的政治形式才是最好的政治形式。」那篇文章發表迄今，已經21年了。

其實，我們無時無刻不是站在一個歷史的關節點上。以這樣的視角定睛細讀每一張照片，你都會有新的聯想和發現；以這樣的思路掩卷長思，你也許會生出對歷史的頓悟。

你閱讀這本畫冊的此刻也是歷史的一個關節點。或許因為那是當年「關節點」上的文本標誌，我又要說到那篇文章了。文中有這樣一段話涉及當時國際上一些著名經濟學家的預言，他們認為：「本世紀末可能發生一場特大的世界性經濟動盪」，「一旦大的動盪發生，就可能帶來大的危機，也可能帶來大的機會。如果趕在大動盪前長硬起飛的翅膀，就可能乘風而起，如果耽誤了這已經不多的時機，就可能在各方轉嫁危機的重壓下更加貧弱。」「這就是幾乎所有國家」，「都不約而同地進行體制和政策調整的深刻背景。」

說到這裡，我忽然想到雍和1991年拍攝的那張照片，那是上一個中國改革的關節點，有人站在十字路口，與遠方通話……

Images are to be viewed. The less said the better. Written language as a symbol system has existed for over three thousand years. Imagery has a history far longer than written language, and its information content is far richer. Moreover, different viewers will have different interpretations; just as the photographer looking through the viewfinder sees differently from our looking at the same scene.

History is a coordinate system. Each of us is a subsystem within that coordinate system. More than twenty years ago, in October 1987, the People's Daily published a momentous, front-age article entitled "The Historical Position of China's Reform". Three still-young reporters, looking to the past and the future, remarked: "Life is changing, notions are changing, people are changing, all is changing. Excitement, shock, bewilderment, anticipation, … torment each of us." Then they ask: "Where have we come from? And where to?"

In the past thirty years, we have been dogged by these Hamlet-type questions.

We are situated on a Cartesian coordinate system where the vertical axis shows historical progression and the horizontal access the process of social change. We can map the development from agricultural responsibility initiatives to voting for village leaders, from material scarcity to abundance and efforts to stimulate demand. Official corruption, though a constant presence, is occurring at expanding magnitudes and higher echelons.

Social development and historical progress can be seen by connecting the dots on the coordinate system. The data chain shows whether we have progressed or regressed. Place images in the coordinate system: vertically, we note change – wealth accumulated over time has changed people's lives. And horizontally? Systematic change is slow, but occurring. Where have we come from? – That's clear. Where to? – We've grasped stones that can steady and guide us, but we are still mid-stream.

That article quoted then-32-year-old associate professor Wang Huning: "Political and democratic forms grow out of particular social, historical, economic and cultural conditions, in an organic process. We cannot transplant or tug at them to hasten their growth." He believes that "advanced democracy is of course the object of social progress … but democracy itself is a developmental process. Only those political forms suited to the particular society, economy and culture are the best."

Actually, we are always at historical junctures. Looking at every photograph with this perspective will yield new connotations and discoveries. Contemplation along these lines may yield revelations about history.

The present moment, as you read this photographic account, is also a juncture in history. The People's Daily article recounted prophesies by contemporary international economists: "At the end of this century, there may be an extraordinarily violent global economic storm. … The turmoil could bring great danger or great opportunity. If you strengthen your wings before the storm, you could launch with the gust. If you miss the diminishing opportunities, you may become poorer and more vulnerable, burdened with the weight of crisis passed off by others. … This is the backdrop against which almost all countries will pursue institutional and policy changes."

The Cartesian Coordinate System

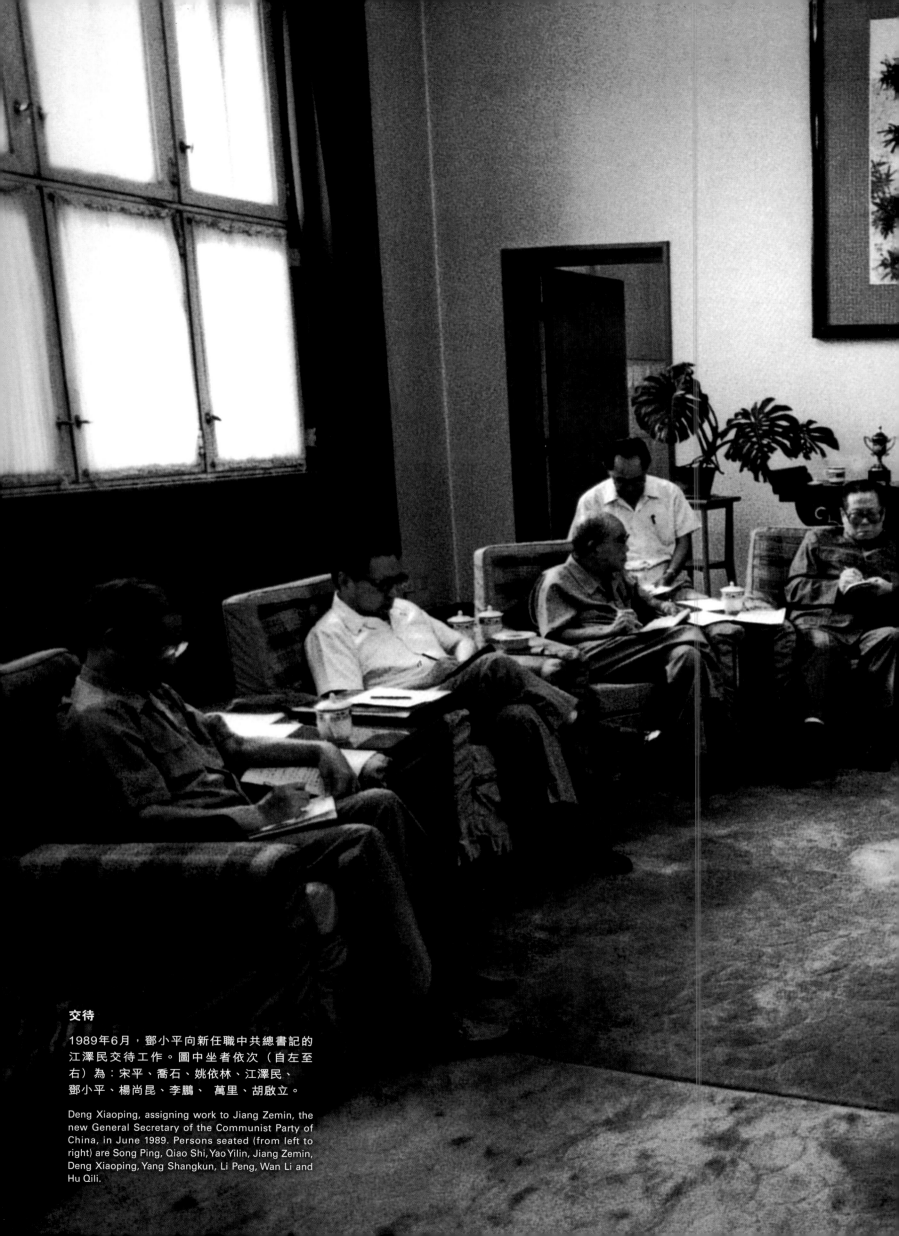

交待

1989年6月，鄧小平向新任職中共總書記的
江澤民交待工作。圖中坐者依次（自左至
右）為：宋平、喬石、姚依林、江澤民、
鄧小平、楊尚昆、李鵬、 萬里、胡啟立。

Deng Xiaoping, assigning work to Jiang Zemin, the
new General Secretary of the Communist Party of
China, in June 1989. Persons seated (from left to
right) are Song Ping, Qiao Shi, Yao Yilin, Jiang Zemin,
Deng Xiaoping, Yang Shangkun, Li Peng, Wan Li and
Hu Qili.

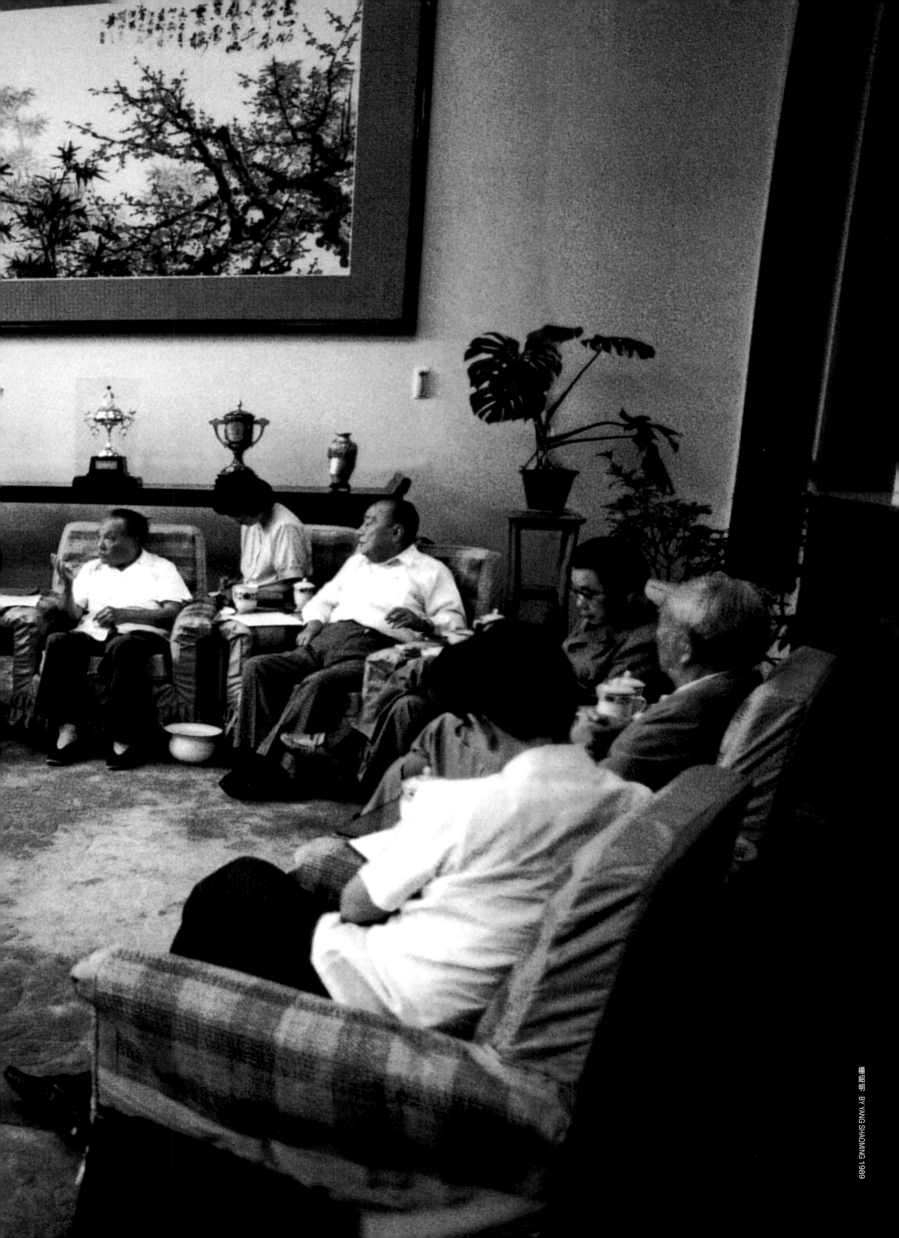

江澤民
Jiang Zemin

　　1989年盛夏，63歲的江澤民出任中共總書記，直至2004年辭去中共中央軍事委員會主席職務，其前後在任15年。此期間中國的變化進步可謂跌宕起伏蔚為大觀。曾經，江到北京赴任時汪道涵以名聯相贈，曰「苟利國家生死已，豈因禍福避趨之」，不乏慷慨之色；經年後，後任語其「從容應對來自各方面的困難和風險，全面推進社會主義現代化建設，開創了中國特色社會主義事業新局面。我國綜合國力大幅度躍升，人民生活總體上實現了由溫飽到小康的歷史性跨越」。江澤民於音樂、篆刻多有愛好，其時有非常之語頗有個人風格，其工程師出身的履歷，更開了中國新一代政治家之先河。

Jiang Zemin, who assumed the post of CPC General Secretary in 1989, was born on August 17, 1926, in Yangzhou, Jiangsu Province. He graduated from the Electrical Machinery Department of Shanghai Transport University in 1947. Jiang held various government and Party posts from 1980 to 1985, when he was appointed Mayor of Shanghai. But his rise to the top came in the wake of the unrest in 1989, and he is credited with helping the recovery of China's international relations and leading China along the road of market economics. Known as a technocrat and a consensus-builder, he was elected president of the People's Republic of China by the National People's Congress in 1993. He was the first Chinese leader to adhere to a system of restricted time in office, serving two five-year terms as state president. Jiang introduced a privatization plan for many of the country's state-owned companies in 1997. Following this theme, Jiang's "Three Represents" theory led to the modernization of the CPC and opened membership to professionals and entrepreneurs. He will also be remembered as the first modern Chinese leader to show an informal side, famously singing Elvis Presley's "Love Me Tender" at the 1996 Asia-Pacific Economic Co-operation summit in the Philippines. He retired as president and CPC General Secretary in 2003 and the following year stepped down as chairman of the CPC Central Military Commission.

郭建設 BY GUO JIANSHE 1991

楊尚昆與江澤民

1991年兩會期間，國家主席楊尚昆和江澤民總書記在主席台上。

Chinese President Yang Shangkun and General Secretary Jiang Zemin, putting their heads together during the 1991 National People's Congress and Chinese People's Political Consultative Conference.

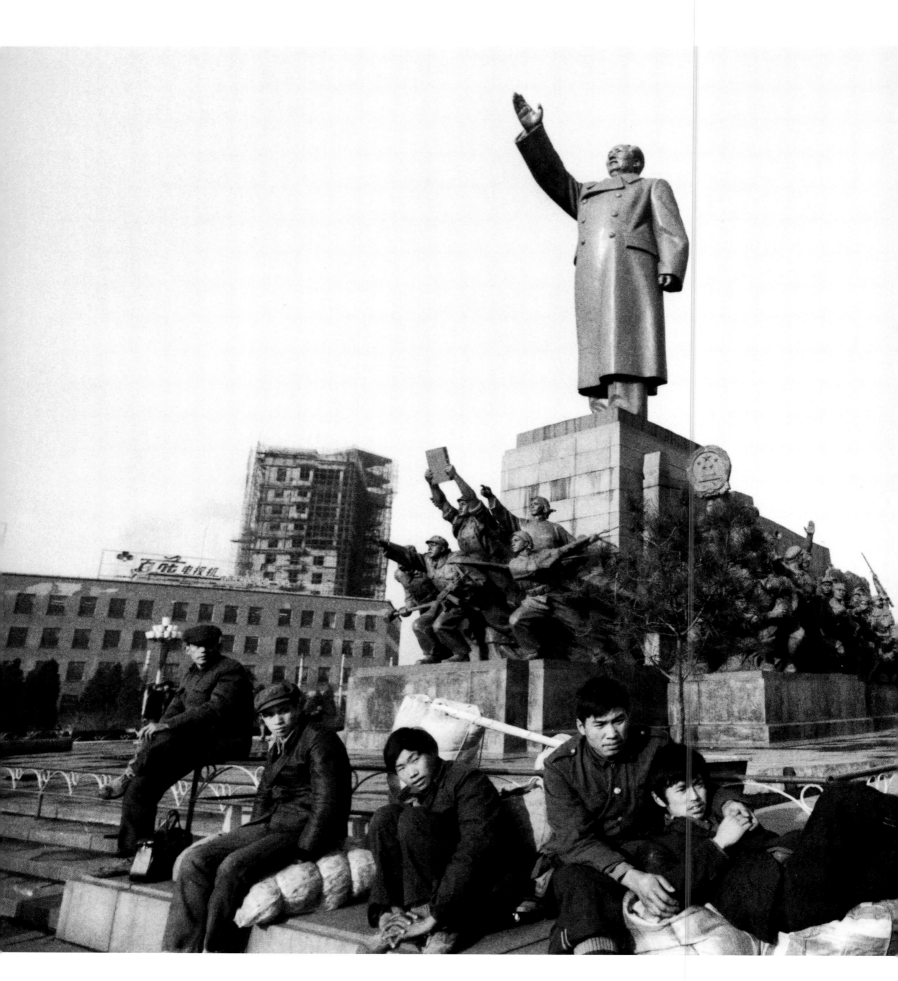

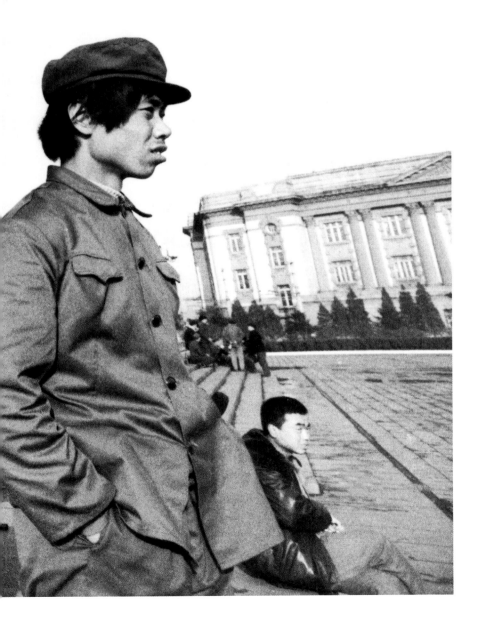

朱憲民 BY ZHU XIANMIN 1990

「毛澤東熱」
Mao Zedong Fever

　　改革開放，深化了中國人對歷史的認知。在社會發展過程中，「毛澤東」是人們始終熱議的一個重要話題。1990年代末，曾經有一盤以《紅太陽》為名的磁帶銷了幾百萬盒，不僅是因為懷舊，而且因為以「毛澤東」為代表的中國發展路徑與現實產生了巨大反差。與毛澤東有關的話題包含當代中國的幾乎所有問題，有時，人們的觀點不免會激烈衝突大相徑庭。與幾十年前不同的是，沒有甚麼對這些議論的懲戒，毛的塑像也依然在許多地方屹立着。

　　Both famous and infamous, Mao Zedong is the leader who got China back on its feet after decades of oppressive colonialism and civil strife. Although some of his policies, such as the Great Leap Forward and Cultural Revolution, were disastrous, he gave the country confidence and a new sense of purpose and is still revered by millions across the country today. The unrelenting queues at his Mausoleum in the heart of Beijing are testament to that. His bust still appears on Chinese banknotes and a large portrait of the revolutionary leader overlooks Tiananmen Square in the capital. Although China's current leaders publicly align themselves more with Deng Xiaoping and Jiang Zemin, Mao's influence remains huge. Mao was named by Time magazine as one of the most influential people of the 20th century.

在紅旗廣場休憩的民工

1990年，進城民工正在遼寧省瀋陽市的紅旗廣場駐留小憩。

Migrant workers resting in Hong Qi Square in Shenyang, Liaoning Province, 1990.

減速的農村
The Slowing Countryside

　　自1980年代始，農村生產關係的調整帶來了生產力的解放和農業發展的增速。1990年代前後，以沿海地區為代表的鄉鎮企業發展又給農業經濟帶來新的活力。到1990年代中後期，鄉鎮企業發展環境不佳影響其成長；農業生產成本提高影響着農民收入。為了生存，大量農業人口向城市流動，使農村留守人口嚴重老齡化；城鄉二元經濟的衝突，使農業、農村和農民問題升溫。

China's 210 million rural households represent a third of the world's farming families, and comprise two-thirds of the country's population. Their lives have improved since the days of collective farming, but rural poverty has persisted and the economic gap between urban and rural incomes has widened. The issue of security of land tenure has also remained contentious as land seizures for development projects have provoked unrest and fueled corruption. Millions of rural people have journeyed to China's cities to find work and support their families. While this has helped to raise rural living standards, it has led to other problems aschildren are left to the care of elderly grandparents and other relatives remaining in the countryside.

賀延光 BY HE YANGUANG 1992?

台上台下

1992年農曆正月十五，陝西鳳翔。這個村莊即將舉辦一年一度的傳統社火活動，一位鄉鎮幹部在大會上向村民們發表講話。

A group of elderly men and children sit about with marked disinterested as a cadre gives a speech during the traditional Shehuo Spring Festival in Fengxiang village, Shaanxi Province, on January 15, 1992.

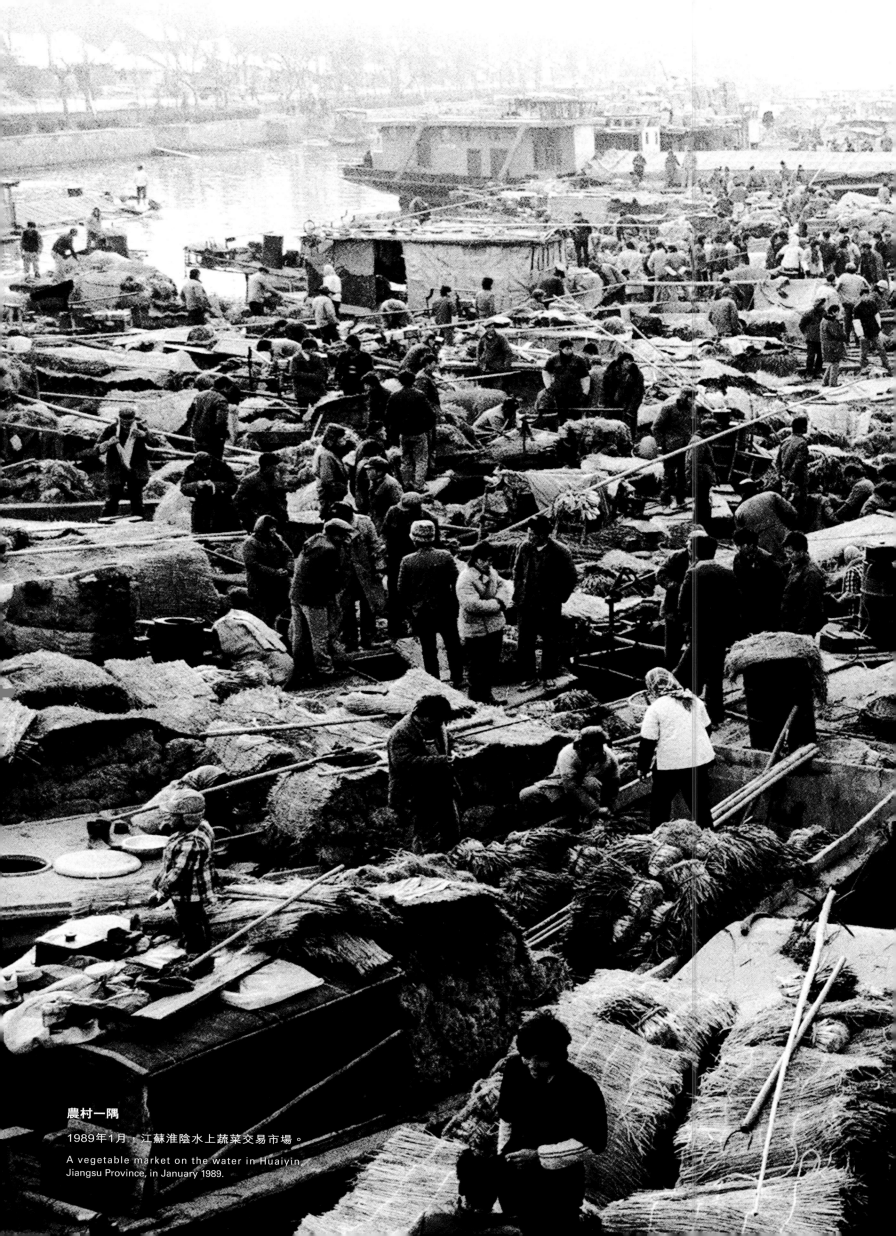

農村一隅

1989年1月，江蘇淮陰水上蔬菜交易市場。

A vegetable market on the water in Huaiyin, Jiangsu Province, in January 1989.

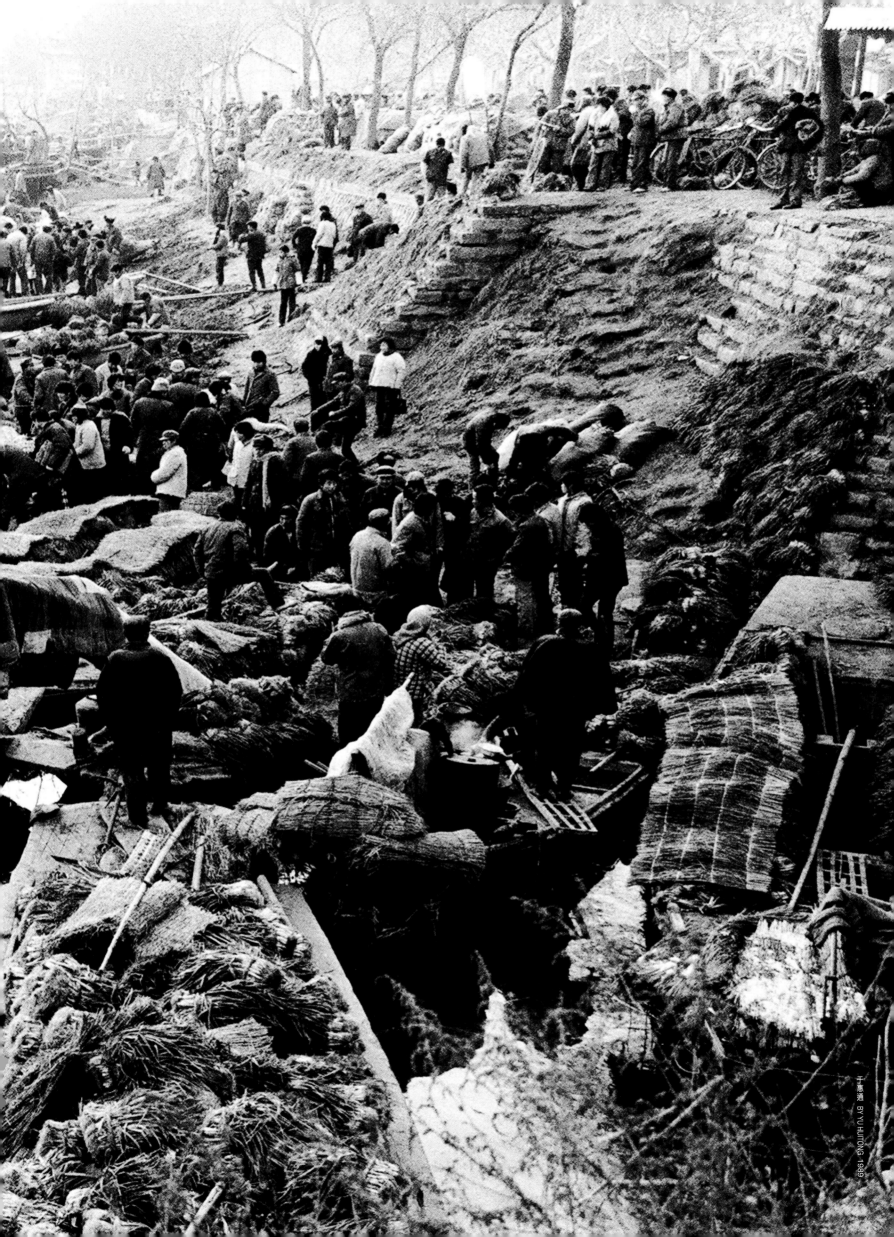

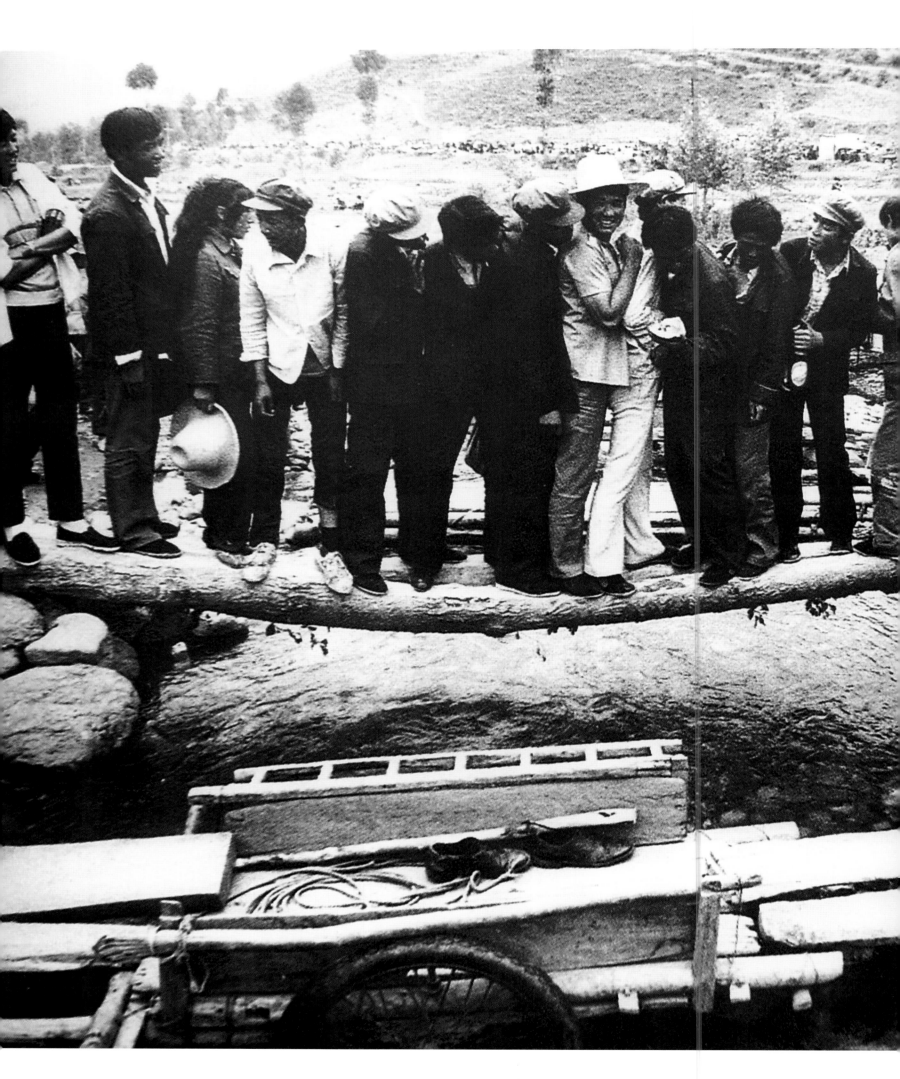

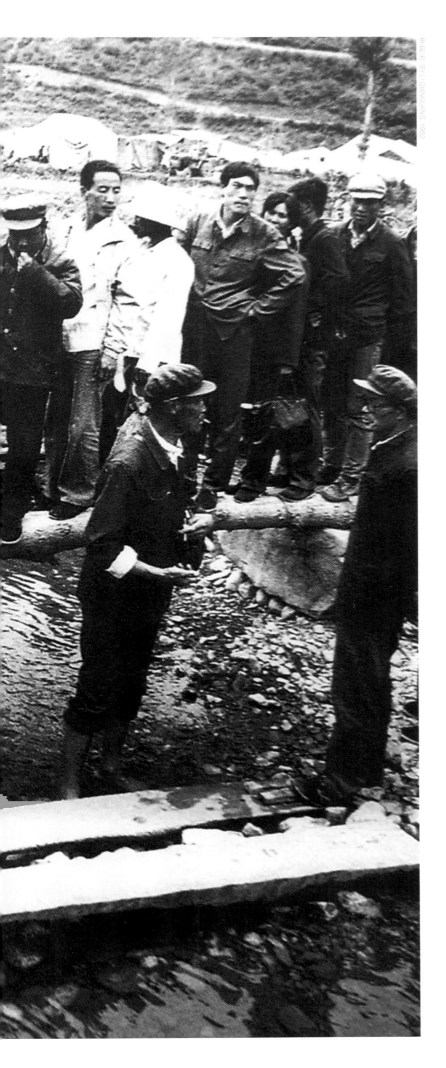

李向光 BY LI QIANGUANG 1992

人·河·橋
The Road to Prosperity

　　這是1990年代很著名的一張紀實照片，說西北農村道路問題的。其實30年前中國的現實就一如這張照片，不過是「人—河—橋」的問題。那麼多的鬆了綁的「人」，面對着匱乏貧弱之「河」，通過怎樣的「橋」到達小康的彼岸？拍照片的時候，都堵着哪！

　　This is a famous photograph from the early 1990s highlighting the lack of roads in China's rural northwest. The image is also a metaphor for China's situation 30 years ago, with crowds of people clamoring to cross a bridge of poverty to reach prosperity beyond.

擁擠的「獨木橋」

這是1992年在甘肅省臨潭縣傳統節日「花兒會」的情景。這一天總有數十萬鄉民趕會，一位老人用自家板車臨時架起另一座橋，收費一角，但鄉民寧願擠在「獨木橋」上動彈不得，也不願交一角錢過老人的「收費橋」。

Villagers crowd precariously onto a log bridge during Hua'er Hui, a traditional festival in Lintan County, Gansu Province, in 1992. Crossing the bridge costs nothing, but it costs ten fen (10 cents) per person to cross over the plank in the foreground.

繁榮的李村大年集

進入1990年代，改革開放已成為共識，人們不必再顧慮「私人」還是「集體」，不必再掛「大隊」等字樣的牌子了。圖為1991年農曆臘月廿二，青島李村的大年集的繁榮景象。

A busy market fair before Spring Festival in Li Village, Qingdao, 1991.

鐵路沿線的小商販

中國福建人和溫州人的經商頭腦似乎是與生俱來的，只要有錢賺，他們就不會在乎體力與腦力的付出，也不會在意經商的環境如何，任何機會他們都不會放棄。這些在金溫鐵路沿線上兜售食物、招徠生意的小販，便是最好的例證。

Farmers living near a railway grab the chance to make a buck by selling food to passengers on the train.

大集
The Spread of Trade

　　民間商業活動的興盛緣於：一、生長的需求；二、有效的供應；三、物流的暢通；四、錢包的保證──當然更由於政策的鬆動。1980年代後期以來，整個中國成為一個大市場，每個人都捲在生意裡，不是需求者就是供應者。商業脈動中，整個國家生機勃勃。

An array of factors led to the growth of commerce in China, namely supply and demand and growing wealth. An easing of government restrictions on trade was also instrumental. From the late 1980s on, the entire country effectively became a huge market, with millions embracing entrepreneurship, and everyone playing a role.

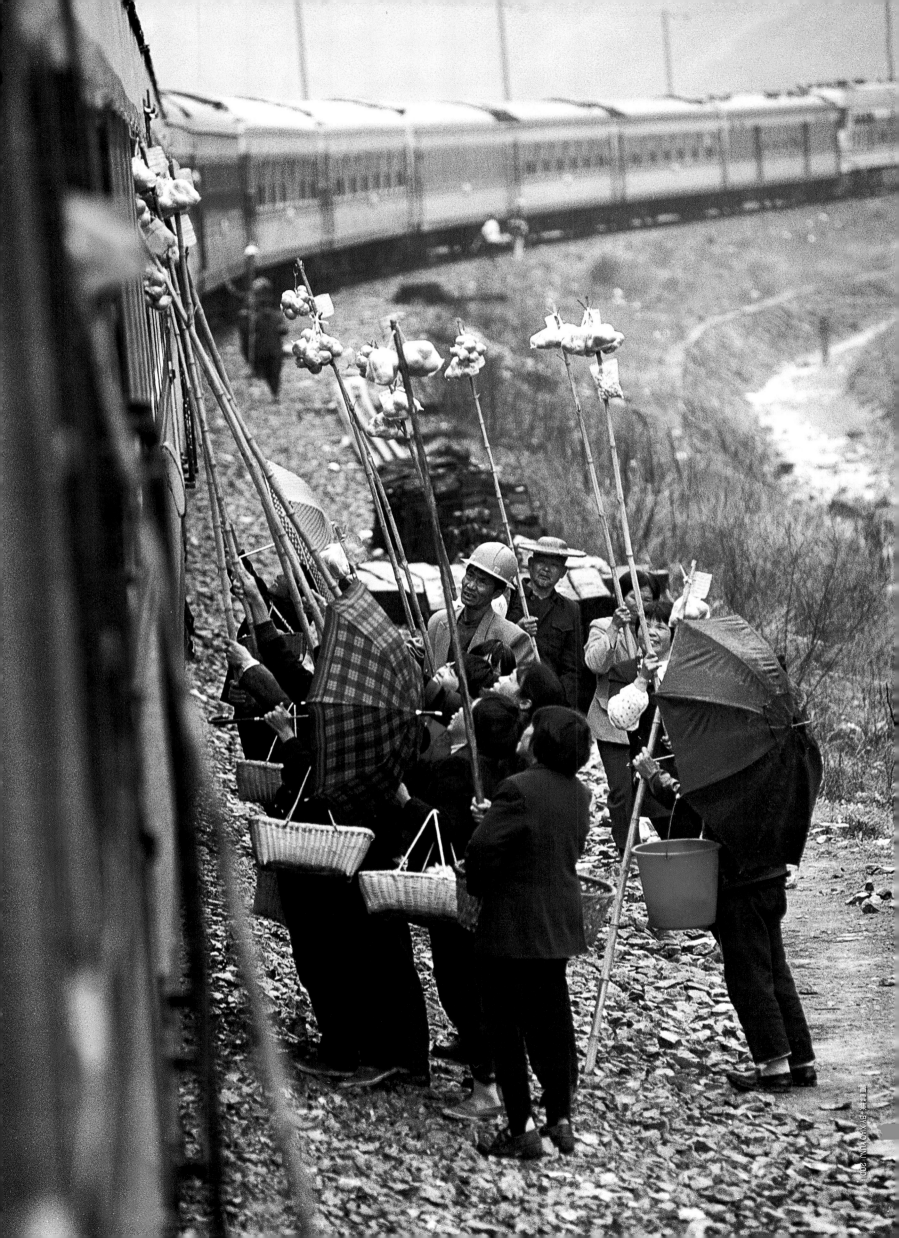

「南巡」
Deng Goes South

　　鄧小平1992年到廣東一帶視察時，講了一些很重要的話。其中，「膽子更大一點，步子更快一點」，「不要問姓『社』姓『資』」等等，膾炙人口。進而，中國改革的又一輪熱潮勃興。後來有一首被後人反覆吟唱的歌中唱道：「1992年 又是一個春天 有一位老人 在中國的南海邊寫下詩篇 天地間盪起滾滾春潮 征途上揚起浩浩風帆……」如果把中國改革的進程區分為某幾個階段的話，「南巡」無疑是其中一個非常重要的起點。在這個起點之前，經歷過重大的風波，改革向哪個方向走？在一些最基本的判斷面前，歷史困頓趑趄。此刻，是鄧公，毅然決然，推動歷史車輪。由此，那首歌裡還唱道「展開一幅百年的新畫卷」，也算不謬。

　　In the spring of 1992 at a crucial juncture of China's reform and opening program, Deng Xiaoping made his now-famous southern tour of China (*nanxun*). Deng, who had officially retired in 1989 but remained an influential figure, used the occasion of his trip to Guangdong and New Year visit to Shanghai to reassert his economic policy. Deng believed that China needed to press ahead with reform more than ever. He made speeches: "We should be bolder than before in conducting reform and opening to the outside and we must have the courage to experiment. We must not act like women with bound feet." Deng's southern tour eliminated any doubt that broadening and intensifying reform would be the guiding principle of national policy, thereby setting China firmly on a course of economic development.

江式高 BY JIANG SHIGAO 1992

鄧小平遊園賞景

1992年1月22日上午，鄧小平和楊尚昆帶領兩家三代人來到深圳仙湖植物園種樹、賞景。10時許，鄧小平和楊尚昆一起種下一株高山榕。在此期間，鄧曾經說：「改革開放膽子要大一些，敢於試驗，不能像小腳女人一樣。看準了的，就大膽地試，大膽地闖。深圳的重要經驗就是敢闖。」

Deng Xiaoping, visiting Xianhu Botanical Garden, Shenzhen, on January 22, 1992. Shenzhen became China's first — and arguably one of the most successful — special economic zones under the reformist leader's economic liberalization policies.

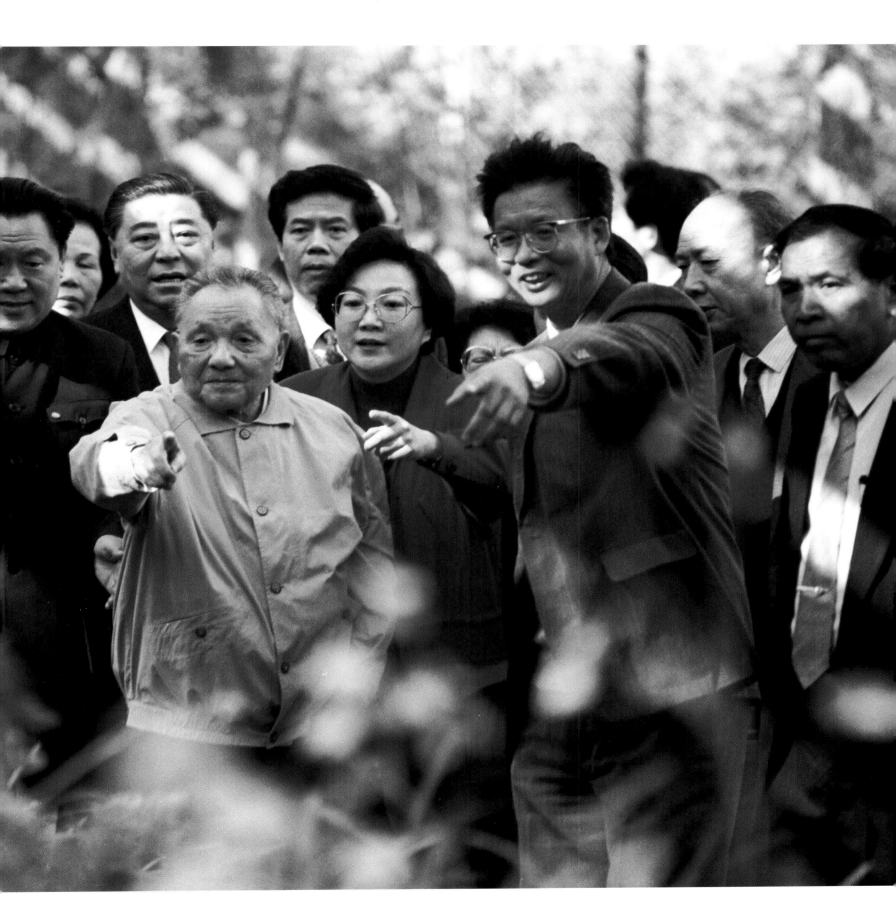

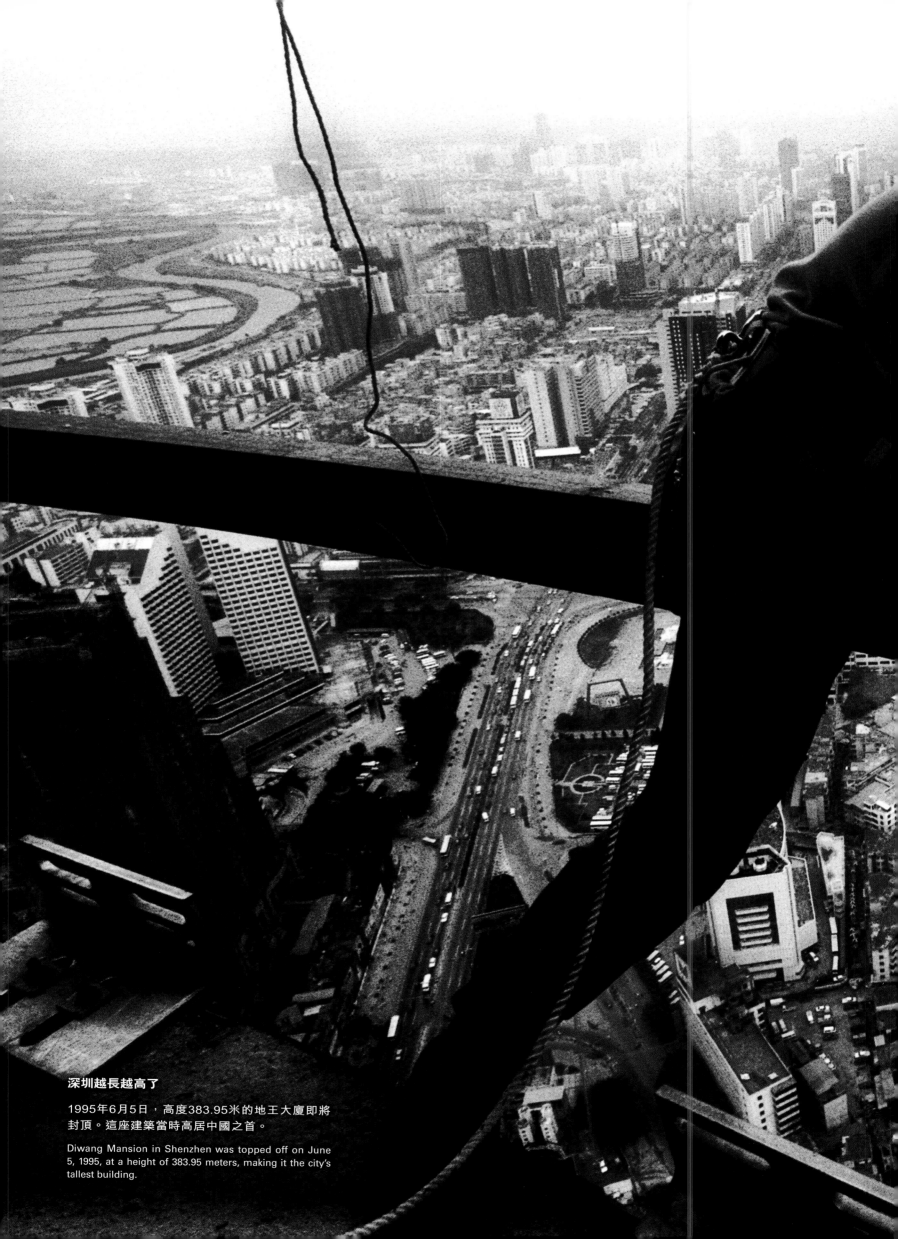

深圳越長越高了

1995年6月5日，高度383.95米的地王大廈即將封頂。這座建築當時高居中國之首。

Diwang Mansion in Shenzhen was topped off on June 5, 1995, at a height of 383.95 meters, making it the city's tallest building.

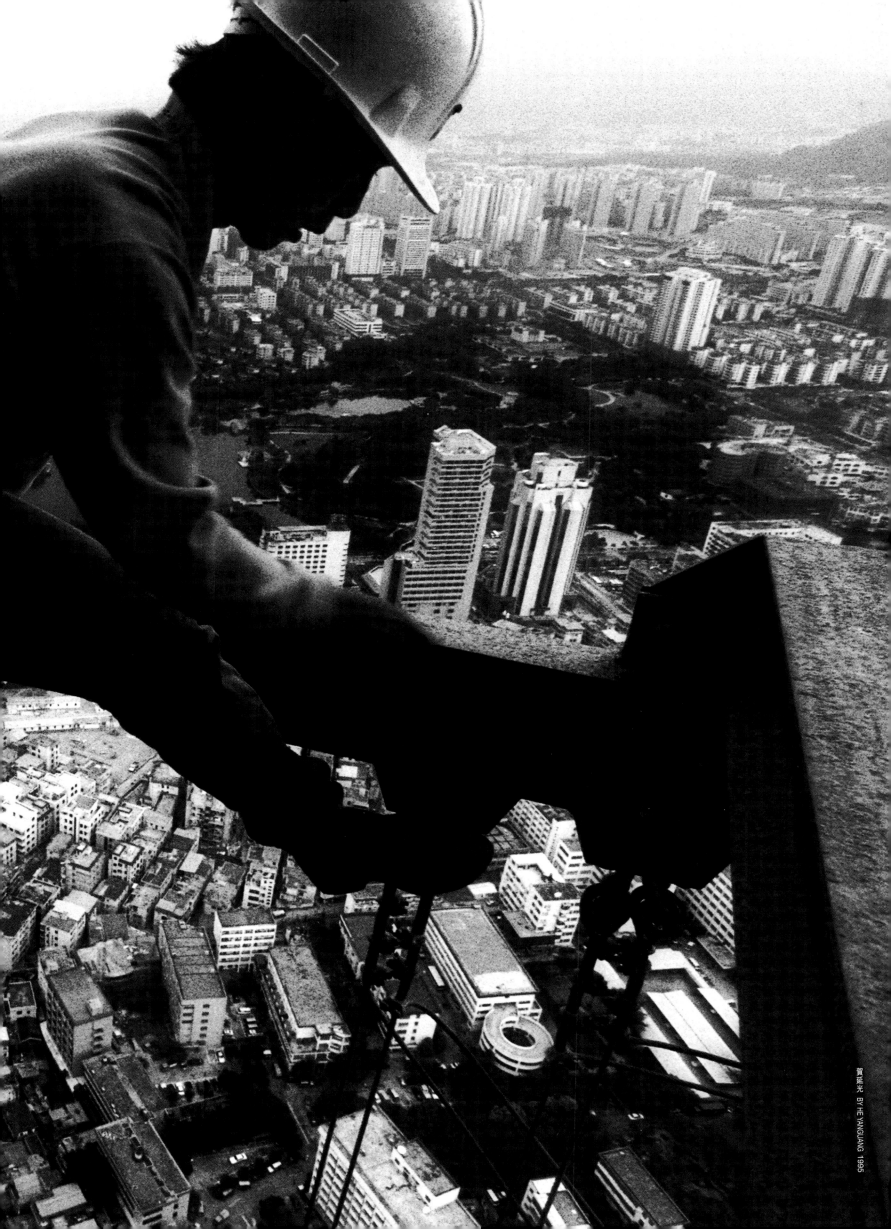

賀延光 BY HE YANGUANG 1995

高度

Shenzhen – From Village to City in the Blink of an Eye

中國人似乎比別的民族更喜歡「當驚世界殊」。深圳地王大廈是亞洲建築之最。但這個稱譽1997年被香港國際金融大廈暫時獲得，第二年就又被上海金茂大廈取代了。到2003年，台北101大廈又衝上建築高度之最。不過看樣子，在建中的上海金融大廈和擬議中的廣州電視塔還會競相登上「之最」榜首。這裡不僅是一組建築高度資料，它們至少說明：一，亞洲是當前世界最活躍經濟區域；二，建築高度與人口密度和土地價格正相關；三，建築速度與經濟發展速度相關；四，如果論總建築面積，中國無疑居近10年來的全球榜首。

Shenzhen is the city that best tells the story of China's rapid development. In the late 1970s it was a tiny and unheard-of fishing village; today it is a major global trading centre that has attracted billions of dollars in foreign investment. The city, located immediately north of Hong Kong, has sub-provincial status and was the country's first special economic zone. It also has its own stock exchange and major financial center and is the second busiest port in China after Shanghai.

蓋樓

Hainan – China's Hawaii

到處都在蓋房子，到處都是大工地。繼而炒房、炒地甚囂塵上。中共「十四大」以後，隨着住房制度改革的逐步推進，催生了新興的房地產市場。而海南，堪稱中國房地產商的「黃埔軍校」。不過，炒地衍生出的地產泡沫埋下許多隱患。在複雜、粗放、無法可依的市場競爭環境下，「爛尾樓」，留下的是房地產業充滿激情的初期記憶。

Described as the "Hawaii of the East", Hainan Island is located in the South China Sea, separated from Guangdong's Leizhou Peninsula to the north by a shallow and narrow strait. The island is fast-becoming a major tourist destination for Chinese tourists and foreigners alike. For centuries Hainan, which has an area of 33,920 square kilometers, was part of Guangdong, but in 1988 this resource-rich tropical island became a separate province. The capital is Haikou. The PRC government claims Hainan's territories to extend to the southern Spratly Islands, Paracel Islands and other disputed marine territory. Hainan is also the largest special economic zone laid out by Chinese leader Deng Xiaoping in the late 1980s.

黃 鳴 BY HUANG YIMING 1990

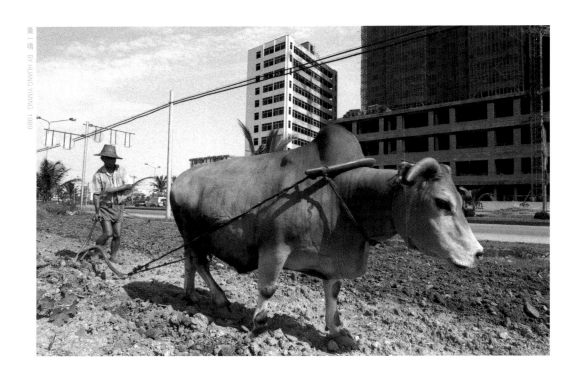

黃 鳴 BY HUANG YIMING 1989

汽車／耕牛一起走

1989年，海南建省之初，海口市僅是個20萬人的小城。市容破爛不堪，馬路上也沒有紅綠燈。城市周圍仍被大片大片的荒野和耕地包圍着。初到海口的人，常常會看到，高樓林立中，汽車和耕牛並駕齊驅的奇特情景。

Tall buildings encroach upon the farmers' fields in Haikou, on Hainan Island. For centuries, Hainan was part of Guangdong, but in 1988, Deng Xiaoping designated the island a special economic zone, making it the largest SEZ by area. Haikou, the capital, had a population of about 200,000 in the late of 1980s, and the surrounding wilderness and farmland quickly disappeared under its spread.

爛尾樓變民工村

1990年代的「半拉子」工程是嚴重影響海南省經濟健康發展的「腫瘤」。1993年，國家緊縮銀根，海南房地產業泡沫盡顯，很多爛尾樓荒置，有的垃圾成堆，有的變成「民工村」，有的則留下積水深達10多米的基坑，溺死兒童事故時有發生。處置「半拉子」工程，成了海南的當務之急。

A property bubble soon developed in Hainan, forcing the government to tighten its financial policy in 1993. The result was that many construction projects, such as this, were abandoned before completion.

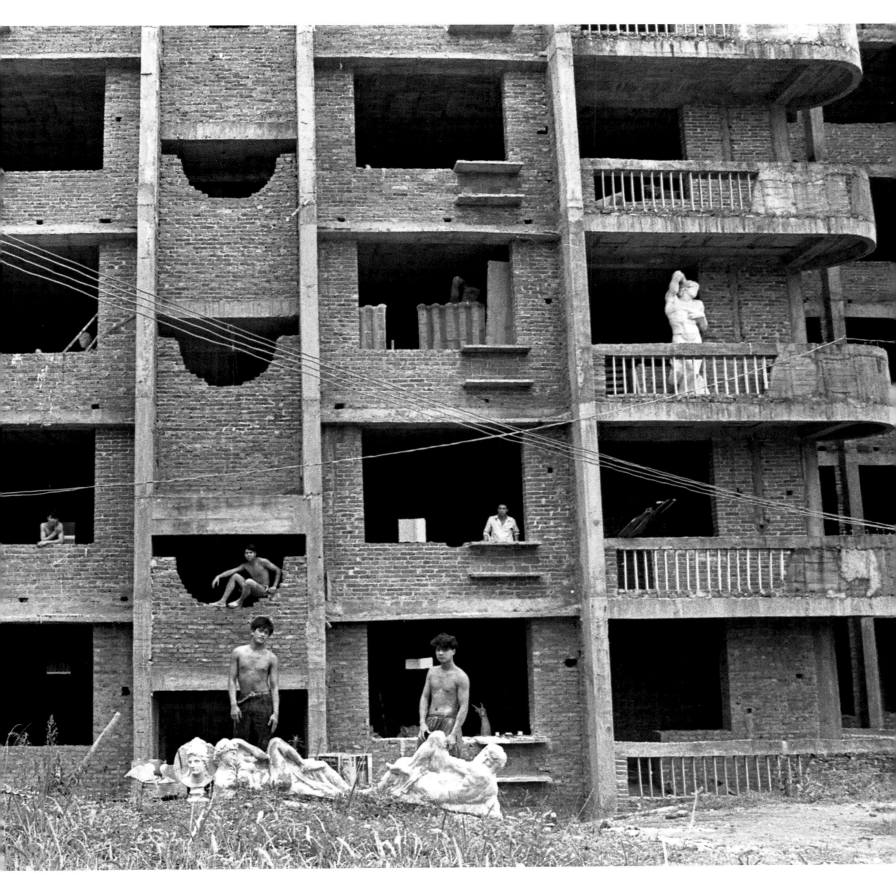

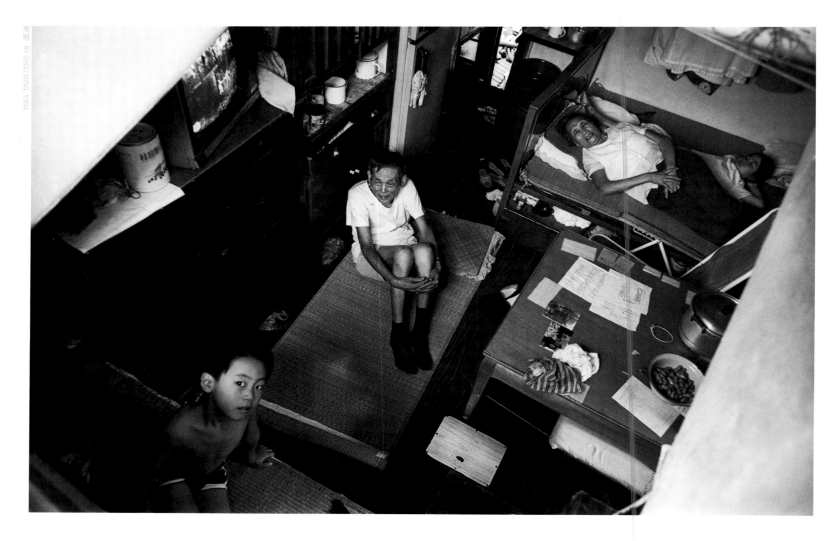

周明 BY ZHOUMING 1994

住房

Housing Issues – Stuck in a Tight Space

「安得廣廈千萬間，大庇天下寒士俱歡顏」，這是千年以前詩聖的祈願。1978年，中國城鎮人均住房面積不過6.7平方米。到2007年，這個數據是28平方米。因為人口高峰、生育高峰和房地產業未啟動，城鎮住房緊張的高峰大約是1990年代初，1990年代以後，城市房地產業高速成長，在緩解城市居民住房緊張的同時，帶動一系列產業的發展，也給中國經濟發展帶來新的活力。

China shares many of the intractable problems that blight developing countries — a shortage of housing supply and housing inequality in urban areas being two examples. In big cities like Beijing and Shenzhen, according to a 1985 survey by the China State Statistical Bureau around 40 percent of families were said to endure crowded housing (per capita dwelling space of less than 4 square meters) or inconvenient housing (married couples sharing a room with parents and teenage children).

三代人同居一室

1994年，上海南市區一戶人家，僅有的一室中住着三代人，晚上睡覺時要打地鋪。

Three generations of one family live in a single room — with a bed on the floor — in Shanghai. The city's housing shortage was so acute in the 1990s that the per-capita living space was less than three square meters.

房間裡搭閣樓

1995年，上海靜安區一戶人家。這是一戶成員眾多的大家庭，為了擺平晚上的睡覺問題，已經很逼仄的房間裡還要再搭閣樓。

Many Shanghai families adapted to the accommodation problem by building a garret floor in their ceilings.

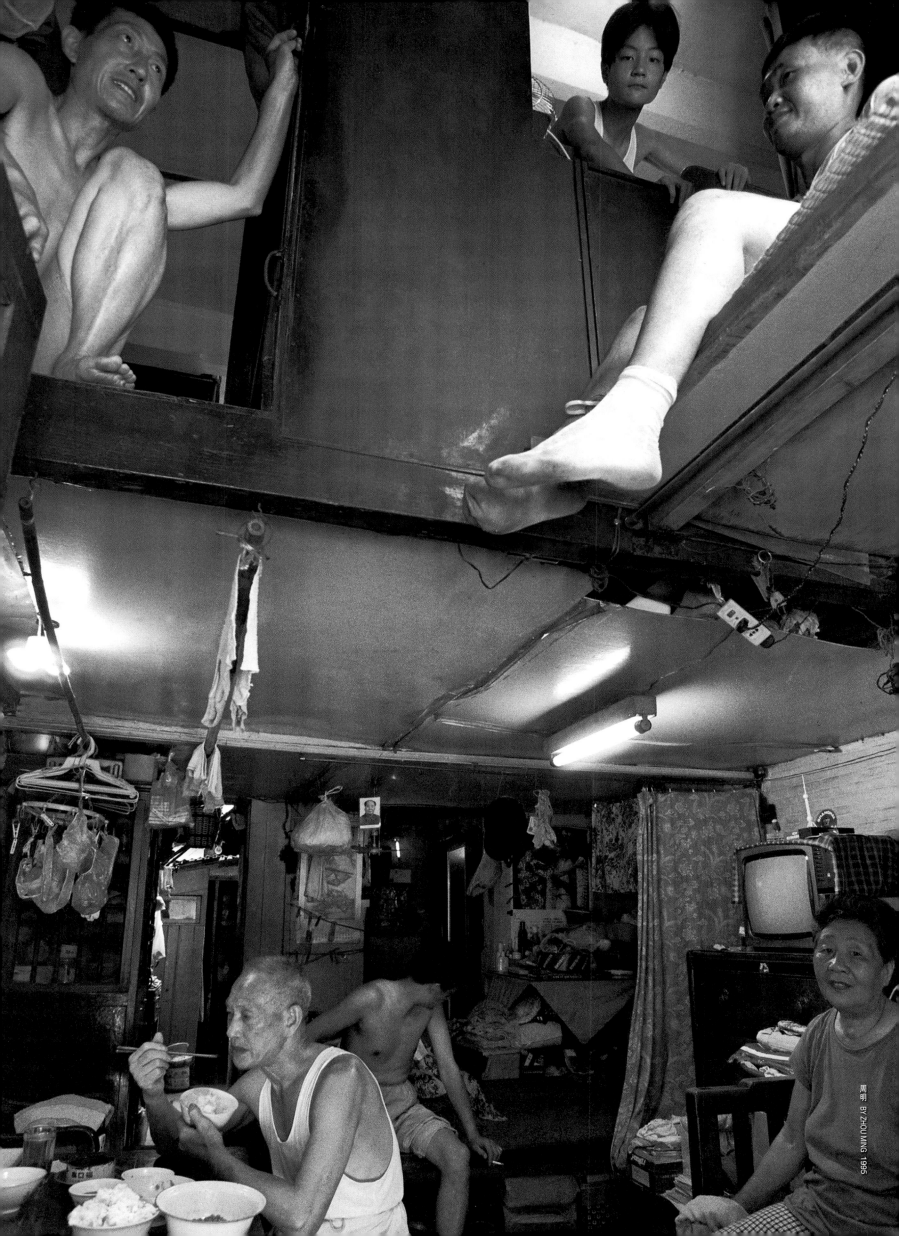

周明 BY ZHOU MING 1995

人口
The World's Biggest Population

　　談經濟成長不能迴避諸如人口、糧食這樣一些基本問題。人口增長是每個國家經濟發展中都要遇到的重要問題，它既創造需求和「人口紅利」，也擴大資源消耗和環境消耗。30年來，中國人口的自然增長率從1981年前後的逾千分之十五到2005年的低於千分之五；人口死亡率保持在千分之六；1970年代平均每個育齡婦女生育3.6個孩子，到2006年下降到1.7個。同樣的，印度1990年育齡婦女平均生4個孩子，2006年生3個。這就是說，從世界範圍上看，中國在保持着經濟增長的同時，為全球範圍內控制人口爆炸起到了重要的制衡作用。

　　China has been the world's most populous nation for many centuries, but it was only in the latter half of the 20th century that population figures started to become a major political issue. When China took its first post-1949 census in 1953, the population stood at 582 million; by the fifth census in 2000, the population had exploded, reaching 1.2 billion. That figure has now exceeded 1.3 billion. In an attempt to tackle the problem, the government brought in the highly publicized One Child Policy in the 1970s, restricting couples to one offspring. The policy has worked, preventing further growth by 400 million, according to some estimates. However, the policy has had its downsides. The country faces an ageing population and a shortage of youngsters. As a result, Shanghai is considering adjusting the limit to two children. The policy is also gaining ground outside China; environmental groups in some developed countries have suggested that more nations consider such measures as part of efforts to fight global warming.

人與車的海洋

1991年的上海光新路口，中間有條鐵軌，火車通過前，兩邊護欄擋住行人；火車通過後，護欄拉起的瞬間，長時間等候的人流車流，從兩邊聚集到一起，形成人與車的海洋⋯⋯

The Bicycle Kingdom: cyclists venture across a railway track after the passing of a train on Guangxin Road, Shanghai, in 1991.

王文瀾 BY WANG WENLAN 1991

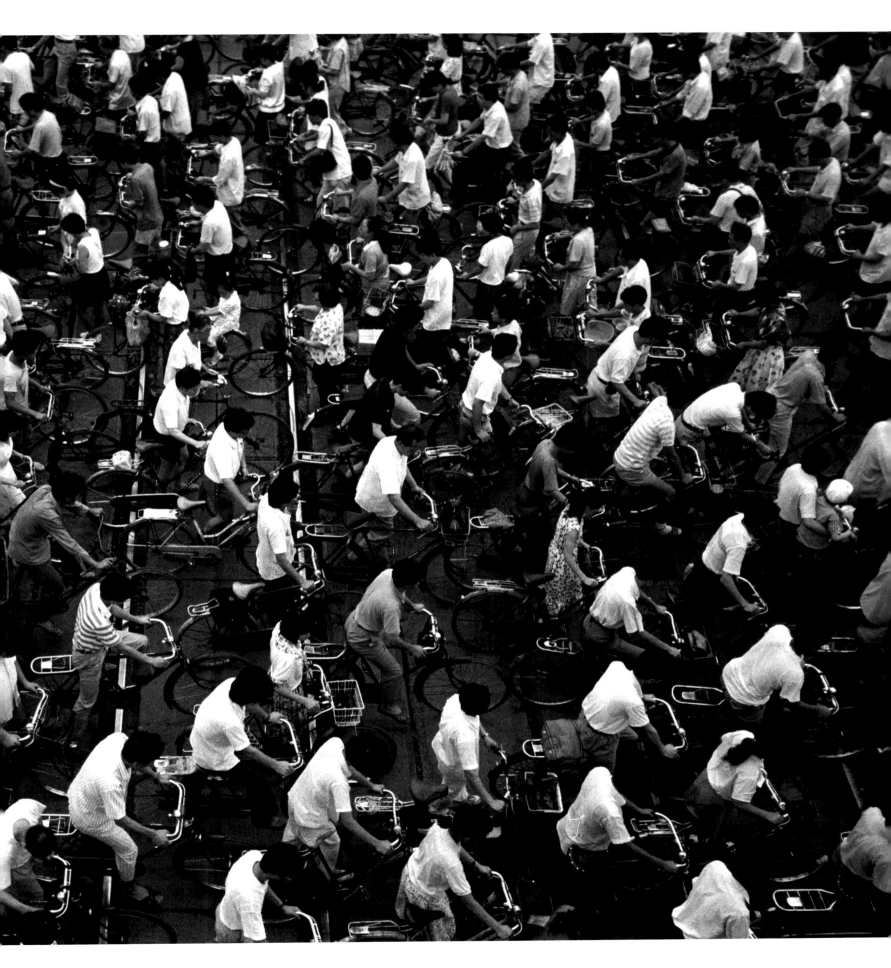

計劃生育
Family Planning Policy

　　1987年中國人口自然增長率達到創紀錄的千分之十六點六一，這時候，中國總人口是除印度之外世界上人口前10位的 8 個國家之和。如果保持1987年的人口增長率，到2008年，中國的人口要比現在多幾億！為這樣大一個國家的人民謀福祉是改革開放必須面對的問題，這也是考慮中國發展問題的基本前提。

　　In 1987 China's population grew by a staggering 1.661 percent. If this rate had continued up to 2008, the country would be home to several hundred million more. Population control has been a major challenge in China's bid to get rich, and the country has become renowned for its policy restricting couples to one offspring.

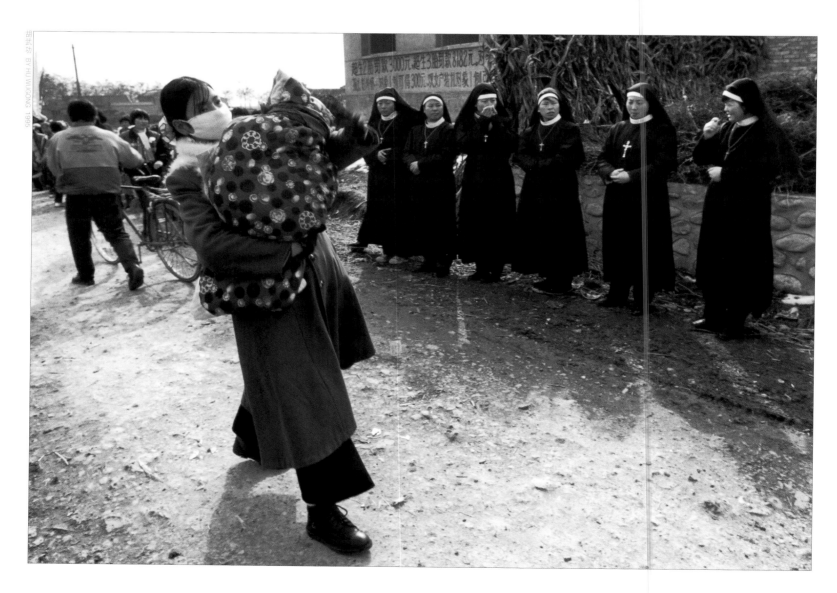

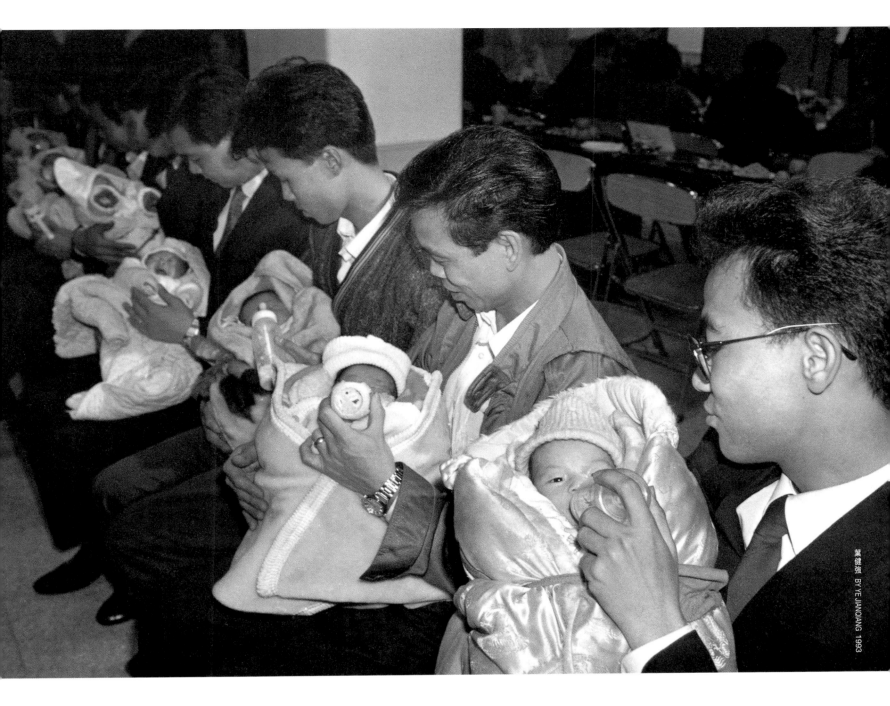

葉健強 BY YE JIANQIANG 1993

母嬰與修女

1995年的陝西鳳翔。抱着孩子的年輕母親從夾道迎送主教遺骨的修女隊列前走過。

A woman holding a baby passes a group of nuns in Fengxiang, Shaanxi, in 1995.

父親也哺乳

中國傳統文化中，父親常常在外闖天下，所以孩子天然地交給母親。但是，當獨生子女越來越普遍的時候，現代父親們更多扮演起非傳統角色。瞧瞧這些年輕的父親懷抱孩子哺乳的神情態度，就知道初為人父的感覺應當很特別。

A group of men look after their heirs in a hospital. For generations, men regarded their role in the family as the breadwinner and the women were left to look after the children, but the One Child Policy prompted many men to pay greater attention to their offspring.

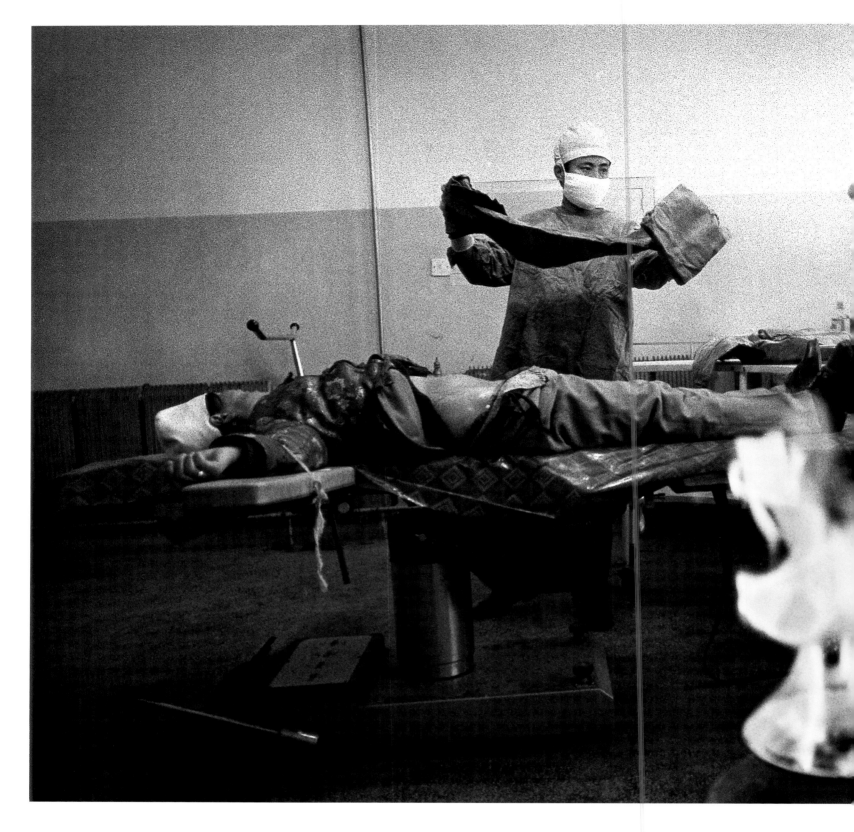

絕育
Sterilization

「不孝有三，無後為大」，因為文化，在中國，「絕育」是比計劃生育還難接受
的事。為了嚴格控制人口，計劃生育、特別是某種情況下的絕育，在一些地方、尤其是
農村，多少是有一些「強制」的，很引起一些人士的異議。但是觀念其實在變化：在城
市，許多家庭自覺少生優育；在農村，育齡婦女的生育率也有明顯下降。畢竟，生育觀
念與文化普及相關，也與生活質量相關。而這30年來，兩者都是朝進步的方向進展着。

Chinese tradition has it that a family must reproduce to be strong, and to show gratitude and respect to
former generations. This outlook has presented a huge obstacle to the One Child Policy, with many people
simply refusing to educate themselves about the necessity to control the country's huge population.

△ **絕育手術前**

1992年，在寧夏回族自治區同心縣。這家
鄉間衛生院的醫生，正在做絕育手術的術
前準備工作。

Doctors prepare to carry out a sterilization
operation on a woman in a village clinic in Ningxia
Hui Autonomous Region in 1992.

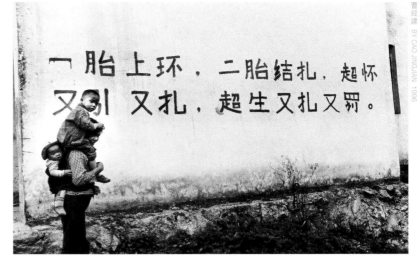

一胎上环，二胎结扎，超怀
又引又扎，超生又扎又罚。

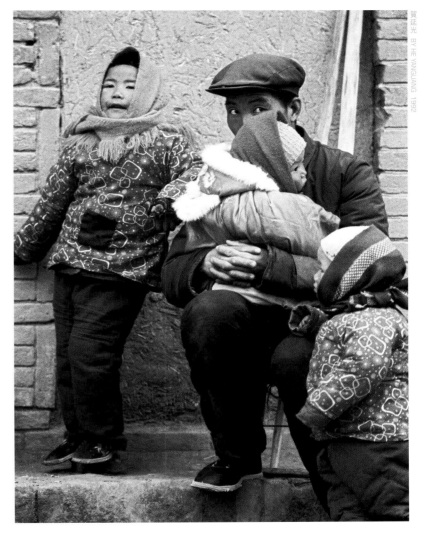

計劃生育宣傳標語

1996年10月，貴州黔南荔波縣瑶山鄉，計劃生育宣傳標語。

Mountain people and family planning slogans in Libo, Guizhou.

第三個是男孩

1992年2月17日，陝西省隴縣某山村的一位農民和他的三個子女。
面對傳統的傳宗接代觀念，計劃生育政策經常受到嚴峻挑戰。

A man holds his son, while his two daughters stand close by. Many Chinese families with daughters flouted the family planning policy because sons were traditionally seen as more important both in supporting parents and continuing the family name.

義務教育
Educating the Masses

　　中國義務教育的歷史，自20世紀初揭開。到1949年，適齡兒童入學率不過百分之二十。1952年，這個數字達百分之四十九點二，小學畢業升學率達百分之九十六。1962年，小學畢業升學率下降到百分之四十二。中國百分之七十的中小學教育都在農村。很顯然，要實現國家的現代化，教育的普及和教學質量的提高是基礎的基礎。1978年肇始的教育改革，重點放在重建高等教育和提高教育質量上。農村地區的中小學被大幅撤銷和合併，教學人才和資金迅速向城鎮回流，造成農村學齡兒童的入學率和小學畢業升學率持續下降。於是在1985年，中共關於教育體制改革的決定要求：「把發展基礎教育的責任交給地方」，中小學教育實行「地方負責，分級管理」。

　　Government-sponsored education in China began about one hundred years ago, but bringing education to the vast countryside has always been a challenge.

　　In 1949, the attendance rate of school-aged children was no more than 20 percent. By 1952, this figure had risen to 49 percent, and the primary graduation rate had reached 96 percent. By 1962, however, that number had dropped again to 42 percent. Seventy percent of primary and secondary education in China occurs in rural areas. The expansion and improvement of education is clearly a fundamental prerequisite to achieving modernization in China. The focus of educational reform in 1978, therefore, was on revising and improving higher education. Many primary and secondary schools in rural areas were dismantled or combined. Educational talent and resources quickly flowed into the cities, causing primary attendance and graduation rates in the countryside to slide further. Accordingly, in 1985, the central government decided to devolve the authority and responsibility for developing primary and secondary education to local governments.

邱曉明 BY QIU XIAOMING 1990

任錫海 BY REN XIHAI 1999

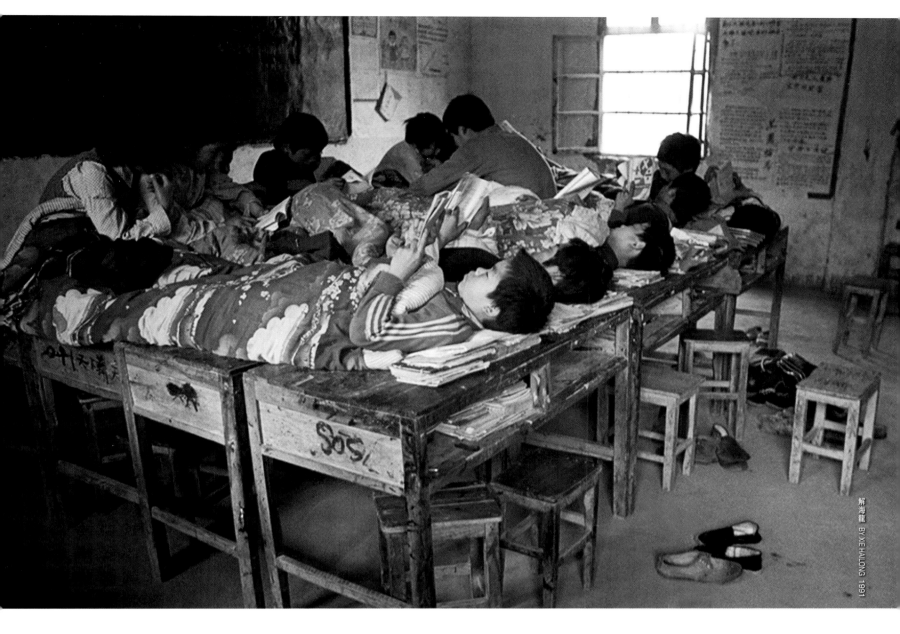

解海龍 BY XIE HAILONG 1991

教室裡的午休

1991年4月，湖北省羅田縣，孩子們在課桌上休息。

Children bed down on their school desks rather than make the long journey home for a nap in Luotian County, Hubei Province, 1994.

大門外的早讀

1990年初春清晨，在甘肅省靈台縣山區一所小學校，孩子們在等待校門打開時，正大聲背誦課文和算術口訣。

Children practicing their reading before the school gate opens in Lingtai County, Gansu Province, 1990.

紙上練琴

1999年，隨着生活水平的提高，讓孩子學彈鋼琴成為青島許多家長的願望。山東省青島市10號大院的居民的生活水平並不高，但他們並沒有因此而放棄對孩子的培養。讓孩子在紙上畫出的黑白相間的「鍵盤」上邊玩邊練，也是個不錯的辦法。

As living standards improved, many parents hoped their children could learn to play the piano. The prohibitive cost of the real thing, however, meant that many children had to rehearse on the "paper keyboard".

黃岩洪 1993
BY HUANG YANHONG 1993

發財之夢
A Dream of Instant Wealth

　　彩票在1980年代中期進入中國的時候，伴隨着不少爭議。不過市民百姓卻不管那一套，只要有發財的可能就趨之若鶩。所有與錢有關的東西都吸引着眾多眼球，對於股市，在經歷了開始的短暫冷淡之後，民眾也投以莫名的瘋狂。幾無風險意識的人們把股票當彩票一般做着一夜發財的大夢，一時間，「股災」、「彩票風波」的議論之聲不絕於耳。與此同時，沿海地區的民間融資經濟也方興未艾。這或許證明，到1980年代後期，豐富金融產品，建立資本市場此其時矣。

China's first lottery took shape as the Sports Center Construction Memorial Lottery in Fujian Province in 1984. Following its success, a year later a sports lottery package for the Sixth National Games was issued in Guangdong Province. In 1986, the Chinese government approved the sale of "social welfare lottery tickets" to help raise funds for social welfare. In 1994, the National Commission of Sports Lottery Management Center was established, and since then, two types of lottery — "Welfare Lottery" and "Sports Lottery" — have operated in China.

搶購福利彩票

1984年，福建省最先發行《福建省體育中心建設紀念獎券》；1985年，廣東省推出《第六屆全運會》體彩套票；1986年，國家批准發行《中國社會福利有獎募捐券》，籌集社會福利資金，發展以「安老、扶幼、助殘、濟困」為主要內容的社會福利事業。1987年，中國社會福利有獎募捐委員會正式成立。1989年，北京發行《第11屆亞運會基金獎券》，這也是第一次在全中國大陸範圍內發行的體育彩票。1991年，廣州、上海、北京、西安等地相繼發行有獎賽馬彩票；1992～1993年，又先後在北京、大連、武漢、成都發行足球體彩；1994年，成立「國家體委體育彩票管理中心」——從此，中國大陸形成「中國福利彩票」和「中國體育彩票」兩大體系。圖為1993年，四川省成都市發行福利彩票，獎品有小臥車、摩托車、家電等，引起數十萬人爭購。

Booths selling lottery tickets, operated like raffles, offer the chance of winning cash, motorcycles, household appliances and other prizes in Chengdu, Sichuan Province, 1993.

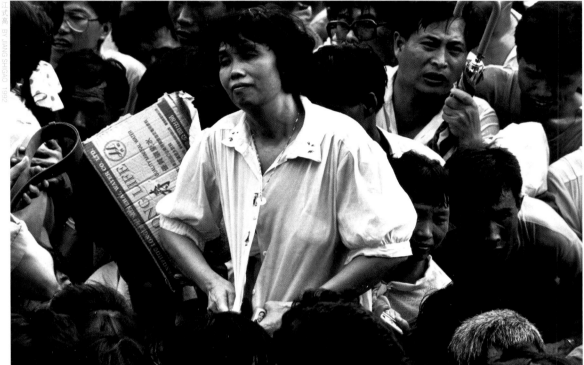

深圳「8.10」股潮

在國民黨撤離大陸之後，中國的證券交易停止了將近半個世紀。在1988年中國大陸恢復股市，但這種恢復並不平靜。圖為1992年深圳特區爆發「8.10股潮」的情景。因市民踴躍購股而發生嚴重混亂，圖中這位婦女的衣扣幾乎被完全擠掉。

A woman who lost the buttons on her blouse in the scramble to buy shares in Shenzhen in 1992. The Chinese mainland had no securities markets for almost four decades after 1949, but they re-merged in 1988.

爭購股權證

1992年，深圳「8.10股潮」中被僱傭來排隊的人們，擁擠不堪秩序大亂。

The rush to buy share certificates in Shenzhen on August 10, 1992.

爭先恐後搶購獎券

1987年，西安市徐家灣街上搶購獎券的人群。

Crowds from AECC clamor for lottery tickets — and the chance to improve their lives — in 1987.

實物兌獎花樣多

獎券、彩票、股票等老百姓廣泛參與的經濟活動，建國後被清除掉了，直到改革開放後才逐步得以恢復。1996年西安街頭以實物兌獎的彩票發售點上，人山人海。此後，以實物兌獎的辦法被取消。

Crowds in Xi'an flock to one of the final lotteries for products in 1996 before the abolition of these kinds of commercial raffle events.

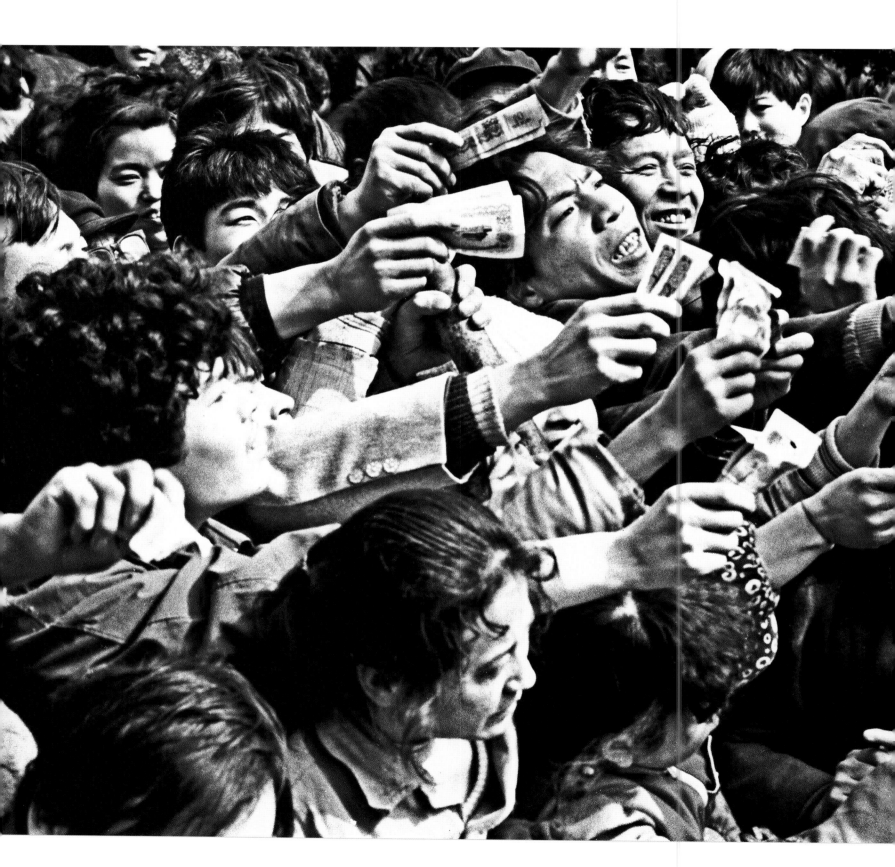

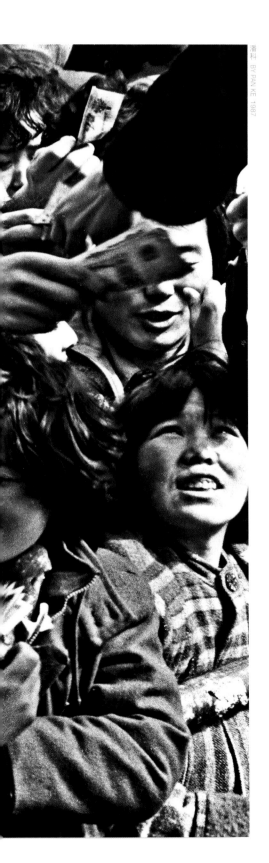

獎券
The Winning Ticket

　　彩票的出現，帶來第一輪街頭的獎券熱。儘管獲獎機率有限，但指望憑運氣發小財的人依然萬頭攢動。緊跟着，商家也參與其中，作為促銷手段的獎券也給城市街頭帶來不少瘋狂。1990年代以後，發財夢既給中國帶來活力，也給中國帶來幾許混亂。

　　The Chinese have embraced lotteries since their emergence in the country over the past few decades. With retail companies promoting sales through raffle tickets, raffle tickets also took off, adding excitement and perhaps also a measure of disorder to the cities. Although there were restrictions on the winnings, many people still pinned hopes on earning a little extra wealth through this form of gambling.

行為 — 藝術
That's Entertainment

「行為藝術」上世紀末現身中國。「現代化」不僅是物質生產的繁榮，還將是精神生活的豐富，農民的精神生活也在豐富。比如，他們在工地上引進了「保齡球」，儘管是啤酒瓶替代的，這娛樂，也帶上了「全球化」的味道。

Entertainment in China is a rich fusion of local and international activities. A more traditional form might come at Beijing's Laoshe Tea House, where guests are treated to a smorgasbord of Chinese acts, from side-splitting cross-talk to mesmerizing Sichuan face-changing performances. On a more personal level, Chinese people love to be outside, and on a hot summer's day groups of men will line the pavements to play Chinese chess, mahjong or poker. *Shufa*, or calligraphy, is also popular, with artists taking to the streets on summer evenings to write stunning Chinese characters using large brushes and water in a benign form of graffiti. Line dancing has also taken off in the big way. In city parks, scores of women gather to shake a leg — not to Country and Western but to traditional Chinese songs. But a look at entertainment in China wouldn't be complete without mentioning karaoke. While bars and nightclubs are "the thing" in the Western world, Chinese youth love to relax with friends by hiring a booth at a KTV center, enjoying a few beers and snacks, and singing their hearts out all night long.

「土」保齡球

1990年湖北武漢農民工利用啤酒瓶和工地的傳送帶自製保齡球。

Workers bowling on a makeshift ten-pin alley made from beer bottles and planks in Wuhan, Hubei Province, 1990.

行為藝術踏上千年長城

在長城上的行為藝術。

Performance art on the Great Wall in the late 1980s.

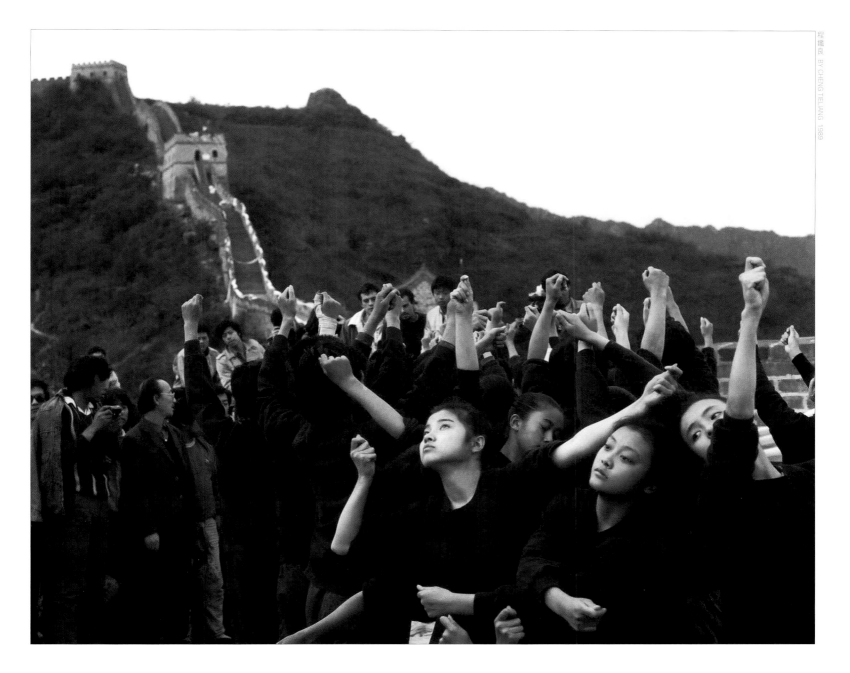

程鐵良 BY CHENG TIELIANG 1989

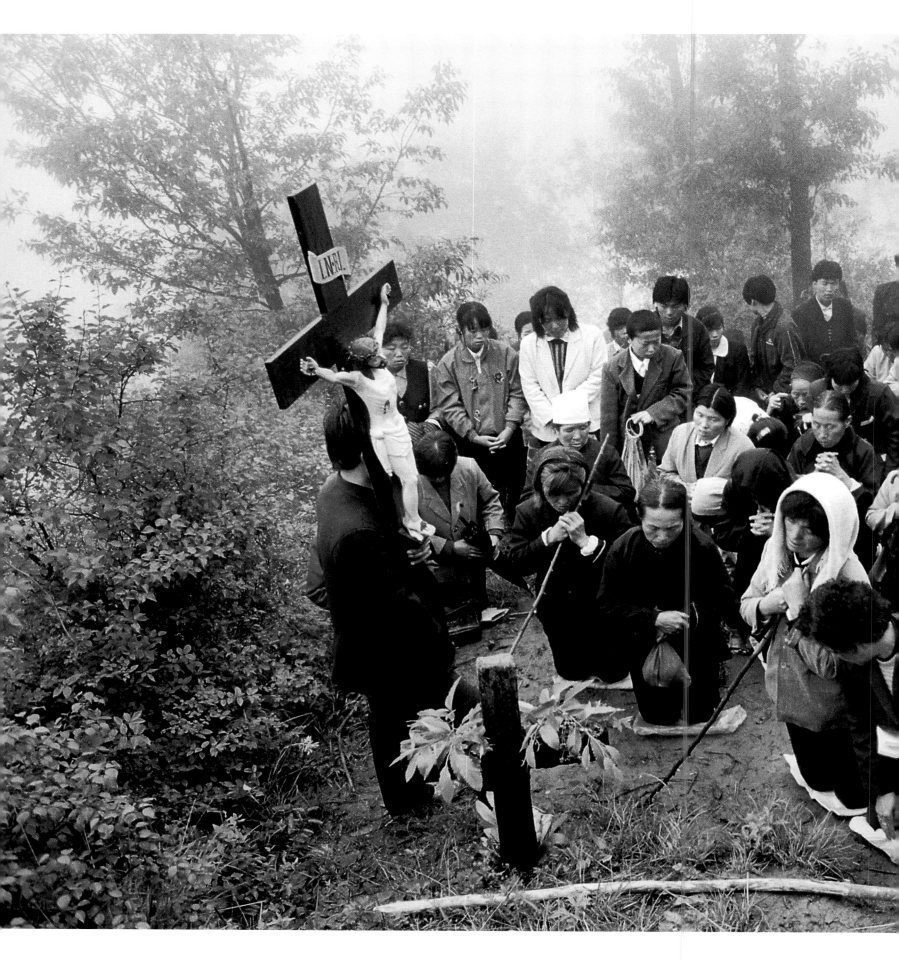

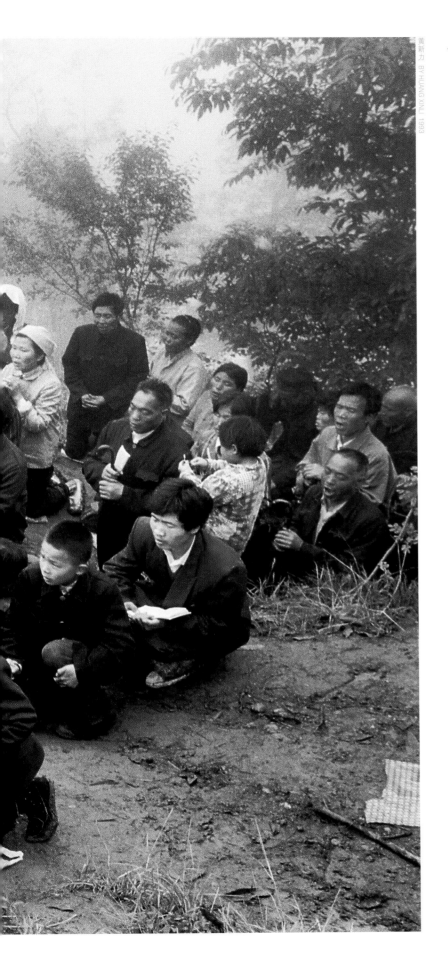

黃新力 BY HUANG XINLI 1993

信仰
Beliefs

　　天主教在一千年以前就傳入中國，那是那個強盛大國在文化上自信包容的痕迹。在對西方宗教疑慮排斥了兩百年之後，那一縷信仰的香火依然暗暗地燃燒。

　　每一種宗教都在此岸與彼岸、人生之意義上建立着自己的信條，人民則依其對現實的判斷選擇遵從。信仰是必須的，無論如何人們需要對生命和生活意義的終極解釋。對人的尊重即包含着對宗教的尊重，這是一個社會自信與包容的標誌，也可能是30年來中國社會進步的一個標誌。

Catholicism arrived in China around 1,000 years ago, when China exemplified the cultural confidence and tolerance of a great power. After two hundred years of rejection and exclusion of Western religion, the incense of this faith is quietly burning once more in China. The respect for others, including the respect for religions that allows these practices to continue, is a sign of a society's self-confidence and tolerance, and can also be considered a sign of the progress toward openness made in China over the past 30 years.

信徒拜山儀式

1993年，陝西省眉縣青化鄉朝聖十字山途中的拜苦路儀式。

Christian peasants praying in a village in Shaanxi Province are participating in a ritual, in 1993.

軌
Track

　　中國的改革有一個現象讓各國經濟學家迷惑不解：在市場取向的改革中，究竟是怎樣從計劃走向市場的？「雙軌制」，當它作為一種價格改革的思路與政策被提出來的時候，誰也沒有想到，它幾乎成了一個象徵，映射了在價格之外的制度、政策、方法，滲透進民間生活。「軌」的選擇，在中國是一件天大的事。經過大的與不大的摩擦和動盪，這個「軌」轉過來了。

　　Many economists from different countries are puzzled by one phenomenon in China's reform: How did China shift from a planned economy to a market economy? The dual-track system was first introduced in price reform. Nobody imagined at the time that it would actually be used extensively in most other areas of reform. Although it has been a bumpy ride, China's reform has finally gotten on the right track.

腳踏車公交車混行不悖

1991年，上海南京東路，路上的腳踏車和公交車。那時私家車不多，交通並不擁堵。1991年上海全市共有機動車228,841輛，到2008年初，上海機動車已達120萬輛，其中私家車逾60萬輛。

Traffic flowing freely along Shanghai's Nanjing East Road in 1991, when the city had just 228,841 registered motor vehicles and traffic jams were virtually unknown. By 2008, however, Shanghai had more than 1.2 million motor vehicles, including 600,000 privately owed cars.

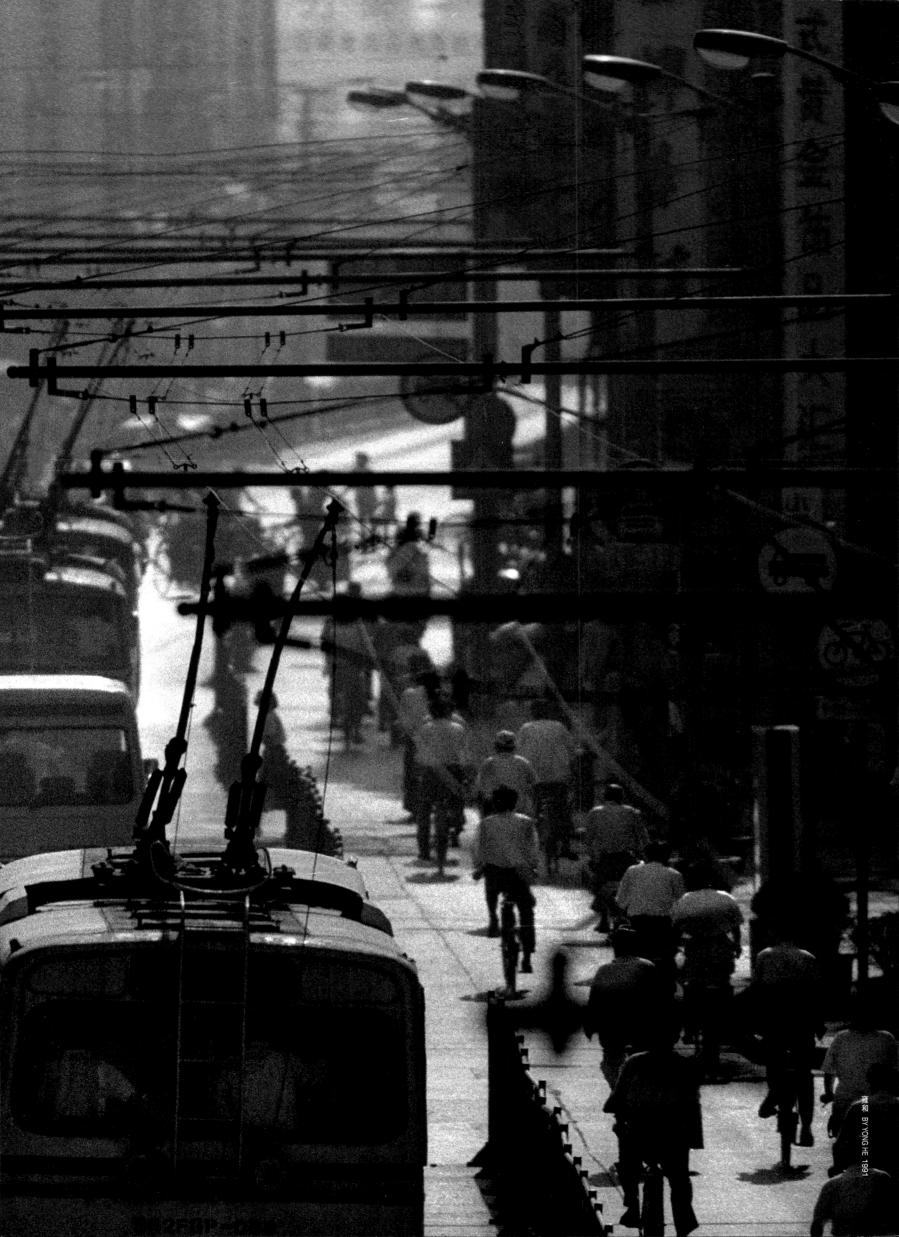

進城
Coming to the Big City

　　1990年代初，隨着新一輪經濟大潮的興起，大批農村勞動力進入城市成為彼時最引人矚目的社會景觀。有資料統計：農民工隊伍從1990年代的2,000萬人到2004年的6,000萬人，他們中百分之六十六點七來自中西部地區，卻有百分之六十九點八的人在東部地區打工，百分之五十以上的打工者在建築業和製造業就業。總人口的二十分之一在全國流動，其中三分之二的人群季節性地在西部和東部間逡巡，將近二分之一的GDP在他們手中產出。與此同時，農村收入上升部分的二分之一出自他們的工資。怎麼看，這都是不得了的事。

With China's economic revival, millions of peasants have flocked from the countryside to the cities in search of wealth. During the 1990s, 20 million migrant workers descended on the cities, but by 2004 that figure topped 60 million. Most came from the central and western areas of the country to work in the eastern urban centers. More than 50 percent of these people were working in construction or manufacturing. They contribute to nearly half of the nation's GDP and income from their salary represents half of the increase in total peasant income.

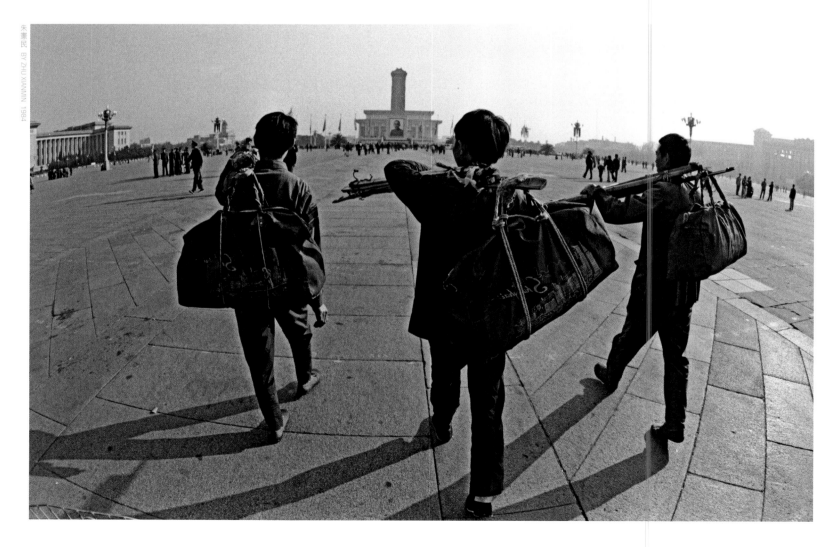

朱憲民 BY ZHU XIANMIN 1984

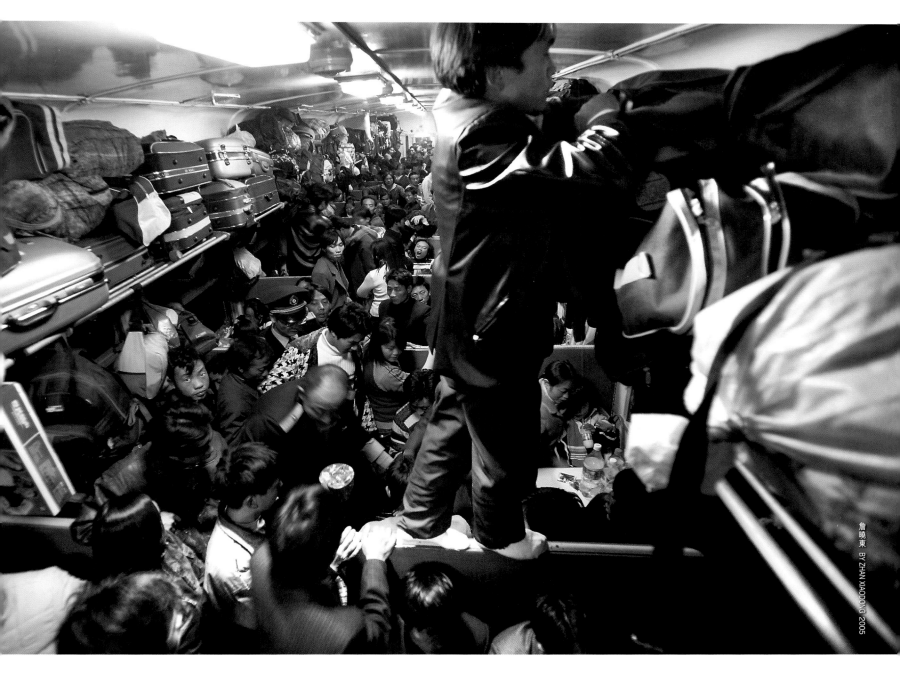

詹曉東 BY ZHAN XIAODONG 2005

來京打工

在天安門廣場遊逛觀光的外地打工者。看他們的行裝神色，像是剛下火車，初進京城。

Migrant workers lug their baggage across Tiananmen Square after arriving in Beijing.

春運印象

春節前後，正是客流往返的高峰期，鐵路部門又迎來春運大潮。2005年1月25日，由杭州始發開往貴陽的L199次列車上，返鄉過年的農民工沿途大量上車，至江西境內，所有車廂均爆滿。

Spring Festival travelers jostle for space on a train from Hangzhou, capital of the eastern Zhejiang Province, to Guiyang, in inland Guizhou Province, in January 2005. Hundreds of thousands of migrant laborers make a rare journey home for the annual Spring Festival, or Lunar New Year holiday.

街道組織
Serving the Community

　　其實可以把改革理解為對社會結構改建、重構的過程。不容忽視的是一個動輒擁有上千萬、幾百萬人口的城市，如何在社會激烈變化的同時，能保證基本穩定？中國城市中的街道組織的功能，頗值得人們關注。這是一幫經常被人戲謔地稱作「小腳偵緝隊」的以中老年婦女為主的隊伍，她們竟然參與了從家庭和睦、鄰里安全到國務活動的所有涉及街道居民的事務。「街道居委會」附屬在基層政府之下，從所有的細節入手保證社會安穩運轉。生活中總有那些須臾不可離開卻往往被人忽視的人和事——這裡，算一個。

　　Community organizations in China perform an array of functions, ranging from aiding the vulnerable to helping maintain security in residential areas. These groups notably came to the fore during the Olympics, when many local groups swung into action to help ensure the smooth running of the Games. Some helped make sure that neighborhoods remained clean and tidy, while others made themselves available to help the tens of thousands of international visitors to various parts of China for the event. Community organizations represent China's civil society and usually operate on a non-profit-making basis. While self-funding and relying on the goodwill of volunteers, these organizations still attach importance to formality, and have their own written constitutions and elected directors' boards. Most members of these organizations tend to be retired elders with a philanthropic bent.

賀延光 BY HE YANGUANG 1990

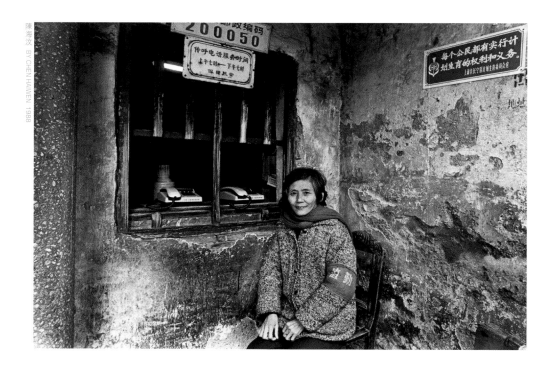

陳海汶 BY CHEN HAIWEN 1988

阿婆傳電話

1980~1990年代，在電話還未在上海居民家庭普及之前，人們交流通訊，特別倚重由里弄居委會阿婆持守的「傳呼電話」。

A telephone booth in Shanghai in the 1990s. People depended on public phones for communication in the 1980s when home telephones were a rarity.

老人巡查隊

1990年9月5日，北京舉辦的第11屆亞洲運動會即將開幕，東直門地區的退休人員正準備上街執勤。

Volunteers assemble for duty before the Asian Games in Beijing on September 5, 1990.

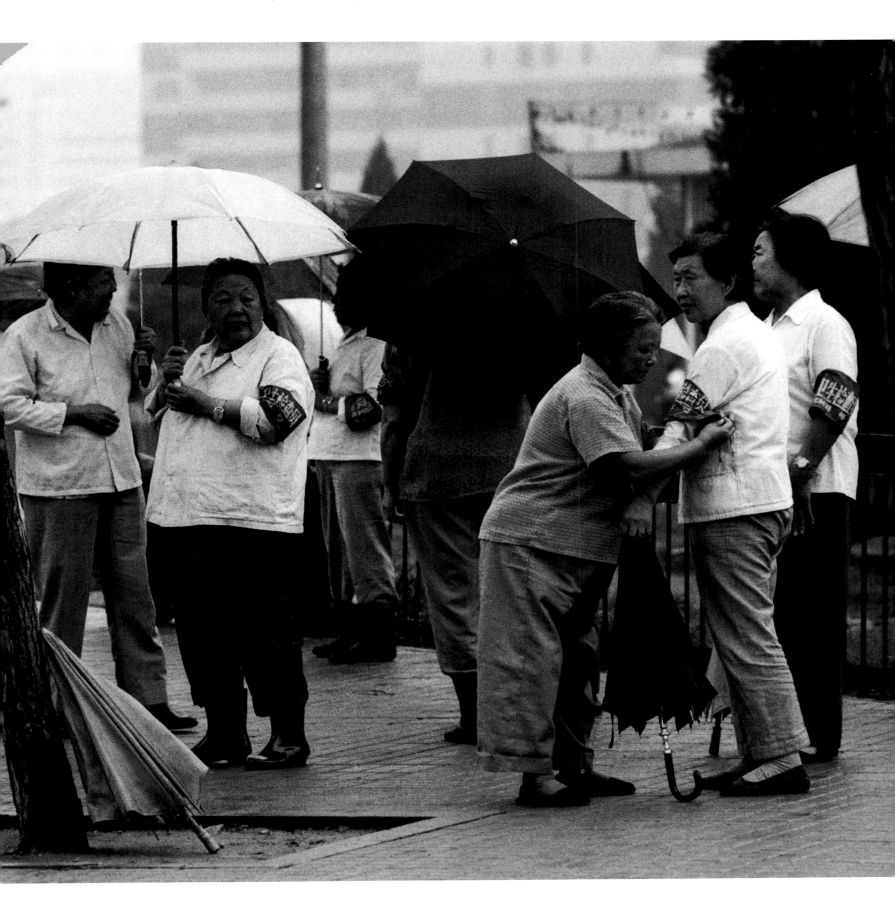

美髮
The Age of Beauty

　　很可能沒有一個國家的攝影師，能圍繞美髮這個行業拍那麼多照片。這兩張是我們在幾十幅同類題材照片中選出來的。這個行業在30年前全國一律都叫做「理髮店」，幾十年裡，由「美髮」而「美容」而「形象設計」，內涵與外延相因相變。美化個人形象，是所有人和所有的社會都不會拒絕的，只是在一個禁錮的社會裡，「美」是單調的，對「美」的約束是社會性的；但是在一個開放的社會裡，「美」就是個性化，是內心呼喚的外在展示，因而是異彩紛呈的。

Beauty is big business in China. Since Deng Xiaoping's economic reforms, people's wealth has soared, as has attention to personal grooming. Between 1984 and 2004, spending on cosmetics in China grew from US$25 million to US$6 billion dollars, with many Western brands such as Olay and Nivea proving popular among consumers. In history, Confucian and Taoist values centering on internal and external beauty held sway, but following the Communist Revolution beauty was defined by one's love for the motherland and Party. Nowadays image is defined by the latest trends on display in Vogue magazine and other members of the haute couture media.

余海波 BY YU HAIBO 2005

蕭雲集 BY XIAO YUNJI 1987

燙頭髮的紹興農婦

1987年，中國百姓的穿着和髮型，早已打破了1970年代單調的款式。圖為浙江省紹興市齊賢鎮的幾個女人，在理髮店窗外圍觀燙髮的情景。

Curious passersby watch a woman having her hair curled in Shaoxing, Zhejiang Province, 1987. By the 1980s, the uniform clothes and hairstyles of the 1970s were on their way out.

面膜美容風靡中國

文革時期，大陸婦女不得塗脂抹粉畫眉，美容和皮膚護理更是鮮為人知。1980年代的改革重新喚起中國女人愛美的天性，美容、美髮、美體形成熱潮。圖為在深圳美容院內進行面膜護理的顧客已經滿員。

Women receiving facial treatments at a thriving beauty parlor in Shenzhen in 1980s. Women were not allowed wear make-up during the Cultural Revolution. Facials and other beauty treatment were virtually unknown then. That changed and the beauty industry took off in the 1980s.

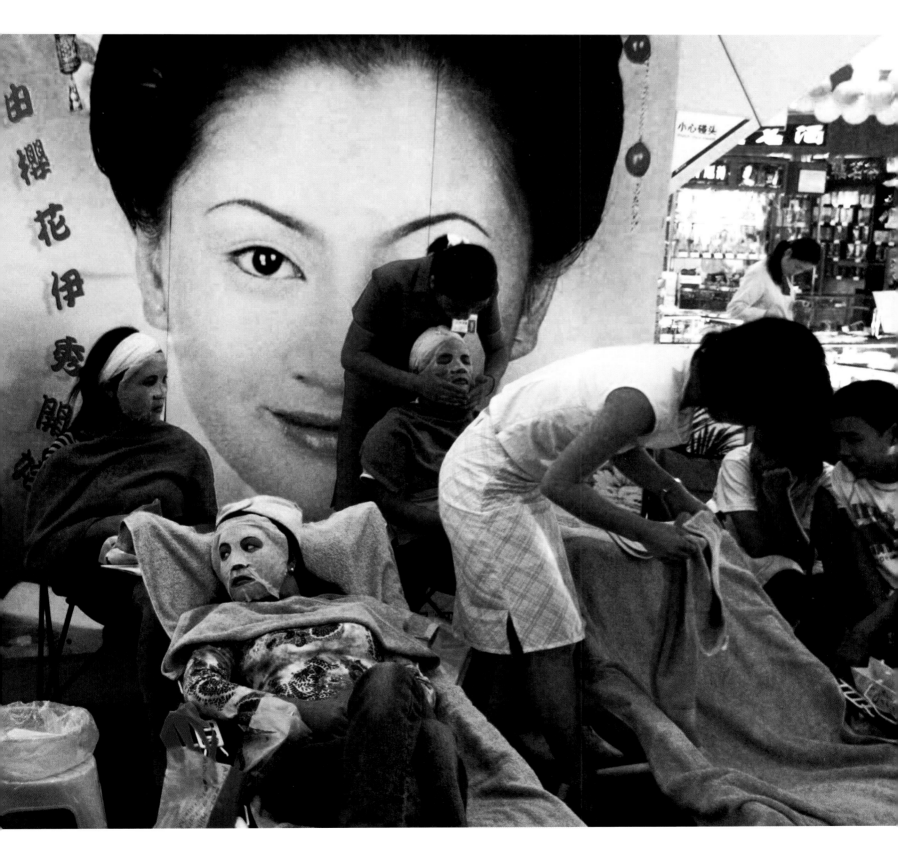

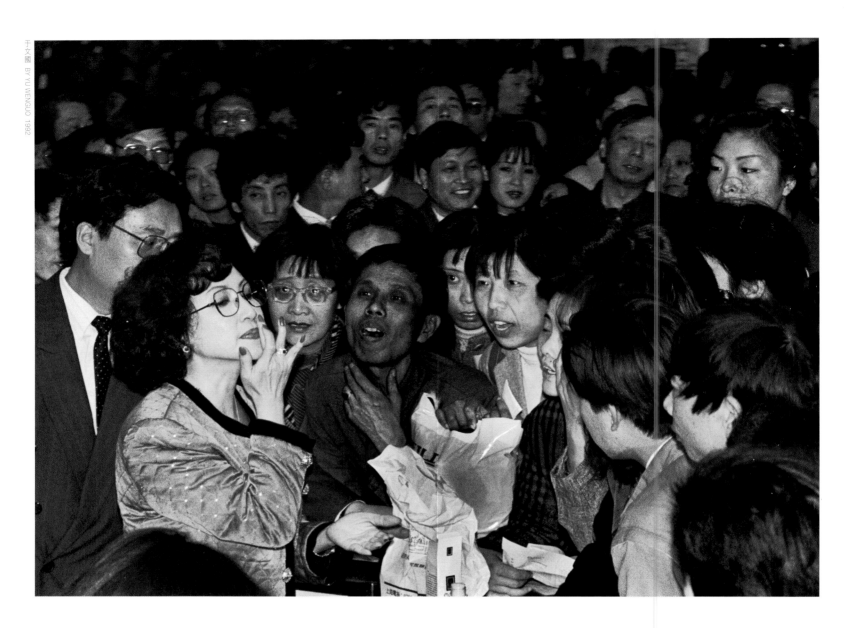

于文國 BY YU WENGUO 1992

▲ 奇妙「換膚」霜

1992年，香港美容師鄭明明在上海華聯商廈推銷其生產的「換膚」霜，吸引眾多市民圍觀。

Hong Kong beautician Cheng Ming Ming doing a promotional demonstration for her own line of cosmetics in Shanghai in 1992.

▷ 老人與花

1990年5月1日，在山東青島中山公園內，為給老人拍一張與櫻花的合影，家人扶老人站到垃圾筒上。

An elderly woman, posing for a photo, stands atop a trashcan so that spring blossoms are framing her face, Shandong, 1990.

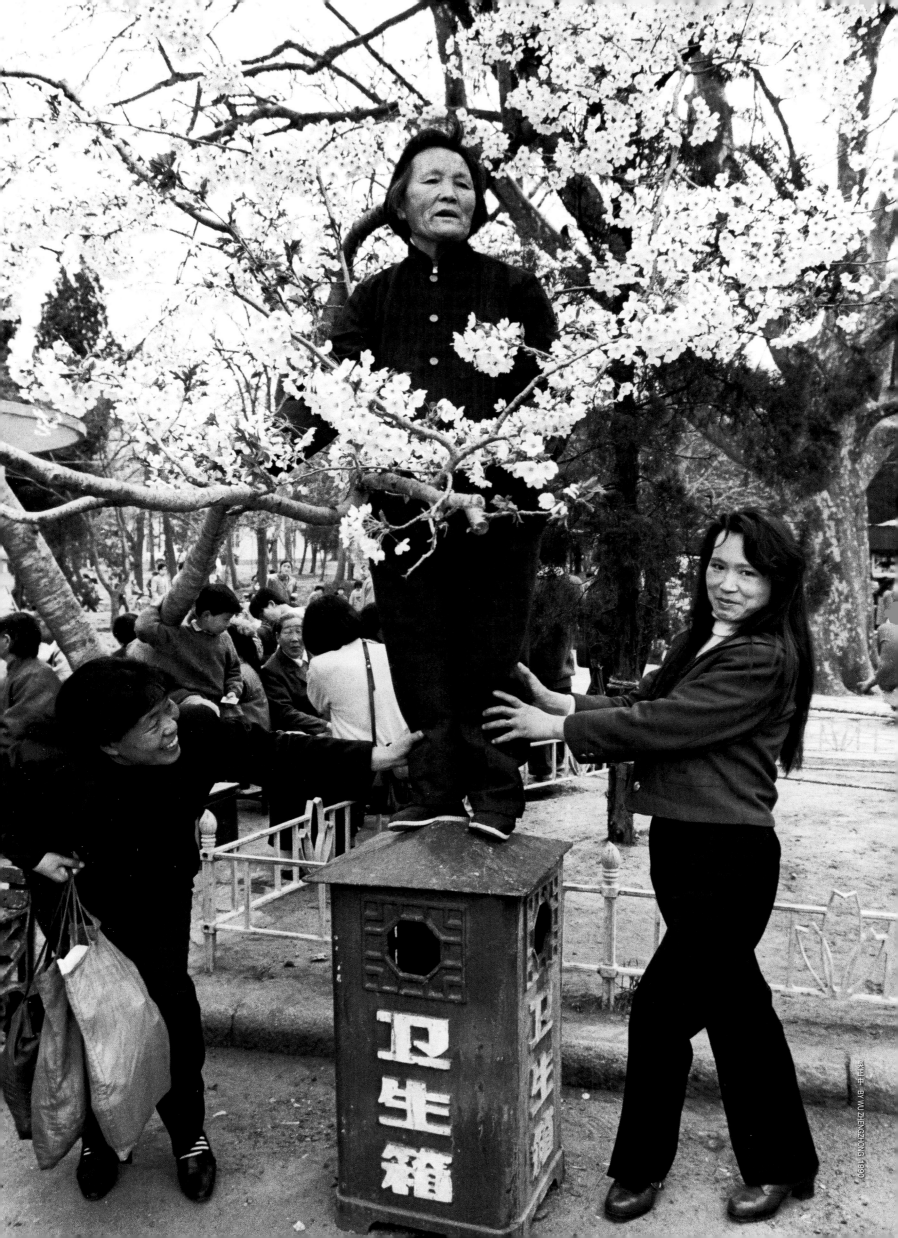

卫生箱

求什牛 BY WU ZHENGZHONG 1990

「流鶯」
A Nation's Guilty Pleasure

　　「性工作者」自1980年代以來在中國再現，開始是沿海城市的街頭，以後更趨向內地且有分層級的擴展。政府、媒體、公眾和社會學界對這個事沒少說話也沒少行動，不過30年來它依然存在着，只是一般不在街頭活動了。很難說這算「進步」還是「倒退」。30年前，有領導說「窗子一開免不了有蒼蠅蚊子飛進來」；有專家說「現代化必然要付出某種代價」；當時人們着急的是前面，後面想得不多；現在知道了。還知道，比起環境代價來，「流鶯站街」只是小事。

　　Prostitution has become more visible in China since the 1980s. The Communist Party eradicated it from the Chinese Mainland for nearly three decades. With the loosening of State control over people's lives in the 1980s, however, prostitutes have become a fairly common sight across the country. The government's effort to eliminate prostitution continues to be challenging and is likely to be long ongoing.

楊俊坡 BY YANG JUNPO 1994

朱憲民 BY ZHU XIANMIN 1986

娛樂場所的陪酒女郎

1986年，廣東省深圳一娛樂場所內。

1986 Shenzhen, Guangdong, Escort girls awaiting clients in a club.

男扮女裝的演出隊

1994年前後，深圳出現一支男扮女裝的演出隊，隊員幾乎全是男青年，但一律以女子的面目和妝扮登台表演歌舞，以此陰陽倒錯的手法掙錢。

Members of a male drag queen troupe prepare for a performance in Shenzhen in 1994.

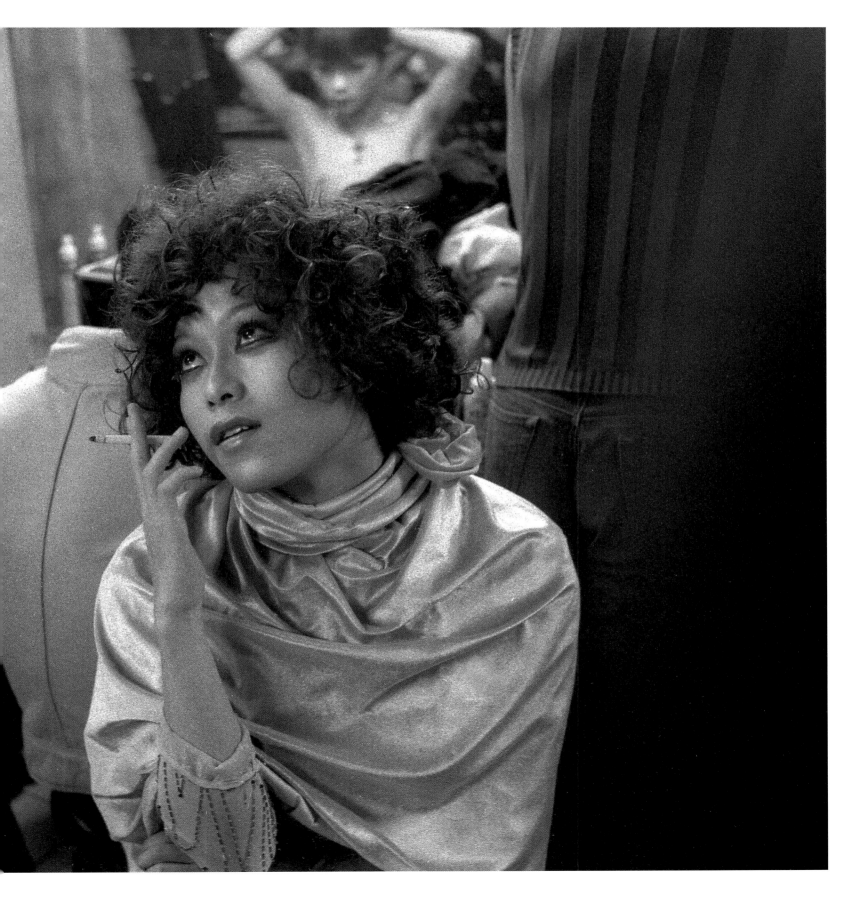

遣送
Controlling the Masses

　　事隔30年，不大聽到「盲流」這個詞兒了，也好。類似中國這樣在幾十年裡有大規模的人口流動現象，在其他各國是不多見的。世界上最大的人群要生存要就業，去城市尋找在農村無法得到的空間，這中間必然出現不少矛盾與陰暗。於是，社會秩序的維護者建立和維護秩序的行為不免強硬，便有衝突有壓抑還有疏導。作為一種政府行政行為的「遣送」，現在或許比當年更規範些了。不過這種場面偶爾還能一見。

　　Before 2003, in an attempt to maintain security, Chinese people without residency permits were barred from remaining in the cities. Anyone caught in breach of the so-called "Custody and Repatriation regulations", set up in 1982, would be extra-judicially detained and sent back to their home province. The policy was originally aimed at reducing the number of homeless and beggars in the cities and was applied to "Three Withouts People" — that is, those without employment, fixed accommodation or a residence permit. But the practice was halted after worker Sun Zhigang, a 27-year-old university graduate and fashion designer who had travelled to Guangdong to work, was beaten to death in a Shenzhen detention center, prompting public outrage and complaints from scholars that the regulations were unconstitutional. The abolishment of the policy was announced by Premier Wen Jiabao in June 2003.

李傑 BY LI JIE 2001

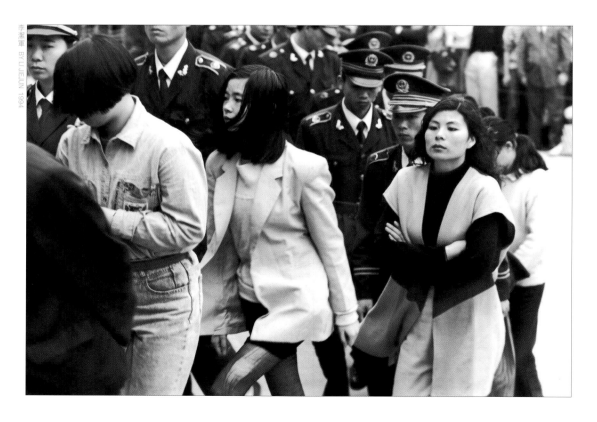
李潔軍 BY LI JIEJUN 1994

深圳特區嚴厲掃黃

1994年3月，深圳警方在一次突襲行動中抓獲的賣淫女子。深圳是中國最早開放的經濟特區，大量外來人口的湧入使得社會治安管理複雜化，賣淫嫖娼現象露頭。

Women arrested in a prostitution crackdown are escorted through the street by police in Shenzhen in 1994. The earliest special economic zones, such as Shenzhen, attracted criminal elements as well as other fortune hunters.

北京遣返民工

2001年4月，為了營造城市環境，對外來進京人員管理非常嚴格。4月15日在北京西站，一群沒有身份證和暫住證的陝西籍民工被抽掉褲帶，強行趕上火車遣送原籍。2003年3月17日，因為「孫志剛事件」，中國政府廢除了收容遣送制度，收容所也改成了救助管理站。

A group of rural migrants from Shaanxi Province being through Beijing West Railway Station on April 4, 2001. They were forced to return home after being caught without residency permits for the city.

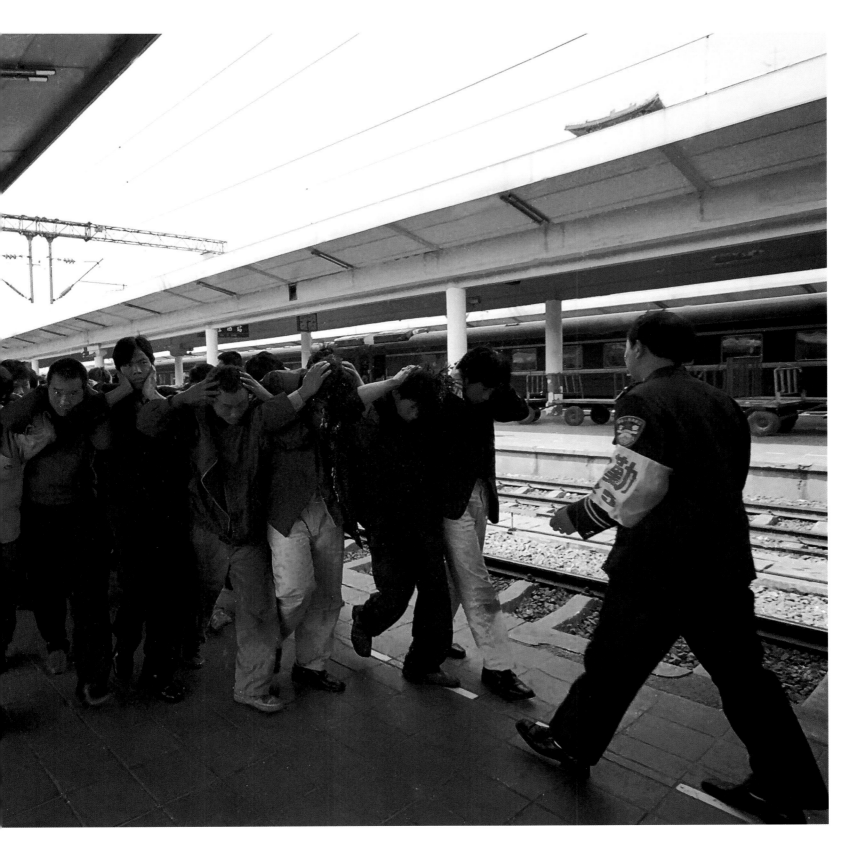

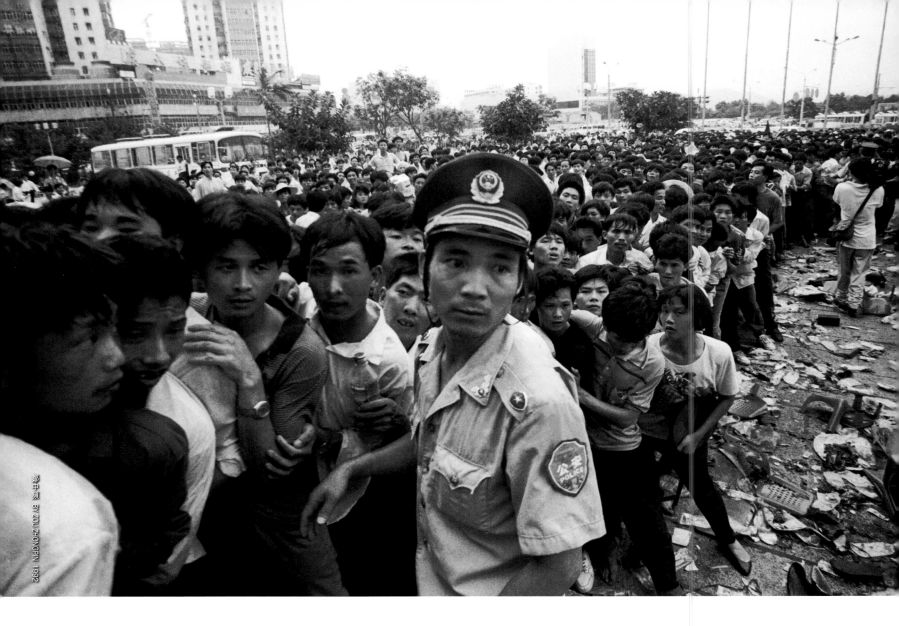

股市門前

1992年，有20多萬人在深圳室內各大銀行的門前排隊購買股票認購證。警力嚴重不足，維持秩序的警察滿臉無奈。

A policeman tries to maintain order as tens of thousands of people gather outside a bank to buy share certificates in Shenzhen in 1992.

股市
Stock Market

1988年，建立中國資本市場的設想開始在高層醞釀。1990年，上海和深圳證券交易所相繼成立。股份制經濟從一開始就顯現出它巨大的生機和活力，儘管中國資本市場經歷了一個漫長的成熟過程，但這應該是整個1980年代中國經濟發展的階段性標誌。在民間資本與企業的互動之間，實體經濟與金融資本之間的通道打開了。

Chinese leaders started to plan for the establishment of China's stock market in 1988. Two years later, both the Shanghai and Shenzhen Stock Exchanges came into existence, reflecting the progress of the Chinese economy during the 1980s. China's stock market immediately demonstrated its importance to China's economy even though it has undergone a long maturing process.

上海股票大賣場

1992年12月，上海文化廣場「股票大賣場」。當時上海股民30多萬人，交易點只有32家，無法滿足股民買賣需求。1992年6月初，許多證券公司開進這裡，增設臨時櫃檯。這是中國特色的「股票大賣場」。

In the frenzy to get in on the stock market, many people thronged to the numerous securities agencies in Shanghai's Wen Hua Square. These became know as "stock hypermarkets".

「寶延風波」爆發

1993年10月，上海海通證券公司營業所，股民瘋狂搶購延中股票。深圳寶安收購上海延中，由此爆發「寶延風波」，這是中國證券市場上開天闢地的第一例收購事件，中國企業從此走上真正的資本運作道路。

The attempt by Shenzhen Bao An Enterprises to takeover Shanghai Yanzhong Industrial was the first large-scale commercial acquisition in the modern Chinese stock market, and the takeover was successful. The move provoked a rush to buy Shanghai Yanzhong stock in October 1993.

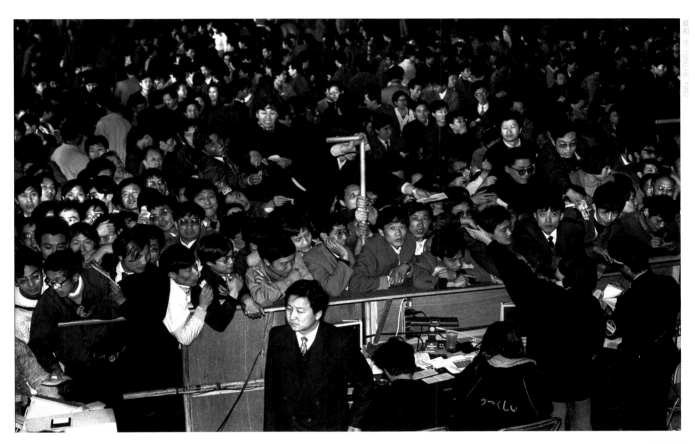

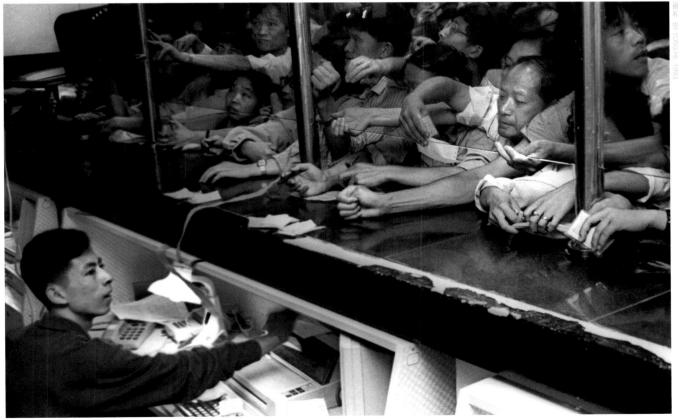

169

申奧失利
Olympic Dreams Shattered

　　那一刻，被中國人深切地印在腦海裡：醞釀着多少喜悅就得到了多少失落。經過了十幾年的改革，中國人總希望世界承認自己，接受自己，因而把操辦奧運當成一種強盛的象徵。其實，在那種怯生生的焦灼中，隱含着一種太渴望被人承認的不自信。中國與世界的關係是奧運會蘊涵的命題，也是200年以來中國人面對的問題。1991年的申奧口號是「給中國一次機會，給世界一個奇蹟」。到2006年，申奧口號是「新北京，新奧運」——「新」了，調也低了！

　　Despite a long campaign by Beijing, China narrowly lost its bid for the 2000 Olympics to Australia: Sydney won with 45 votes, just two more than Beijing, in September 1993. The result was a severe blow to China, which had expected to be awarded the games. Some commentators said the obstructions from some countries and lobbying by NGOs and politicians over China's human rights record had played a major part in swinging the decision. Others said Australia's long sporting history was the reason.

申奧

1993年9月24日凌晨2時27分，在北京國際會議中心，電視牆上國際奧委會主席薩馬蘭奇宣佈的結果，驚呆了收看《北京之夜》申辦奧運直播晚會的所有人。北京輸給了澳大利亞悉尼，失去2000年夏季奧林匹克運動會的主辦權。

Beijing lost its first race to host the Olympic Games when Sydney won the bid to host the 2000 event. Disappointment was recorded on the faces of Chinese viewers at the Beijing International Convention Center watching a live broadcast of the decision to awerd the Olympic Games to Sydney on September 24, 1993.

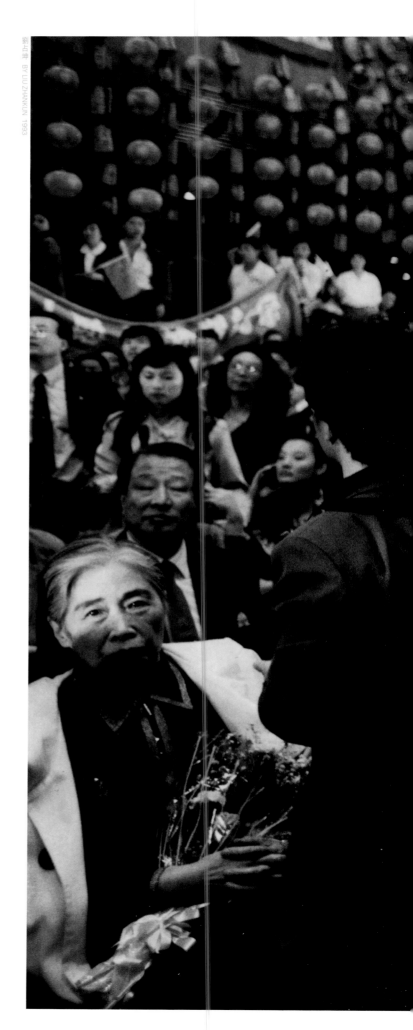

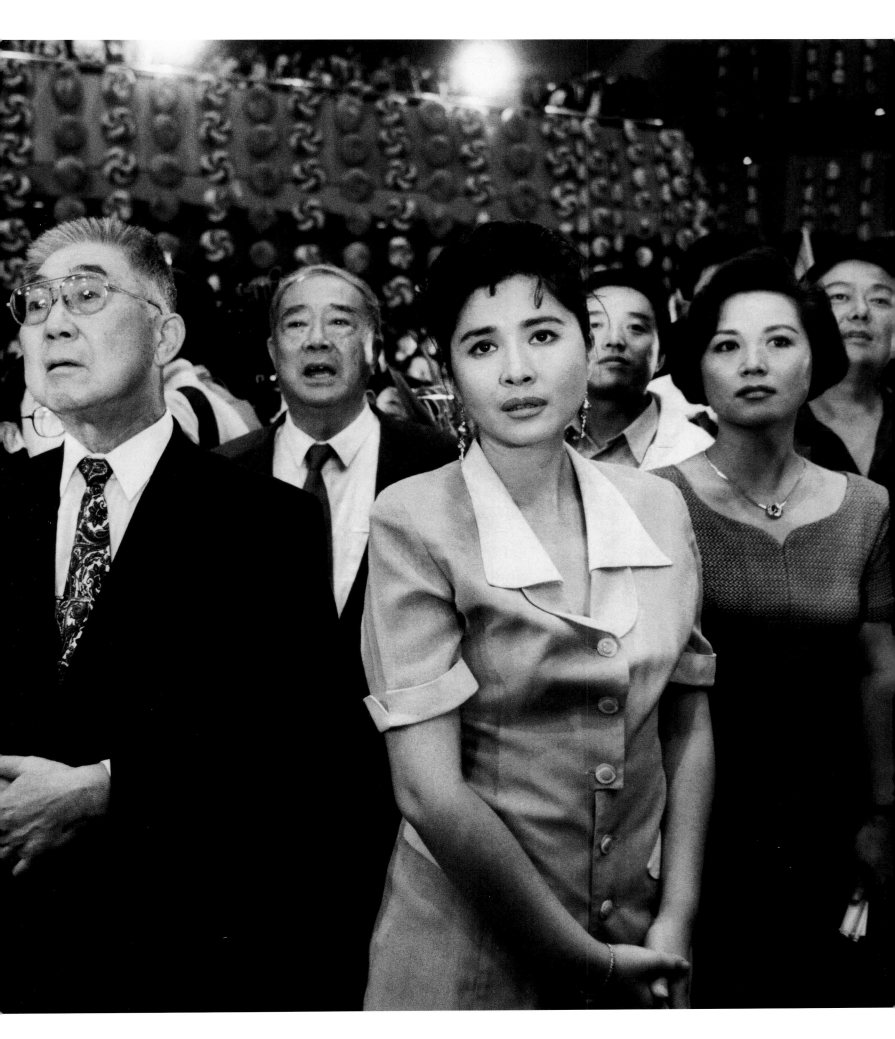

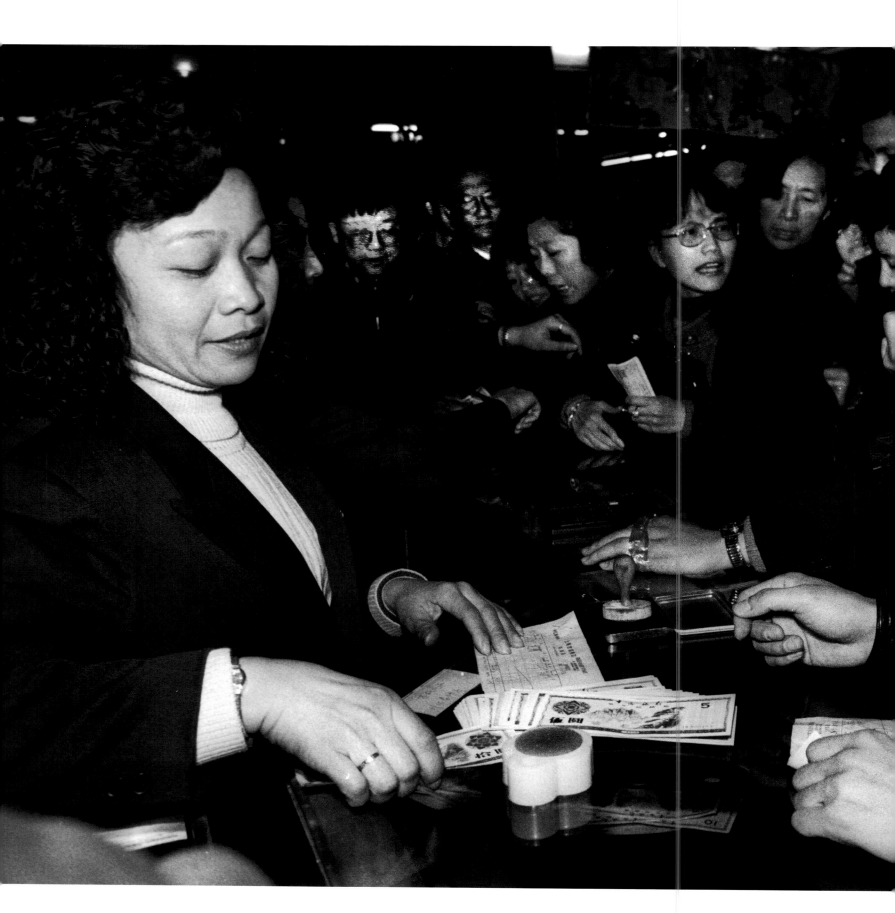

外匯券

Closed for Business – Foreign Exchange Certificates

　　1995年，外匯兌換券退出流通領域。改革開放之初，在物資供應、外匯管理一時跟不上形勢發展的特定時期，外匯券在替代、肅清外幣在市場上的非法流通上，起到了維護我國貨幣主權尊嚴的作用，並且作為一種有效的管理手段，堵塞了非法套購非貿易外匯渠道，防止外供單位的商品被搶購，和進口商品外匯供應無保證。作為一種起過特殊作用的券證，外匯券在改革中具有特殊的歷史意義。

To get an idea of how closed to the world China was before Deng Xiaoping's reform and opening policy, one only has to look at Beijing's approach to foreigners and Chinese currency. Thirty years ago it was illegal for non-Chinese nationals to possess *renminbi* or the "People's Money". In order to accommodate the few foreigners who did travel to or live in China at the time, they were issued with Foreign Exchange Certificates (FECs), which could only be used at certain stores, such as the Friendship Store in Beijing which sold imported goods alongside a selection of tourist merchandise such as silk and jade. By doing this, the ideologically driven Chinese authorities were able to minimize contact between Chinese citizens and foreigners and to monitor their movements. The certificates were issued by the Bank of China and sold at a premium of about 20 percent more than the actual value of the *renminbi*.

結束使命退出流通

1994年12月31日，上海友誼商店，市民用外匯券購買商品。外匯券全稱「中國銀行外匯兌換券」，是一種替代外幣在國內流通的人民幣憑證。外匯券於1980年4月1日發行，面值分1角、5角、1元、5元、10元、50元、100元7種。1995年1月，經過15年，外匯券終於完成了它的歷史使命，退出流通領域。

Shoppers using Foreign Exchange Certificates to buy luxuries at the Shanghai Friendship Store, November 31, 1994. Foreign Exchange Certificates were in circulation for 15 years before they were abolished in January 1995.

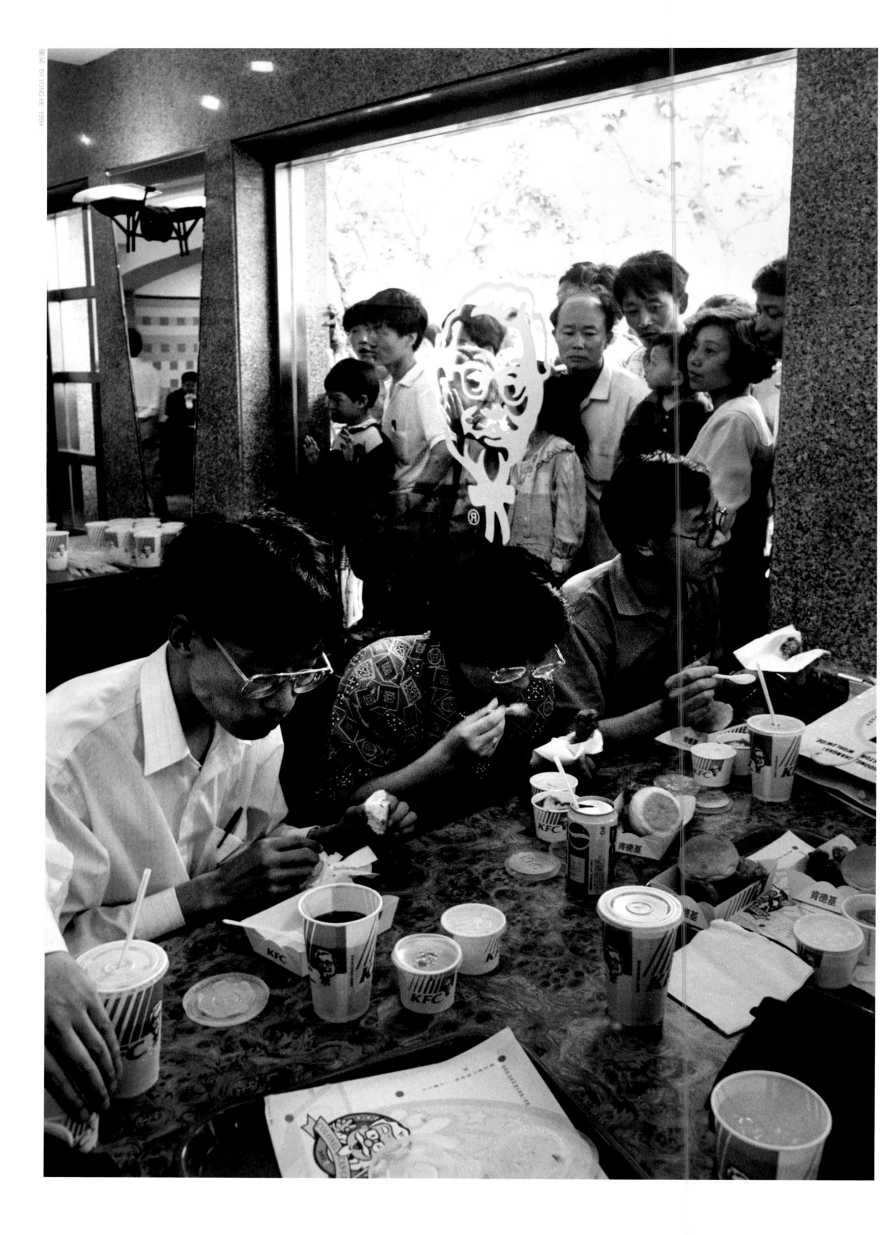

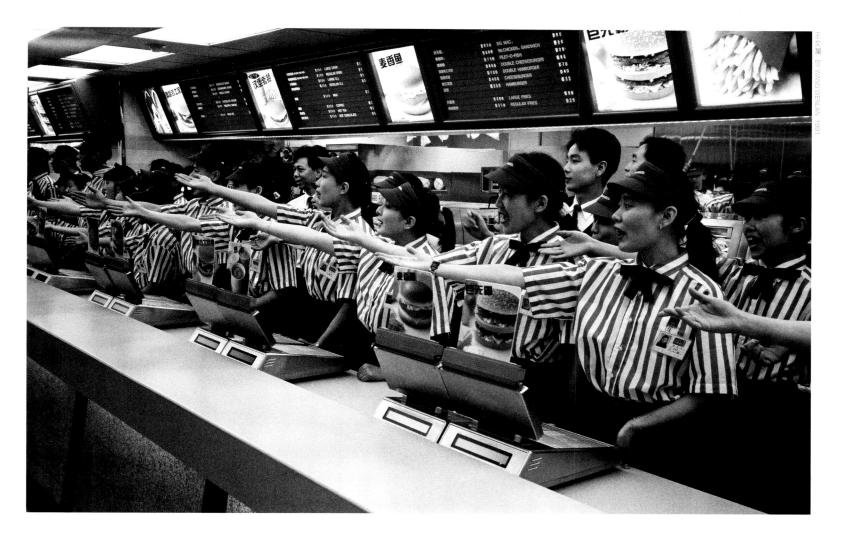

浦東首家KFC開張

1994年5月28日，上海浦東東昌路開出第一家肯德基餐廳，這也是全球國際肯德基第9,000家分店，一些市民在窗外觀望。

Kentucky Fried Chicken was still a novelty for many Chinese when the first outlet was opened in Shanghai's Pudong district on May 28, 1994. The restaurant in Dongchang Road was the 9,000th outlet in KFC's global chain.

麥當勞開業

1991年，北京的一家麥當勞餐廳，清晨開門迎客的情景。

The Beijing, McDonald's opens for business in 1991.

接軌
Foreign Investment – Opening the Floodgates

　　當肯德基在全球擁有9,000家連鎖店的時候，人們在中國第一家連鎖店的窗外觀景——真是歷史性的一瞬。開始，人們還把對「洋速食」的接受當作一種生活方式，甚至有媒體鼓噪「土快餐」向「洋快餐」叫板抵抗。漸漸地，沒有人把它當作一件事關民族尊嚴的事情了。在提高生活質量，豐富人民生活，繁榮城鄉經濟的需求下，被人們接受的不但是餐飲形式，還有所有有利於人們改善生活的東西。

　　Following Deng Xiaoping's reforms, foreign investment flooded into China at a staggering rate, and by 1985 represented 20 percent of the nation's gross national product. Textiles led the way in exports, ahead of petrol and foodstuffs. Eager to join the industrialized world, the country imported machinery, transport, manufactured goods and chemicals. Initially, Japan was the dominant trading partner, accounting for 28.9 percent of imports and 15.2 percent of exports in 1986. Hong Kong was a leading market for exports (31.6 percent) but a source of only 13 percent of imports. In 1979 the United States became China's second largest source of imports and in 1986 was the third largest overall trade partner. (Nowadays, the European Union is said to be China's largest trading partner.) Meanwhile, with China's more open outlook toward foreigners — and people from abroad keen to catch a glimpse of this ancient land — tourism began to take off.

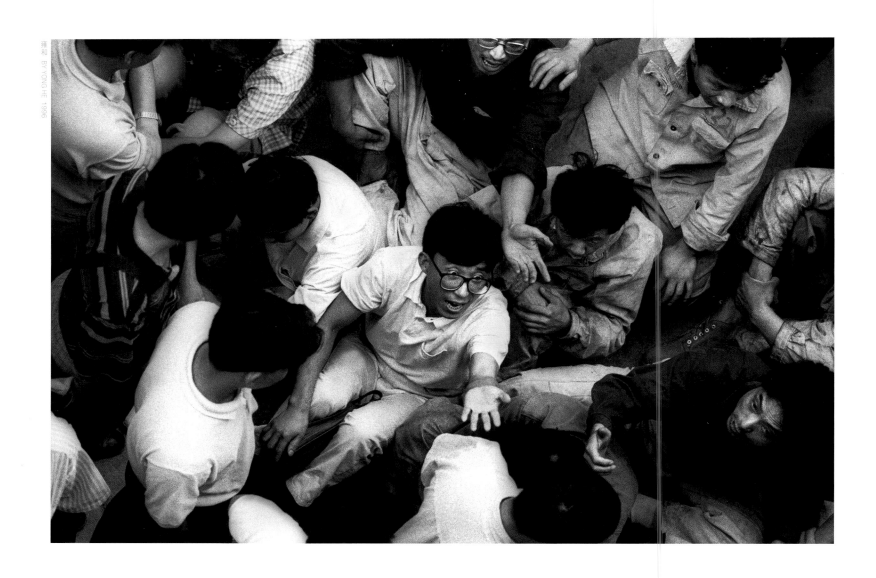

攝和 BY YONG HE 1996

三角債
Debt Chains

　　改革的進程從來就不是一帆風順的。1990年代初期，由於資金的相互拖欠，大多數企業——無論是國企還是鄉鎮企業、民營企業，都陷入「應收而未收，應付而未付」的債務糾紛之中。這是由於1980年代後期中央政府為了應付經濟局面而抽緊銀根所造成的新問題。一時間，越來越多的企業陷入債務糾葛之中，既不願意償債，債權也無法得到清償。中國經濟發展因此受到嚴重困擾。為此，中央政府及時向數千個企業注入愈百億元貸款，輔之以其他綜合措施。經過兩年時間，基本解決了「三角債」問題。

During the conversion from the old command economy to the socialist market system, economic order was disrupted by so-called "debt chains". Debt chains describes the phenomenon in the Chinese economy of triangular debt relationships among creditors and debtors. If Company A owes Company B accounts payable, while Company B owes Company C, and Company C owes Company A, that will create a triangular debt relationship between companies A, B and C. This problem dealt a blow to investor enthusiasm and inhibited the development of the market economy.

「三角債」愈演愈烈

1996年9月27日，上海東湖路17號，新滬鋼鐵廠工人
上門討債不成，就把大門堵住。「三角債」是改革開放
後、新舊經濟體制轉換過程中深層次矛盾的反映。「三
角債」打亂了市場經濟秩序，打擊了投資者的投資熱
情，抑制了市場經濟的發展。

Workers blocking the door of an iron and steel factory to demand
payment of debts in Shanghai in 1996. Chains of debt formed
between enterprises after the 1980s threatened to disrupt the
country's economic development.

討債人搶搬貨物

1997年3月19日，上海景福針織廠，討債人在搶搬貨
物。該廠生產「飛馬」牌針織服裝，是全國針織行業著
名創匯大戶。後來被行政指令兼併兩家針織廠，從此揹
上近億元債務。

On March 19, 1997, debt collectors seized goods from a Shanghai
company that had run up a debt of close to 100 million yuan.

浙葉山村計票選舉村幹部

1999年，浙江省溫州市泰順縣葉山村進行村幹部選舉。

Villagers tally votes for village cadres in Wenzhou, Zhejiang Province, in 1999.

鄂喻家灣投票評議村幹部

1997年，湖北省隨州市曾都區長崗鎮喻家灣村4名在職村幹部，正在經受46名村民代表的信任投票。

Villagers putting their votes in the ballot box in an election for four cadres in Suizhou, Hubei Province, in 1997.

新需求新問題
Elections

　　「村」也是一級基層政權。直選（直接票選幹部）的方式適應農民在獲得經營自主權之後在更多決策上實現意志的要求，被視為中國式民主政治的鄉村試驗，但也使鄉村社會結構中出現新問題——中國農村的管理結構是從上到下垂直的，直選前，農村的矛盾主要是村委會與鎮的矛盾，村委會與村民的矛盾；直選後，名義上是村黨支部領導下的村民自治，但「兩委成員」（黨支委和村委）誰也難管誰的現象普遍存在。同時，在直選中，以宗族、姓氏之類的名義聚集起來一些新的勢力，也會影響或擾動選舉結果。儘管媒體把「鄉村直選」視為中國式的民主政治建設，但是它並未在更深層次和更廣的意義上推行起來。

　　Direct elections in the People's Republic of China take two forms: elections for village leaders in selected rural villages and elections for local People's Congresses. Since taking power in 1978, Deng Xiaoping experimented with direct democracy at the grassroots level. Village leaders traditionally have been the lowest level of government in China's complicated hierarchy of governance. In the early 1980s, a few southern villages began implementing "Vote for your Chief" policies, in which free elections were held to choose the village chief, who traditionally holds much power and influence in rural society. Many of these elections have been successful, involving candidate debates, formal platforms, and the initiation of secret ballot boxes. For these elections, suffrage is universal, that is, all citizens above the age of 18 have the right to vote and be elected. The local elections tend to be small, with no more than 2,000 voters, and the "first-past-the-post" system is used to determine the winner. The elections are always supervised by a higher level of government.

西藏
Tibet

　　中國是一個多民族國家，佔人口總數不到百分之十的少數民族集中居住在超過國土五分之二的地區，而且大多處在經濟相對不發達的狀態。少數民族的經濟發展不但是一個經濟問題，更是一個時常涉及國際政治的問題。因此，在整個改革開放的過程中，中央政府始終採取積極穩妥的政策扶持和幫助民族地區的經濟發展。1980年代以來，中央政府僅在西藏文化遺產的保護和發展上就投入了十幾億元的資金。1959～2008年，中央財政向西藏的財政轉移支付纍計達到2,019億元，1994年以來，西藏生產總值年均增長達百分之十二點八，高於全國同期年均增長水平。

　　The central government has invested massive amounts of cash in an effort to bring wealth to the impoverished Himalayas region. Between 1959 and 2008, fiscal transfer from the central government to Tibet has reached over 200 billion yuan. Since 1994 Tibet has maintained a 12.8 percent annual GDP growth.

第十一世班禪首次進京

1996年元月，經金瓶掣簽後的第十一世班禪首次進京。這是 6 歲的班禪第一次來到人民大會堂西藏廳時高興的情景。

The six-year old 11th Panchen Lama on his first visit to the Tibet Hall at the Great Hall of the People in Beijing China, in January 1996.

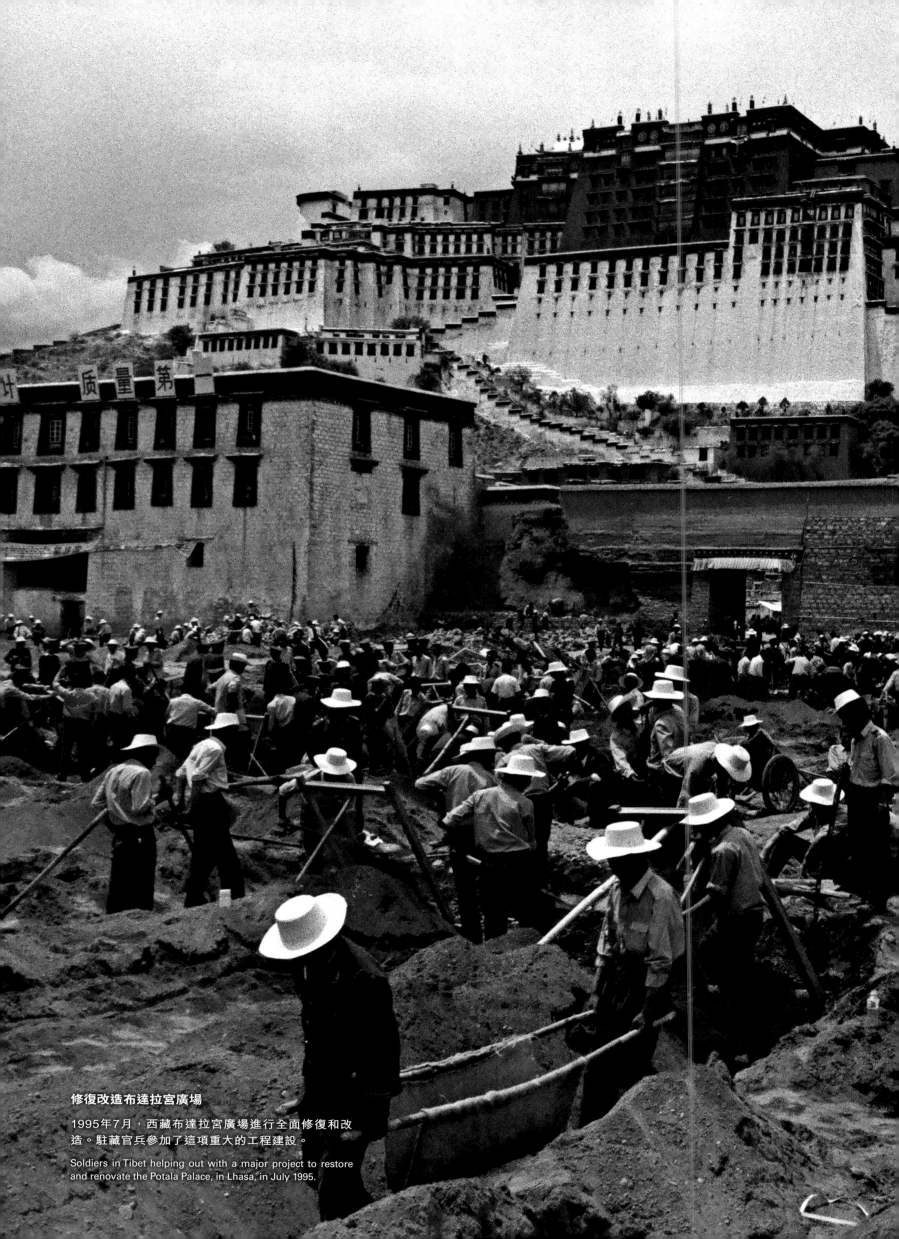

修復改造布達拉宮廣場

1995年7月，西藏布達拉宮廣場進行全面修復和改造。駐藏官兵參加了這項重大的工程建設。

Soldiers in Tibet helping out with a major project to restore and renovate the Potala Palace, in Lhasa, in July 1995.

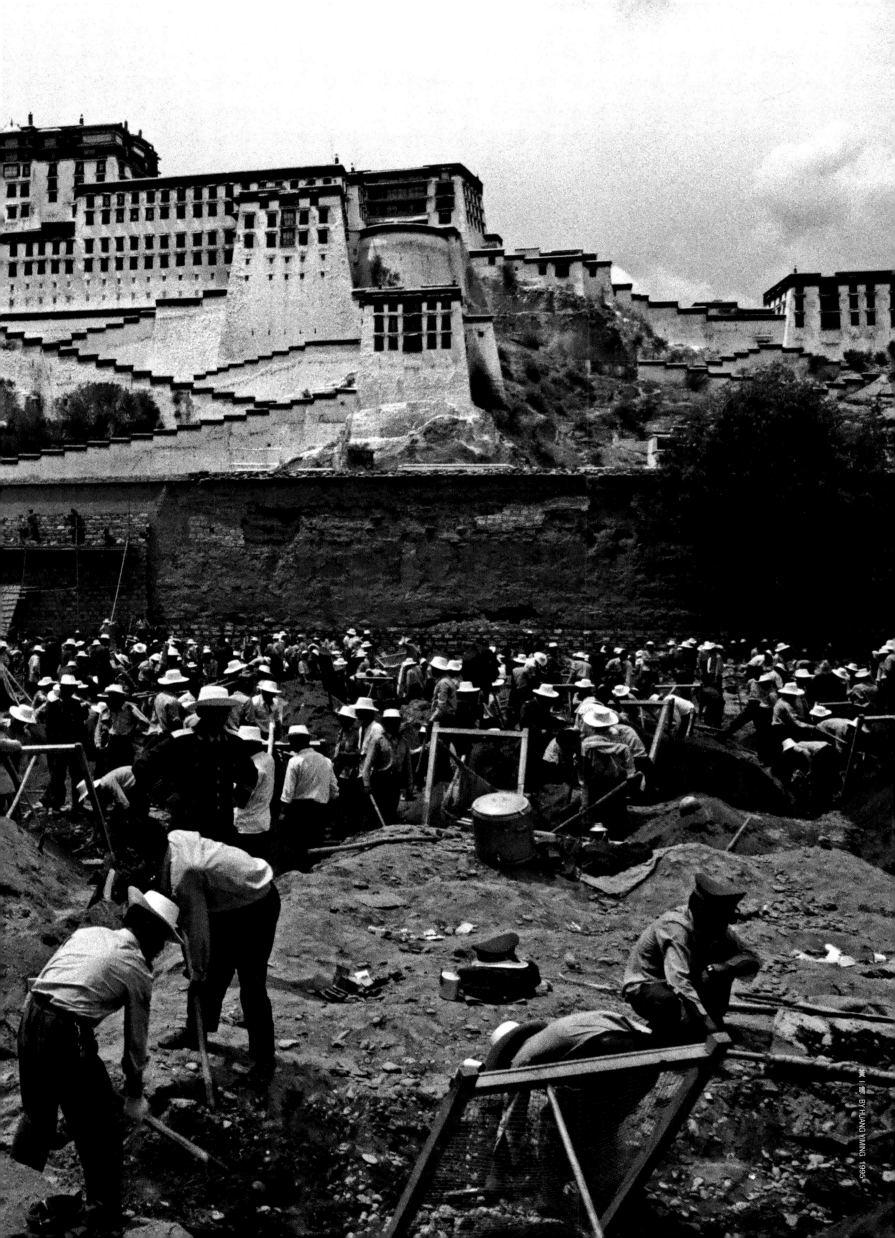

黄 | 鸣 BY HUANG YIMING, 1995

民間收藏熱
Fashionable Relics

　　1990年代以後，民間收藏熱遍全國。作為一種社會文化現象，民間收藏熱的興起，說明精神文化的需求在民間升溫。收藏，既是一種精神享受，同時也是財富聚斂和升值的一種形式。

　　潘家園舊貨市場形成於1992年，是中國最大的古玩和舊貨市場。潘家園市場最初位於一片荒地上，因此得了一個「鬼市」的不雅名稱，其實它是中國最繁榮的舊貨市場之一。愛逛跳蚤市場的人們雲集到這裡，挑選着最新的農村手工藝品，手工製作的西藏美術品，舊時的毛澤東紀念章，或是新近上市的玉器等，現在潘家園舊貨市場是購買、鑒賞古玩舊貨、工藝品、收藏品、裝飾品的絕好去處。

Since the mid-1990s collecting antiques has become hugely popular across China. In 1994, laws restricting the sale or auction of art were relaxed and hawkers operating on the black market became bona fide traders. As people have found themselves with more disposable income, attention has naturally turned from solely putting food on the table to finer pursuits such as home design and collecting *objets d'art*. Beijing is home to Panjiayuan, said to be Asia's largest antiques market. What began as a huddle of hutong-based hawkers now boasts 3,000 stalls. The market is a bargain-hunter's paradise and among the fakes there are many genuine antiques to be found. It offers Buddhist relics, ancient calligraphy and dynastic furniture, as well as literature from the Cultural Revolution. Initially only a weekend market, it is now open seven days a week, indicating the scale of interest in antiques in China. There are also large antiques markets in Shanghai and Guangzhou.

攝影 BY SONG JIHE

◁ **此碗身價逾億元**

世界各大拍賣行把香港作為亞太區的主要拍賣場。這隻清乾隆瓷碗在香港拍賣，以1億5千萬港元天價成交。

An 18th-century bowl sold for 151 million Hong Kong dollars in 2006. The bowl bears the mark of the reign of the Emperor Qianlong (1736-1795) on its base.

▷ **古董攤前淘寶人**

1989年，上海號稱「集藏」半壁江山的古董攤，擺攤、淘寶的人擠得水洩不通。

Collectors in an antique market in Shanghai.

陳 1 年　BY CHEN YINIAN 1989

王文瀾 BY WANG WENLAN 1993

思 想 者

High Culture Prospers

　　文化繁榮是經濟繁榮的映射。中國人創造了偉大的文化，而且根植民間，一旦政治氛圍寬鬆，「文化」就蓬勃生長。文化是交流的產物，對中國人而言，「現代化」是過去200年追求奮鬥的母題。110年前，第一批留學生漂洋過海登陸美利堅；90年前，又一批仁人志士去了法蘭西。現在，歐美人都爭相把他們的好東西搬到中國來，讓中國人看看。100多年前，羅丹雕塑了這尊人像，它在1888年第一次出國展出的時候還叫做《詩人》；1993年，每一個看到他的中國人都知道：他叫《思想者》——當年羅丹在創作他的時候，賦予他的是一首跨文化的詩歌嗎？

　　Not only have people's pockets benefited from the reform and opening policy, but their interest in culture, both domestic and foreign, has exploded too.

攝和 BY YONG HE 1990

「思想者」運抵中國美術館

1993年，法國藝術大師羅丹的著名雕塑《思想者》，首次運抵中國美術館，準備展出。

Auguste Rodin's statue, "The Thinker," is unveiled upon arrival in China for the first time in 1993. It was put on display at the National Art Museum of China in Beijing.

滬老人在茶館消磨時光

1990年，上海青浦一家茶館裡，老年人正在喝茶、聽戲。上海是中國老齡化程度最高的城市。在公園、廣場和茶館，到處可見優哉遊哉、自娛自樂的老人家在消磨時光。

Traditional Chinese Opera was still popular at this busy Shanghai teahouse in 1990.

崔健：新長征路上的搖滾

2008年1月，崔健在北京工人體育館再次唱響「新長征路上的搖滾」。崔健，這位中國搖滾的奠基者，以驚人的活力奔跑在中國搖滾的新長征路上。

Pioneering Chinese musician Cui Jian, known as "the Father of Chinese Rock" performed his signature song "Rock 'n Roll" on the New Long March at Beijing Workers Stadium in January 2008.

譚盾：在音樂廳擺開音樂盛宴

1994年1月，旅美音樂家譚盾在北京音樂廳指揮樂團演奏他自己的作品。

Tan Dun conducted his pieces at the Beijing Concert Hall in January, 1994. Tan, a composer of contemporary music, now lives in the United States.

音樂新潮
Pop Music – A Rocky Road to Freedom

1980年代初，以鄧麗君為代表的港台音樂熱遍內地城市的街坊里巷。到1980年代中期，崔健的搖滾和「西北風」迅速使大陸的原創音樂佔領大眾視聽。當代音樂的迅速成熟是與「開放」共生共榮的。日益密切的東西方文化交流，催生一批具有世界影響力的對歷史、文化和現實的詮釋性音樂作品，也在世界藝術殿堂中留下中國人的腳印。

Chinese popular music these days is pretty much on a par with that of Western countries. A skim across the TV channels is guaranteed to turn up at least one show featuring a troupe of scantily clad teenage girls strutting their stuff to electronic pop music. That said, pop videos remain conservative by Western standards, something possibly more reflective of society's attitudes rather than government controls. A typical Lady Gaga video would undoubtedly cause public outrage.

In China, pop music is said to have been founded by Li Jinhui with a fusion of Chinese folk and European jazz popular in arty 1920s Shanghai. But after the Communist Revolution, pop music was branded "pornography" and political songs dominated. In the 1970s, Cantopop took off in Hong Kong, while Mandopop grew in Taiwan, although the market remained stilted on the mainland. Indeed, the authorities' fear of rebellious youth was illustrated when, as recently as 1995, they banned Hong Kong icon Anita Mui for performing "Bad Girl".

南京路邊舞翩翩

1991年7月，上海南京西路，街頭學習跳交誼舞的市民。

Shanghai people learn ballroom dancing on Nanjing West Road, July 1991.

教頭來自黑非洲

青年人引領時尚潮流，他們大概沒想到，在痛快的玩樂中，充當了中外文化交融的使者。20世紀末，一種嶄新的「街舞」在西安悄然興起。南非人凱利於2001年6月闖入西安，成為西安「街舞」的首任教頭。

A South African instructor teaches the art of hip-hop in Xi'an, June 2001.

維和 BY YONG HE 1991

舞步
Keeping in Step

　　1990年代初期在城市街頭躍動的舞步，有一部分逐漸進入商業化的「健身房」或文化中心。每個城市都出現作為舞蹈教練的「老外」，這說明自發的文化需求的旺盛。與此同時，各種各樣的「秧歌隊」也在街頭帶來許多喧鬧與歡樂。

　　As living standards have improved, Chinese people have started to pay attention to their physical wellbeing, leading to the spread of commercial fitness centers. Additionally, healthy pastimes such as yoga and dancing have taken off in a big way.

踢武功 BY HU WUGONG 2001

江式高 BY JIANG SHIGAO 1994

美國比基尼驚艷中國

1994年9月24日，美國健美隊來中國深圳表演。穿
著暴露的比基尼裝的女子在舞台上狂放跳躍，驚倒
全場觀者。此次極其局限的演出照片拍出之後，竟
然遭到幾乎所有中國大陸報紙的「拒載」。最後作
者只好將這張照片以《USA在中國》為題在《深圳
特區報》發表。

The United States women's bodybuilding team provoked
a boycott by almost every mainland newspaper after their
performance in scanty bikinis in Shenzhen on September
24, 1994.

五色雜陳
A Fusion of Cultures

　　外來文化與本土文化的碰撞，在民間出現了許多令人瞠乎其目的現象。在
商業市場和文化市場管理的中間地帶，香花和異草都在生長。而數以千萬計的
農民進入城市打工，他們的文化需求處於無人滿足的狀況，「異草們」就容易
長得更茂盛。攝影師是注重視覺的，他們拍攝的這些場景，一定會為未來的社
會學家留下可供研究的材料。

　　The collision of foreign and domestic culture since China started opening up to the world has
caught many people's attention. This fusion of both business and cultural markets is giving birth to a
vibrant nation, and the process is captured in these images.

春節廟會上的泳裝女子

1985年，北京地壇公園首屆春節文化廟會。女子身着泳裝表演絕活。

A woman in a bathing suit draws the crowds to a performance at the first Spring Festival Temple Fair in Beijing's Ditan Park in 1985.

農家婚典宴上的迪斯科

2003年正月十六，河南三門峽市靈寶縣陽店一戶農家舉辦婚典，請來鄉村歌舞團大跳現代迪斯科。從古至今，在河南鄉下每遇到婚事、為老人祝壽、辦喪事，都會請老戲班子演豫劇、皮影戲、木偶劇；1980年之後，開始放電影。2000年前後，文化更加開放，一切與世界接軌，迪斯科、艷舞也進入曾經純樸的農家慶典中。

A dance troupe breaks with tradition by entertaining a wedding party with a disco performance in a rural area in Henan Province in 2003.

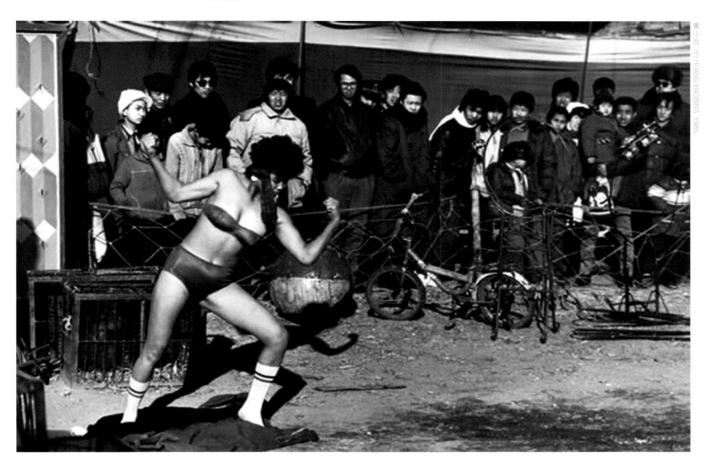

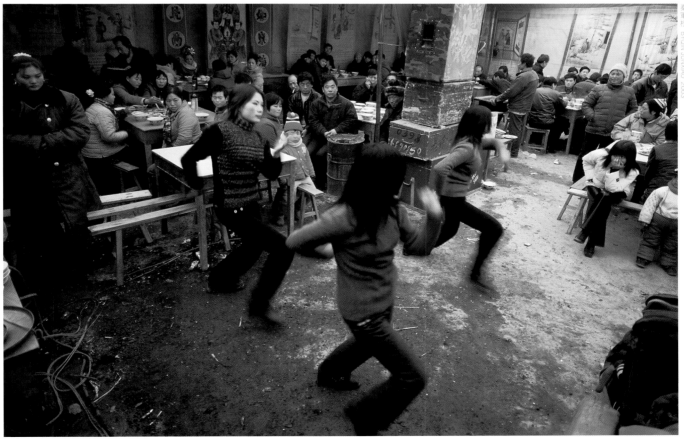

193

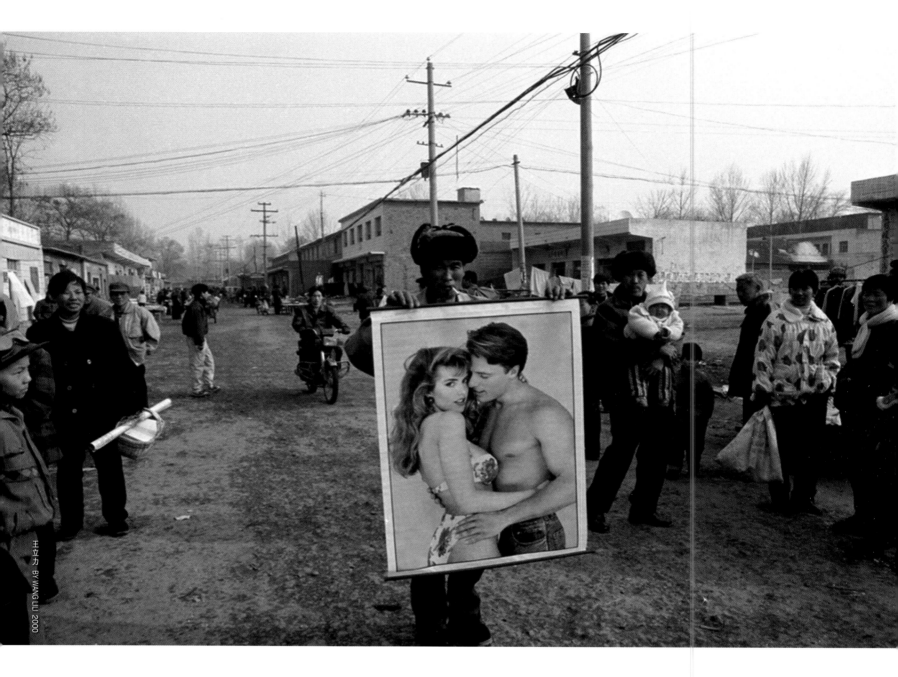

王立力 BY WANG LILI 2000

小販展示新潮畫

2000年2月3日，河南省伊川縣白沙鄉。春節前的年貨市場上，一位小販在向行人展示新潮年畫。

A hawker tries to sell a Western poster on a rural street in Henan Province in 2000.

書 · 畫
Brightening Up the Place

　　中國北方的鄉鎮居民家裡，多愛掛一些色彩鮮艷的圖畫。從色彩、環境、心理上分析，這或許由於中國人以黃皮膚為種，以黃土為地，因而生活中需要一些鮮艷的補色。攝影師們總是敏銳地捕捉到那些細節：老百姓把哪些畫掛到自己的家裡，會在無意間流露出他們本能的生活旨趣，這種旨趣不但是傳統的繼承，也是時尚的符號。開放帶來的「多元」文化，還有甚麼比民間的這些變化更能證明的呢？

　　In order to bring light and color into their lives, peasants in arid northern China have a tradition of decorating their homes with bright paintings and artwork. The contrast of hues and images against the bleak backdrop of northern winters are a photographers delighted.

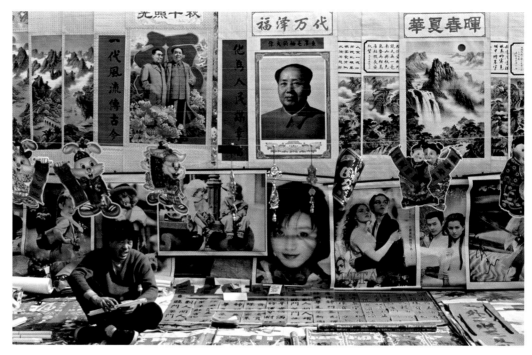

家家戶戶買年畫

鄉村過年，家家戶戶都會買對聯、爆竹和年畫。有人在家裡掛起年畫：堂屋貼領袖畫像，大門口貼張飛、關羽畫像。而男女青年，則在臥室四周牆上張貼自己崇拜的歌星、影星和美人圖像——張張畫像，給家家戶戶增添了節日氣氛。

Pop idols and movie stars join more traditional images in decorations to celebrate the Chinese Lunar New Year, or Spring Festival.

盜版書盛行

1991年，海南賣盜版書的青年。上世紀90年代盜版書橫行，海南的書販子在公共場所公開銷售盜版書，真可謂一本萬利。

A young man selling pirated books on the street in Hainan Province in 1991. The piracy of books and other publications ran rampant and became a lucrative trade in the 1990s.

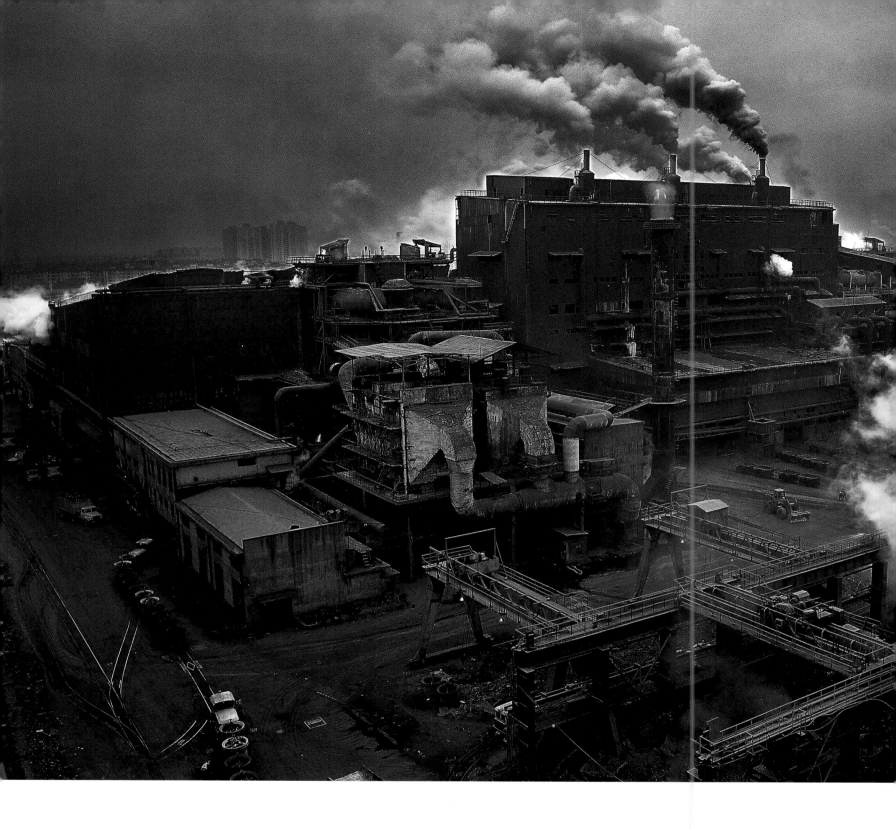

國有企業
State-Owned Enterprises

　　國有企業的改革，是1990年代中國改革的重中之重。當年圍繞着國企改革的許多爭論，如今大體上已經煙消雲散。「轉制」、「抓大放小」……中國國企改革既是智慧的也是堅定的。與其他體制轉換國家在轉軌中發生的陣痛相比，中國的國企改革無疑成功而且平和。考慮到這個制度的意識形態和理論基礎原是依靠和弘揚「產業工人」的，我們就該意識到：這場國企改革不啻於一場革命。今天，167家大型國企依然控制着國家的經濟命脈，而數以萬計的中小企業繼續保有着活力。不容易！

Following the 1949 Communist Revolution, all business entities in China were brought under government control and ownership. It was only in the late 1980s, that the government began to reform state-owned enterprises. During the 1990s and 2000s, many mid-sized and small-sized state-owned enterprises were privatized and went public. In recent years, state-owned enterprises are increasingly being replaced by listed companies. China's economy, howeve, is still dominated by 167 large state-owned enterprises.

上海鋼鐵三廠

黃浦江畔的上海第三鋼鐵廠，在九十年代還是上海重要的鋼鐵生產基地，但因嚴重的污染等問題已搬遷。

During the 1990s, the No. 3 Iron and Steel Works were Shanghai's main production base, but as a result of serious pollution of the Huangpu River and other problems the operation was moved.

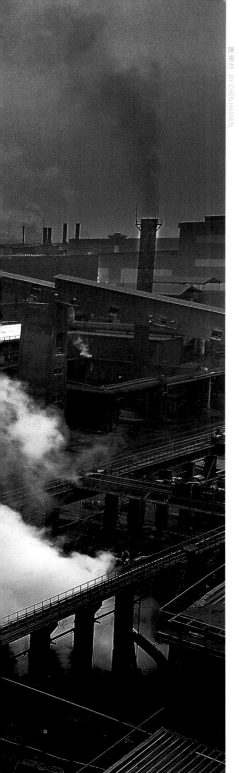

陳每文 BY CHEN HAIWEN

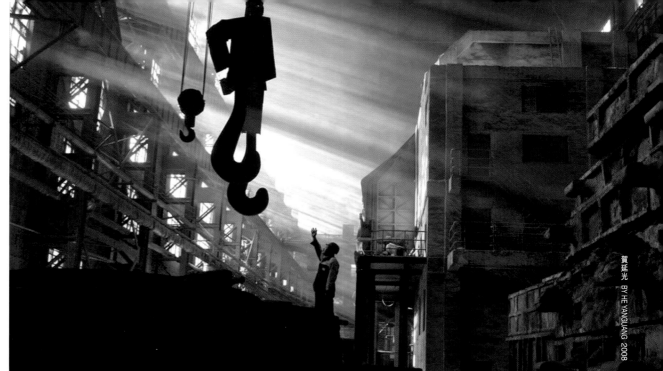

賀延光 BY HE YANGUANG 2008

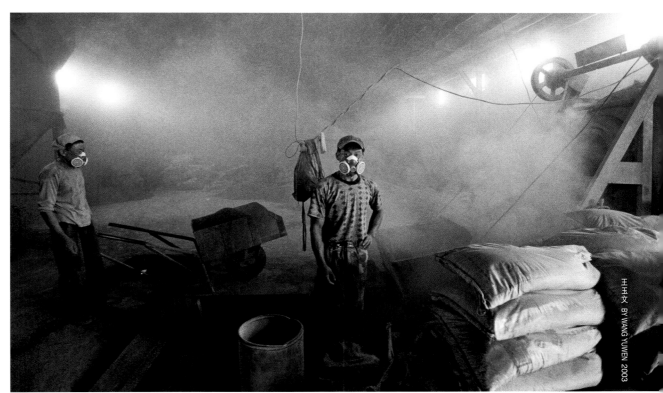

王禹文 BY WANG YUWEN 2003

△ 瀋陽老工業

一位工人正在指揮吊車作業。瀋陽重工的鑄鋼產業公司
有近80年的歷史，不久， 該廠即將遷入瀋陽鐵西區的
新廠區。5 年來，遼寧對老企業重新進行調整和改造，
加快了振興老工業基地的步伐。

A worker from Shenzhong Group, which has a history of over 80
years, directing a crane operation, in September 2008. Liaoning
Province began to implement the policy for revitalizing industry five
years before, and had already made a lot of progress.

▽ 傳統工藝造成粉塵污染

遼寧海城一家鎂礦，正在用傳統工藝對鎂粉進行深加工。

Workers from a magnesium mine in Haicheng, Liaoning Province,
using traditional methods for processing magnesium powder.

197

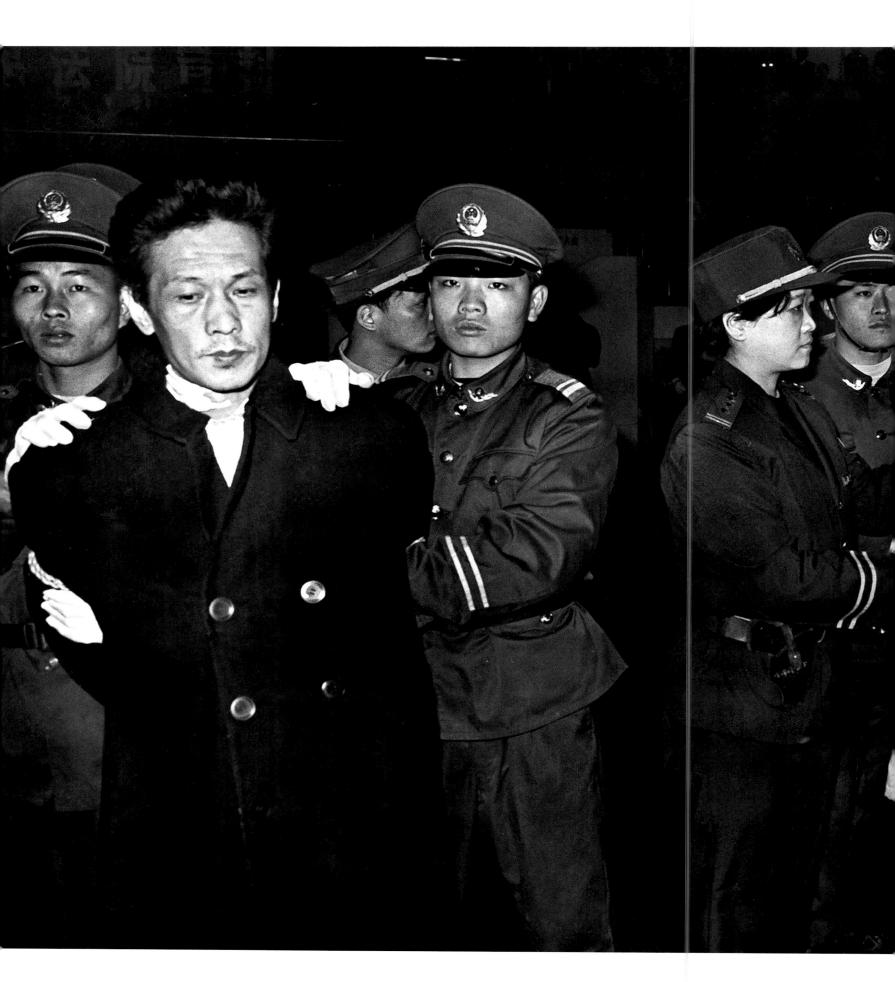

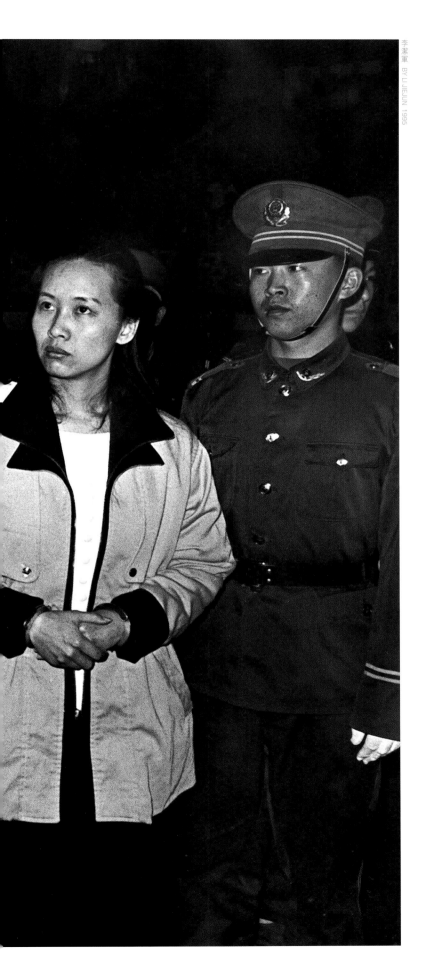

李潔軍 BY LI JIEJUN 1995

腐敗滋生
Corruption – Crackdowns and Supervision

　　腐敗滋生是貫穿經濟發展整個過程的突出現象。除了與個人操守相關，這一社會毒瘤亦是有時代特徵的。1980年代，腐敗多利用價格雙軌制中的空隙；1990年代，腐敗則在地產、金融等大宗資源的非法獲得中滋生。毫無疑問，多數腐敗現象總是與權力和利用權力尋租有關，是以權錢交易為主要方式的。1990年代，執政黨就已經把反腐敗鬥爭提升到「黨的生死攸關」高度上來了。

　　If one thing scares the Communist Party more than anything, it's growing public anger over official corruption. While the central authorities have launched various initiatives to reduce the problem, such as watchdogs, anonymous reporting hotlines and crackdowns, an ever-confident body of Internet users is taking government supervision to a whole new level. Photographs of officials smoking expensive cigarettes and wearing luxury watches have appeared on the Internet, leading to the high-profile downfalls of a number of Communist Party cadres. The courts have also made a number of examples, handing down the death penalty to corrupt Party members. The most notable case was Zheng Xiaoyu, Director of the State Food and Drug Administration, who was executed in 2007 for corruption.

王建業被判死刑

1995年12月28日上午，在深圳體育館召開的宣判大會上，原深圳市計劃局財貿計劃處處長王建業（左）被判處死刑。圖為王建業與其同案犯史燕青一起接受審判。在這起案件中，兩人同謀受賄、貪污1,300餘萬元人民幣，是當時深圳經濟特區最大的貪污受賄案。

Former Section Chief of the Shenzhen Planning Department Wang Jianye (left) stands impassively as he is sentenced to death for corruption (amounting to 13 million yuan siphoned from businesses in the city). The sentence was passed and carried out on December 28, 1995. Wang's mistress, Shi Yanqing, (second from right) was given a suspended death sentence for her part in the scandal. It was the biggest-ever corruption case in Shenzhen Special Economic Zone at the time.

環境惡化
Choking on Growth

　　經濟成長與環境惡化，是幾十年來始終困擾着中國官員和百姓的問題。1990年代，環境的急劇惡化越來越成為人們無法迴避的現實。這既是因為資源消耗的增加，因為環境管理的無序，也因為各級官員們急於提升GDP的短視和盲動。還有一種環境惡化是與文化市場的混亂相關的，大量盜版的低劣文化產品充斥市場，既迷亂人們視聽，也攪亂管理環境。環境整治與環境破壞，一直是經濟發展過程中的一條副線。

One of the serious negative consequences of China's rapid industrial development has been increased pollution, smog and degradation of natural resources. Much solid waste is not properly disposed of, and water pollution is a source of health problems across the country. China's polluted environment is largely a result of the country's large increase in primary energy consumption and lack of regulation on environmental protection.

王福春 BY WANG FUCHUN 2000

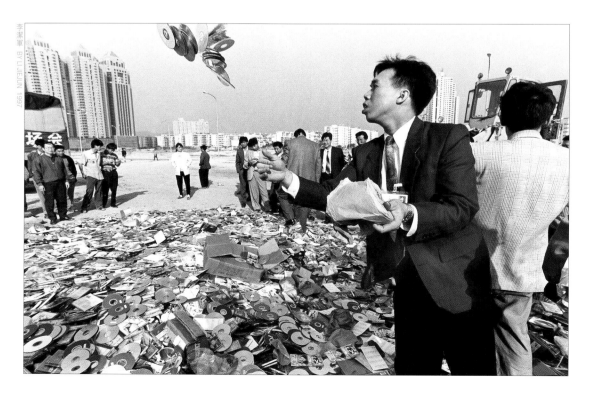

李潔軍 BY LI JIEJUN 1997

銷毀盜版光碟

近年來，每當世界知識產權日（4月26日）前後，中國各地的警方都會有打擊銷毀盜版光碟的行動，其中當以廣東地區為甚。圖為1997年3月，深圳黃田警方採取集中打擊行動，銷毀盜版光碟。

Police in Shenzhen carry out one of the regular public disposals of pirated CDs in March 1997. Such displays were common around World Intellectual Property Rights Day, which falls every April 26.

白色垃圾泛濫

中國是世界上十大塑膠製品生產和消費國之一。1995年，全國塑膠消費總量約1,100萬噸，其中包裝用塑膠達211萬噸。包裝用塑膠的大部分以廢舊薄膜、塑膠袋和泡沫塑料食具的形式，被丟棄在環境中。圖為2000年，哈爾濱一列客車通過某站台，滿地滿樹掛滿白色垃圾。

Discarded plastic bags and other garbage blot out the scenery by a train track near Harbin, Heilongjiang Province, 2000.

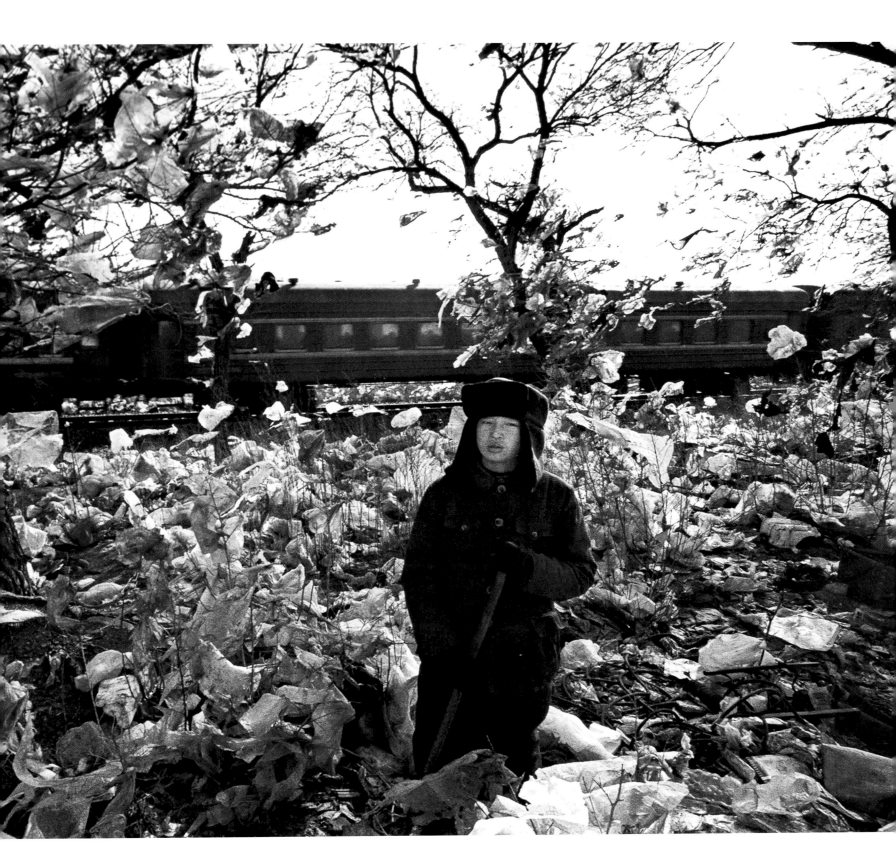

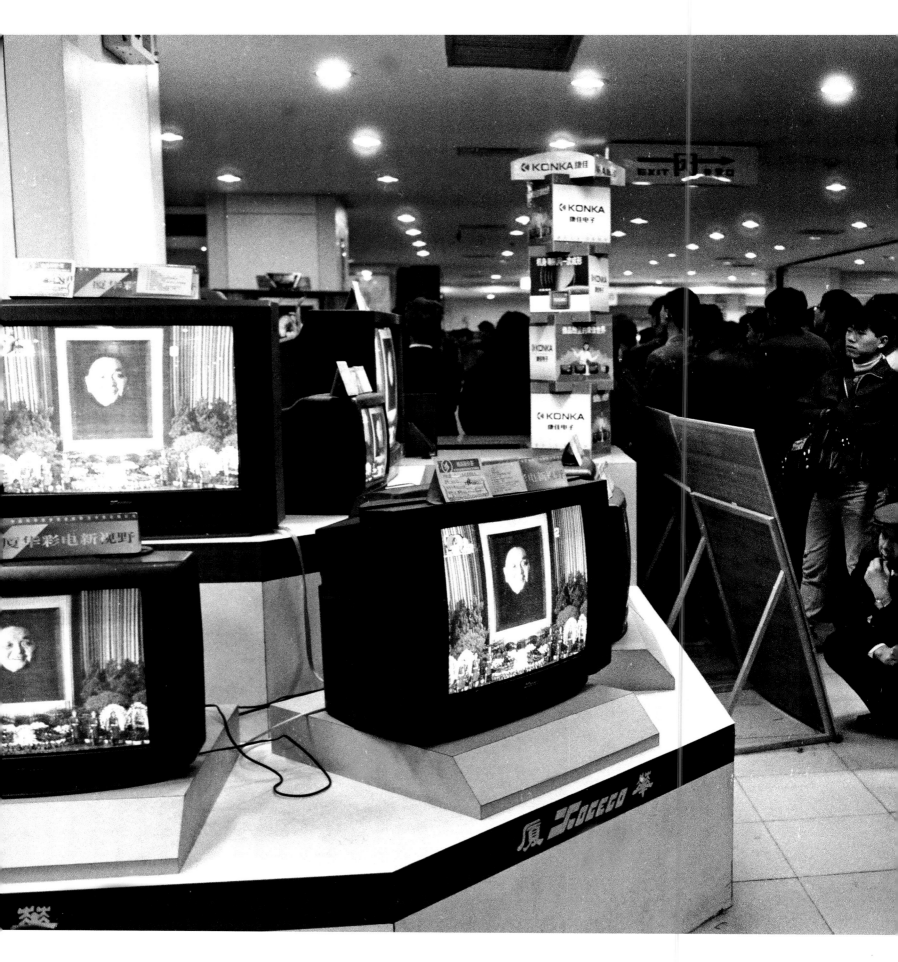

胡武功 BY HU WUGONG 1997

鄧小平逝世

Deng Xiaoping, the Architect of Prosperity

不同於1976年的時候，1997年「總設計師」鄧小平的去世，並沒有給國家帶來太大的震動。沒有懸念，人們對國家的未來發展和經濟的走勢也沒有不安與疑慮——這個國家的道路已經鋪墊好了，無人可以移易。鄧小平走的時候已經是一位卸去其所有職務的普通老人，這或許是鄧公於他的國家的最大貢獻。於是，人們的關切和悲痛是由衷的。

Deng Xiaoping is the man who set China on its present course, lifting hundreds of millions out of poverty. He is the bold reformer who led China toward market economics, serving as paramount leader of the People's Republic of China from 1978 to the early 1990s. Born into a farming family in Sichuan, Deng studied and worked in France in the 1920s, where he became a follower of Marxism. He joined the Communist Party in 1923. Upon his return he worked as a political commissar in rural regions and was a "revolutionary veteran" of the Long March. Later, Deng's economic policies proved to be at odds with Mao Zedong's political ideologies and as a result, he was purged twice during the Cultural Revolution. He regained prominence in 1978, outmaneuvering Mao's chosen successor, Hua Guofeng. Inheriting a country plagued with problems following the Cultural Revolution, as well as other political campaigns from the Mao era, Deng became the core of the "second generation" of Chinese leadership. He is called "the architect" of a new brand of socialist thinking, for developing "socialism with Chinese characteristics", and creating the "socialist market economy". Deng opened China to foreign investment, the global market, and limited private competition. He died on February 19, 1997.

鄧小平逝世

1997年2月19日，鄧小平逝世。2月25日，在北京人民大會堂舉行追悼會。這期間國人反應十分平靜，人們的日常生活沒有受到任何影響。圖為西安市民在商場櫃檯的電視樣機前收看追悼會的情景。

People in a Xi'an department store watch the memorial service, for Deng Xiaoping, which was broadcast live from the Great Hall of the People in Beijing.

香港回歸
Hong Kong is Returned

300年前，英國東印度公司開始進入中英兩國的海運，爾後因為英國的嚴重貿易逆差向中國傾銷鴉片。以後，英國人一直試圖在中國附近尋找一個地點作為駐地以便交易，終於在兩次鴉片戰爭中國戰敗以後，英國人的目的實現了。1842～1898年期間，清政府在英國的武力威逼下，先後3次與英國簽訂不平等條約，分別割讓香港島、九龍半島及租借新界（包括新九龍）給予英國，成為英國殖民地。1997年7月，香港回歸祖國，這是一個標誌，不但標誌着香港作為殖民地的歷史的結束，還標誌着中國不但作為一個大國而且作為一個強國的崛起。

While the rest of China experienced a Communist Revolution, Hong Kong (and Macau) embraced the capitalist model of development as one of the last outposts of the declining British Empire. Hong Kong, meaning "Fragrant Port" in Chinese, became a crown colony of the United Kingdom under the Treaty of Nanking in 1842. It was re-designated a dependent British territory in 1983 until sovereignty was returned to China in 1997.

香港回歸，彭去董來

1997年，黃昏，前港督府門外。時任港督彭定康與香港特區候任行政長官董建華，在跟各方媒體記者簡短見面後，彭定康低頭轉身離去，而董建華則笑容滿面地向記者揮手。

Former Governor of Hong Kong, Chris Patten, turns to go as Tung Chee-hwa steps up to take over as Chief Executive of the new special administrative region in 1997.

「米字旗」降落

1997年6月30日，彭定康在雨中接過降下的英國國旗和港督旗。

Chris Patten takes receipt of the British flag after it comes down for the final time in Hong Kong on July 1, 1997.

在地鐵上看「回歸」

1997年7月1日，回歸了，香港市民在第一時間翻看特區政府成立所出版的報紙。

Hong Kong commuters read a newspaper published by the new government after the territory's return to Chinese administration.

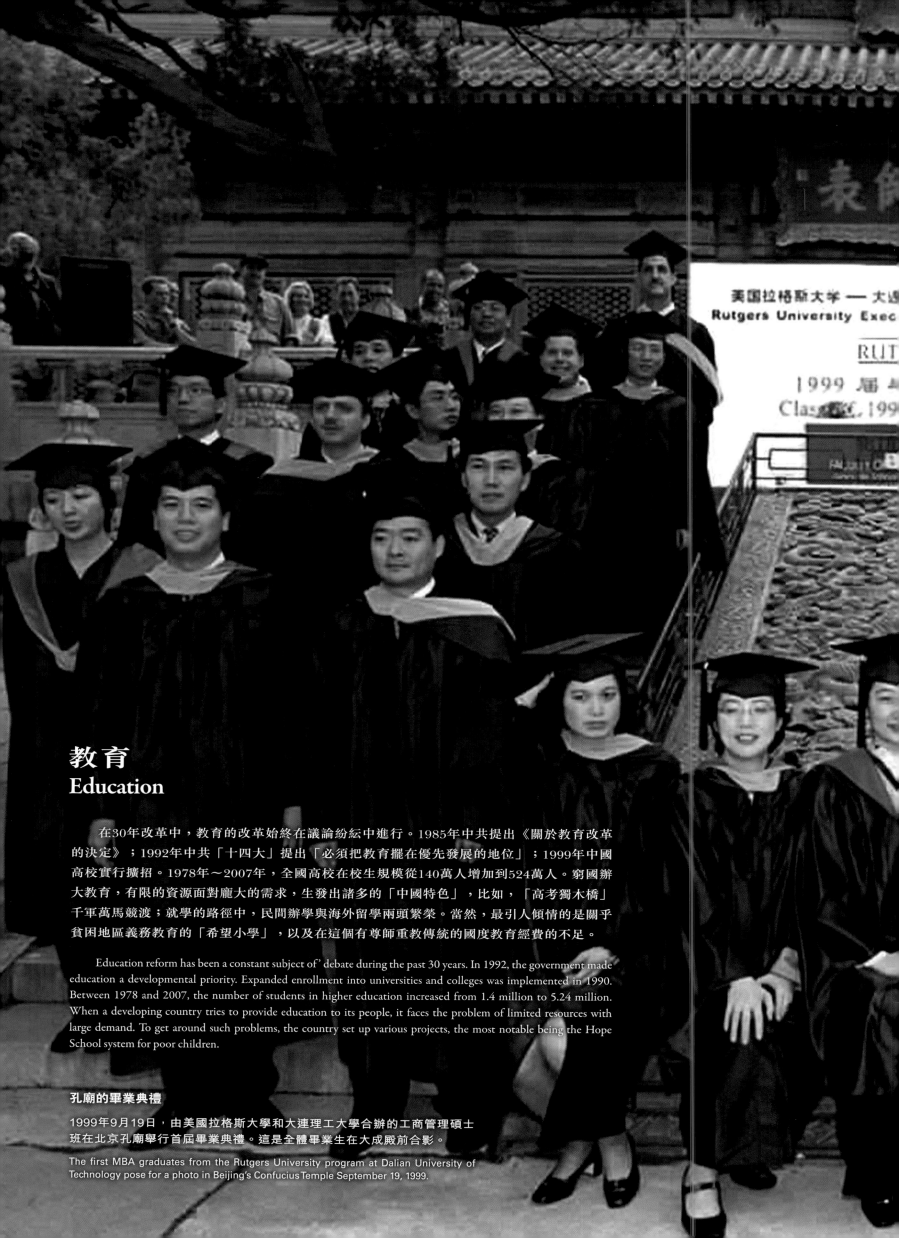

教育
Education

　　在30年改革中，教育的改革始終在議論紛紜中進行。1985年中共提出《關於教育改革的決定》；1992年中共「十四大」提出「必須把教育擺在優先發展的地位」；1999年中國高校實行擴招。1978年～2007年，全國高校在校生規模從140萬人增加到524萬人。窮國辦大教育，有限的資源面對龐大的需求，生發出諸多的「中國特色」，比如，「高考獨木橋」千軍萬馬競渡；就學的路徑中，民間辦學與海外留學兩頭繁榮。當然，最引人傾情的是關乎貧困地區義務教育的「希望小學」，以及在這個有尊師重教傳統的國度教育經費的不足。

Education reform has been a constant subject of' debate during the past 30 years. In 1992, the government made education a developmental priority. Expanded enrollment into universities and colleges was implemented in 1990. Between 1978 and 2007, the number of students in higher education increased from 1.4 million to 5.24 million. When a developing country tries to provide education to its people, it faces the problem of limited resources with large demand. To get around such problems, the country set up various projects, the most notable being the Hope School system for poor children.

孔廟的畢業典禮

1999年9月19日，由美國拉格斯大學和大連理工大學合辦的工商管理碩士班在北京孔廟舉行首屆畢業典禮。這是全體畢業生在大成殿前合影。

The first MBA graduates from the Rutgers University program at Dalian University of Technology pose for a photo in Beijing's Confucius Temple September 19, 1999.

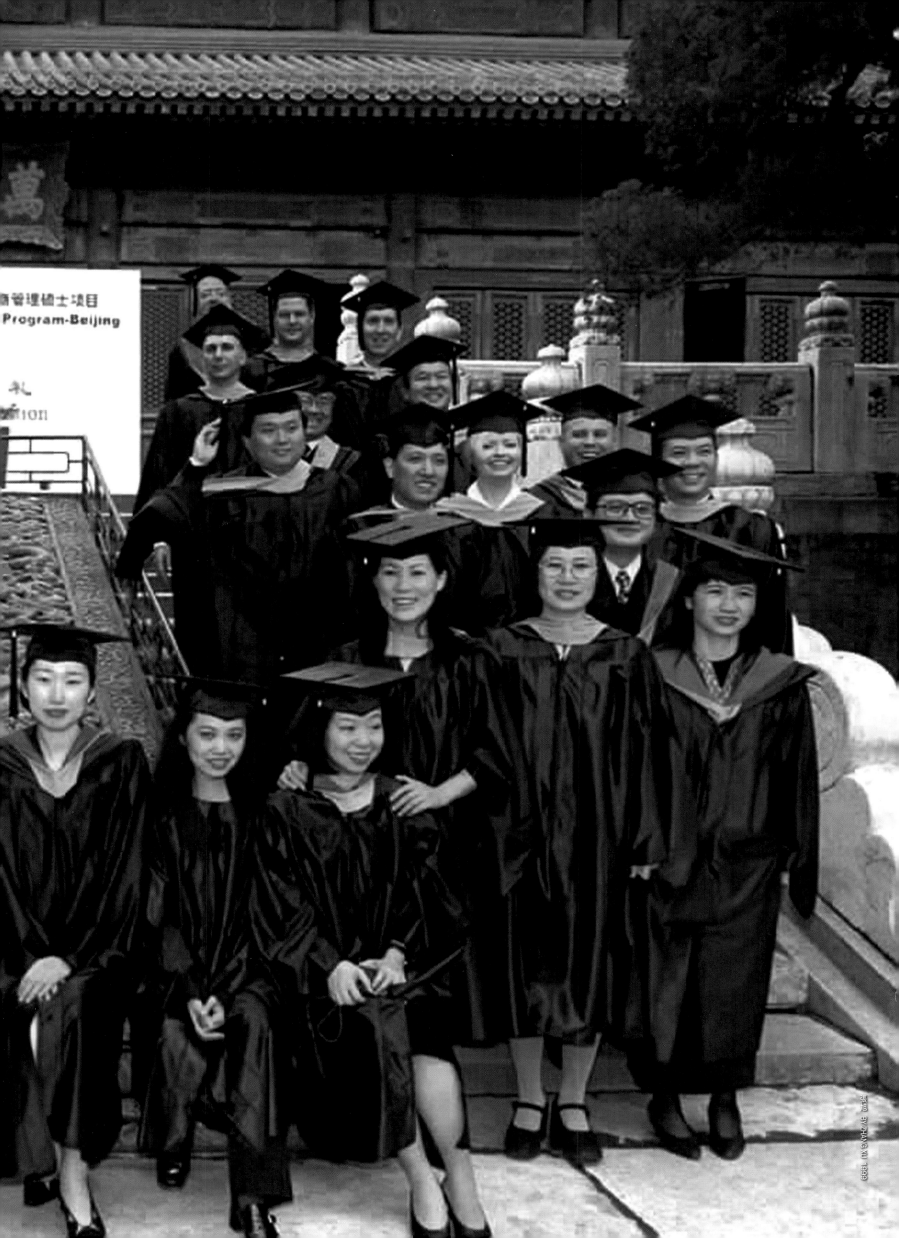

開張
Grand Opening

　　每一家店舖的開張都是商業洪流中掀起的一簇浪花；每一次開張也都是一次商業機會，吸引着三教九流各色人等分享。中國有重農抑商輕視商業的文化傳統，歷千年而未經稍變。而至1980年代，有「老大（工人）靠了邊；老二（農民）分了田；不三不四掙大錢」之民間俗語。1990年代民間拜年時多祝「恭喜發財」，始而不適，繼而風行——世風日變。

China's reform and opening has led to an explosion of private business. And the development of these establishments has been nudged along by the influx of foreign culture and investment, which has led to a greater awareness of the concept of service.

胡武功 BY HU WUGONG 2005

雍和 BY YONG HE 1990

禮儀公司應運而生

奠基、開工、落成、慶祝，都要舉行剪綵儀式，於是各種各樣的禮儀公司應運而生。禮儀小姐的培訓任務更是十分繁重，常常為幾分鐘的剪綵活動，需要幾天的培訓和演練。圖為西安一家禮儀公司在綵排。

Event hostesses receive training in 2005.

外資酒店隆重開業

1990年6月，上海靜安區，美國人投資的波特曼酒店舉行開業酒會。改革開放後，上海大力發展第三產業，各種經濟成分和旅館日益增多，1980年代末，涉外賓館接連開業，到1992年，上海旅遊涉外飯店有94家，可接待賓客4萬餘人。

Shanghai's Portman Hotel holds a grand opening party in 1990. The 50-story hotel on Nanjing Road was built with U.S. investment.

就業
Working on Unemployment – A Big Job for China

　　1990年代是中國新增就業人口的高峰，在龐大的人口基數下，每年有1,000萬人的新增就業需求，此外還有1,200萬農村人口向城市轉移的壓力。正當此時，國有企業改革所分流的一大批下崗職工也有待安置，這也是中國經濟發展的持久性陣痛之一。「與民生計」是社會安定、經濟成長的前提，除了國民經濟發展吸納了大批就業，通過產業結構調整，尤其是沿海外向型工業帶來的勞動密集型企業的成長，使得就業壓力得以部分緩解。

　　Among China's population of more than 1.3 billion, 9 percent of the eligible workforce is out of work, according to government figures. But this is still a success story — for most of the 1980s and 90s unemployment went into double-digit territory. Things have improved vastly compared to the days of the planned economy when the incentive to work was low. Following years of looking at the experiences of other nations, the Chinese government has introduced various policies to get people doing their bit for the economy. As a result of the global financial crisis in 2009, 20 million rural migrant workers, or more than 15 percent of the migrant workforce, were unemployed, while 4.6 percent of the urban workforce was out of work.

停業工廠發生活補助

1998年，四川省成都市歇業工廠通知職工回來領取生活補助。

1998 Chengdu, Sichuan, A factory out of business notifying its employees of life allowance.

招工現場人潮洶湧

深圳特區開埠之時，幾乎每天都有從中國大陸各地來的學生、工人、農民、教師、技術人員、退伍軍人，甚至一些企業的職員、政府機關的公務員來深圳尋找職業。圖為2000年福田工業區的某企業招工現場。

Women rushing a window with their residency registration and identification documents in the hopes of getting a job at a factory in Shenzhen in 2000. The city was a magnet for people seeking work from all over China.

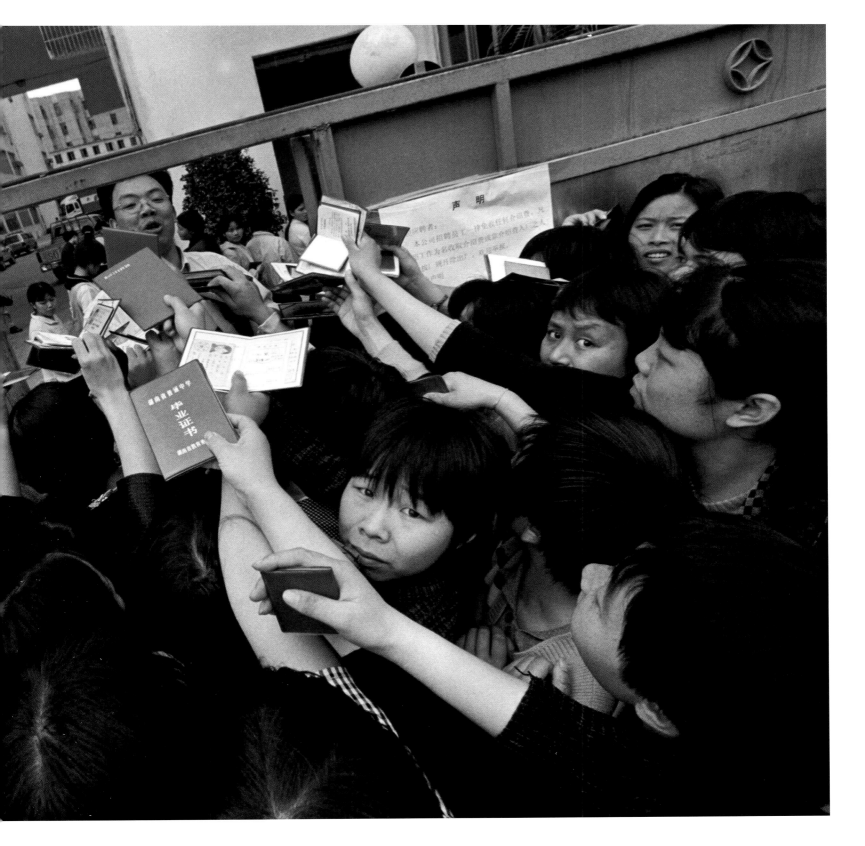

涉外
Foreign Affairs

　　1970年代以前，有港澳關係或海外關係是一件帶來疑惑及麻煩的事，因為國家在敵對勢力包圍中，對外封閉對內警惕。由「開放」所帶來的不適與適，應歷經整個的1980年代。在新一輪經濟大潮中，由於引進外資、鼓勵外銷的拉動，海外關係成為一種資源。對於一個長期閉關鎖國的國家來說，民眾由衷地把眼睛望向國外，把手伸向「老外」，證明「開放」國策已深入人心，民眾也空前自信。

　　In a closed China, people looked at those on the outside including Hong Kong and Taiwan as enemies. But as reform and opening took hold, and with China's entry to the World Trade Organization, the country embarked on an unprecedented exchange with the rest of the world. Since then, Chinese people have become more open hospitable and welcoming to people from other cultures.

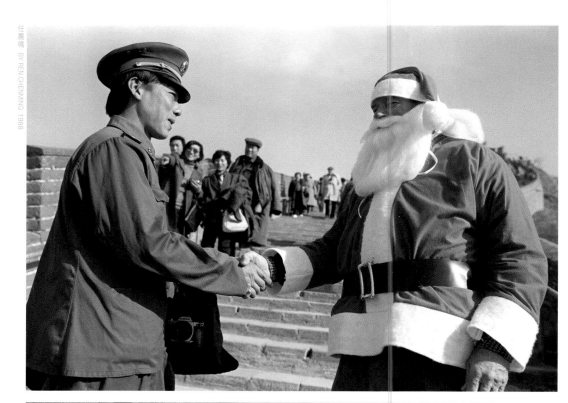

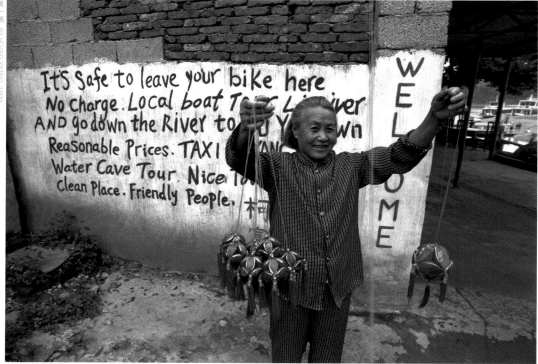

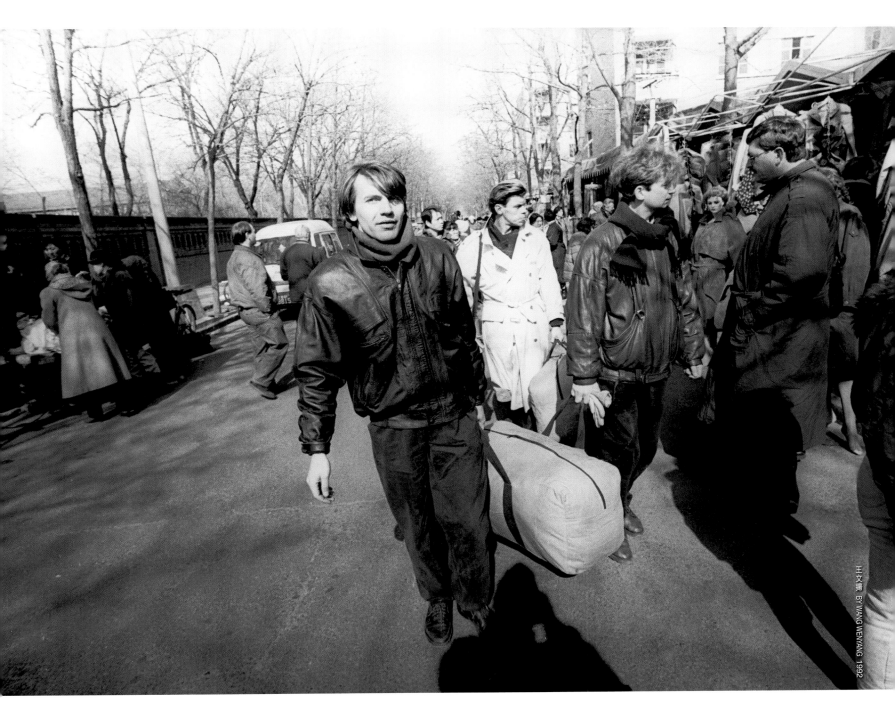

王文揚 BY WANG WENYANG 1992

「洋倒爺」在秀水街

1992年3月，北京秀水街。90年代初期，北京秀水街成了許多外國個體經營者的購物批發市場，他們將在中國採購的大批貨物運回本國販賣，因而北京人都叫他們「洋倒爺」。

Xiushui Street in Beijing in March 1992. In the early 1990s, Xiushui Street become a trade market for foreign individual merchants to purchase Chinese goods.

聖誕老人與中國士兵

1988年，66歲的美國人戴維森來中國旅遊。他扮做聖誕老人，在北京八達嶺長城上與解放軍士兵互致問候。

A Santa Claus from the United States shakes hands with a soldier of the People's Liberation Army on the Great Wall at Badaling, Beijing, in 1988.

家門口就有好生意

在廣西桂林的許多旅遊景區，當地居民在家門口就可以和遊客做生意，並且在自家的門庭圍牆上用英語寫上廣告。圖為1999年當地一家農婦在自家門前招攬生意。

A woman sells crafts outside her home in the scenic city of Guilin in 1999.

攝和 BY YONG HE 1999

財富年會
Fortune Global Forum

　　一家著名的美國雜誌把它的會議放到中國來舉行，這事情已經具有象徵意義。這個會議的議題居然是《中國——未來的50年》，而且引得中國國家首腦出席，這就非同一般了！過去30年來，中國對外關係中最重要的關係就是中美關係，經過1980年代的相依相近，1990年代後多有波折危機。中美關係有一點像猴皮筋，一會兒拉緊一會兒放鬆，那隻作用力量的「手」，就是開這個會的雜誌的名稱——「財富」；之所以這根皮筋誰也不會放下，就是因為畫面上富豪們討論的主題——《中國——未來的50年》。所以，這個會還會開下去。

In a sure sign of the world's confidence in China as a leading business player, the Fortune Global Forum has been staged three times in the country – Shanghai (1999), Hong Kong (2001) and Beijing (2005). The event brings together the leaders of global business including chairmen, presidents and CEOs of the world's largest companies. At the Beijing summit, Premier Wen Jiabao promised businessmen and women that China would remain a profitable place to do business for the foreseeable future. The event, with the theme of "China and the New Asian Century", wrapped up with talk of a fourth Forum in China, such was its success. It also illustrated how quickly China had integrated into the world trade system, as the Shanghai summit spent much time discussing how the country would enter the World Trade Organization.

財富論壇

1999年9月27日，美國《財富雜誌》年會在上海浦東舉行，60多位「世界500強企業」總裁和300多位跨國公司CEO蒞會，論壇的題目就叫《中國——未來的50年》。

Presidents from more than 60 of the Fortune 500 enterprises and 300 chief executives of transnational corporations including Sumner Redstone second from right, the Chaiman and CEO of Viacom International, Inc. participated in the 1999 Fortune Global Forum in Shanghai, hosted by *Fortune Magazine*.

攝影 BY QIAN HAN, 1999

澳門回歸
Macau, Gambling on a Booming Economy

1999年澳門回歸的時候,有一首歌沁透人心——
你可知Macau不是我的真名姓?
我離開你的襁褓太久了,母親!
但是他們擄去的是我的肉體,
你依然保管着我內心的靈魂。
三百年來夢寐不忘的生母啊!
請叫兒的乳名,叫我一聲「澳門」!
母親!我要回來,母親!

這首題為《七子之歌》的歌詞由聞一多先生1925年作於紐約。到20世紀末,這「七子」裡的澳門、香港、台灣、威海衛、廣州灣(湛江)、九龍、大連、旅順,全部屬於中國!

The first and last European colony in China – Macau, or Macao – was returned to PRC sovereignty in 1999. The city sits on the western banks of the Pearl River Delta opposite Hong Kong. Like Hong Kong, she falls under the "one country, two systems" policy and thus enjoys a high degree of autonomy. While gambling remains illegal on the Chinese mainland, it is anything but in Macau, which is said to be the highest volume gambling center in the world. The industry makes a major contribution to the city's tourism-reliant economy, alongside textile exports. Now officially called the "Macau Special Administrative Region", Macau was first settled by Portuguese traders in the 16th century. The Sino-Portuguese Joint Declaration and the Basic Law of Macau stipulate that Macau will operate with a high degree of autonomy until at least 2049, 50 years after the transfer. Macau is the highest density city in the world at more than 18,400 people per square kilometer. Although more than 95 percent of the city's population is ethnic Chinese, there remains a strong Portuguese community as well as many people of Portuguese – Chinese mixed descent, known as the Macanese ethnic group.

澳門民眾慶回歸

1999年12月20日0時,中葡兩國政府舉行澳門政權交接儀式,中華人民共和國正式恢復對澳門行使主權,澳門結束了葡萄牙政府百多年的統治。圖為澳門民眾歡慶回歸祖國。

Macau people on December 20, 1999, celebrating the handover of the territory to China after more than a century of rule by Portugal.

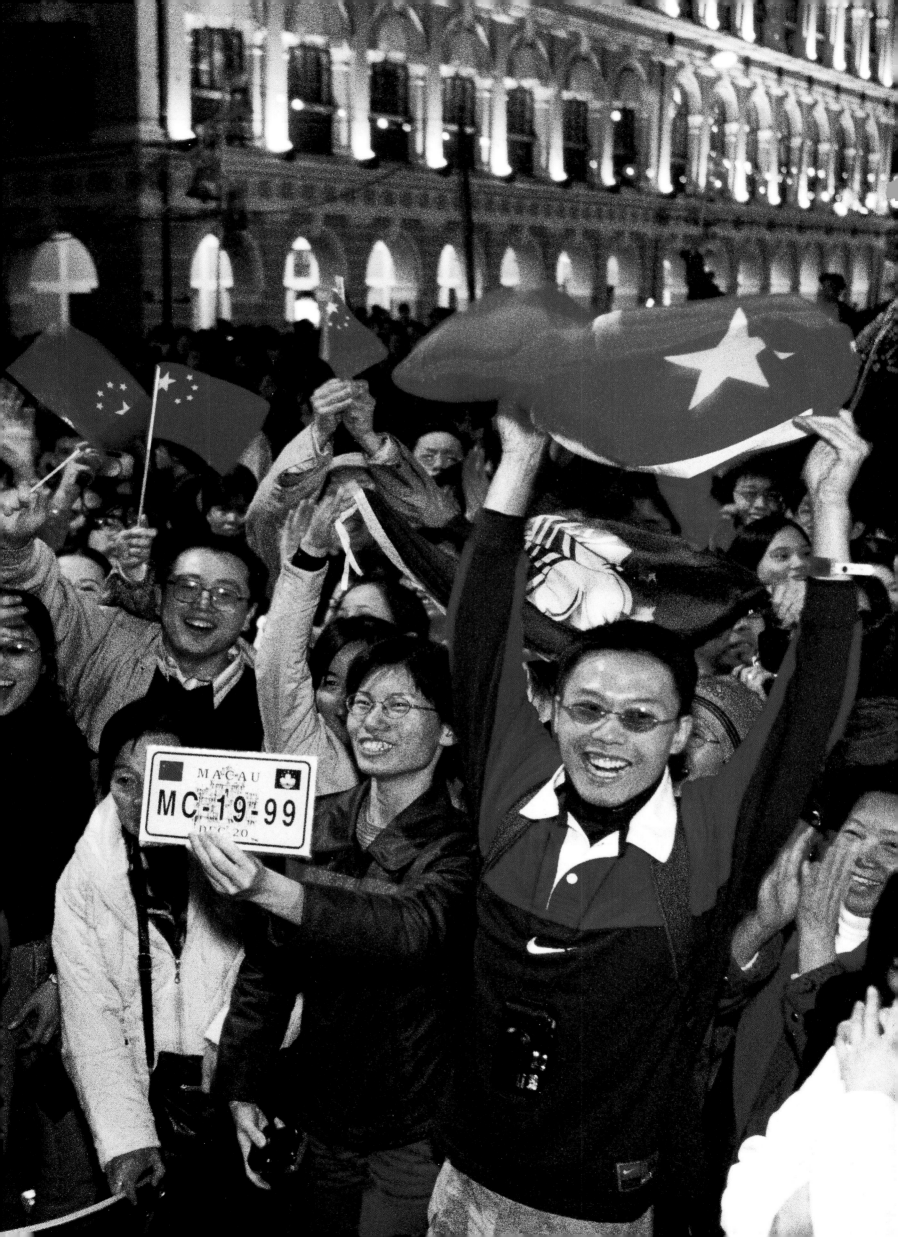

2000～2008

戊子

年

2008年歲在戊子。按四千年前中國人天干地支的理論，戊屬陽土，子屬陽水，流年土剋水。年初就有人演繹，主剛柔不濟，經濟蹇促，旺而見危。

你可以信或者不信這種很古老高深的理論，不過逢「戊」必「旺」，「旺」而萌動，真似乎是中國運數的一個十年規律。1998年，歲在戊寅，這一年開年就是各地「開發區」發展的峰年，也是房地產業啟動的年頭，開年的中央財政報告完成了上年計劃的百分之一百零二，預算收入增長百分之十六，1990年代初期的緊縮局面全面緩解。1988年，歲在戊辰，這一年是全民辦公司的大潮，是物價闖關的臨口，也是熱議黨政分開，政體改革的時候。再30年前的戊午，則陽干逢陽支，按干支，兆大旺，三千年未有之大變局由是興起。

至少在近百年的當代史裡，每當戊年，總是要孕育或發生些大事情。戊戌（1898年）變法是不必舉了；1928年（戊辰）的井岡山，1938年（戊寅）的抗戰，1948年（戊子）中國命運選擇，乃至1958、1968年發生的事情，我們都念茲在茲了。這樣眺望下去，2018年（戊戌），2028年（戊申）還會發生甚麼，今天的我們不很知道。知道的是，在建國100年時「實現中華民族的偉大歷史復興」，所以那一定是在建成現代化的社會主義強國的通路上。

30年是一個「甲子」即一個干支循環的一半。在絕大多數計量單位都以百進制的同時，有關時間和空間的計量，比如經緯度卻都是60進制的，這不應該是一個偶然！回望上世紀中國歷史，30年是一個很有些意味深長的數字。1919年「五四運動」到1949年新中國成立，這是爭取民族獨立的30年；從1949年新中國成立到1978年改革開放啟動，這是探索現代化道路的30年；從彼時到2008年奧運會召開又是中國走向世界，重新崛起的30年。再乘以5或乘以10，我們還會看到！近代中國是一個不斷試圖急起直追實現自己強國夢想的古老國家。以一種長程的眼光看，她的變化之激烈之頻繁之驚心動魄為亙古未有。因此，換一種眼光看，她每時每刻都在發生着變化，不唯戊年。

關於天干地支的學說是中華民族的一大智慧，它涵蓋了從宇宙、日月到天地玄黃運行規律的所有原始觀察；包含了對物質生長形態，事物運行方式的豐富描述。由22個漢字凝聚起來的，實際上是對原始視覺形態的高度抽象，這是攝影家們不很知道卻應該知道的。

即時的或瞬間的攝影，完成了鏡頭對事物的「目擊」，但它是否可能成為對歷史的「見證」是可以存疑的。每一個紀實攝影師都知道自己的職業價值在於「記錄今天的歷史」，這當然不意味着你揿動快門的那一瞬間必然具有歷史意義。為了這本畫冊，我們搜集了數以千計的圖片，有些被我們選用了，有些被我們放棄了——經常，我們在放棄的時候，腦海裡迴旋的就是它可能具有的歷史感。

真的，有時候你去讀一讀司馬遷，讀一讀班固，乃至讀一讀百年前康、梁的文筆，就會發現我們的胸臆中缺少甚麼！在這個意義上，先人們歸納的干支紀年喻物，正是一種大尺度的對歷史規律、物態循環的理解，是一種基於視覺更超越視覺的偉大記憶力和想像力。當物質的誘惑，世俗的快樂，膚淺的感受充溢於當下的時候，思考和感悟攝影術遠未萌發的時候，祖先們記錄和釐清事物運行和發展規律的那種強大的思想能力和精神成果，這恐怕不屬於八卦！

有王文瀾君在改革開放之初拍攝的一張練氣功的人們，其時勢洶湧，動態恣肆，竟於500年前祭祀天地之壇上（第99頁）；與本集封面與鄧公合影之少女一樣，它們都是這個時代的見證。

天行有數，無須遮蔽也不可覆蓋。我們對這30年歷史的影像觀照力求真實素樸，讀者諸君或有見怒與見教，端緣我們的史觀與功力。在此先謝過了！

戊子年冬至之日

The year 2008 is numbered "wuzi" under the Chinese 60-year cycle calendar. "*Wu*" years correspond to the years ending in the number eight. The ancient Chinese belief that *wu* years augur growth coincides with our experience in the reform years. 2008 was a year of prosperity threatened by crisis. 1998 marks the peak of "development zone" expansion, the launch of the real estate boom, and a 16 percent projected budgetary growth. 1988 saw a great wave entrepreneurship and accelerating inflation. It was also a year in which the separation of party and state and the reform of political institutions were hotly debated. 1978 marked the inception of the greatest transformation in 3000 years. Even before that, for the last hundred years, it seems uncanny that the years ending in the number eight have all seen or begotten major landmark events in Chinese history. Looking forward, what will the coming *wu* years bring? While we cannot know, because we will have "realized the great historical revitalization of the Chinese nation" a century after the founding of the People's Republic, the coming decades should find us on the road to becoming a modern socialist powerhouse.

Since its pre-modern era, China has ceaselessly endeavored to build up its national strength to join the ranks of major powers. Seen from a long-term perspective, the violence and frequency of her changes may be historically unprecedented. Thus, she can also be said to be constantly changing, not just in years ending in the number eight.

The 60-year cycle calendar encompasses observations and patterns by the ancients of the workings of celestial and earthly bodies and processes. They are, in a way, abstractions from visual activity. Photographers may not be aware of this.

The camera captures the image of the instant. Whether that constitutes a witness to history is doubtful. Every documentary photographer knows that the value of his work inheres in "recording today's history". Of course this does not mean that the moment of the shutter clicking will necessarily have historical significance. To put together this book, we collected thousands of photographs. Some we included; others we left out. Often as we pass over an image, a thought crosses our minds that it may have historical significance.

If you revisit the histories written by Si Maqian or Ban Gu a millennium or two ago, or even the works of Kang Youwei or Liang Qichao from a century ago, you will discover what we moderns lack. The 60-year cycle calendar of our forefathers is a gauge reflecting their appreciation of historical patterns and natural rhythms. It is a prodigious instrument of memory and creativity derived from the visual but transcends its visual origins. When inundated by material lures, worldly pleasures and superficial feelings, if we take a moment to contemplate the reflective powers and conceptual results that our ancestors achieved, long before photography, for the recording and analysis of material processes and developmental patterns - I trust that is not guilty of horoscopy.

The laws of universal motion need not be obscured and cannot be concealed. In this look upon the past 30 years, we strive for honesty and truthfulness, implementing our view of history. The reader may at points feel affronted or take exception. But for your cognizance, we thank you in advance.

Winter solstice, *Wuzi* year or 2008

The *Wu Zi* Years

入世
Entering the World Trade Organization

　　加入世界貿易組織被中國人簡稱為「入世」。並非中國人喜歡「出世」，喜歡「閉關」，而是在不短的時間裡，西方人刻意把中國封閉封鎖起來。因此，「入世」是對中國開放國策的一個檢驗，於西方人對中國的態度也是一個檢驗。中國的入世談判是個波詭雲譎的漫長過程，這個過程中我們學習並接受着世界貿易的國際規則，推動着國內產業結構的調整和提升。可以認為，「入世」是中國20年開放國策的一個關節點，從此，中國與世界的關係按照它既定的方針在加速運轉。

Following 15 years of tough negotiations, China officially entered the World Trade Organization on December 11, 2001 — a major milestone marking the country's transition from a command economy to a market-oriented economy. The 143rd member of the trade body, China was admitted following a near unanimous vote in favor by existing members. For China, WTO membership has meant the lifting of restrictions on its capital markets and movement of people. Membership has also brought greater external pressure to bear on the country's leaders to cut the corruption, counterfeiting and fraud blighting the economy. Eight years later, China's economy is having a major impact on world trade. Many experts cite the country as the globe's main engine of growth in the aftermath of the devastating financial crisis of 2008.

WTO 給中國百姓帶來甚麼？

2001年11月11日，是一個應載入中國史冊的日子——這一天，中美關於中國加入世界貿易組織的協定終於簽字達成。圖為中國「入世」時，某街道的黑板報和曬太陽休憩的人們。

A notice on a public blackboard lists out the benefits for ordinary people of China's WTO membership. China's government heralded the country's accession to the WTO, on December 11, 2001, as its entry into the global economic and trade system.

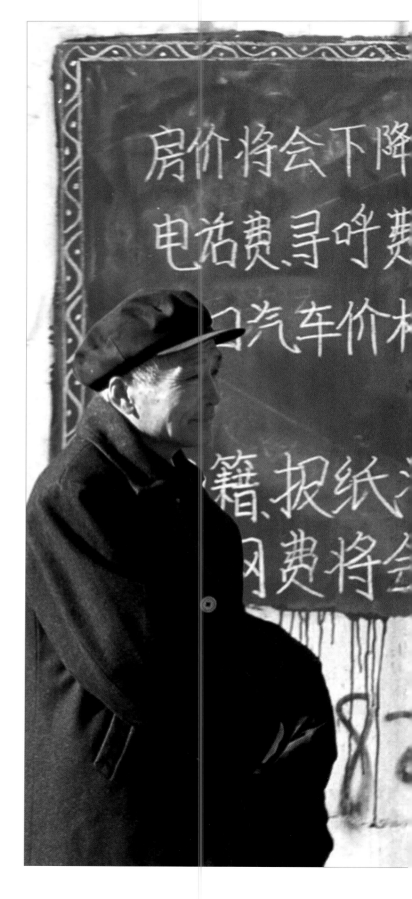

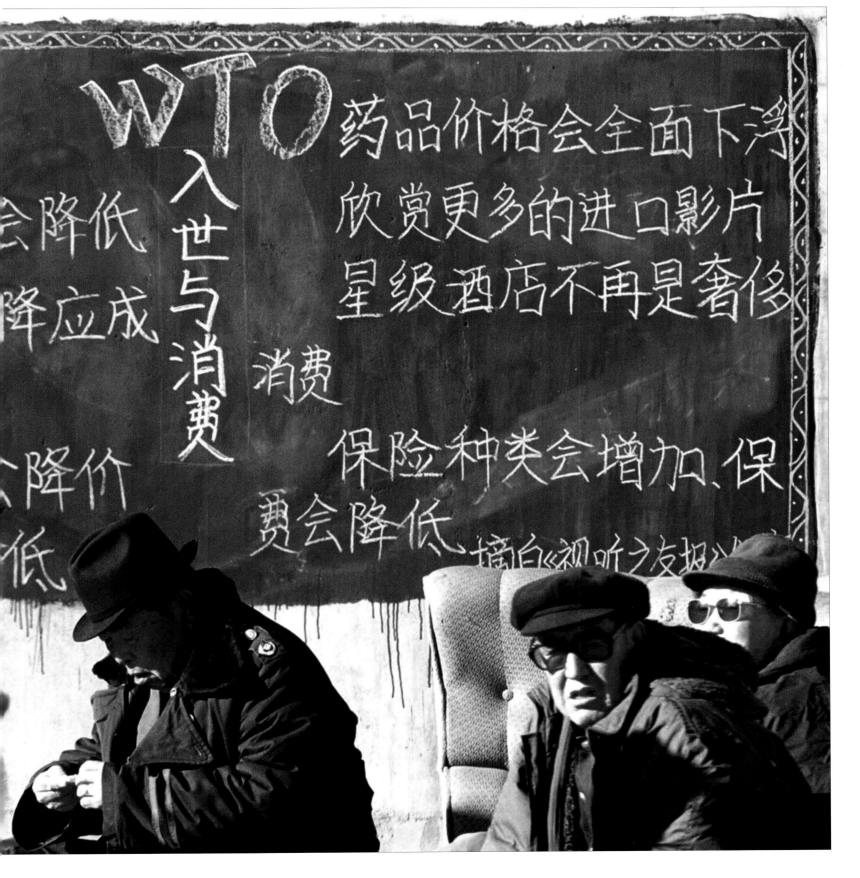

中國入世簽字儀式現場

2001年11月11日，卡塔爾首都多哈，中國加入世界貿易組織簽字儀式現場。

The signing ceremony for China's accession to the WTO in Doha, Qatar, on November 11, 2001. Minister of Commerce Shi Guangsheng represented China.

▽ 國際汽車展

1987年6月17日～22日，第二屆上海國際汽車工業展覽會在上海展覽中心舉行，有來自20多個國家和地區的約200個廠商、公司參展。舉辦當初，轎車對於普通老百姓而言，是個可望不可及的高檔消費品，汽車展會也還是一個空白，上海是中國最早舉辦專業國際汽車展覽會的城市。

The second Shanghai International Automobile Expo was held in the Shanghai Expo Center from June 17 to 22, 1987. Shanghai was the first Chinese city to host the automobile expo.

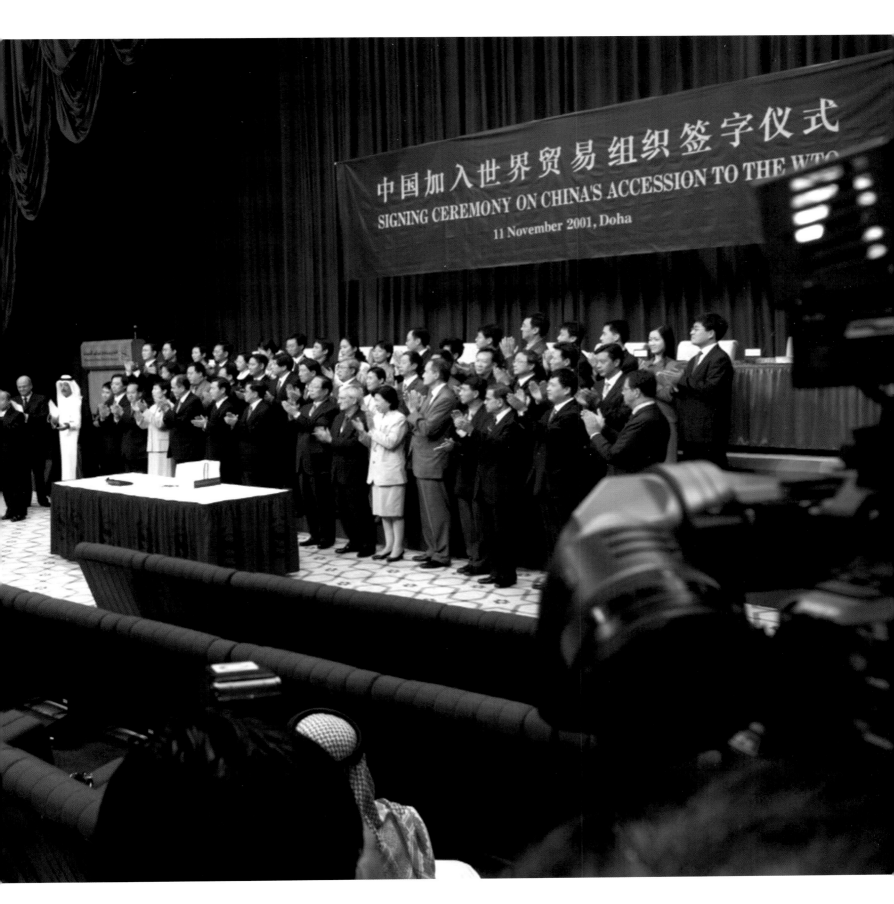

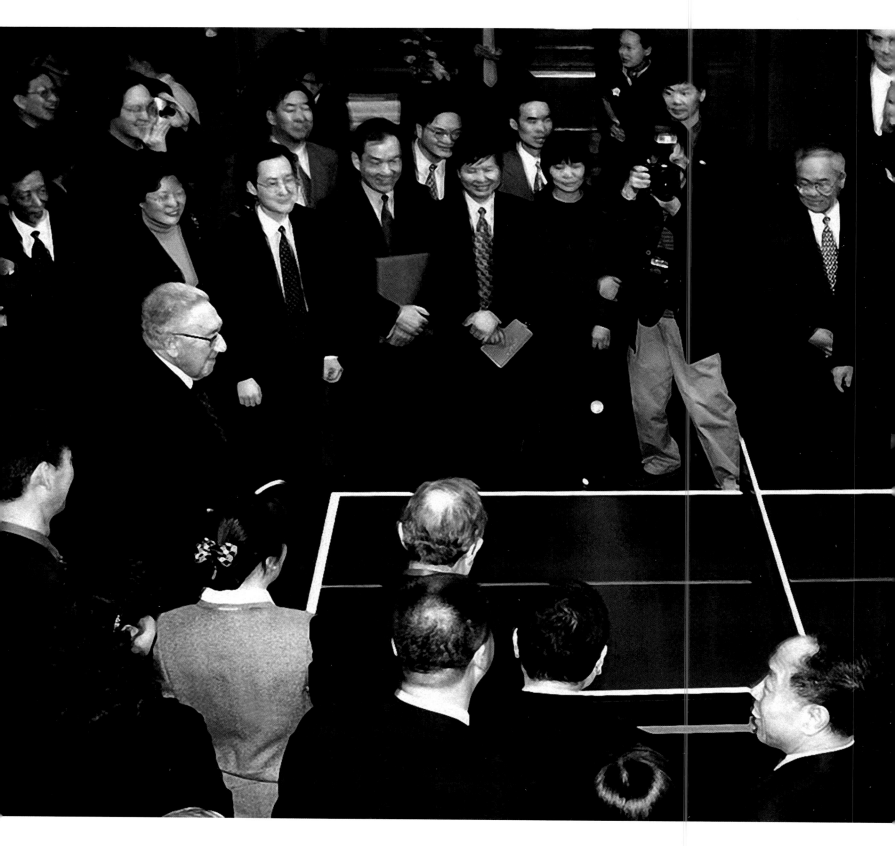

「乒乓外交」
Ping-pong Diplomacy

　　所謂「乒乓外交」，緣於毛澤東某一次睡眠之前意識朦朧中的決策反覆。由是，中美從民間到國家關係發展進入了新的篇章。在20世紀後半葉大國關係的「新三國演義」中，最先聯手的必是獲得最大戰略利益的，在國家戰略利益選擇面前，意識形態的障礙並不難克服，比如，那隻小小的乒乓球的力量。

If the Beijing Olympics was the crowning moment of China's 30 years of reform and opening, then it is perhaps right to recall that it was a sporting event which fired the starting pistol on greater openness to the outside world. In 1971, Chairman Mao, in an iconic gesture of friendship, invited American table tennis players competing in Japan to visit Beijing. The move was quickly labeled "Ping-pong Diplomacy" and marked the thawing of relations between Beijing and Washington, culminating in the historic visit to China by U.S. President Richard Nixon in February 1972. The visit was the first by an American president since the founding of the People's Republic of China.

重溫「乒乓外交」

2001年3月18日晚，中國人民對外友好協會在北京釣魚台國賓館舉行招待會，紀念中美乒乓外交30週年。招待會前，國務院副總理李嵐清與年近80高齡的美國前國務卿基辛格博士揮拍上陣，重溫「乒乓外交」。

Chinese Vice Premier Li Lanqing plays table tennis with former U.S. Secretary of State Henry Kissinger at the Diaoyutai State Guesthouse in Beijing March 18, 2001. A grand reception marked the 30th anniversary of the "Ping-pong Diplomacy" that had ended more than two decades of mutual hostility between China and the United States.

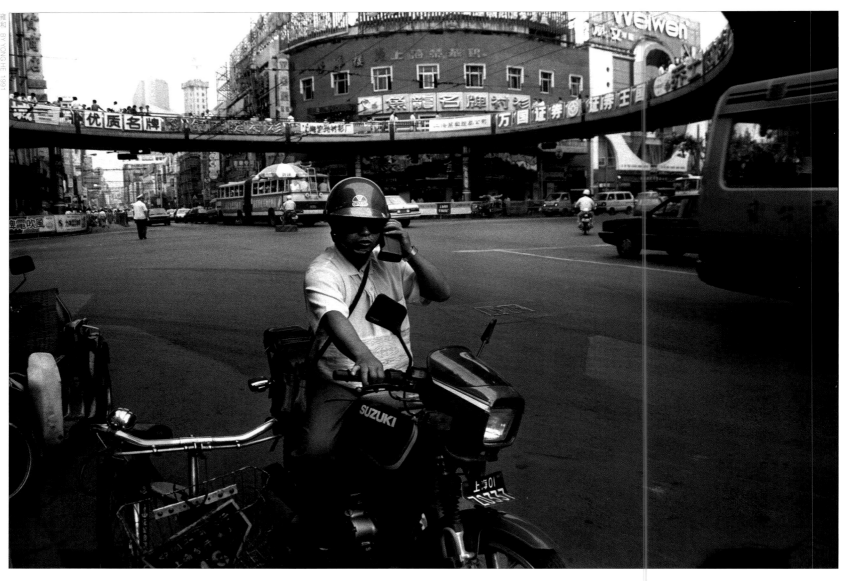

手機
China Calling – The Telecommunications Industry

到2001年7月，中國人手機的擁有量已經超過美國成為世界第一。此前10年，手機還是動輒要一、兩萬元一部的奢侈品，為先富階層獨有。再往前10年，則安裝一部普通的座機電話在城市裡還要「走後門」呢。1990年代初，有一幅獲獎的紀實照片，拍的是一個時髦女郎一邊擦皮鞋一邊炫耀地打「大哥大」——今天，街邊擦皮鞋的師傅八成也有一部手機。除了人口總數，手機擁有量的數字實際上說明着人際交往密切的程度，以及電信運營和網路發展的程度。「精神」與「物質」，共同繁榮。

China's telecommunications industry has experienced a revolution over the past 15 years or so, moving from a single state operator to multiple state-owned groups, and is now heading towards granting market access to foreign operators. Before the reforms, a mobile phone could cost up to 30,000 RMB – well beyond the means of many earning the average annual salary of 600 RMB. But the country is now home to the world's largest fixed-line and mobile network. One in three people have a fixed telephone subscription and more than 1.25 million cellular subscribers are signing up each week.

上海街頭大哥大

1991年，上海街頭打手機的人。當時這種磚頭一樣的手機，大家都叫它「大哥大」，黑市賣到35,000元的奢侈品，擁有者大多是做生意發財的「萬元戶」。當年，全國也不足20,000用戶。

A man uses a primitive cell phone to make a call on a Shanghai street in 1991. In the early 1990s, a cell phone was a luxury that could cost as much as 35,000 yuan. The number of users at the time was fewer than 20,000

販假證靠手機

2003年3月，北京地鐵站口的廣告牌。廣告牌上寫滿了辦假證的電話號碼。

A billboard covered with the cell phone numbers of people offering illegal services such as false documents in Beijing in 2003.

移動公司業績

2000年，中國移動（香港）有限公司在港業務蓬勃發展，佔據重要地位。圖為公司董事長王曉初在新聞發佈會上展示業績。

Wang Xiaochu, Chairman of China Mobile Ltd, delivers a company report in Hong Kong in 2002. The company, listed in Hong Kong and New York, went on to have more subscribers than any other mobile phone service provider in the world.

「三個代表」

Innovating Marxist Theory

経濟高速發展中意識形態的適應與否是一個無法迴避的理論問題與現實問題。執政黨的執政地位與其理論基礎是互為因果的。1990年代末，中共提出「三個代表」理論，即：中國共產黨應當代表先進生產力發展需求；代表先進文化前進方向；代表最廣大人民的根本利益。「三個代表」的提出具有重大的理論創新意義，為經典理論在新時期的適用開闢了新的路徑，也為執政黨行為找到有力的理論依據。

In China, rulers have a tradition of defining political campaigns and theory with a numerical set of principles. And during the past 30 years, President Jiang Zemin's "Three Represents" is arguably the most high-profile example. The policy, launched as official theory at the 16th Party Congress in 2002, reminded the Communist Party of what it stood for and was a logical extension of Deng Xiaoping's earlier reforms. It stipulated that the Party should be representative of: advanced social productive forces; advanced culture; and the interests of the overwhelming majority.

王台力 BY WANG LILI 2002

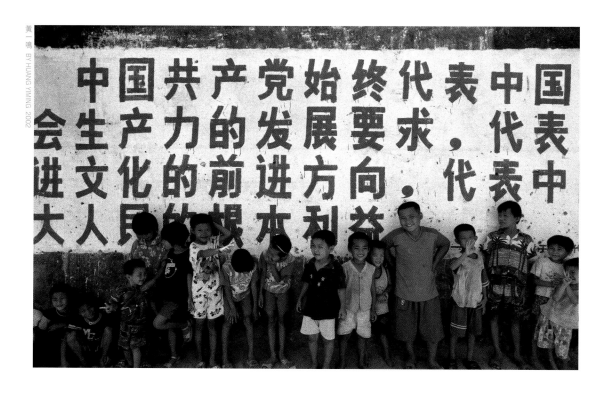

黄一鳴 BY HUANG YIMING 2002

老宅牆上刷標語

2002年4月，海南省陵水縣英州鎮。一面老宅的牆上新刷着當時的總書記提出不久的「三個代表」建黨新綱領。當時在中國幾乎每個鄉鎮和村莊，都會在顯眼的位置書寫這種綱領性語錄。

Slogans promoting the "Three Represents" on the wall of an old house in Lingshui County, Hainan, in April 2004. The "Three Represents", formulated by Communist Party General Secretary and Chinese President Jiang Zemin, outlined the three main focuses of the Communist Party of China: "To always represent the development trend of China's advanced productive forces, the orientation of China's advanced culture, and the fundamental interests of the overwhelming majority of the people in China."

廟會上的「三個代表」宣傳隊

2002年4月，河南省洛陽市伊川縣農民自發組織「三個代表」宣傳隊，到廟會上宣傳。

A propaganda team organized by peasants in Yichuan County, Henan Province, promotes the "Three Represents" with a statue of Mao Zedong at a temple fair.

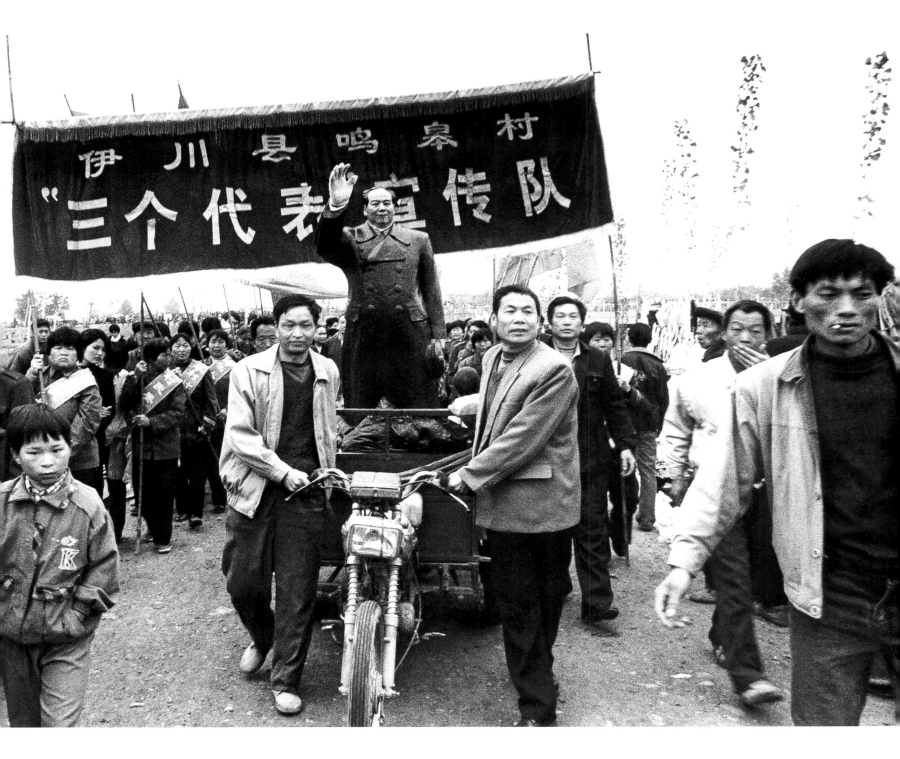

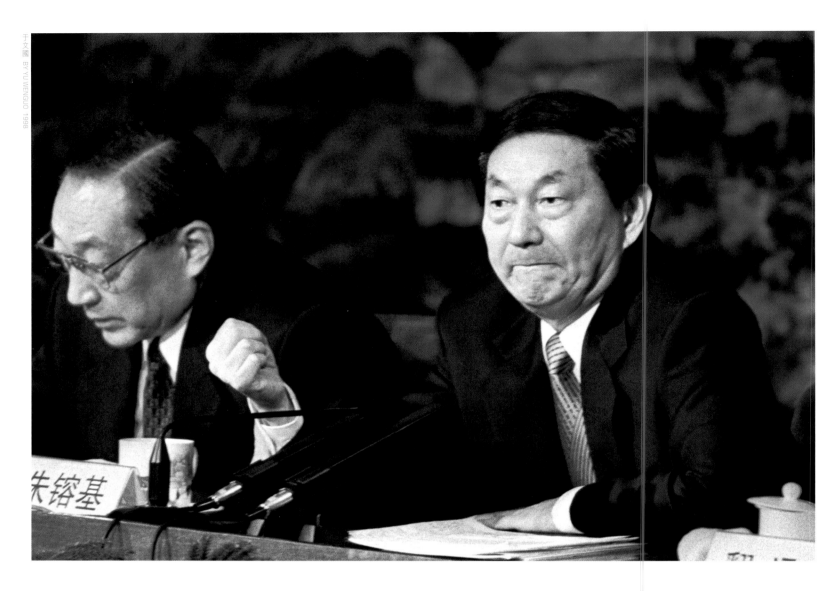

▷ 朱鎔基當選總理

1998年3月19日，在九屆全國人大一次會議上，朱鎔基當選為國務院總理。在此後的記者招待會上，朱鎔基緊繃雙唇、手握拳頭的形象，生動展示了朱鎔基的性格特徵。

A purse-lipped Zhu Rongji meets the international media after his election as Premier at the first session of the Ninth National People's Congress on March 19, 1998. Known for his firm manner and decisiveness, Premier Zhu became popular for his self-deprecating sense of humor.

▷ 溫家寶與礦工嘮家常

2003年6月1日，溫家寶總理來到遼寧省本溪市牛心台小南溝實地察看採煤沉陷區的百姓房屋受損情況。他握着礦工羅運德的手仔細詢問有關情況，然後彎腰走進門框已經傾斜的屋內。

Premier Wen Jiabao inspects homes damaged in a mining accident in the village of Xiao Nangou, Liaoning Province. During the visit on June 1, 2003, Wen inquired after the well-being and lives of the villagers, asking about food, medical care and housing conditions.

總理
Premiers

　　世紀之交，中國政府的兩位總理給人留下了深刻印象。上一任總理上任的時候，正值那一輪國際金融危機衝擊亞洲的時候；這一任總理，則在任上面臨着諸多複雜的國內國際問題。從影像上觀察兩位總理的性格，不知能不能用「堅毅」和「親民」做一個顯然是掛一漏萬的形容。想當年朱總理曾經用「地雷陣」、「萬丈深淵」來描述他面臨的局面；溫總理就職時，則告訴記者「我是農民的兒子」。如果未來中國真的將迎來一個中興之治的時代的話，恐怕歷史會記得這兩位同樣坦誠、辛勞而且不乏智慧的首輔的音容。

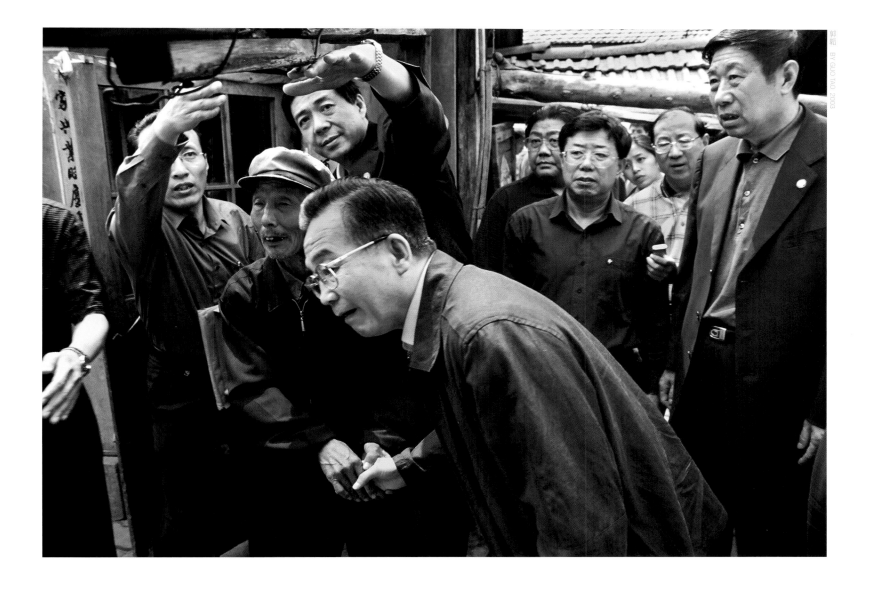

Zhu Rongji

If nothing else, Zhu Rongji has to be one of the most determined politicians of the 20th century. Twice purged by Mao for being a "rightist," reformist Zhu showed a remarkable ability to survive. He was finally rehabilitated by Chairman Deng Xiaoping in the late 1970s for his forward-thinking and bold economic ideas. Deng appears to have been vindicated, as Zhu went on to oversee double-digit growth in China. Zhu was born on October 20, 1928, in Hunan Province. He made his mark on the public imagination in Shanghai, where he played a senior role at the State Economic Commission, before being appointed mayor of that city. He will be remembered for developing the Pudong Special Economic Zone, which brought prosperity to Shanghai. In 1991 Zhu was elected Vice Premier of the State Council in Beijing and played a major role in guiding China's market liberalization. In 1998, he began his tenure as Premier and led China's bid for WTO membership. While many analysts have described Zhu's management style as "tough", the public praised him for fighting nepotism and corruption.

Wen Jiabao

Arguably China's most popular politician both at home and abroad, Wen Jiaobao has built a reputation as the caring elder statesman for his response to the Sichuan Earthquake and the severe snow storms of 2008. His actions earned him the affectionate nicknames, "Grandpa Wen" and the "People's Premier". Born in Tianjin in September 1942, Wen was elected Premier of the State Council in 2003. He graduated from the Beijing Institute of Geology, majoring in geological structure. Among his political peers, Wen has a reputation for meticulousness and an ability to get results. Wen is also seen as a survivor, having recovered his career after accompanying General Secretary Zhao Ziyang to Tiananmen Square to visit the student protesters in 1989. His magnanimous side came to the fore again after a protester threw a shoe at him while giving a lecture at Cambridge University in England. Wen urged forgiveness, saying that education was the best remedy for his assailant. In his second term, Wen has led efforts to control inflation and to boost China's image ahead of the Beijing Olympics. The Premier is also said to have a Facebook profile that has attracted more popular support than any other non-U.S. leader who has taken up the networking site.

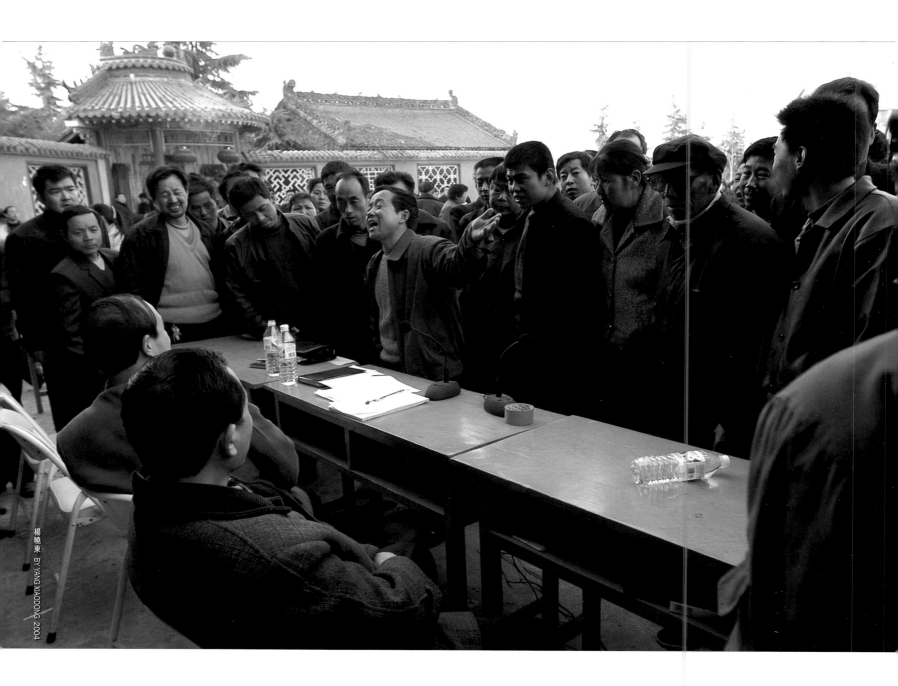

村民直選
The Green Shoots of Democracy

　　始於1990年代末的中國農村村級直選，被視為中國式政治民主建設的基層起點。作為繼聯產承包責任制和發展鄉鎮企業後的農村政策的又一重大創舉，1998年全國人大常委會通過《中華人民共和國村民委員會組織法》，就「村民委員會實行民主選舉、民主決策、民主管理、民主監督」等事項作出法律規定。中共十六大修訂的新黨章，也規定中共的基層組織「支持和保證行政組織、經濟組織和群眾自治組織充分行使職權。」中共中央制定的《農村基層組織工作條例》還規定村黨支部的主要職責包括：領導和推進村級民主選舉、民主決策、民主管理、民主監督，支援和保障村民依法開展自治活動。

　　Villagers' committees (VCs) in China were formed in 1980. They were set up as a way to maintain social order in the hinterlands and to prevent a broader political crisis believed to be threatening Communist Party rule. Every three years, villagers are allowed to vote in what is touted by national leaders as "grassroots democracy". In 1998 National People's Congress (NPC) leaders devised the "Organic Law", prescribing election procedures for head officials and increasing transparency of the VCs. The measures have gone some way toward improving social order in rural areas, although widespread protests and disputes continue over land seizures and corruption. Nevertheless, anger is generally directed against local individuals rather than the Communist Party per se.

村官罷免會流產

2004年2月11日下午，陝西省寶雞市渭濱區神農鎮陳家村罷免村委員會部分成員大會在村委會前的戲樓召開。在此之前，這個村群眾不滿現任4位主要村委員會成員，要求罷免。這次罷免大會因部分工作人員疏忽，將死亡和出嫁多年的村民也列入選民而造成混亂。大會被迫休會，罷免村官會流產了。

Residents of Chenjia Village, Shaanxi Province, assembling before the village committee on February 11, 2004, to demand the removal of four officials accused of being negligent in their duties.

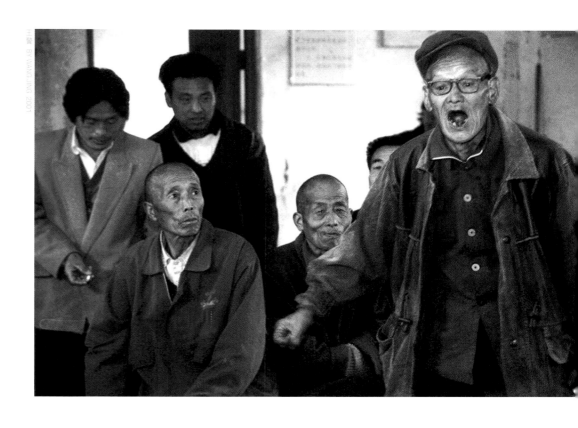

村官罷免答辯會

2001年3月27日，陝西省長安縣祥峪鄉東石村村民，因對現任村委會主任工作不滿，要求罷免其村主任職務。在罷免表決之前，村民們按照村民委員會組織法的有關規定，在村委會辦公室為現任村主任舉行了答辯會。圖為在罷免村官會上，一村民質問村官。

Residents of Dongshi Village, Shaanxi Province, argue for the removal of the head of the village committee, who they claim has been negligent in his duties, March 27, 2001.

村官的思索

2001年，被村民要求罷免的現任村委會主任在抽煙。

The head of Dongshi Village draws on a cigarette during a public hearing on whether he should be recalled. He was later removed from office.

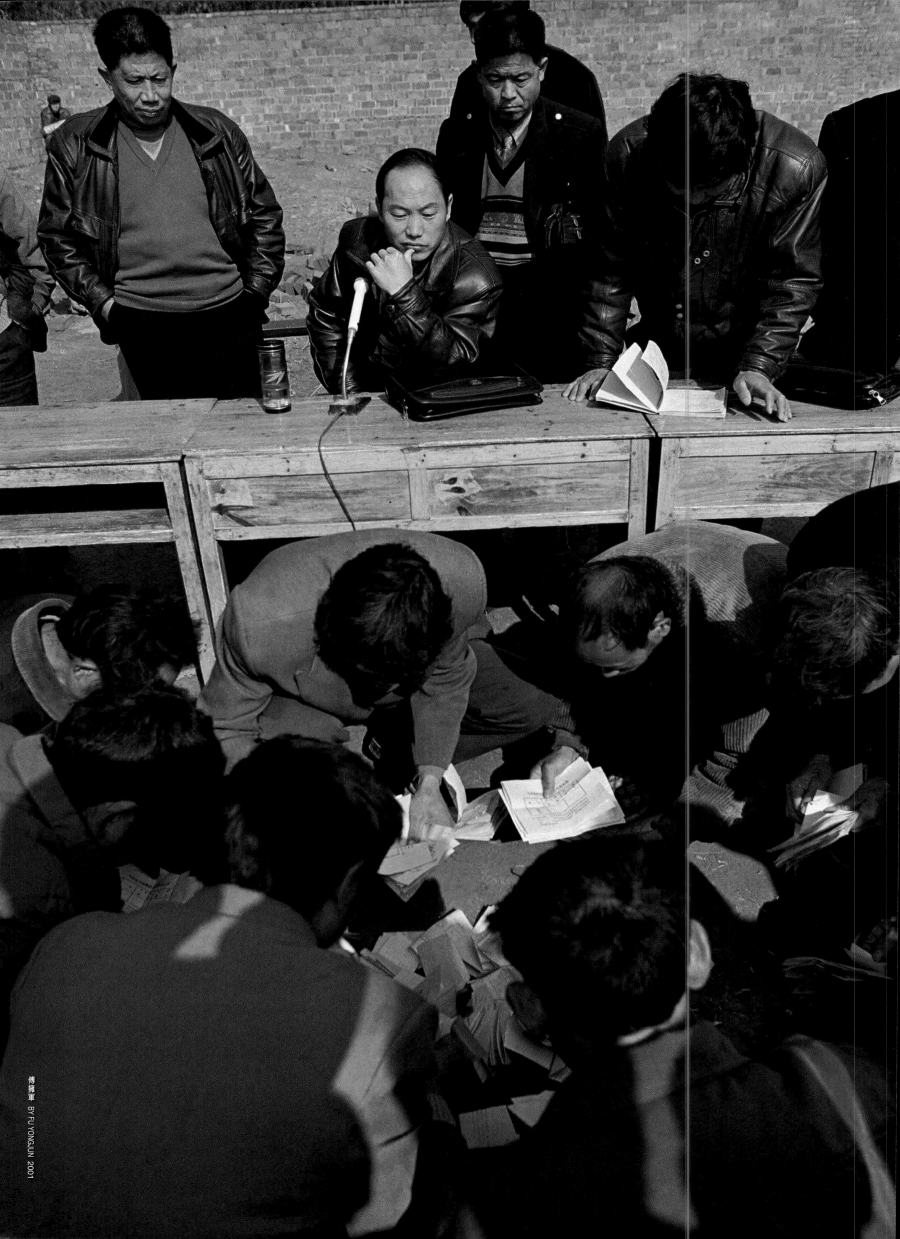

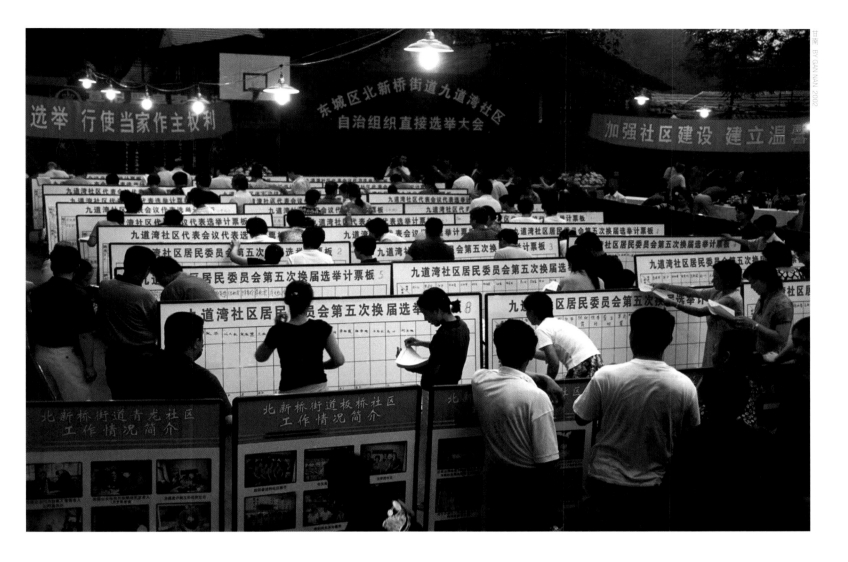

甘南 BY GAN NAN, 2002

彈劾村官

2000年10月～2001年3月，一個僅有141戶人家的小山村，因一項「豆腐渣」工程而引發一起前所未有的「彈劾」風波。圖為在鎮幹部的注目下，村民在認真計票。

Villagers counting ballots in a vote on whether to impeach the village head, who presided over building construction quality problems. The impeachment process in the small mountain village of just 141 households ran from October 2000 to March 2001.

民主選舉

2002年8月17日，北京市東城區九道灣社區在進行基層民主選舉。

Residents of Jiudaowan Community, Dongcheng District, Beijing, vote for the leaders of the neighborhood committee on August 17, 2002.

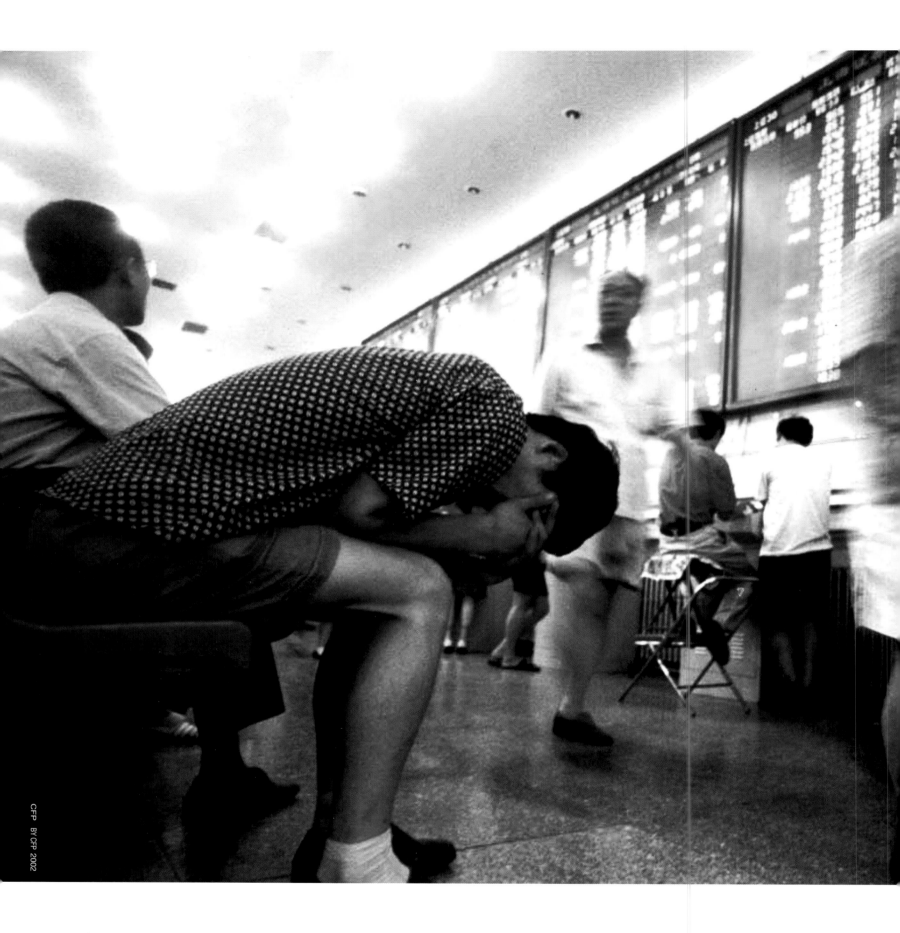

股市低迷

股市是世界經濟狀況最靈敏的晴雨錶。2002年，互聯網泡沫破裂，美日等西方國家經濟狀況不良，帶累全球股市，中國股市也受波及。圖為2002年8月14日，北京某證券交易大廳，看盤的股民情緒低落。

An investor waiting anxiously for the rebound of the market index in a securities trading hall in Beijing on August 14, 2002. The burst of the dot-coms bubble in 2000 affected Western economies and triggered a chain reaction that eventually hit China's stock market.

子承父業，楊百萬教子炒股

「楊百萬」是中國最著名的散戶股民。圖為2000年12月19日，在上海閘北區，他帶着兒子在家中炒股。

China's most famous securities tycoon, Yang Baiwan (Millionaire Yang), instructs his son on trading in the stock market on computer terminals at their Shanghai home, December 19, 2000.

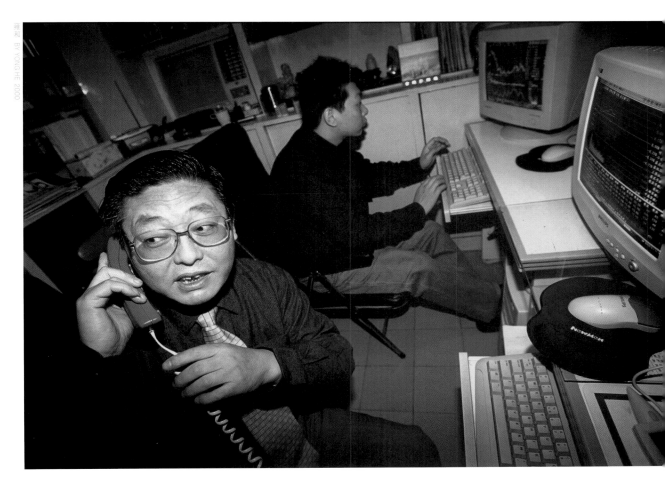

股市波動

Market Fluctuation

　　1990年代之後，股市越來越成為老百姓關注的熱點。自1990年代初股市幾乎單邊上揚，引發炒股狂熱後，1990年代後半葉，中國股市有幾輪重大波動。不過，這個市場一直在高速發展，從1990年的10家上市公司，到2007年已經有了1,500家，總市值也從1,000億元到超過 3 萬億元。中國資本市場在波動中成熟，它由幾個因素構成：一是證券市場管理的制度環境；一是上市公司的自身規範和約束；一是投資人風險意識的形成。

　　Since the 1990s, investors have become increasingly concerned with China's stock market. While stock prices almost invariably went up and resulted in the stock craze of the early 1990s, China's stock market then went through several rounds of major fluctuations in the second half of the decade. Nonetheless, the market expanded dramatically with the number of listed companies rising from 10 in 1990 to over 1,500 in 2007. Market capitalization also went up — from 100 billion yuan to over 3 trillion yuan. China's stock market will mature, despite such fluctuations as a result of the regulation of the securities markets, self regulation and discipline of the listed companies and risk awareness of the investors.

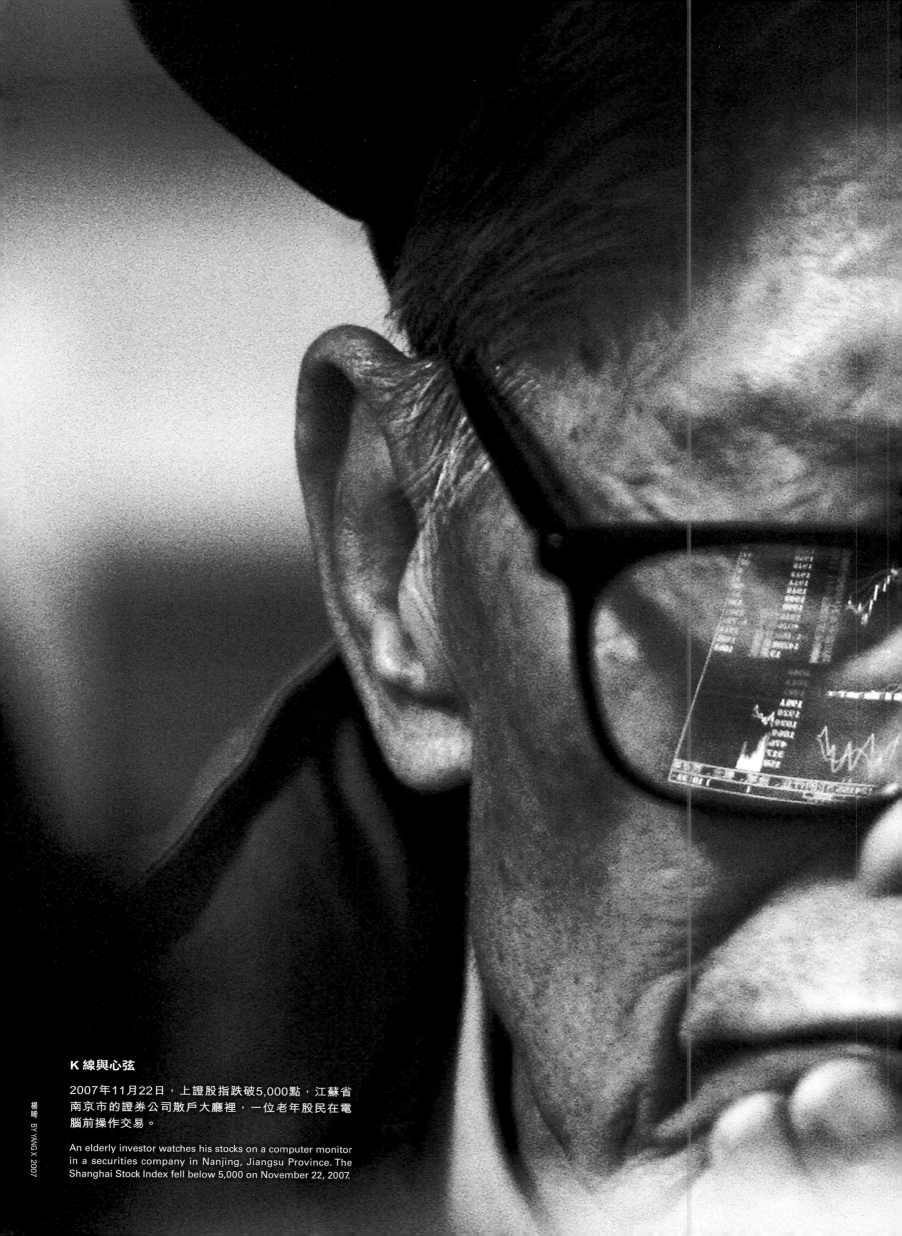

K 線與心弦

2007年11月22日，上證股指跌破5,000點，江蘇省
南京市的證券公司散戶大廳裡，一位老年股民在電
腦前操作交易。

An elderly investor watches his stocks on a computer monitor
in a securities company in Nanjing, Jiangsu Province. The
Shanghai Stock Index fell below 5,000 on November 22, 2007.

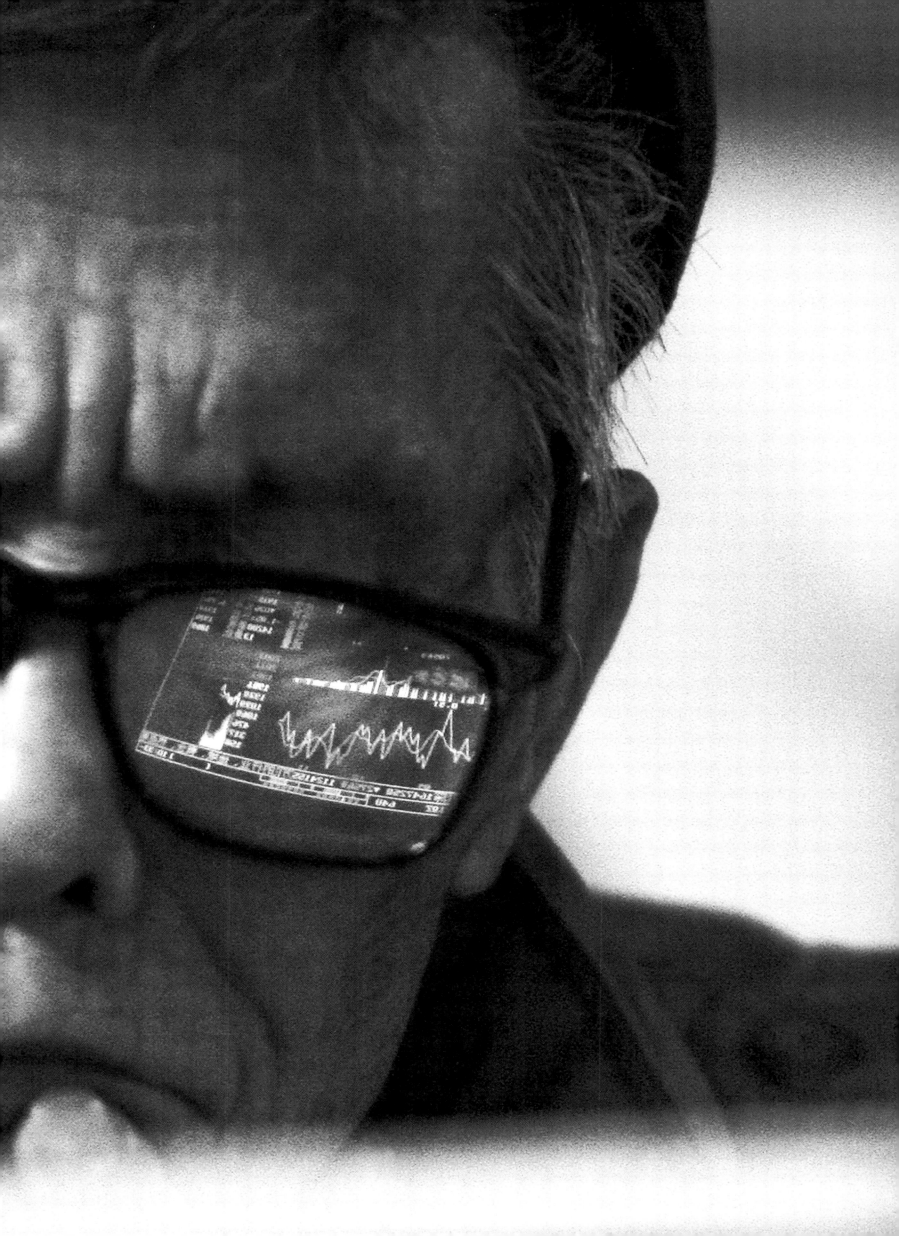

傳銷
Pyramid Selling Becomes a Social Evil

BY YU HAIBO 2003 余海波

「沒有實際產品，通過發展上、下線，建立金字塔式聯繫，限制人身自由的非法銷售模式叫做傳銷」。1990年代後期，這種被政府定為非法的「銷售」方式在各地滋生。這是一種看似銷售鏈條的組織鏈條，組織者以欺騙為目的。不過因為它在某些環節的某些「上線」確實能騙得錢財，對一些夢想發財的人頗具誘惑，故而生生不絕。不惟傳銷，經濟大潮中，各種騙術一如泥沙泛起，層出不窮。

Multi-level marketing (MLM), or pyramid selling, deemed a social evil, has been banned in China for a number of years. The activity continues apace, however, and reports of pyramid-selling scheme busts can be seen on a daily basis in the Chinese media. MLM relies on commission-based selling and often leaves people struggling in debt. It operates by luring would-be sales reps into buying a company's sample product for promotional purposes. But if they make no sales, they make no money — and they still have to cough up for the promotional merchandise. One official from China's Ministry of Public Security said pyramid-selling scheme organizers had "achieved psychological mastery over members, violating the law and basic ethics by repeatedly brainwashing them with distorted facts".

清查打擊非法傳銷

2003年，深圳工商局清查出一個非法傳銷窩點。自1998年以來，中國政府開始打擊和杜絕從台灣、香港傳入的傳銷活動。中國政府要打擊的「傳銷和變相傳銷」就是世界直銷聯盟講的「金字塔式或類似的銷售法」，在台灣、香港俗稱為「老鼠會」。

Operators of an illegal pyramid scheme reflect on their change in fortunes after their arrest and the seizure of their earnings in Shenzhen in 2003. The Chinese government has waged a campaign against pyramid schemes, introduced from Hong Kong and Taiwan, since 1998.

鄭黎崗 BY ZHENG LIGANG 1993

環境事件
Paying the Price of the Economic Miracle

與經濟發展同步，各地環境事件時或發生。以一種系統回顧式的眼光，我們可以觀察到的變化是：這種原來被媒體習慣性遮蔽的突發事件，現在進行公開甚至追蹤性報道了；政府的及時組織、動員和應對能力明顯提高，並且據說形成了各種「應急預案」。更重要的是，以2007年廈門PX項目為標誌，公眾對環境安全的意願表達開始為政府所接納。如果考慮到廈門公眾是採取「集體散步」這種介乎法律邊緣的形式表達意願的，那麼政府的決策轉換得到輿論的一致好評就更加可以被理解為一種集體默契——在引入外資和經濟發展之上，環境安全是更加重要的！還應當記取的是，在2007年，中共提出了建立「和諧社會」與「可持續發展」的理念。

The downside of China's economic miracle has been the nightmare of environmental devastation. Anyone who has visited a Chinese city cannot fail but to have choked a little on the persistent smog. Water pollution from factories is also a major problem for both public health and political stability across the country. Despite this, Beijing successfully cleaned up its air for the Olympic Games with measures that both government officials and environmental activists have said are making a positive, long-term impact. Still, by developed world standards there is a long way to go. China is also forging ahead with renewable energy projects. The country is home to the world's largest wind farm, in western Gansu Province, and homegrown company Suntech Power is fast becoming the world's leading producer of solar technology. Beijing has also boosted cooperation with Washington on environmental issues since Barack Obama was elected U.S. President in 2008, marking major progress since George W. Bush's era of climate change denial.

深圳 8.5 大爆炸

1993年8月5日，與清水河油氣庫相鄰的一危險品倉庫發生火災，並導致連續爆炸，隨即天空升起巨大的煙雲。這次事故導致15人喪生，800多人受傷，3.9萬平方米建築物毀壞，直接經濟損失2.5億元。

People flee from the site of a blazing warehouse in Shenzhen on August 15, 1993. The fire started in a warehouse filled with hazardous products and spread through a series of explosions, filling the sky with plumes of smoke. Fifteen people died, more than 800 people were injured and 390 million square meters of building space were destroyed in the blaze. The disaster prompted the Shenzhen government to move all dangerous warehouses to the city's outskirts.

「環保主義」走入昆明

1999年世界園藝博覽會在雲南昆明舉行。在英國週的活動上，4個英國人將花盆頂在頭上，呼籲大家「把我們的地球建成美麗的花園」。

Four British visitors wearing flowerpots on their heads call for a green world at the 1999 World Gardening Expo in Kunming, Yunnan Province. People from around the world came to the expo to call for greater environmental protection.

為廈門 PX「散步」

2007年5月29日12時，廈門市民披掛着「反對PX，保衛廈門」的橫幅和黃絲帶，在廈門世貿商城進行和平「散步」，反對政府在距廈門市中心和鼓浪嶼不遠的海邊開辦嚴重污染環境的化工產業。此次民眾抗議活動和平進行，沒有發生衝突性事件。廈門PX事件是中國民眾合法理性表達自己意願，保護自己權益的實驗性典範。

About 10,000 people in Xiamen, Fujian Province, marched in protest against a paraxylene factory planned for the city on May 29, 2007. Tenglong Aromatic PX (Xiamen) Co. Ltd. planned to build a plant that would produce 800,000 tons of the carcinogenic chemical each year. The plant was eventually relocated after a series of peaceful protests and public hearings.

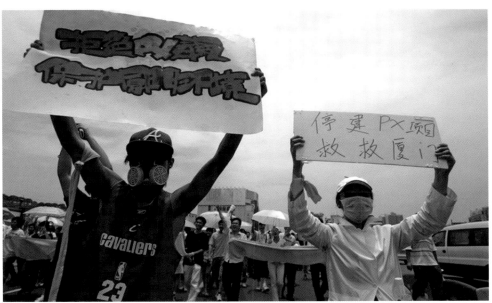

黃沙
Sandstorms

　　不僅是一種特殊氣象，而且是一種環境趨勢——20世紀末，風沙正越來越頻繁地降臨京城。1980年代，政府曾號召在西北種草種樹，並且斥鉅資在北方建立大規模防護林帶。然而，人們越來越發現，環境惡化是一個不容忽視的世界性問題，非綠化一途可以遏止。與經濟高速成長相關的環境因素有資源的過度消耗和國土開發的原因。與自然和國際因素相關的環境因素則需要世界性的合作與協調。21世紀初，人們已經意識到「可持續發展」的必要，環境安全漸成普遍被接受的發展理念。

　　Toward the end of the 20th century, sandstorms began to afflict Beijing in a big way. Spreading desertification in north China has resulted in worse and more frequent sandstorms in the capital. Environmental concerns and crises are not just confined to China, of course, but are a matter of ragidly rising concern aroud the world.

無處藏身

2006年4月18日傍晚，6級大風挾着沙塵再次襲擊北京，天安門廣場上兩個等人的男孩把頭縮進衣服裡遮擋風沙。從4月16日晚上開始，中國北方地區出現自2003年以來最大範圍的強浮塵天氣。

Two boys shield themselves from the dust blowing into Beijing's Tiananmen Square during a sandstorm on April 18, 2006.

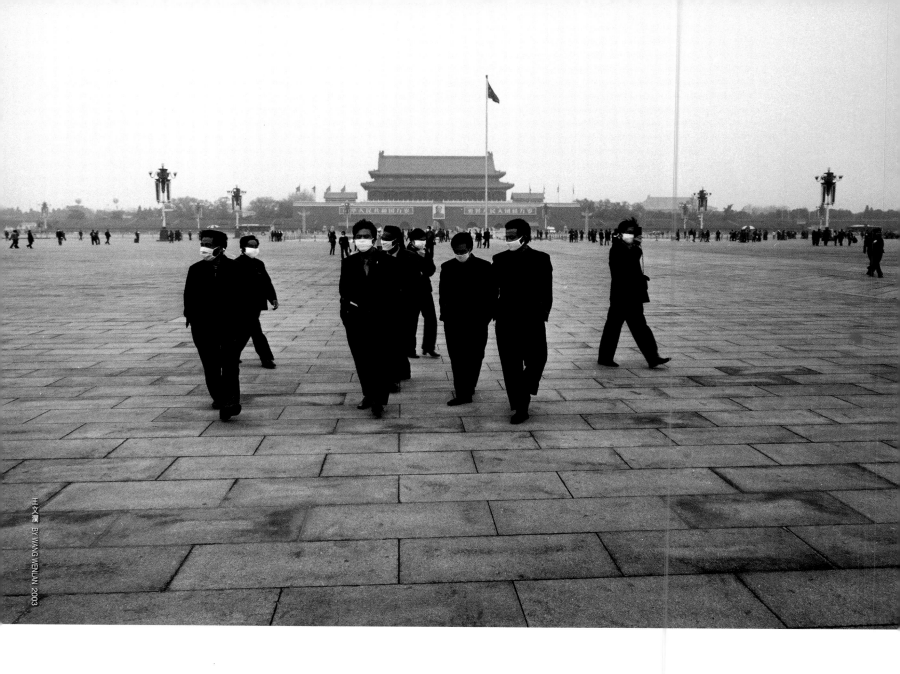

BY WANG WENLAN 2003

SARS

SARS – The Deadly Pandemic That Panicked the World

進入新世紀，重大突發公共衛生事件頻頻襲擾中國。在經歷了開始時的失措和慌亂之後，政府作出了堅決有效的反應。對疫情的報道更加公開透明，整個社會的動員組織積極有效，大面積突發疫情迅速得以控制。事實證明，改革在分權和細化國家經濟組織的同時，保有了強大的中央集權的能力，這種對資源的集中組織有利於應對重大突發事件。SARS以及SARS以前和以後發生的水災、南方冰雪災害、汶川地震災害都證明，在這樣一個人口、民族眾多的國家裡，一個強力有效能的中央政府是維護國家統一、社會安定的必須。

The 2002 SARS pandemic marked a low point in China's reform and opening period, with the country coming in for strong international criticism over its handling of the crisis. The first outbreak is thought to have occurred in Guangdong Province in November 2002 with the death of a Foshan farmer. The Chinese authorities were unable to make an accurate diagnosis of the man's death and failed to immediately report the case to the World Health Organization. Many said this delay helped the virus spread, mainly by air travelers, and it eventually claimed the lives of 349 people. The political fallout peaked with the sacking of Chinese Health Minister Zhang Wenkang for "wrongdoings" and "irresponsibility" during the crisis. To help stabilize the situation, President Hu Jintao visited Guangdong and Premier Wen allayed fears by taking lunch with students at Peking University. After initially stalling and prevaricating, the Chinese government managed to control SARS before it became a global catastrophe, an accomplishment that required political will and national mobilization. China appears to have learned hard lessons from the ordeal, obvious in the strict quarantine measures applied to air travelers during the swine flu pandemic, which began in the spring of 2009.

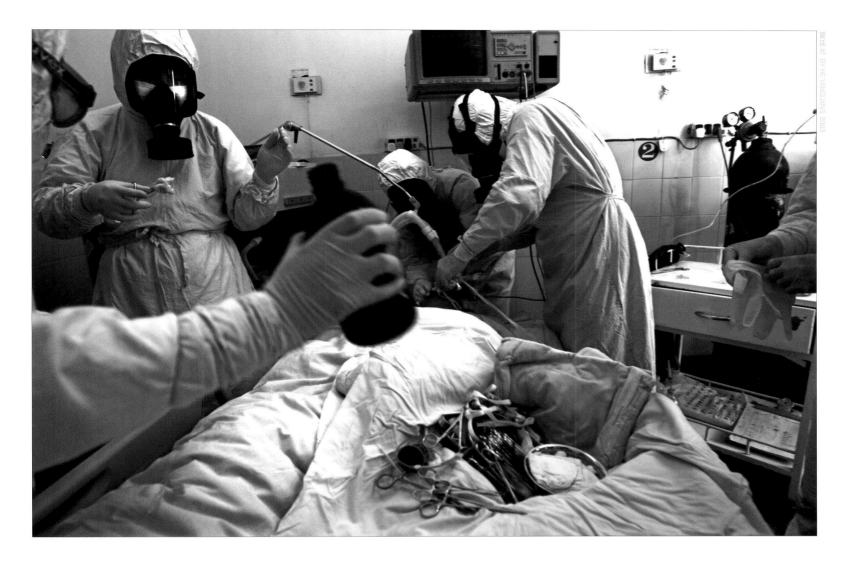

羅延光 BY HE YANGUANG 2003

廣場人稀，SARS 襲擊北京

2003年的北京天安門廣場。在人們毫不知情和毫無防備的時候，「非典」襲擊了北京，擾亂了人們的正常生活。

The outbreak of SARS (severe acute respiratory syndrome) in 2003 led to public panic in Beijing. The streets emptied as people avoided contact with others and the few who did venture out, such as these men in Tiananmen Square, wore face masks at all times.

地壇醫院，患者接受手術

2003年4月30日，北京地壇醫院，幾位醫生戴着防毒面具，緊張地為一名SARS重症患者實施有創氣管手術。

Surgeons wearing virus-proof masks operate on a patient infected with SARS at Beijing's Ditan Hospital on April 30, 2003.

張棹 BY ZHANG TAO 2004

羅湖口岸，司機要測體溫

2004年1月8日，深圳羅湖口岸，香港開往內地的貨車司機接受體溫檢測——禽流感的影響還未消除。

A truck driver taking a shipment of poultry from Hong Kong to the mainland has his temperature taken at Luo Hu Port, Shenzhen, on January 8, 2004. The Asian outbreak of bird flu, or avian influenza, among humans in late December 2003 came as the nation was still recovering from SARS. Temperature checks were introduced at all major ports to screen out anyone showing symptoms of fever.

抵制日貨遊行

2005年4月3日，廣東省深圳市福田區發生上萬人的自發遊行，遊行主題是「抵制日貨、反日入常」和「愛我中國、振興中華」。深圳警方投入數百警力在現場維持秩序。嗣後，日外交部長召見中國駐日大使王毅，對中國群眾破壞日本使館和日本餐館等提出強烈抗議，要中國道歉與賠償。中方未予回應。

Tens of thousands of people marched through the streets of Futian District, in Shenzhen, on April 3, 2005, to protest against proposals to give Japan a permanent seat on the United Nations Security Council. The protesters called for a mass boycott of Japanese products in response.

抗議使館遭轟炸

1999年5月8日，中國駐南聯盟大使館遭到從美國本土起飛的轟炸機的轟炸。邵雲環、許杏虎、朱穎3位同胞罹難，中國掀起了大規模民間抗議浪潮。圖為廣東省廣州市大學生上街抗議。

A Chinese demonstrator takes aim at the United States Embassy in Beijing. A U.S. aircraft, on a bombing run against the Yugoslavian capital of Belgrade, hit the Chinese Embassy on May 8, 1999, killing three Chinese occupants: Shao Yunhuan, of the Xinhua News Agency, Xu Xinghu and his wife, Zhu Ying, reporters with Guangming Daily newspaper. The bombing strained relations between China and the United States and provoked angry protests against the West.

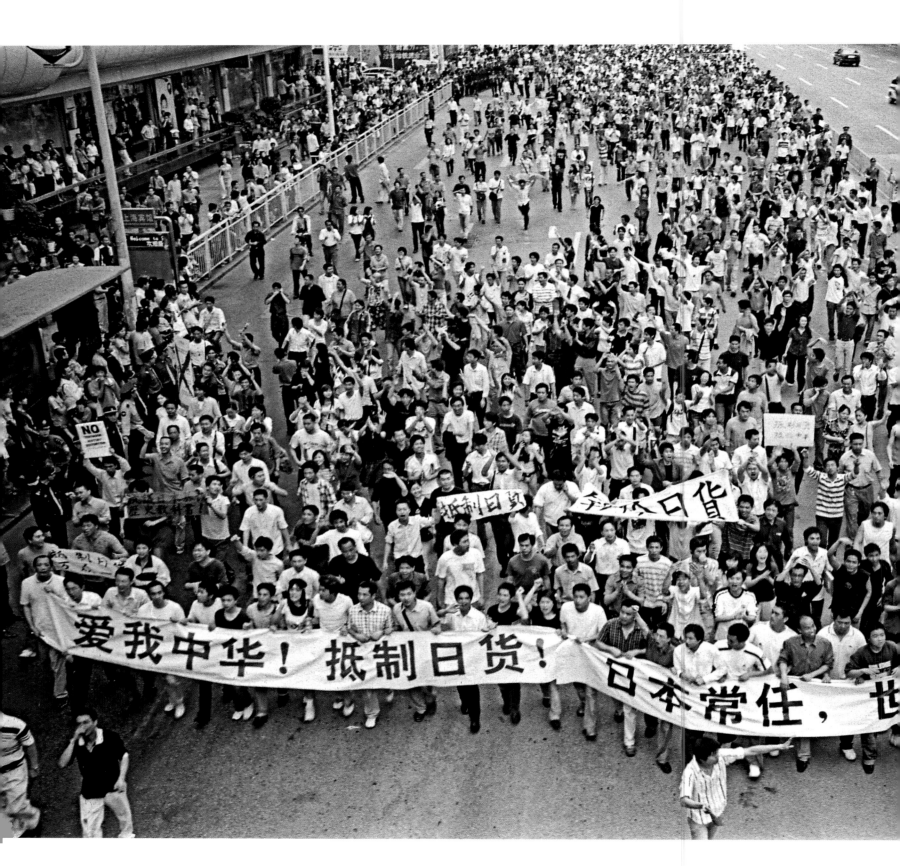

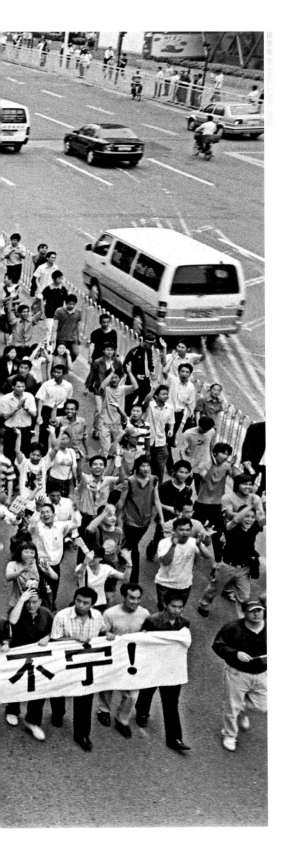

民族情緒
The Mood of the People

　　在中國越來越快地加入國際化的步伐中，幾次緣於國際問題的風潮興起。中美撞機事件、轟炸中國駐南聯盟大使館事件、抵制日貨和反對日本「入常」、中法摩擦，都在中國民間引發不小的抗議聲浪。有人擔心日益興起的民族主義情緒會影響開放的步伐，也有人期待中國崛起過程中民族意識的覺醒。其實，在中國人試圖完成現代化的百年歷史中，「國際主義」與「民族主義」是一直並行並且在糾葛中推進的兩條重要線索。30年來，中國已成為世界最大和最活躍的經濟體，在中國與世界契合交融的過程中，摩擦和衝突是難免的；在發展需求和國家利益之間，人民的思考在深入，政府行為也日益成熟。

　　During China's development, the nation has encountered many crises related to external relations, such as the 1999 U.S. the Chinese Embassy in the former Yugoslavia and Chinese consumers boycotted Japanese goods in 2005. Many people feared nationalism sparked by such incidents would affect China's pace of opening, but others felt they were a sign of the Chinese people's awakening.

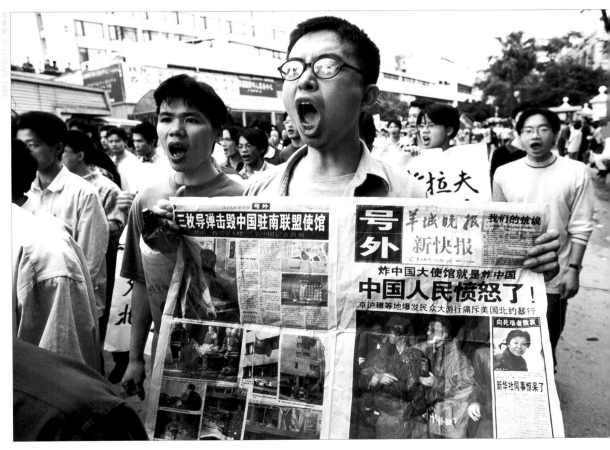

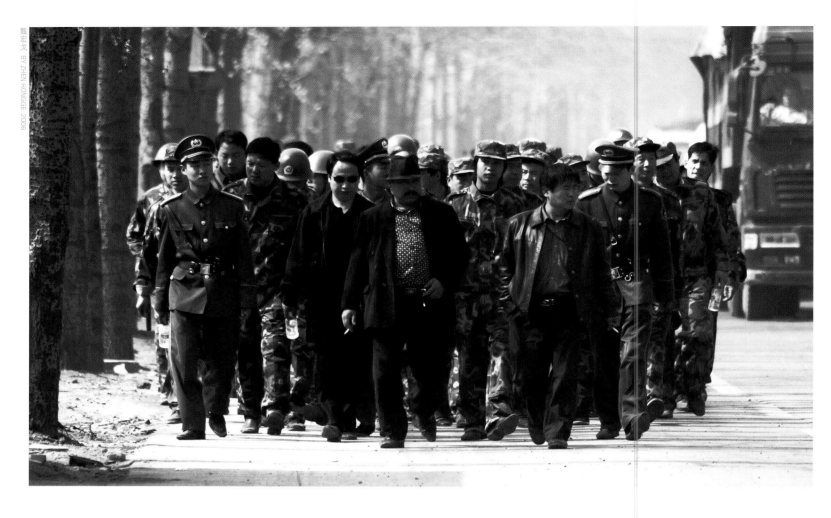

△ **村裡來了拆遷隊**

2006年4月7日，北京市豐台區羊坊村工作人員帶着大批聯防隊員去拆除違章建築。當天，豐台區花鄉羊坊村村民王豔榮家100多平方米的花棚，被當作違章建築強制推翻。

Security guards escort demolition workers on their way to remove illegally constructed buildings in Yangfang Village, in Beijing's Fengtai District, on April 7, 2006.

▷ **漫長艱辛討薪路**

2004年1月15日，北京。數十位討薪受挫的民工抬着被打傷的同伴上街抗議，整條馬路為之癱瘓。

Traffic builds up behind migrant workers who carry colleagues injured in a protest over their unpaid wages in Beijing in 2004.

衝突
Clash

　　每個社會中都有衝突，不同的時期，衝突的熱點不一樣。改革初期，在開放與保守、制度與打破制度中多有衝突；後來在「雙軌制」裡，權力尋租、特權、貪腐與平民多有衝突。一些衝突積累下來，又有放大。當房地產業興起，有關地權、房權、物權的衝突經常令人感情激動。上千萬農民工進城，勞資之間的權利衝突也時常成為社會關注的問題。在每個衝突背後，實際上都有權力使用和適用的問題，因此，官民衝突也時隱時現，有時候會以群體事件的形式暴露出來。

　　Clashes are unavoidable in any society undergoing major change. Since the early days of opening up, China has experienced struggles in many areas including opening-up vs. conservatism; power/corruption vs. the people; real estate development vs. property ownership; and migrant workers vs. employers, and more. These tensions sometimes lead to mass protest.

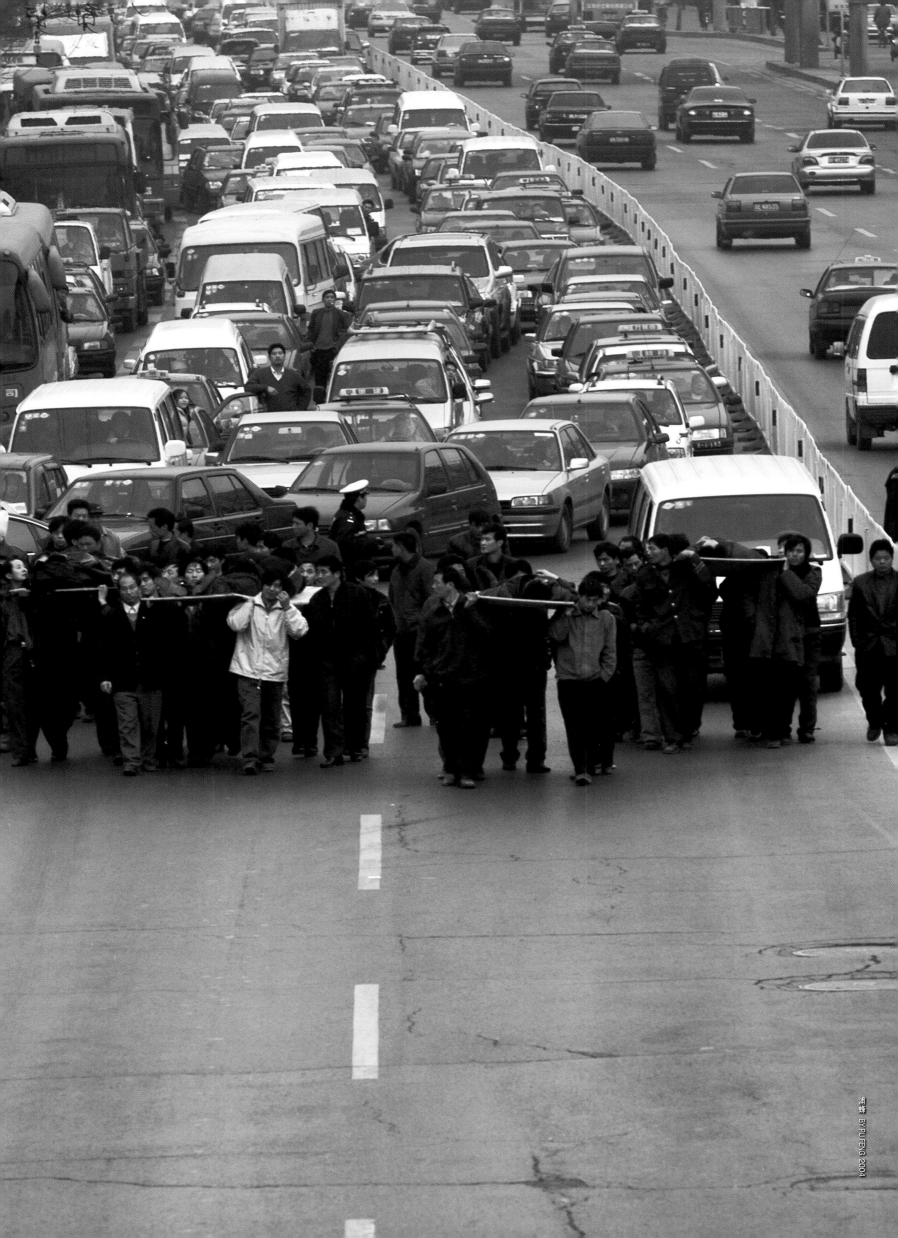

浦蜂 BY PU FENG 2004

航天
The Space Program

迄今為止，似乎並沒有一項資料表明，除了把人送到外太空，航天技術究竟在哪些地方改變和改善了人類生活。所以，這項耗費鉅資的技術更像是為人類未來發展的一項投資，着眼於人類利益而不僅是國家利益。中國加入航天俱樂部只有30多年，近10年裡以載人航天和登月工程為目標，還申明了其飛船向軌道站發展的方向。我們還應當看到，綜合國力的提升還有一個顯著標誌，這就是尖端技術向民用需求的轉移，衛星遙感遙控、大型幹線客機研製、火箭國際搭載，還有海南火箭發射場的建設，等等。在未來有更多中國色彩的國際格局下，中華民族為人類作更多貢獻是可能實現的。

China's space program is relatively young, but certainly ambitious. Its aim during the last ten years has been to send manned spacecraft to the moon and its progress toward this end began to take off in 2003, with the successful orbit of China's first manned vehicle in space. In 2007, China became the fifth nation to have successfully orbited the moon, and the nation achieved its first space walk with a three-manned vehicle in September of 2009.

楊利偉出艙

2003年10月16日，神舟 5 號飛船經歷20多個小時首次載人航天飛行任務後，在內蒙古主着陸場成功降落。圖為中國航天第一人楊利偉，平安打開返回艙艙門，準備出艙。

China's first astronaut, or *taikonaut*, in space, Yang Liwei, peers out from the Shenzhou V spacecraft after its return to earth on October 16, 2003. Shenzhou V orbited the earth 14 times over more than 20 hours, successfully completing its mission. The craft landed safely in Inner Mongolia.

青藏鐵路
Qinghai – Tibet Railway
– On Track to the Roof of the World

　　歷經30年的籌備、醞釀，青藏鐵路第二期工程在本世紀開工建設後，終於在2005年全線通車。為了這條世界上海拔最高、施工最艱難的鐵路，中央政府投入鉅資，鐵路建設者們付出了艱辛和汗水。這是一條具有重大戰略意義的鐵路，從此，雪域高原與祖國內地的聯繫更緊密，西藏的經濟和社會發展更通暢，西南邊疆更強固。

The Qinghai – Tibet Railway was a landmark project in modern China's development, connecting the remote Himalayan region to the rest of the country. It means travelers can now take the train all the way from Beijing in north China to the Tibet Autonomous Region in the southwest, in a journey that takes two days. Towering more than 5,000 meters above sea level in places, the line is the highest in the world and carriages are fitted with special oxygen supply tanks to prevent altitude sickness. Engineers were presented with many challenges while building the line due to the frozen terrain it crosses.

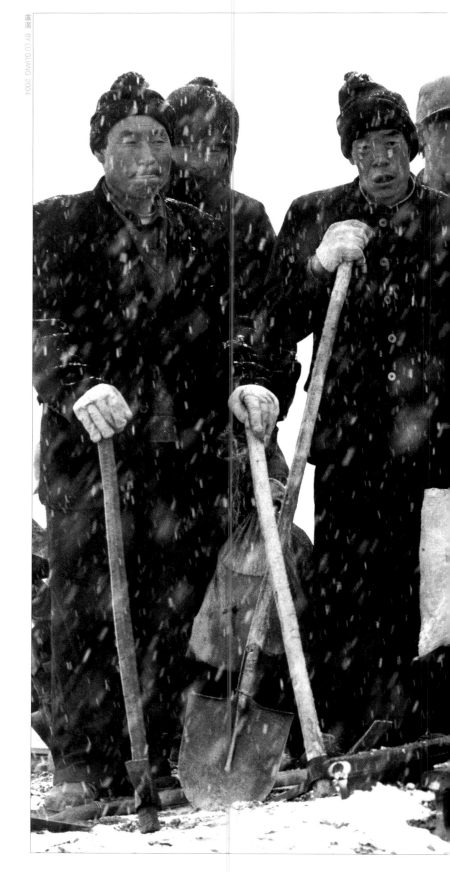

盧廣 BY LU GUANG 2004

鐵路建設者

2004年5月，風雪中的中鐵十八局青藏鐵路建設者。

A construction team stops work to pose for a photograph during the building of the Qinghai – Tibet Railway in May 2005. The first-ever rail link to Tibet, the line extended from Lhasa to Xining, in Qinghai Province.

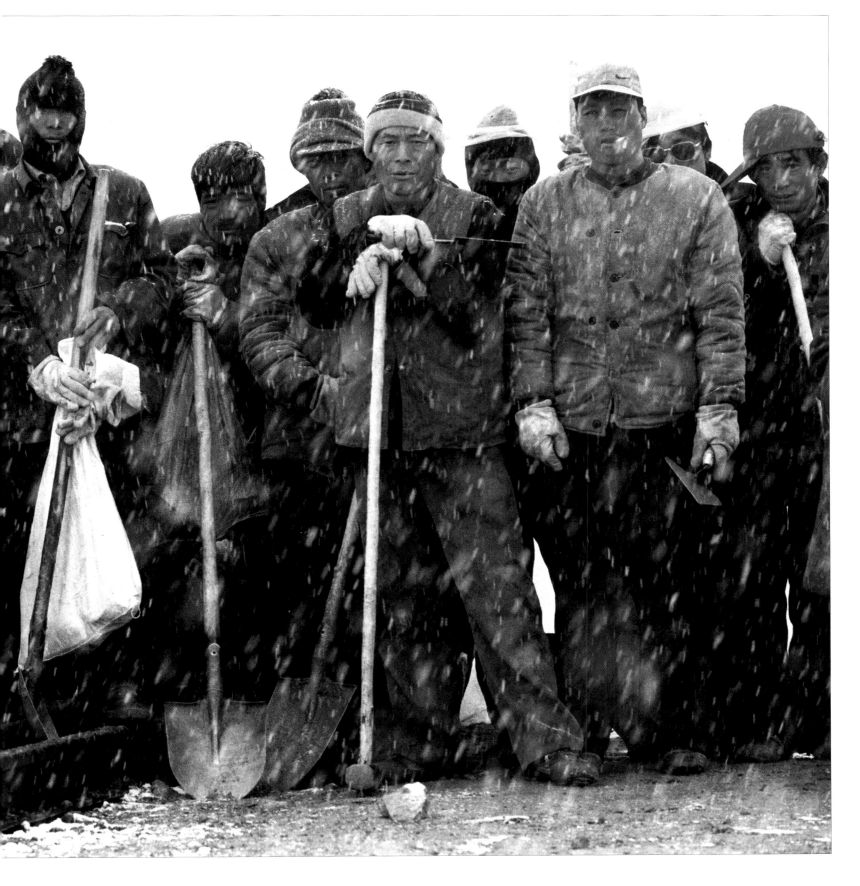

婚姻
Marriage

　　沒有甚麼比婚姻選擇和家庭關係更能反映社會觀念變化的了。1950年代擇偶的上佳人選是幹部；1960年代是軍人；1970年代是工人；1980年代是海外關係；1990年代以後則更多摻入了財富因素。與此同時，由於商業關係和經濟關係離間了情感關係，「大齡青年」也成為社會問題，而對情感和對婚姻的忠誠越來越成為人們懷戀的主題。

　　Matchmaking by parents was a long-standing Chinese tradition, before marriage became liberated, along with the rest of the nation in 1949. Since Chinese people have had more freedom to make "love matches" and choose their partners on other criteria, popular trends have shifted over the decades along with social values. Communist cadres were considered a great catch in the 1950s, while soldiers and workers were most sought after in the 1960s and 1970s respectively. In the 1980s, many hoped to marry someone with overseas relatives. From 1990 until now, however, the most popular quality of a prospective spouse, not surprisingly, has been wealth. Attempts at matchmaking by parents is also making something of a comeback in recent times, as many busy young people put finding a marriage partner on the backburner while pursuing careers. On the other side of the coin of greater social freedom: the number of divorces is said to have quadrupled since reforms, up from a negligible number during earlier years, when it was relatively difficult to obtain one.

杭州植物園萬人交友會

2006年3月19日，浙江省婦兒活動中心在杭州植物園舉辦了一場萬人公益交友活動。在活動現場，除了組織派對，為單身男女穿針引線外，婚姻專家還現場為大齡青年和他們的父母諮詢出主意。

Thousands of parents of *da ling qing nian* (single, young people older than the normal marriage age) meet in a park in Hangzhou, Zhejiang Province to find suitable spouses for their children, March 19, 2006. These events sprung up around China as social changes were making it harder for many young people to find partners on their own.

百對恩愛夫妻歡聚一堂

1999年4月24日，《恩愛夫妻相會鵬城》活動在深圳市舉行。來自全國各大城市的百對恩愛夫妻歡聚一堂。原深圳市寶安縣政府副主席，71歲的原東江縱隊戰士曾通和他70歲的妻子，粵贛湘邊縱隊老戰士施阿姨拿出50年前的結婚照說：「我們夫妻志同道合、風風雨雨、恩恩愛愛一起攜手走過半個世紀，這是我們人生最大的幸福。」

A 71-year-old man and his 70-year-old wife hold a photograph of themselves 50 years earlier as they celebrate their silver wedding anniversary on April 24, 1999.

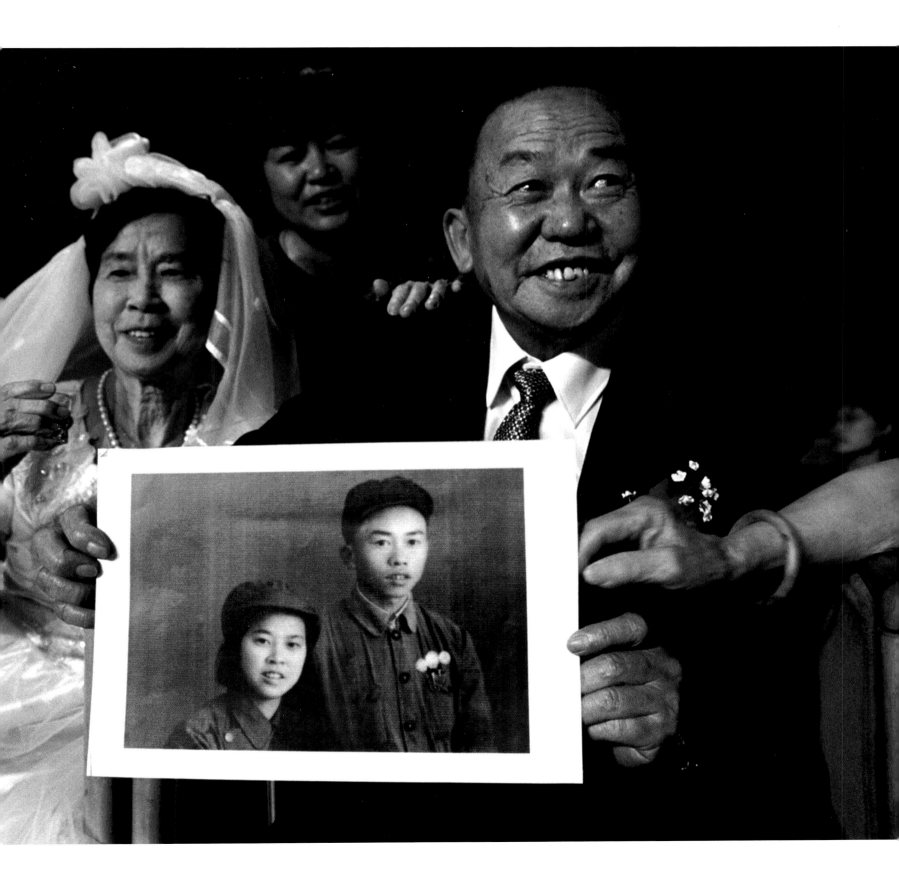

259

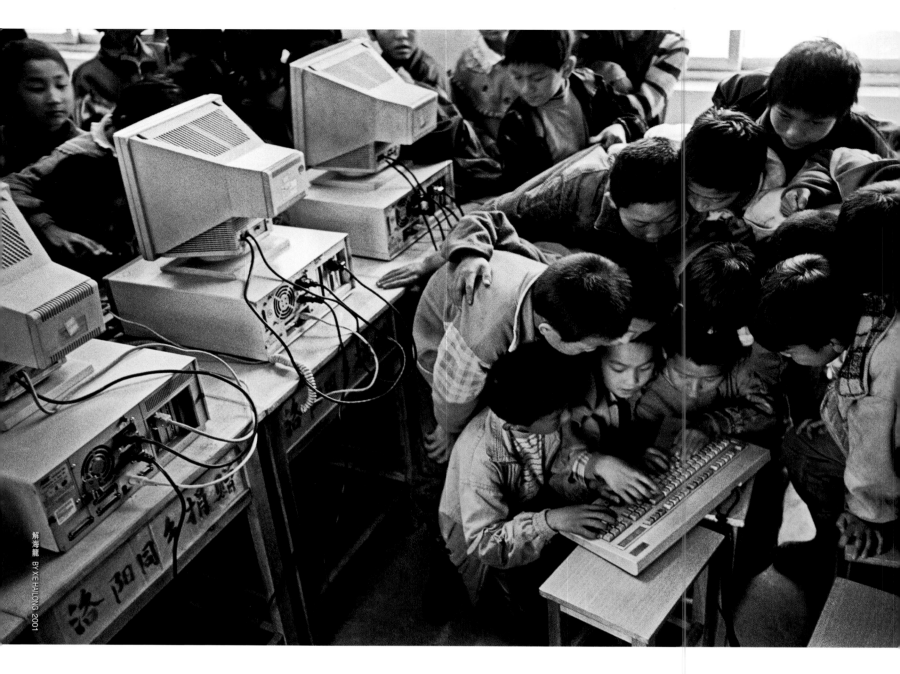

解海龍 BY XIE HAILONG 2001

新一代
New Generation Education

　　無論是「80後」還是「90後」，這些年輕一代的生活方式與上幾代已經大不相同。新一代的人生活和成長於經濟單邊上揚的時代，他們在信息獲取、消費習慣、人際交往中都更呈現開放，更少負擔。他們是「社會發展紅利」的享受者，現代都市的充分商業化給他們提供了充分的消費場所，互聯網所創造的虛擬世界給他們提供了幾乎所有可能的行為空間。作為一個新興的消費群體，「新經濟」把創新鏈條的起始都繫在他們身上。更值得注意的是，從他們中間生長的新語言、新文學，與那些生機勃勃的新生活方式一起，正在為這個社會帶來一波一波新的活力和新的問題。

　　China's contemporary young people, particularly to those born after 1980s, are living in a world unimaginable to their parents. They have more freedom to explore, to innovate and make a better life for themselves. They are keen to earn big money, to dress fashionably, and to express themselves on the Worldwide Web. Thanks to three decades of the open door policy, China's young people today also have an international outlook, which will inspire and facilitate China's future role in the world. These young people are bringing to Chinese society fresh energy as well as new problems with their new slang, new style of literature and new ways of life.

青酒吧的狂歡

2005年5月，某夜，青年人在深圳青酒吧內忘情狂舞。深圳是一個以年輕人為主的城市，到2005年，深圳有風格各異的酒吧數百間。中國都市青年一代在社會變革中獲得了與祖輩不一樣的夜生活。

Dance clubs such as this one in Shenzhen, along with bars and other venues frequented by the new generation, have spread throughout the country.

活在網上的男孩

CARBOY是一個十分適合生活在網絡社區裡的現代男孩，他需要每天「趴」在網絡上，也喜歡在網絡上結識朋友。CARBOY不少朋友都是從網絡上「下載」的，他和這些朋友在網絡上認識在現實中交流，CARBOY對現在的生活很滿意。

The government has become increasingly concerned about computer addiction among young people, and has brought in a series of measures to limit the amount of time they spend in the virtual world.

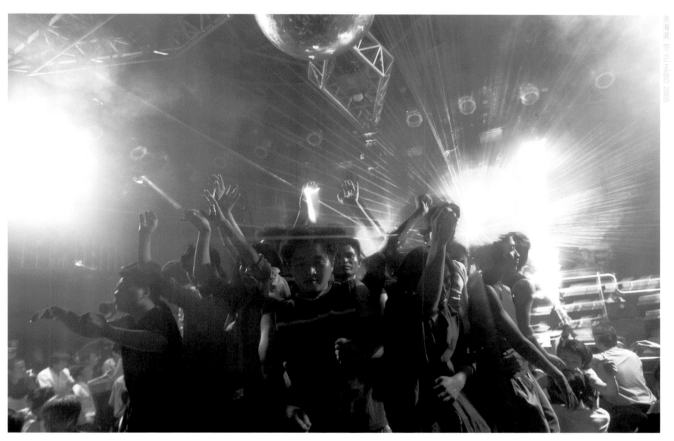

鄉村學校的午休

2006年5月5日，山西省芮城縣六官村小學離家遠的走讀學生們，利用中午時間在教室內睡午覺。

Children nap beneath and on top of their desks after lunch in a village school in Shanxi Province, May 2005.

幼稚園來了「洋老師」

海南建省後，各方有識之士認識到外語在建設新海南中的重要性，大力引進和培養外語人才。海口市英語幼稚園開始興起，許多家長用高價把子女送到英語幼稚園上學。這是從澳大利亞請來外教的海口市英特幼稚園的外國老師在上課。

A foreign teacher at work in a kindergarten in Haikou, Hainan Province. The Hainan government invited foreign teachers to help improve English education.

黃一鳴 BY HUANG YIMING 1993

微觀看教育
Education

「兩極分化」是「後改革」時代普遍出現的社會現象。不僅體現在收入差距上——作為國民素質基礎的教育，依然為人關注。宏觀地看，幾十年來政府對義務教育的投入逐年加大，教師人數、教師平均學歷水平都在提高。到2007年，全國義務教育普及率達到百分之九十九。不過，微觀地看，義務教育中城鄉之間的差距不但沒有縮小反而在擴大，這主要反映在大量優秀教師從農村流向城市。當城市民辦學校在請外籍教師的時候，農村小學、初中教師的學歷合格率只有百分之五十三和百分之三十。

China's education system involves 9-year compulsory education from elementary to high school. By 2007, gross enrollment has reached 99%. However, the gap in education quality is widening between urban and rural school with a large number of qualified teachers moving from countrysides to cities.

王文揚 BY WANG WENYANG 2007

兒童游泳班

2007年署期，北京首都鋼鐵廠體育館少年兒童游泳俱樂部的學員在做訓練。

Children are having swimming lesson at Beijing Shougang Group Stadium, Summer 2007.

2004年8月，重慶三峽庫區最後一批外遷移民乘船經過湖北省宜昌市前往江西省安置新家。在船舷邊的走廊上，3位身掛《移民證》的少年。他們未來的命運如何？可能誰也說不清楚。在三峽大壩全線建成一年後，重慶提出了從現在起到2020年，渝東北三峽庫區將向重慶主城區和萬州區繼續轉移約23萬人。二次移民計劃的產生可能和移民村受到因庫區水位上漲而造成山體移動甚至滑坡的威脅，以及嚴重水污染有關。

Three boys wearing migration identity cards peer through the railings of a boat as they leave their hometown in the Three Gorges area.

▷ 回望故鄉

2000年8月14日，重慶雲陽縣南溪鎮一位外遷移民，途經三峽峽谷時回望故鄉。自2000年8月～2004年8月，因三峽工程建設，中國政府歷時5年，從三峽庫區向東部11省市移民166,000餘人。

A child takes a last look back at the Three Gorges from the boat carrying him to a new home. From August 2000 to August 2004, the government had relocated over 166,000 people.

三峽移民
The Three Gorges Electrifies the Nation

　　1992年，人類歷史上最大規模的水利樞紐工程——三峽工程開工。儘管伴隨着尖銳的爭論，到2003年，工程依然按時下閘、蓄水、發電。與工程同時，歷史應當記住的是，三峽浩大的移民工程也在世界水利史上亙古未有。根據規劃，三峽蓄水至175米水位時，最終移民將達120萬人。這相當於一個歐洲中等國家的人口！在中國這樣一個地少人多的國家裡實現這樣大的人口遷移，是一件必定影響深遠的事。與三峽工程前後進行的還有「西氣東輸」、「南水北調」等一批國土和資源再造的巨大工程。

　　The world's largest electricity-generating plant, the Three Gorges Dam, is a hydroelectric river reservoir that spans the Yangtze River at Sandouping in Yichang, Hubei Province. The dam has been a controversial project from start to finish, as its construction meant that 1.2 million people would have to leave their homes. Officials have also admitted that the dam, completed in October 2008, by some measures has had a severe impact on the local environment.

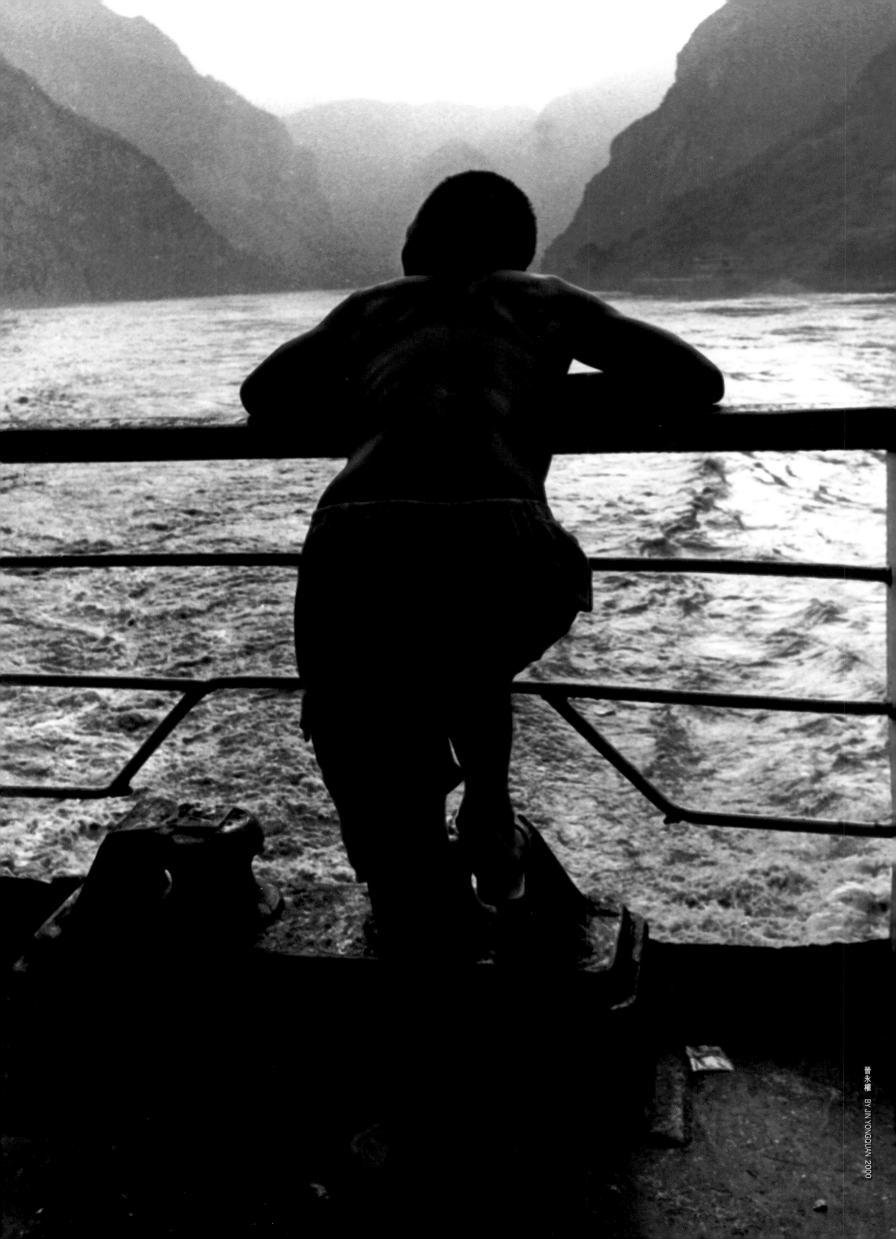

菅永權 BY JIN YONGQUAN 2000

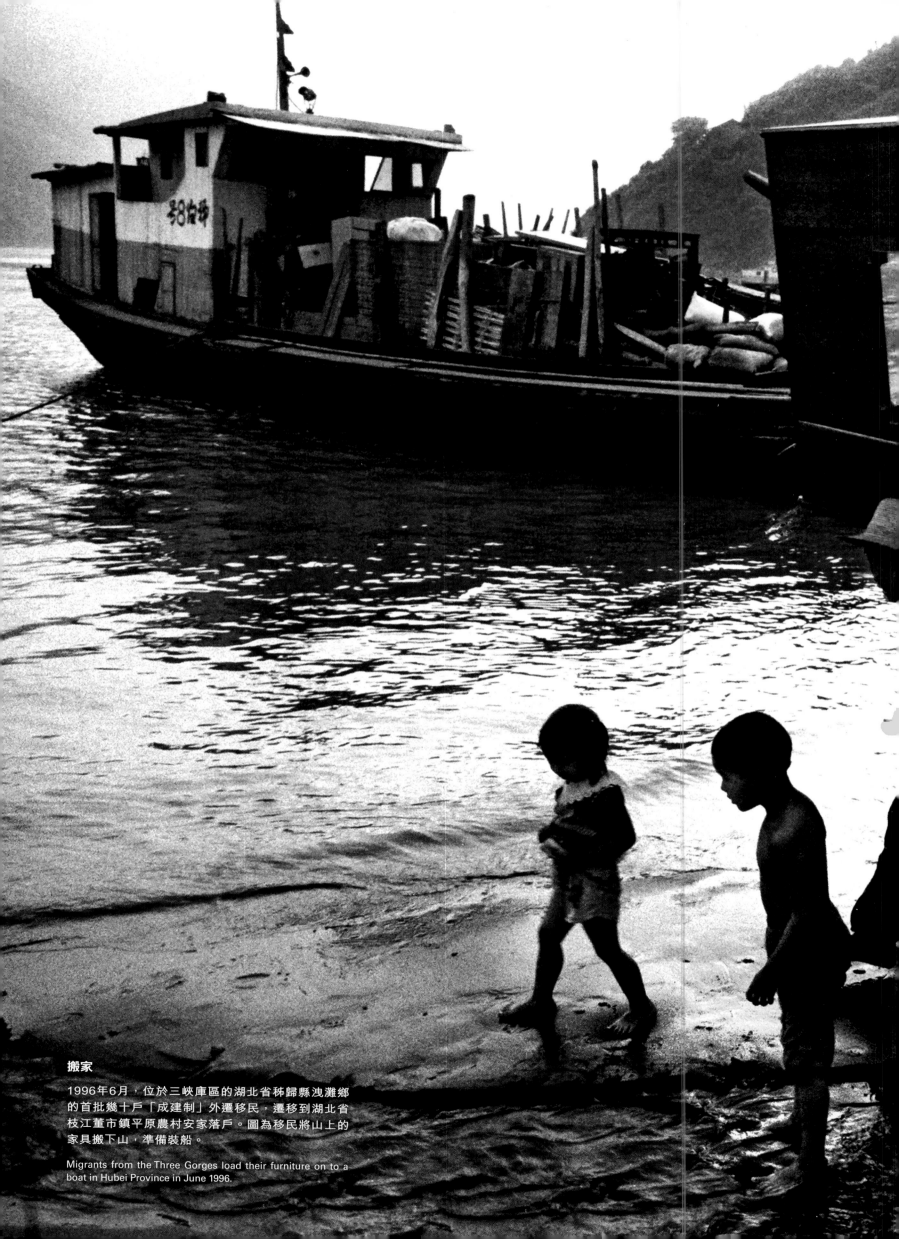

搬家

1996年6月，位於三峽庫區的湖北省秭歸縣洩灘鄉的首批幾十戶「成建制」外遷移民，遷移到湖北省枝江董市鎮平原農村安家落戶。圖為移民將山上的家具搬下山，準備裝船。

Migrants from the Three Gorges load their furniture on to a boat in Hubei Province in June 1996.

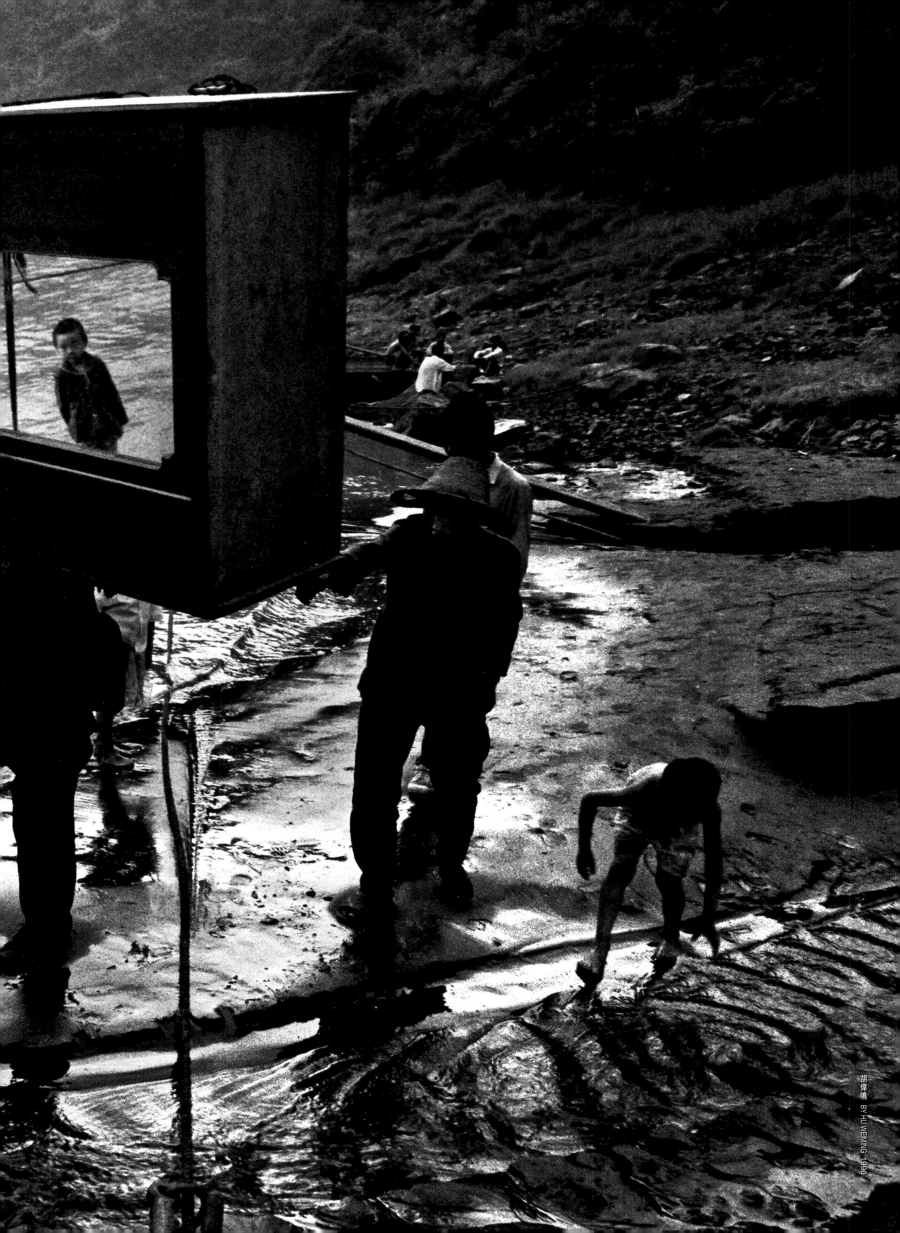

胡偉鳴 BY HU WEIMING 1996

需求拉動與投資拉動
Stimulating Domestic Demand and Investment

　　1980年代城鄉經濟活躍以後，面臨的突出矛盾是基礎設施的落後。猛然增加的人口的流動和物資流動凸顯出道路、交通工具、交通管理的嚴重不足，由此帶來的經濟損失和交通事故傷亡難以計數。不過，也正因此，「要致富，先修路」成為頗具中國特色且官民共識的口號。1990年代以後，政府幾次在宏觀經濟出現問題時，通過加大投入拉動經濟，這加大的投入又主要地落在基礎設施建設上。需求拉動與投資拉動成為近十幾年來中國經濟成長的主要發動機。

　　Since 1980, China has been lagging behind with its basic infrastructure. To improve the situation, and at the same time boost domestic demand, the country came up with the slogan, "If you want to get rich, we must first fix the roads."

◁ 繁忙的公路交通

河北省灤縣的公路上呈現出一片繁忙的景象。

A scene of the busy traffic in Luan County, Hebei Province.

▷ 擁擠的大巴

2004年，深圳特區大規模開發，開埠之初規劃80萬人口的城市，到2000年就增加到1,000多萬人口。平均每天約有300輛新車上路，公共交通也十分擁擠。每逢上下班，城區及主要道路的大巴車人滿為患。

Commuters are crammed on to a bus in Shenzhen. From 1980 to 2000, the city's population soared from 800,000 to 10 million, resulting in crowded public transport and rush-hour traffic jams.

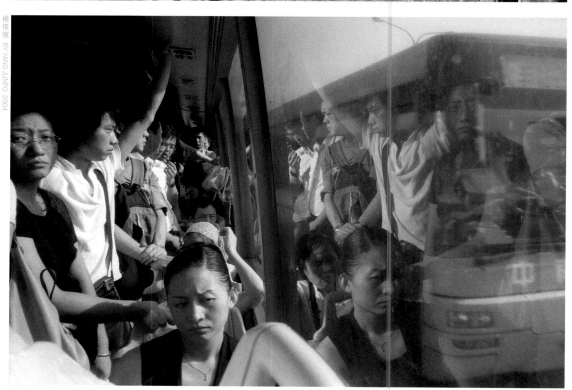

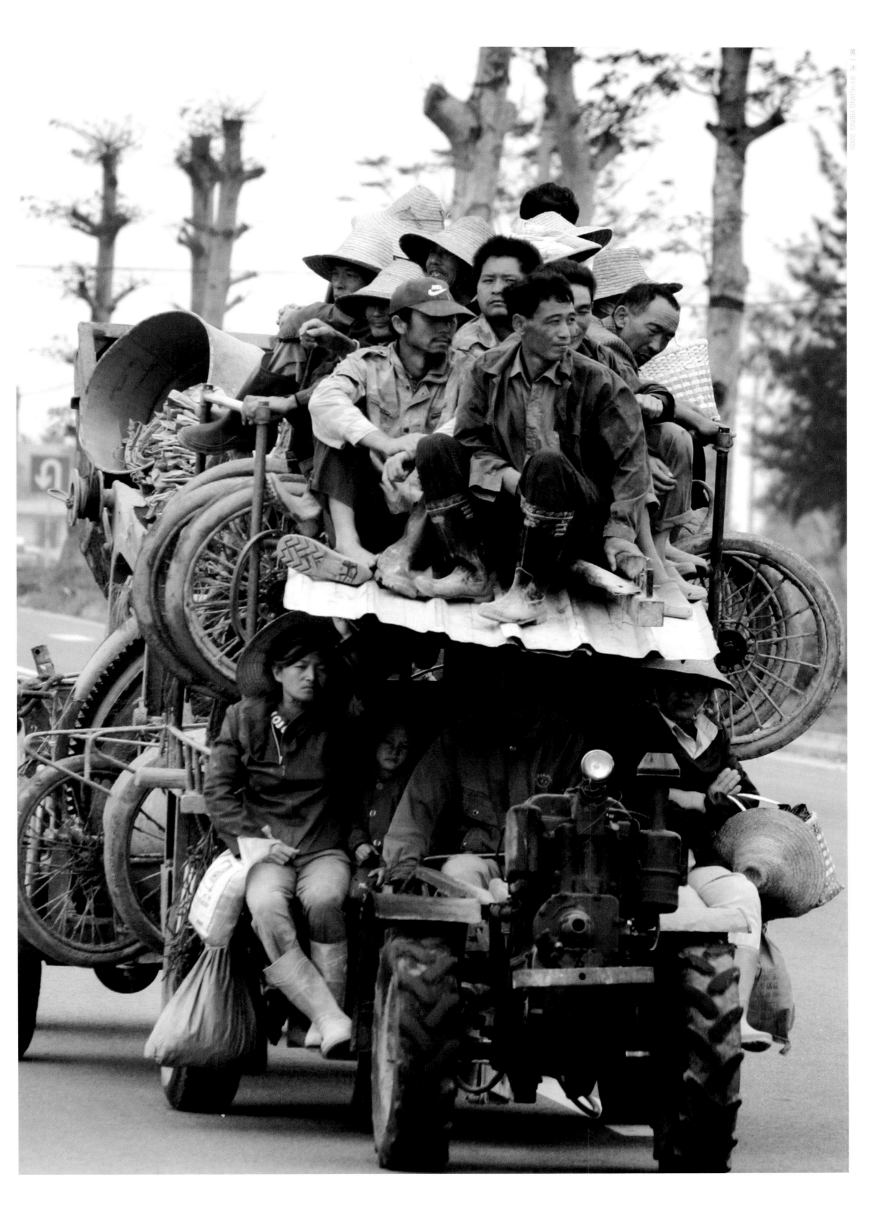

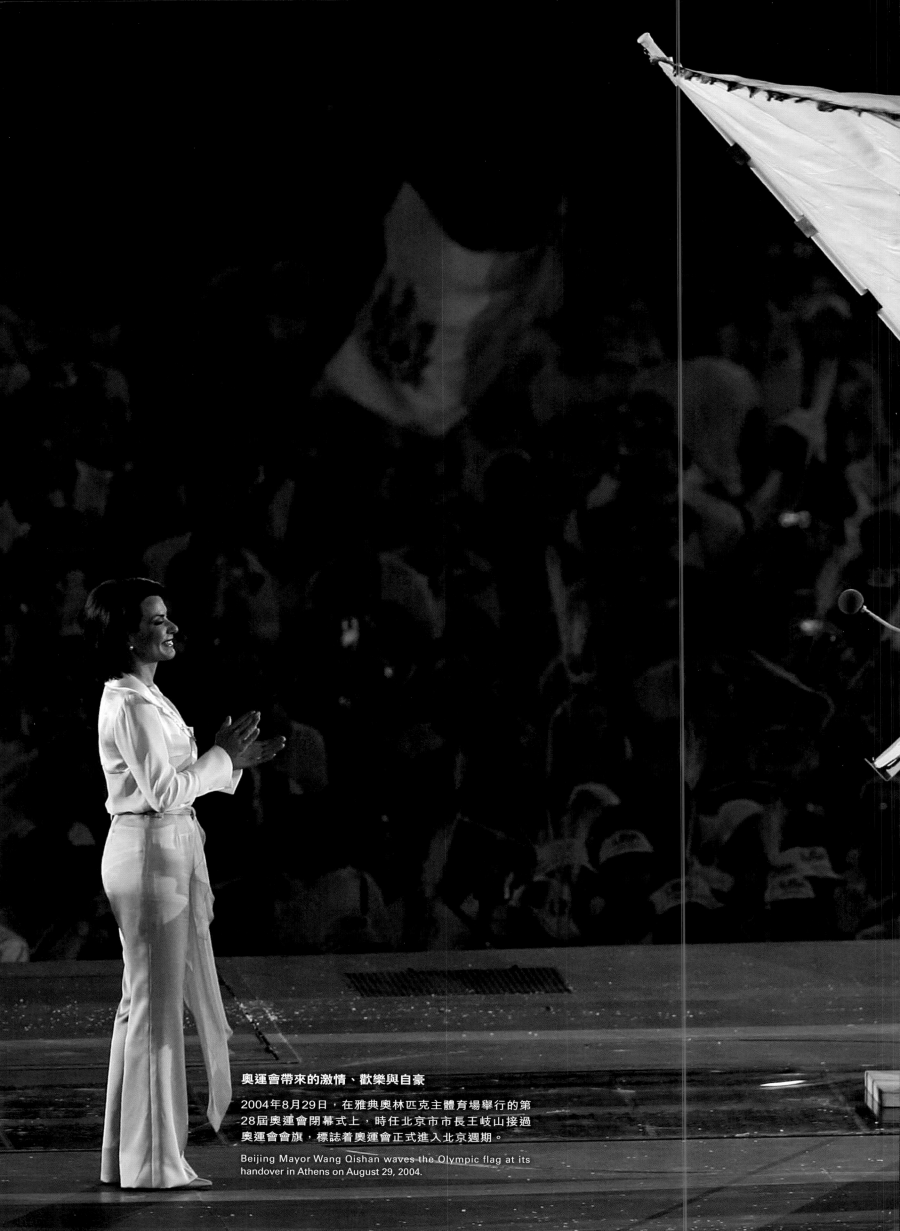

奧運會帶來的激情、歡樂與自豪

2004年8月29日，在雅典奧林匹克主體育場舉行的第28屆奧運會閉幕式上，時任北京市市長王岐山接過奧運會會旗，標誌着奧運會正式進入北京週期。

Beijing Mayor Wang Qishan waves the Olympic flag at its handover in Athens on August 29, 2004.

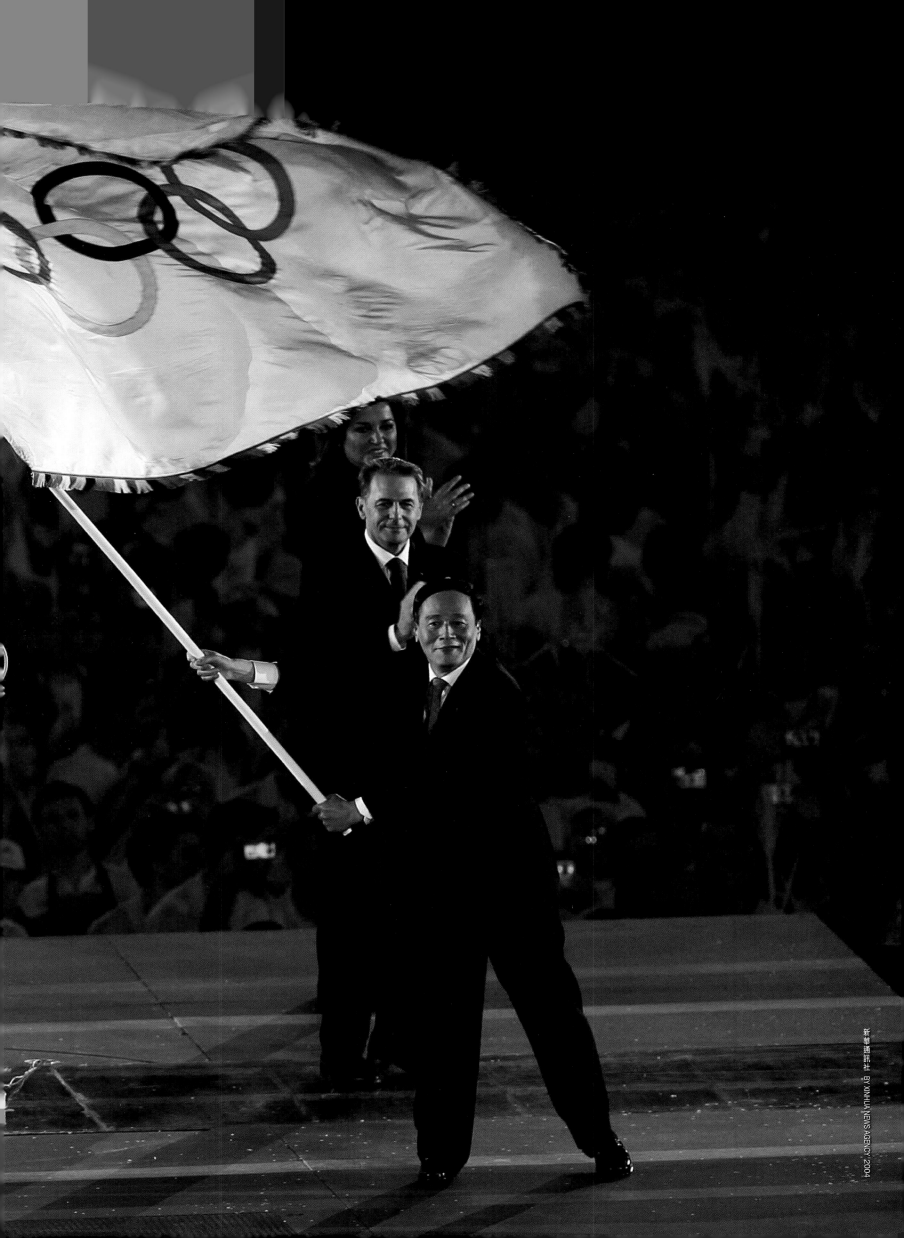

市場創新
Market Innovation

中國證券市場是中國經濟體制改革的產物。從1990年代初開始，證券市場從無到有，從小到大，在市場容量、交易品種、交易手段、清算體系以及法規建設和監管措施等各方面實現了歷史性跨越，成為亞洲僅次於東京和香港的第三大證券市場。2004年初「國九條」發佈以來，證券市場進入快速發展時期，旨在解決中國證券市場的股權分置問題的制度創新解決了困擾市場的基礎性問題，券商綜合治理工作提高了證券公司的綜合風險管理水平和經營能力。2004年8月，證監會《關於推進證券業創新活動有關問題的通知》發佈，以制度創新牽動的市場創新成為解決深層次的矛盾，推進市場化進程的發動機。

China's securities market, a byproduct of the reform and opening, was born in the early 1990s. It has grown dramatically since then in market size, diversity of products, and trading methods, and developed a clearing system, as well as laws and regulatory regimes. China now boasts the third largest securities market in Asia (after Tokyo and Hong Kong).

深圳二板市場開市

2004年5月27日，深交所中小企業板正式啟動，中國的二板市場建設也從這天開始正式起步。作為二板市場的雛形，中小企業板啟動將對中國高科技產業的發展產生推動作用。

Ringing in the changes: the Shenzhen Stock Exchange on May 27, 2004, formally launched a board for the listing of small and medium-sized enterprises (SMEs), to help boost the development of China's high-tech sector.

金融
Finance

「開放」就是中國經濟加入世界經濟體系的代名詞。30年來，中國經濟的蓬勃發展，已經成為世界上最大的經濟體，在「金融危機」爆發後，更被公認為世界經濟的發動機。在經濟學家們還在討論中國經濟總量是在2009年還是2010年超過日本的時候，CCTV編播了一部題為《大國崛起》系列片，並引起了一番爭論。如果放眼過去500年的人類歷史，中國的崛起確是事實，問題是中國崛起的內涵是否均衡，是否可持續，以及中國與世界的關係。

For 30 years, China's economy has boomed, becoming the world's biggest economic system. Beginning in the 1990s, China began to create its own banking and finance sectors to provide capital to match the economic miracle. Following the 2008 financial crisis, the country's economy was widely acknowledged as a key driver of world economic growth.

美聯儲主席格林斯潘出席 G20 會議與周小川交談

美國聯儲局主席格林斯潘與中國人民銀行行長周小川在2005年第 7 屆20國集團財長與央行行長會議上。他們是對手，又是朋友，一位因美國的金融危機備受批評，一位則因外匯儲備過大而備感壓力，人民幣真正成為國際貨幣是中國面臨的巨大挑戰。

Alan Greenspan, Chairman of the U.S. Federal Reserve, holds a hushed conversation with Zhou Xiaochuan, Governor of the People's Bank of China, on October 15, 2005, during the 7th Group-20 Summit in Hebei Province.

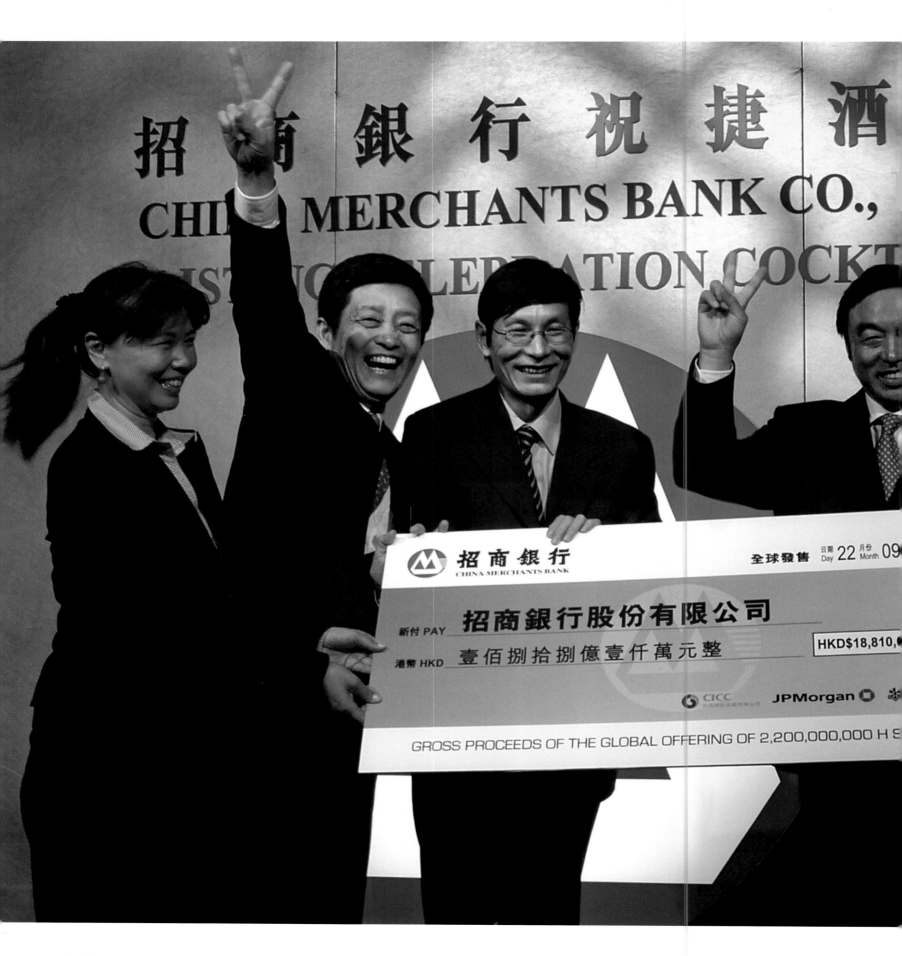

摄影 BY WANG MIAO 2006

金融變革
Financial Reform

　　曾有西方人士預言，中國的銀行在技術上已經破產，中國金融體系將面臨崩潰。但是，在本世紀初啟動的中國國有銀行的改革，歷經重組、引進戰略投資者、整體上市，在2005~2007年兩年時間內完成了建設銀行、中國銀行和工商銀行的海內外證券市場上市，股份制銀行也邁向國際資本市場。中國的銀行頂住了此次全球金融危機的衝擊，成為目前世界上市值最大，贏利最多的銀行。

　　Some people in the West once predicted that China's banks had become technically bankrupt and China's financial system would collapse. However, China began to reform its state-owned banks from the beginning of this century, including reorganization, acceptance of strategic investors and issuing shares on stock exchanges. China Construction Bank, Bank of China and the Industrial and Commercial Bank of China all completed their initial public offerings on domestic and overseas stock exchanges during the period of 2005 – 2007. China's banks have weathered the storm of the current global financial crisis and become the biggest (in terms of market capitalization) and most profitable banks in the world.

股份制招商銀行在香港成功上市

2006年9月22日，招商銀行H股上市成功後的祝捷會上，董事長秦曉、行長馬蔚華接受主承銷商中金、瑞銀，摩根大通融資支票。

The cocktail party celebrating China Merchants Bank's (CMB) listing on the Hong Kong Stock Exchange on 22 October, 2006. Qian Xiao, Chairman of CMB and Ma Weihua, president of CMB are receiving the check endowed by He Di, Vice Chairman of UBS Investment Bank and Zhu Yunlai, CEO of China International Capital Corporation Limited.

吳儀與保爾森共同主持首次中美戰略經濟對話

2006年12月14日，首次中美戰略經濟對話在北京人民大
會堂開幕。中國國家主席特別代表、國務院副總理吳儀和
美國總統特別代表、財政部長保爾森共同主持此次對話
會。圖為吳儀與保爾森步入會場。

U.S. Treasury Secretary Henry Paulson meets Chinese Vice Premier
Wu Yi at the Great Hall of the People in Beijing, December 14, 2006.

中美經濟高峰會
China and America Talk

　　北京的鐵娘子面對華爾街的悍將，中美經濟高峰會開拓了世界最
大的發達國家與發展中國家的對話，對話從2006年開始，至今已進行
多次，成為中美關係中最重要的事項之一，也是中美關係走向成熟的
標誌。

　　The China – U.S. Strategic Economic Dialogue (SED) was created in an effort to
boost relations between the United States and the People's Republic of China. Initiated
in 2006 by President George W. Bush and President Hu Jintao, it is described by officials
as a framework in which the two sides can discuss topics of mutual concern. Top leaders
of both countries meet twice a year alternating between China and the United States.
Under the Presidency of Barack Obama, the SED was expanded to give the U.S. State
Department a bigger role and was renamed the U.S. – China Strategic and Economic
Dialogue. The talks have been particularly helpful in keeping the two sides in close
conversation in the aftermath of the 2008 financial crisis, when both sides have had many
issues of mutual concern about the state of world finance to talk about.

維權
Consumers Get Protection

　　還有一個新詞兒也在30年中、後期流行:「維權」。因為消費者在商業活動中容易處於被動、弱勢地位,所以這個詞基本上指的是維護消費者的權益。還有以「打假」、「維權」為目的的專業組織和專門人士出現。商業活動的泛濫以及趨利動機下的種種欺騙、造假行為有時候會釀成激烈的衝突,使這種「維權活動」呈現某種情緒激昂的街頭形式。不過正是在這類衝突中,公民權利間的制衡機制逐漸形成,法律、社會組織和商業規則也在逐步完善之中。

With a burgeoning middle class, demands for consumer rights have come to the fore in China. As a result, the Consumer Protection Law came into effect on January 1, 1994. It was created specifically to protect the interests and safety of end-users of products or services, and is overseen by the Consumer Protection Commission, which issues public notices about unsafe products or services.

「血淚維權」

2006年3月15日,中國鄭州的房產消費者打着「血淚維權」的橫幅,支援「3.15維權日」。我國房地產行業的投訴數量居於十大投訴榜首,消費者主要反映購買的商品房存在面積縮水、房屋建築質量差、用料環保指數嚴重超標、物業管理等問題。

March 15, World Consumer Rights Day, 2006. Homeowners in Zhengzhou, Henan Province, hold a demonstration behind a phalanx of policemen to complain about the poor quality of their apartments.

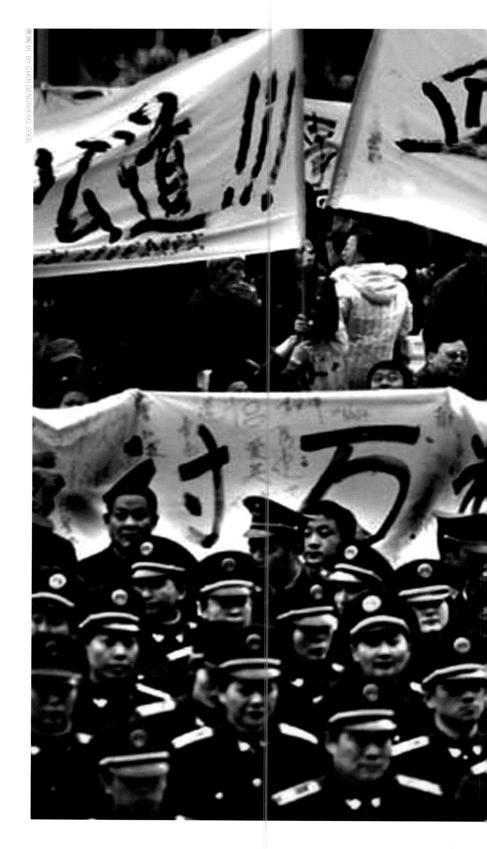

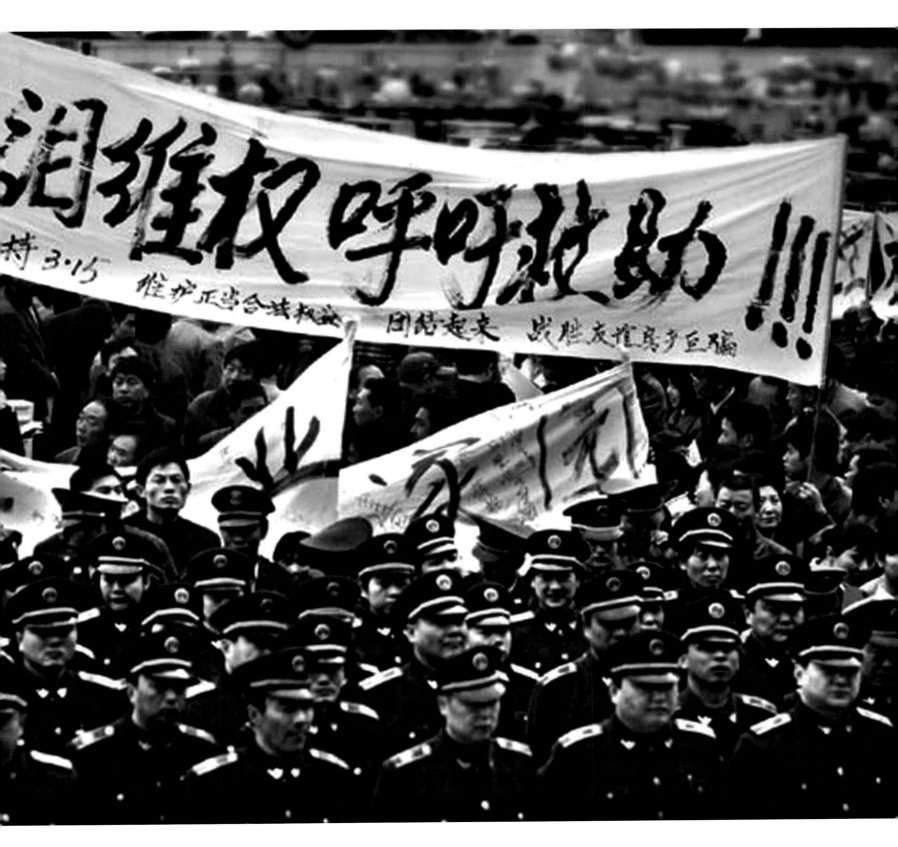

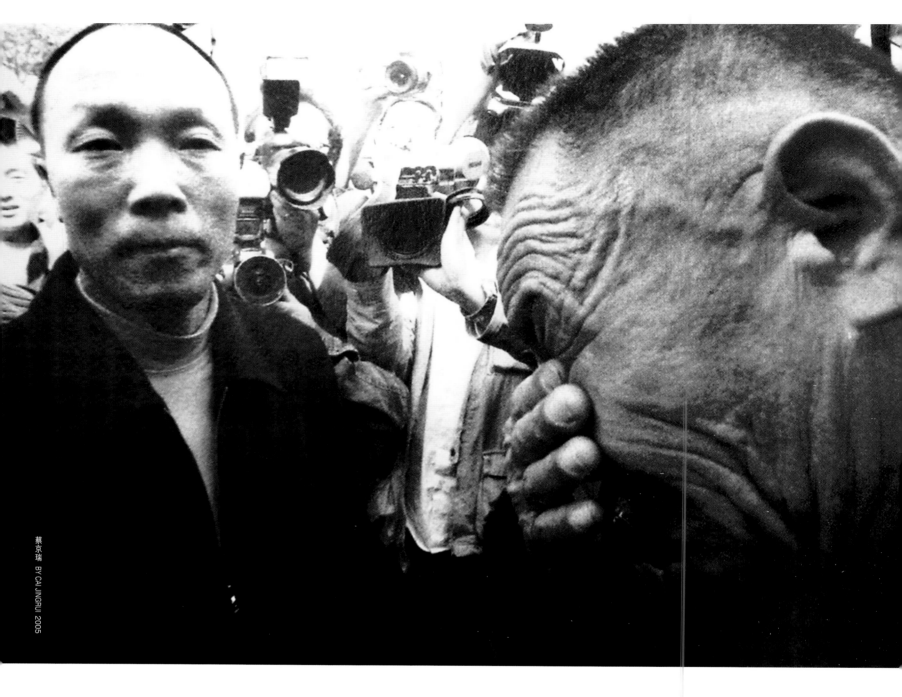

11 年，沉冤得雪

2005年4月13日，在湖北省京山縣，沉冤得雪的佘祥林終於回家。經歷了生離死別的父子相見，無語凝噎。11年前，佘祥林因「殺妻」罪名入獄。11年後，妻子突然現身，佘祥林方得以除去罪名，釋放回家，並獲國家賠償45萬元。

Convicted murderer Xu Xianglin (right) weeps at the reunion with his son after his release from prison on April 13, 2005. Xu, of Jiangshan County, Hubei Province, was acquitted of killing his wife after serving 11 years in prison. His name was cleared after his wife, whose body was never found, turned up alive and well. The government paid him 450,000 yuan in compensation for the miscarriage of justice.

法制建設
Rule of Law Takes Hold

　　據說一個北京法官一年要審結200多樁案子。這個數字真是耐人尋味。法律是調整人們社會行為的準繩，是國家制度建設的基礎。30年來，中國法制建設的成就不僅體現在那數以千計的成文法規的完善上，也體現在老百姓自覺地用法律衡量自己的社會行為，通過法律求解自己的困惑和困境上。在這個過程中，各種形式的法律服務、法律幫助滲透進社會生活和經濟生活之中，當然，也有執法過程中的許多粗糙為人所詬病。

　　It is reported that a judge in Beijing handles an average of 200 cases per year. It is a telling figure. During the past 30 years, the progress in the development of China's legal system can be seen not only from the thousands of laws and regulations passed, but also from the fact that Chinese citizens are increasingly using legal means to protect their rights and settle disputes.

城管隊街頭查抄

2006年3月9日，城管隊員身着便裝，對北京木樨園地區進行查抄。

Unlicensed street vendors spill their goods as they flee approaching urban management officers (known as *chengguan*) in Beijing, March 2006.

公安局長接訪

2005年5月18日，瀋陽市公安機關面對面接待信訪群眾的「大接訪」首日。322名上訪群眾當面向局長「訴冤」。為了維持秩序，上訪群眾需要經過登記——填表——排號——等待——面對面的程序。

A police commander stands behind the station gates as more than 300 people seek to submit petitions presenting their grievances in Shenyang, Liaoning Province, on May 18, 2005.

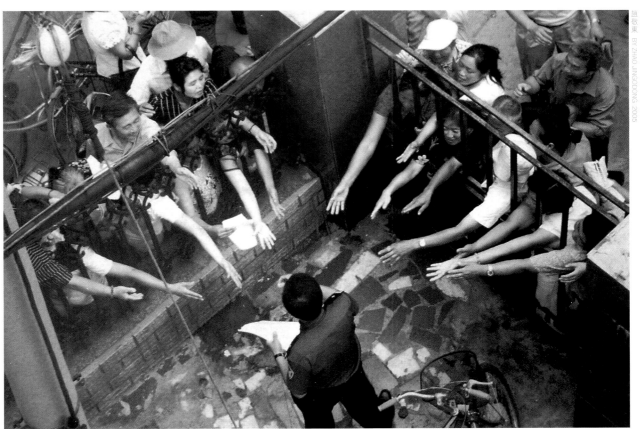

礦難
Mining Accidents – Pit of Despair

　　頻發的礦難考驗着官員和公眾的神經。一方面，經濟高速成長加大了對能源與礦產資源的需求，為此，民間的礦產開採一度得到放縱，但其普遍的安全隱患迅速暴露。另一方面，腐敗的滋生與權力尋租在高利潤的礦產行業中尤其嚴重。再加上大量低素質勞動力在這類勞動密集型產業就業，缺少權力維護機制，礦難問題與普遍的勞動保護缺失是同一個問題，在付出了許多慘痛代價之後，像礦難這類盤踞着諸多社會積弊的問題，還需要強化綜合管理才可能得以緩解。

　　With its insatiable appetite for coal, it is no surprise that China suffers from the world's highest number of annual mining fatalities — 80 percent of the global total. According to China's Xinhua News Agency, there were 188 accidents between January 2001 and October 2004, each claiming an average of ten lives. In 2006, the Work Safety Supervision Administration said there had been 4,749 fatalities in mining accidents ranging from explosions to floods. But other estimates from labor rights groups suggest that as many as 20,000 miners die in accidents each year in the country. In an attempt to tackle the problem, the authorities have adopted various measures. Following the devastating Sunjiawan mine disaster in 2005, in which more than 200 died, the State Council promised a three-million-yuan investment to fund gas monitoring technology. Nevertheless, many problems exist with small, unregulated mines, with no apparent safety standards.

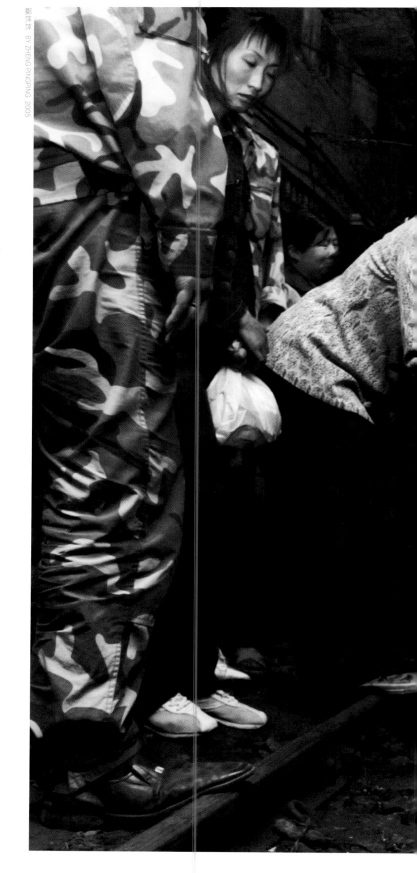

鄭萍萍 BY ZHENG PINGPING 2005

承德暖兒河礦難

2005年5月19日凌晨3時20分，承德暖兒河礦業有限公司礦井下發生瓦斯爆炸，51人被困井下，生死不明。經搶救，1名礦工生還，並相繼發現49具遇難礦工遺體，另有一人失蹤。圖為哀慟的遇難礦工家屬。

Relatives of miners hear the bad news after a coal mine gas explosion in Nuan'erhe, Hebei Province, on May 19, 2005. The blast claimed the lives of 50 miners.

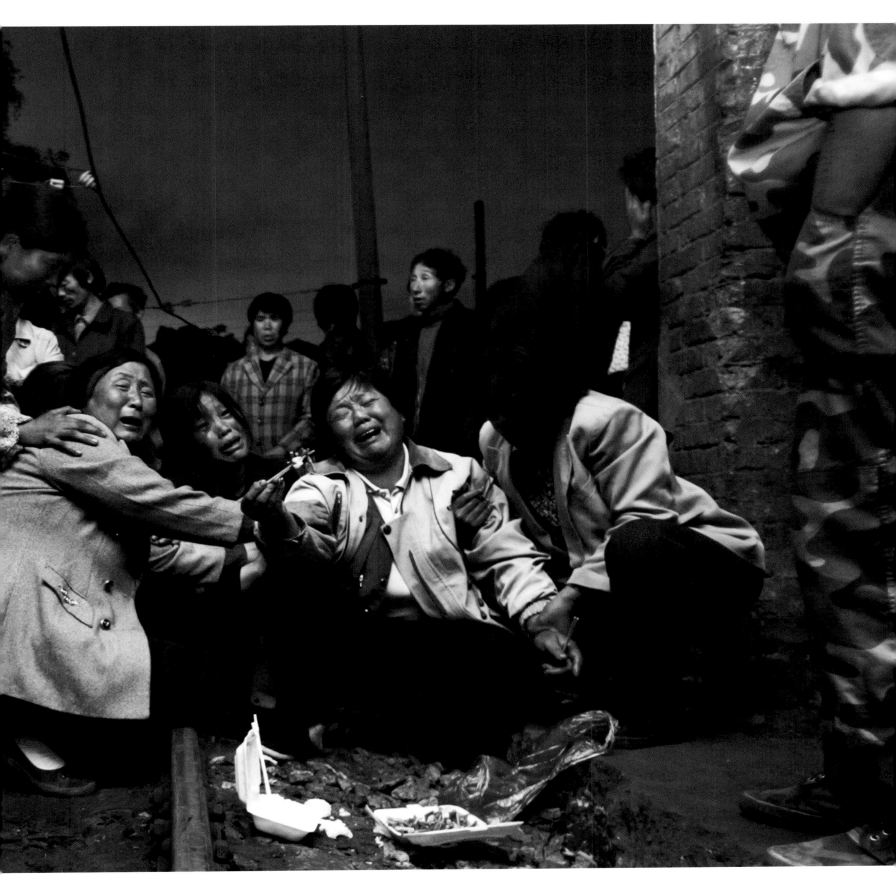

雍和 BY YONG HE 2005

禽流感
Bird Flu Hits China

一種本來在禽鳥中傳染的疾病，1997年進入香港，2003年進入大陸並在2005年幾乎泛濫。雍和的這一張照片畫面語言精粹、簡潔，在同題材的新聞攝影中幾乎無出其右。因為有了2003年應對大規模SARS疫情的經驗教訓，這一回政府、輿論、公眾的應對，鎮定而且有條不紊。應付突發災害性事件的社會機制顯然正在成熟起來。

Following the panic brought by SARS in China, the country is particularly wary of pandemics. Bird flu is one such disease that has claimed a number of lives in the country, but has yet to take hold in a major way. Fears were raised in early 2009 when a number of outbreaks were reported in north China, leading to several deaths, but the disease sputtered out with the arrival of spring. Experts feared that the virus could mutate and begin spreading from human to human, as happened with the less deadly swine flu. Bird flu was first reported in China in 2003, with the most serious outbreak occurring two years later. By 2009, 25 people had died from avian influenza in China. Globally the virus has claimed more than 260 lives.

風聲鶴唳

2005年11月15日，在外地進入上海市區的8個交通道口，動物檢疫人員佈下層層防線，對裝載家禽的卡車進行檢查，抽血驗樣，嚴防病雞病鴨進城。

An animal quarantine official tests chickens in a truck bound for Shanghai after a major outbreak of avian influenza in 2005.

營銷
Marketing in the New Consumer Age

　　市場經濟的基本律動圍繞着銷售進行。今天的中國可以被理解為一個大工地，一個大市場。無論作為銷售者或是需求者，人們都處在一個大的物流平台的這一端或那一端。中國人的智慧被賣東西的需求刺激着，為所有的需求提供供給，為所有的供給提供渠道，為所有的渠道提供服務。對一種「人」的界定越來越時興：「商務人群」，指的是那些從事商業活動並有特定消費能力的人群。這個幾十年前被叫做「推銷員」的人群現在成了商家的新寵。關於營銷的著作擺滿了書店的各個角落，更有著作的名稱就叫《營銷中國》。

Since the launch of the reform and opening policy, China has adopted many Western business practices, including marketing techniques. Businesses now need to spend billions on promoting their products across a range of media, from traditional newspapers to the Internet. Companies now vie to get their products placed in any public arena they can. Soap operas are a popular format, and famous brands are often prominently visible on the set. News and sport commentators also make a point of ensuring that the camera can see exactly which locally made brand of laptop computer they're using.

史上最牛業務員

2007年11月13日上午，在廣東東莞南城勝和大朗街，一名身穿南城醫院病服、頭部被包紮着的中年男子右手抱着輸液鐵架，左手拿着手機，邊打電話邊急步行走着。男子自稱從事服務性經營業務，此前在病房接到一客戶電話，趁醫務人員不注意，忍不住溜出來想談下業務。

A salesman continues working outside a hospital despite being hooked up to a drip.

商家促銷牀上用品

2007年1月27日上午，重慶市區南坪某超市門外一場牀上用品推廣活動。商家打出「挑戰你的勇氣和自信」的旗號：只要女性顧客身着內衣當眾體驗牀上用品，就有機會贏取價值1,260元的禮包。活動僅限18～25週歲的女性參加。

A woman tested bedding in a promotion outside a supermarket in Chongqing in January, 2007. A bedding supplier promised female customers aged between 18 and 25 a chance to win gifts worth over 1,000 yuan if they agreed to try out the beddings in their underwear in public.

相容
Co-Existence

　　與改革開放之初面對新事物的大驚小怪相映照，世紀末，人們對各色新鮮事物多了許多平和甚至漠然。當然還有那些商業炒作，不過人們對炒作也不那麼大驚小怪了。與此同時，傳統、民間、土著的各種文化也在重新興起，在寬鬆的氛圍裡找到它們繼承和展開的空間。從容的基礎是寬容，而寬容是自信的表現。這個社會經過了30年的變遷，正在自信起來。

　　When China's opening to the outside world began, people tended to overreact (in favor or against) to new, and particularly foreign things that came in with the breeze of the open door. By the end of the century, reform and opening had progressed to the point that Chinese people were accustomed to, and tolerant of new forms of art and culture. Now, in a sign of Chinese society's new comfort level and confidence, they peacefully coexist along with Chinese folk, ethnic and traditional cultures (some of which, themselves, are experiencing a new round of revival in the more relaxed environment).

黃｜冰｜BY HUANG YIBING 2002

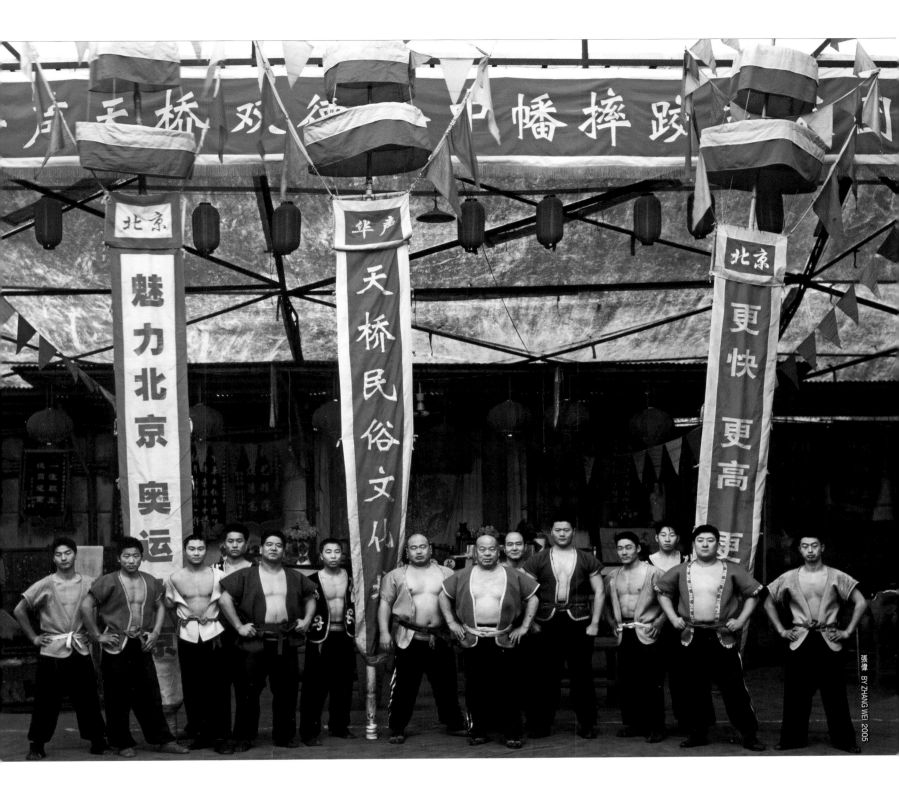

張偉 BY ZHANG WEI 2005

人體彩繪

2002年海南島歡樂節首屆國際人體彩繪藝術大賽在三亞市西島旅遊區舉辦。來自中國、美國、加拿大、阿根廷、俄羅斯、瑞典、芬蘭、新加坡、羅馬尼亞等30多個國家和地區的人體模特參加了比賽。北京、上海、廣州等城市的彩繪師登台競技。12,000多名遊客免費欣賞了這一目前在中國尚屬前衛的裸露藝術。圖為2002年11月26日，在海口新世界商城舉行的人體彩繪表演現場。

Preparing for the first of International Festival of Body Painting in Sanya, Hainan Province in 2002. Models from more than 30 countries participated in the festival.

北京跤藝傳人

跤藝源於清朝皇家善撲營。民國初年，原善撲營跤手無以為生，遂擇地賣藝，令跤藝成為京城逐漸興起的一項娛樂活動。老北京跤藝的傳人雙德全和其弟雙德祿創建的跤場，是北京現存的唯一的一家民間跤場。由於空手道、跆拳道等「洋」體育的強力競爭以及市場的疲軟，老北京跤藝的生存空間被逐步壓縮，生計艱難。2007年4月，「老北京跤藝」被列為北京市級非物質文化遺產項目。

Traditional wrestlers gather for a competition in Beijing's downtown Tianqiao area, a place known for Beijing's traditional folk art. Their art has been listed as an "intangible cultural heritage".

BY SONG QIAO 2007

民生
Livelihood

　　中國最主要的「特色」就是人多。人多需求多、問題多。解決甚麼事情都要動員巨大的社會資源，發生甚麼問題也牽涉到眾多的人口。改革進入21世紀初葉，各種社會問題積纍，熱點、難點問題集中呈現，群體事件層出不窮。被稱作「胡溫體制」的新一代領導人疾言「權為民所用，情為民所繫，利為民所謀」的「新三民主義」，在農業、農村和農民問題上加大投入，完善社會保險制度，推動醫療改革，關注大學生就業，與網民直接溝通，給房地產市場降溫……眾多社會問題非一時能夠解決，但政府的親民姿態得到不少好評。

Graduates Struggle

Graduate unemployment in China has been a long-term headache for the governing class. The recent upsurge is linked to education policy-making and economic development, as well as crises and reforms affecting the economy. By 2008, university enrollments had risen by about 6 million, with 24 million students in total. Given that students are typically society's most ideologically charged and outspoken critics, it is no surprise that the problem has gained widespread media coverage and that tackling this problem has become a major priority.

Healthcare on Life Support

Healthcare reform is a long-ongoing project for the People's Republic of China. Policymakers have spent much time studying foreign models, but have yet to create a definitive system that suits China's needs. For now, the focus seems to be on making sure the poorest in society can get basic care and improving administration management and the health insurance system.

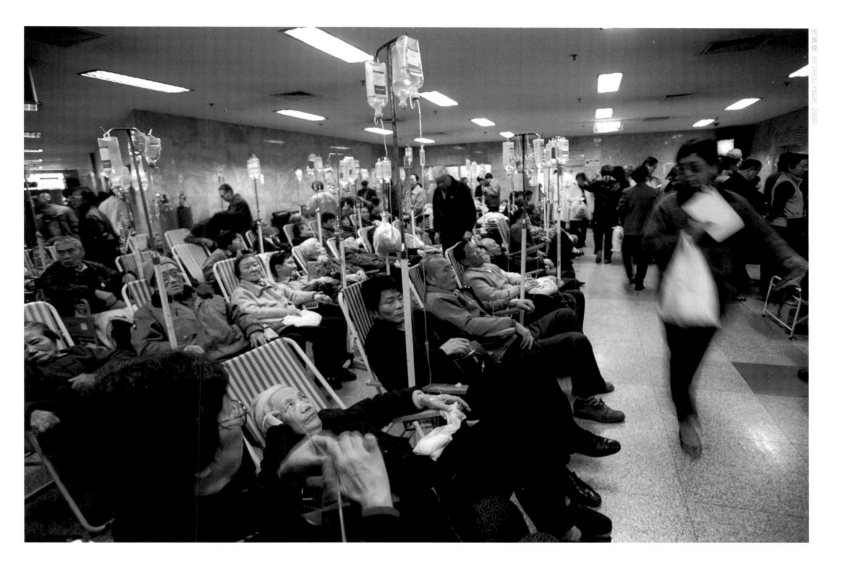

圖寬傑 BY ZHOU YINJIE 2000

應屆大學生就業難

一位進入室內正在應聘的大學生，身後是數以萬計正在尋找工作的應屆大學生。2007年江蘇省2008屆畢業生招聘會大約有5.8萬應屆大學生來此尋找工作，一些熱門職業出現數百人競爭一個崗位的情況。

A young man is interviewed in a room (right), while thousands of graduates (left), search outside for vacancies at a job fair in Jiangsu Province, which produced some 58,000 graduates in 2008.

上海醫保改革倒計時

2000年12月底，開創性的上海市城鎮職工基本醫療保險制度改革即將實施，醫院依舊人滿為患。新的醫保制度覆蓋到全市530萬職工，他們開始按新辦法就診配藥、支付結算費用。

Patients sitting in deck chairs are treated in a crowded waiting room in a Shanghai hospital in December 2000. Health care reforms piloted in Shanghai brought improvements to hospital administration and medical insurance systems.

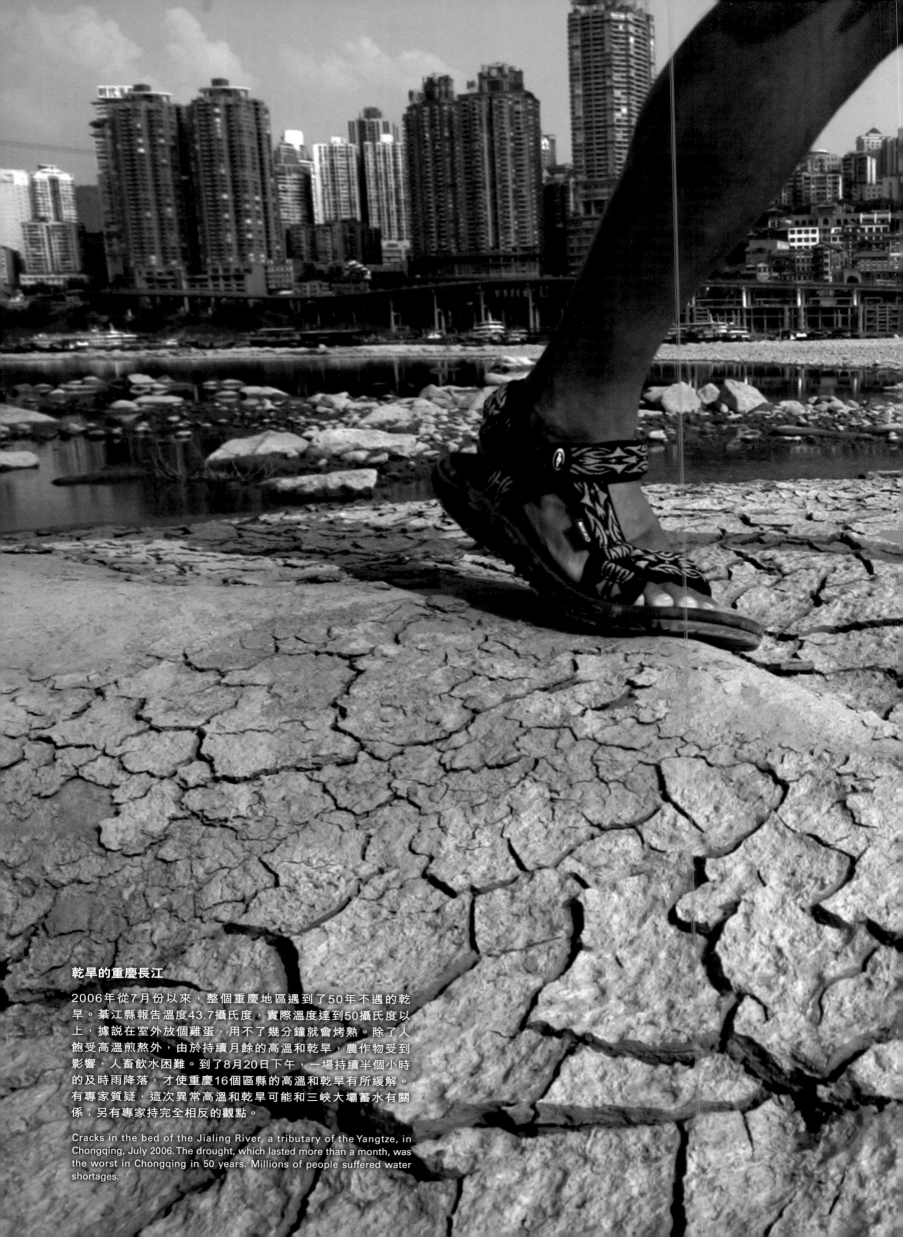

乾旱的重慶長江

2006年從7月份以來，整個重慶地區遇到了50年不遇的乾旱。綦江縣報告溫度43.7攝氏度，實際溫度達到50攝氏度以上，據說在室外放個雞蛋，用不了幾分鐘就會烤熟。除了人飽受高溫煎熬外，由於持續月餘的高溫和乾旱，農作物受到影響，人畜飲水困難。到了8月20日下午，一場持續半個小時的及時雨降落，才使重慶16個區縣的高溫和乾旱有所緩解。有專家質疑，這次異常高溫和乾旱可能和三峽大壩蓄水有關係；另有專家持完全相反的觀點。

Cracks in the bed of the Jialing River, a tributary of the Yangtze, in Chongqing, July 2006. The drought, which lasted more than a month, was the worst in Chongqing in 50 years. Millions of people suffered water shortages.

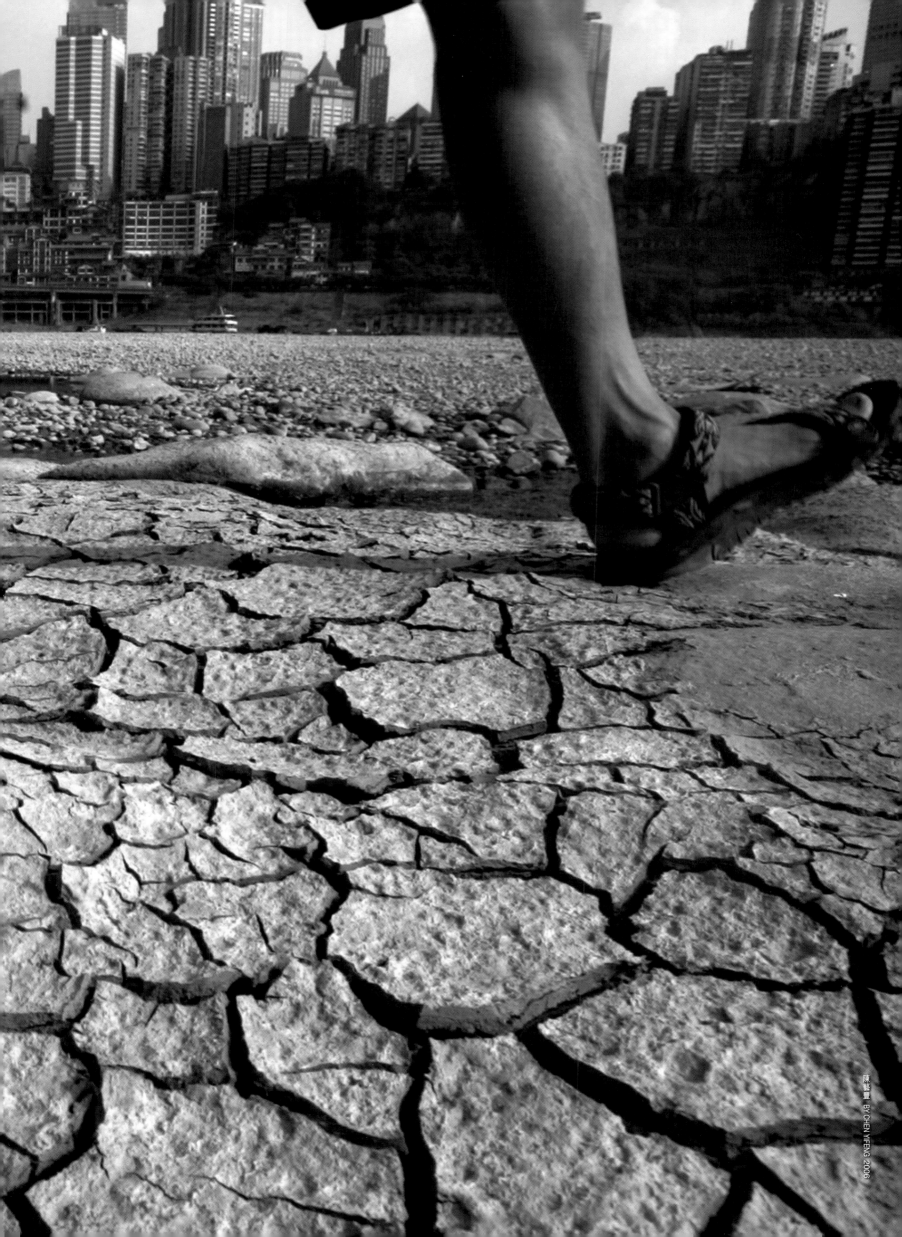

陳藝豐 BY CHEN YIFENG 2006

城市化

Urbanization – From Country to Town

　　現代化的過程就是城市化的過程。城市作為區域經濟中心,有效聚斂資源;也作為交通樞紐,發散物流人流。工業化和信息化首先展開的空間一定是城市,因為這裡投入產出的效益最高;農村勞動力必定向城市集中,這裡既是大量需要勞動力的地方,也是不斷生長着需求的地方──而需求,就是生機和生計。30年間,中國城市的規模體量在迅速擴大,其中上海、北京已經位列世界人口前 8 名城市之列;以人口計列入世界前30名的城市還有一批,而長江三角、珠江三角、京津地區已經發展成為世界上企業密度最大的區域。而上百個近年來「縣改市」的城市,則繼省級中心城市成為新興的中國城市「三級台地」。繼而,隨着城市化帶來的種種社會問題,也引發了人們的熱切討論。

Compared with Western developed countries, the degree of urbanization in China remains low. Over the coming decades China's leaders expect to see hundreds of millions move to the cities for a better life. But preparing the cities to build up to accommodate and sustain the rise in their populations will be no mean feat. The United Nations estimates that half of China's 1.4-billion population will live in cities by 2015. The government has announced that between 2010 and 2025, 300 million people will move from rural to urban areas, boosting the economy with annual investment opportunities worth 1 trillion yuan.

浴缸裡的流浪兒

珠江新城,廣州21世紀的中央商務區。2008年這裡已經初具規模。而在 3 年前這裡還是江灘和農田。圖為2006年4月3日黃昏時分,乞兒臥在珠江新城附近一具廢棄的浴缸內。

Left behind by China's economic development, a homeless child beds down in a discarded bathtub in downtown Guangzhou in 2006. The government has begun a project to establish shelters and arrange accommodation for homeless children as part of its poverty relief system.

拆遷
Demolition

　　如果存在着這種統計資料的話，這10年中國城市的發展一定超過以往的500年！成片城區的拆建伴隨着不絕於耳的質疑與爭論，不過這爭論幾乎沒有妨礙大片老舊街區的消失。每年，中國的新建築面積等於全世界新建築面積的總和。看到城市面貌在迅速變化，人們的心態是矛盾的：沒聽說有誰拒絕遷入新居，畢竟，經濟增長給人們帶來了更加舒適的生活，便捷的路網也使人們的活動半徑大大拓展。在失去了那些本不該失去的遺址的同時，城市得到了它眼前想得到的一切。只是，多少年以後倘若回望，我們會不會譴責當年拆得太急切了呢？

If such statistics were available, the rate of China's urban development in the past 10 years must have surpassed that in the past 500 years! In order to boost urbanization, many areas of Beijing, Shanghai and other big cities have been demolished urban development trend which has caused mixed reactions among the populace.

「史上最牛」釘子戶

　　2007年3月22日，重慶楊家坪商圈。號稱「史上最牛」的釘子戶坐落在商業街某個樓盤的工地中央。隨着全國兩會關於《物權法》的頒佈實施，這家釘子戶成為全國的焦點，戶主吳蘋與開發商長達一年的對峙，因為有了法律的保障，戶主吳蘋得到了近400萬元的賠償。

A "nail house", sitting like an island in a construction site in a Chongqing business area, made headlines around the world in March, 2007. Nail house (dingzihu) is a Chinese term for homes belonging to people (sometimes called "stubborn nails") who refuse to make way for development, often in an attempt to negotiate a higher selling price. The National People's Congress in 2007 passed a property law, the first in the history of China to recognize the rights of private property owners. Wu Ping and Yang Wu, the owners of the only two-story brick building eventually received a payment of 4 million yuan from the developer.

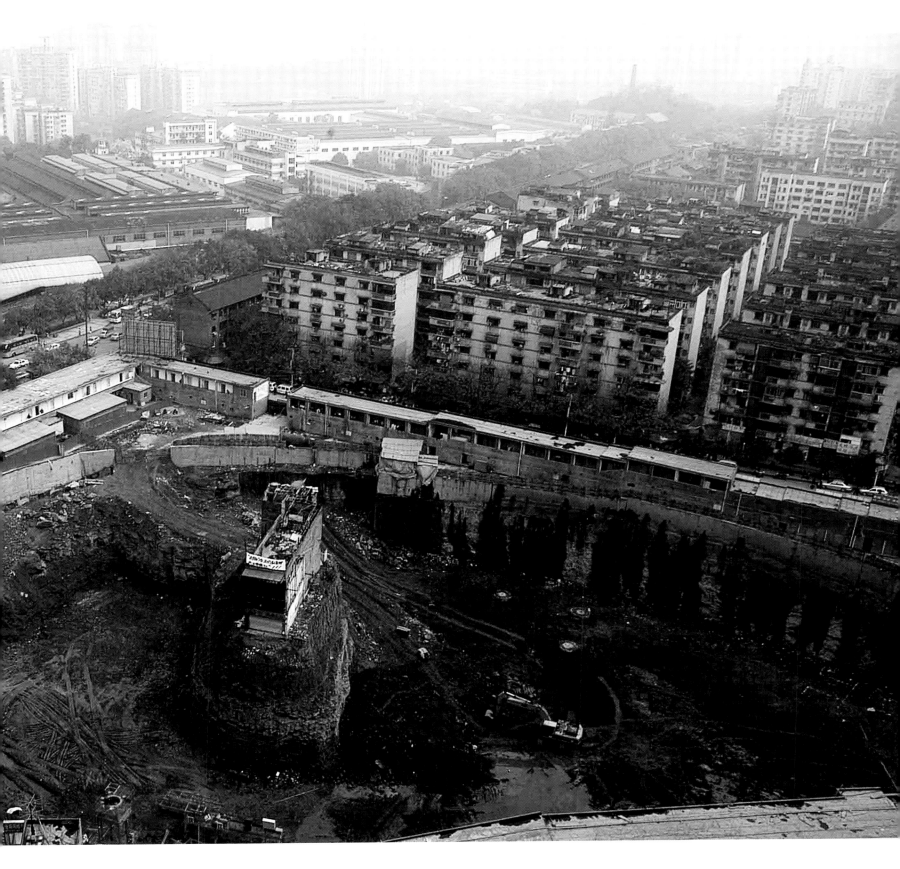

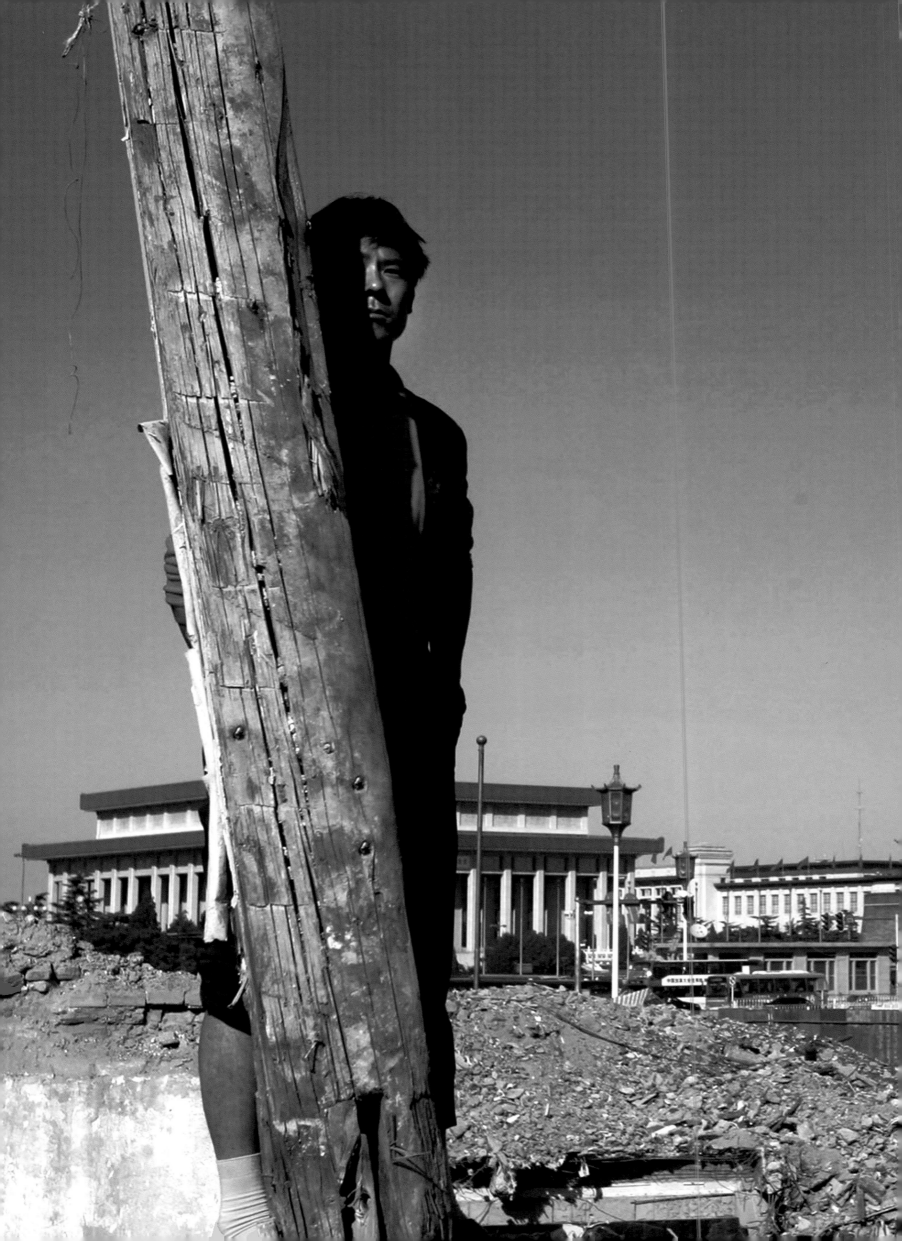

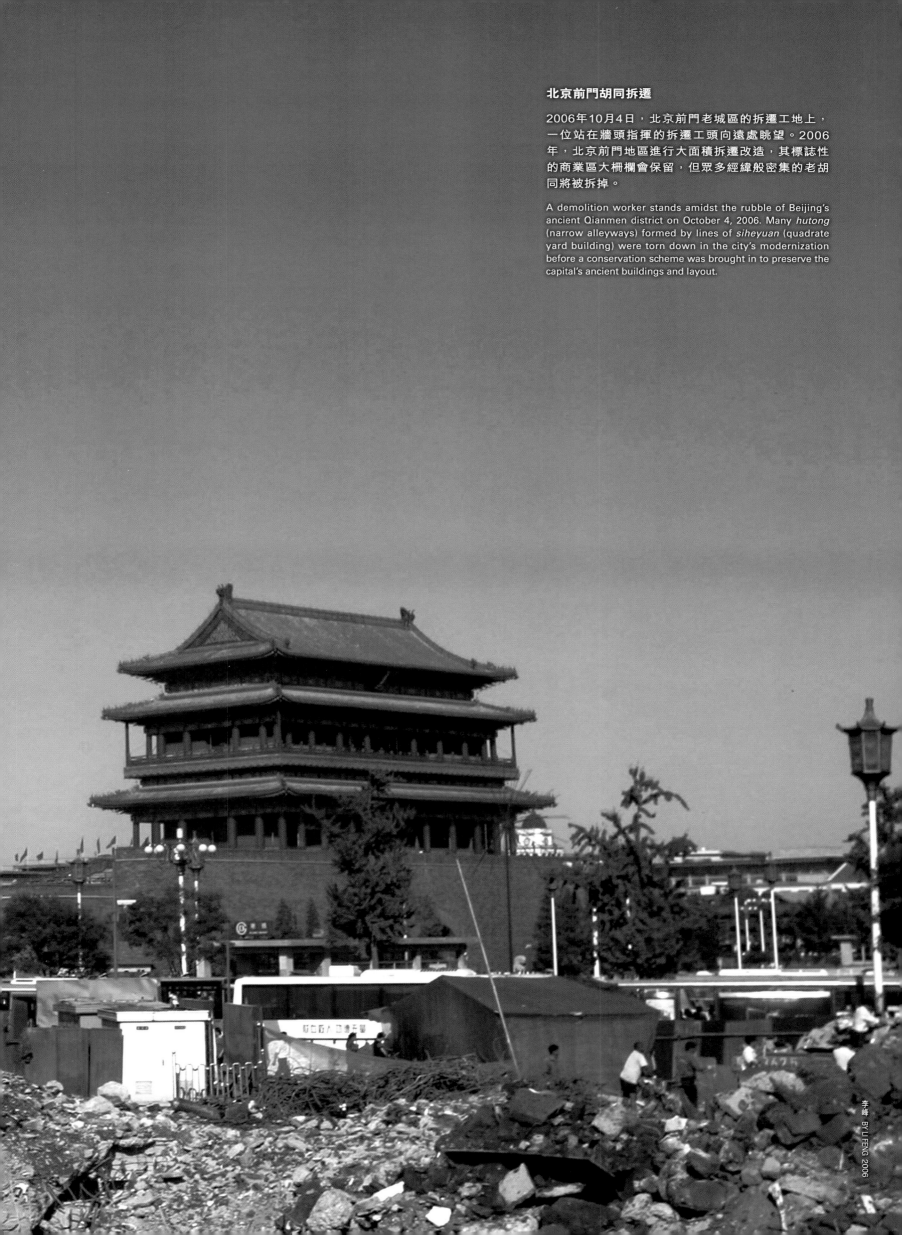

北京前門胡同拆遷

2006年10月4日，北京前門老城區的拆遷工地上，一位站在牆頭指揮的拆遷工頭向遠處眺望。2006年，北京前門地區進行大面積拆遷改造，其標誌性的商業區大柵欄會保留，但眾多經緯般密集的老胡同將被拆掉。

A demolition worker stands amidst the rubble of Beijing's ancient Qianmen district on October 4, 2006. Many *hutong* (narrow alleyways) formed by lines of *siheyuan* (quadrate yard building) were torn down in the city's modernization before a conservation scheme was brought in to preserve the capital's ancient buildings and layout.

三代領導
Three Generations of Leaders

　　這個話是鄧公講過的。他把中共的領袖群體劃分為「三代」，即毛澤東的一代，大體上是戎馬一生，打天下的一代；然後是鄧小平的一代，上承打天下那代，經過對一個複雜過程的掌控，使國家走上了建設的道路；第三代即江澤民以後的一代，他們主要是在建國以後成長起來，領導國家實現現代化並且不斷融入整個世界格局。值得注意的是第三代領導人，他們普遍受過良好的教育，許多人本身就是技術專家或行政專家；他們有寬泛的國際視野及較豐富的國際經驗，一般在當任之前都有從基層逐級向上的工作經驗。對領導人的這種代際劃分其實是有歷史意義的，它既印證了國家不同發展階段中領袖群體的特質，也使我們意識到中國不但在發展的道路，而且在領導人的稟賦上也越來越與國際接軌。

　　People often separate China's leaders into three generations. Mao Zedong founded the state, Deng Xiaoping put the country on the road to revival, and Jiang Zemin and Hu Jintao have realized the nation's modernization and global integration.

上海街景

2001年7月，上海南京東路天橋，兩個青年人在吃冰棒，後面是中共三代領導人的宣傳畫像。兩個世紀交替之際，這樣的宣傳畫遍佈中國各個城市的中心廣場。

A young couple share an ice cream under the gaze of three generations of Communist Party Chairmen — Mao Zedong, Deng Xiaoping and Jiang Zemin — on a pedestrian bridge over. Shanghai's Nanjing Road, June 23, 2001. Such propaganda posters were visible all over the country at the turn of the century.

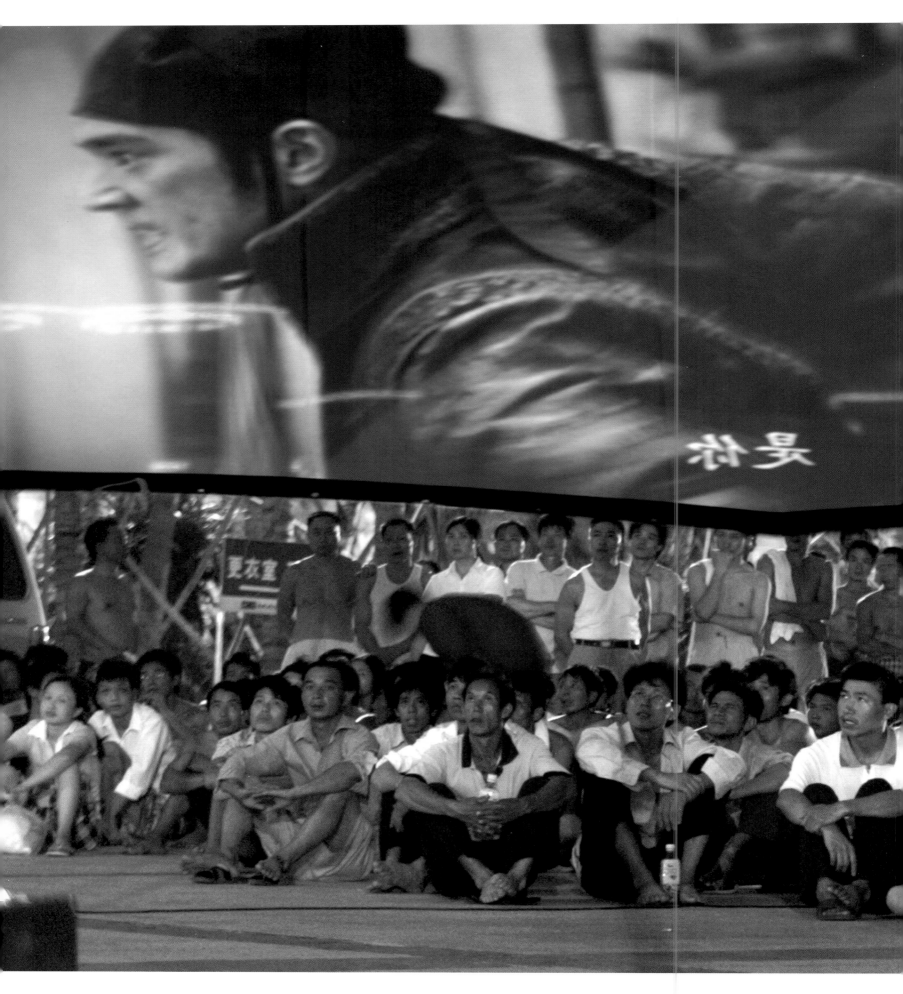

農民工露天看電影

2006年夏，深圳某工地農民工在工地露天觀看張藝謀執導的大片《十面埋伏》——屬於包場，每人收費 2 元。而此時深圳劇院的 1 張電影票價已經高達 50～100元，是低薪的農民工月收入的百分之十。

Migrant workers watch "Ambush on All Sides", directed by China's most renowned filmmaker, Zhang Yimou, at an open-air screening in a construction site in Shenzhen in 2006. Many companies provide low-cost entertainment for their workers.

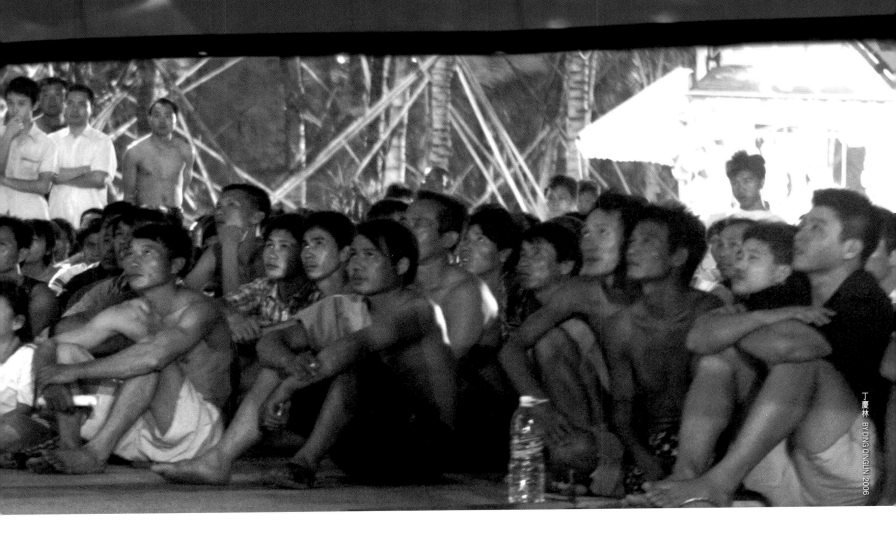

大片
Leisure Time – Time for Fun

1980年代末，國外大片進入中國的時候，人們多慨嘆好萊塢文化的不可抵擋。後來發現那不過是文化產品生產的一種模式，儘管它需要由奧斯卡之類的影賽進行認證，搞得不少大導演趨之若鶩。中國電影被國際上認同是1980年代的事，但是電影生產形成完整的商業化體制應該到了20世紀末。商業化的文化產品製作和市場推廣包括影視產品和音像製品，在1990年代與經濟大潮同步，逐步壯大着產業規模，漸漸向基層滲透。經歷了國產電影的一段低迷之後，在商業化製作和放映的雙向推動下，國內的電影生產行業大興其道，形成興旺的產－供－銷－院線系統。倒是改革前國有電影製片廠的體制在競爭中日見式微，因為資金和人才都在向市場化的方向流去。說到底，電影業的興盛，最終得益的還是觀眾。

As the reform and opening have bought modernization and prosperity to China, leisure has become a big business. And this is set to expand with greater expectations of longer holidays, which will enable people to travel more and spend more of their days on cultivating hobbies and pastimes such as music and dance. There's also plenty of evidence that society is producing a vibrant counterculture. Go to any big Chinese city and you will see skateboarders performing awe-inspiring tricks on the urban furniture. Beijing also has a thriving art scene, which is currently attracting international attention, at its innovative 798 art district.

丁慶林 BY DING QINGLIN 2006

街頭音樂會
Street Concerts

　　音樂源於那種有節奏有韻律的情緒宣洩，當這種情緒越來越個性化，而且願意向公眾展示的時候，它便顯現在街頭。30年前，中國僅有的街頭藝術都是政治性的，而且是為集體組織進行的。而今，獨立於商業之外的個人街頭藝術隨處可見。

　　Thirty years ago, China's street arts were all of a political theme, but nowadays all kinds of free thinking artistic expression can be seen.

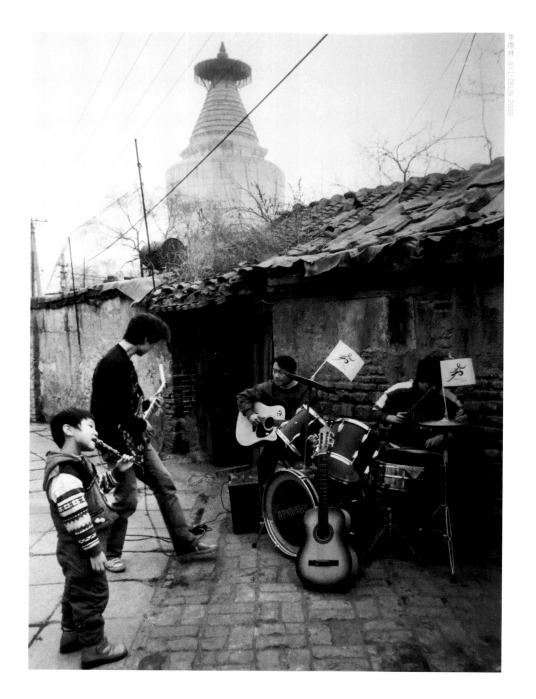

李德林 BY LI DELIN 2000

▷ 家門口的音樂會

2000年，北京市白塔寺的一戶人家在家門口舉辦音樂會。

Three youths practice their music outside a Beijing home in 2000.

▷ 「三高」音樂會

2001年6月23日，世界三大男高音放歌北京故宮午門，當晚西直門地鐵站的通道，上演著另一場「三高音樂會」。

The "Three Tenors" — Spaniards Plácido Domingo and José Carreras, and Italian Luciano Pavarotti — performed at Beijing's Forbidden City on June 23, 2001. Another trio sings beneath their poster in the underground passage of Xizhimen subway.

精粹
Chinese Ballet Lifts High Culture

　　把異質的「文化」摻和到一起，總會有特殊的精彩呈現出來，這就是「交流」、「融通」的意義。在中國歷史上，漢、唐兩代，這種隨着開放帶來的異質文化之間的交流，對中華民族文化的豐富起了極其重要的作用。20世紀的兩端，中外文化之間的交流都呈熱切狀。不同的是，世紀初大體是西方文化向中國的「進口」，多「碰撞」而少「融合」；而世紀末，是雙向的交流而非單向的引入，而且越來越具有融合的趨勢。融合中，傳統文化也呈現出新的活力。

　　The National Ballet of China (NBC) was founded on the 31st of December, 1959 and is the country's sole national ballet troupe. Over the past 45 years, the company devoted much energy to raising awareness of ballet and improving its skills. Today the NBC has an extensive repertoire and has trained many generations of outstanding artists, winning praise from around the globe. The NBC has brought Western classical ballet and contemporary ballet works to the Chinese audience and has successfully fused classical ballet and Chinese culture, with pieces such as "The Red Detachment of Women", "Ode to the Yimeng Mountains" and "The Son and Daughter of the Grassland". A number of other ballet pieces have won international acclaim, such as "Coppelia", "Fate", and "Rainbow of the Night", "Chairman Dancers", "Rite of Spring" and "Swan Lake".

中國芭蕾在英國

2008年7月27日至8月2日，在團長趙汝蘅的帶領下，中國國家芭蕾舞團應邀赴英國皇家歌劇院演出古典芭蕾《天鵝湖》和中國芭蕾《大紅燈籠高高掛》。觀眾和英國媒體對中國國家芭蕾舞團的演出給予很高的評價，出現一票難求、場場爆滿的局面。

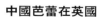

Charm offensive: Members of the National Ballet of China in the Royal National Theatre, while on tour in London from July 27 to August 2, 2008. The troupe, under the lead of Zhao Ruheng, performed "Swan Lake" and the Chinese ballet "Raise the Red Lantern", to general acclaim.

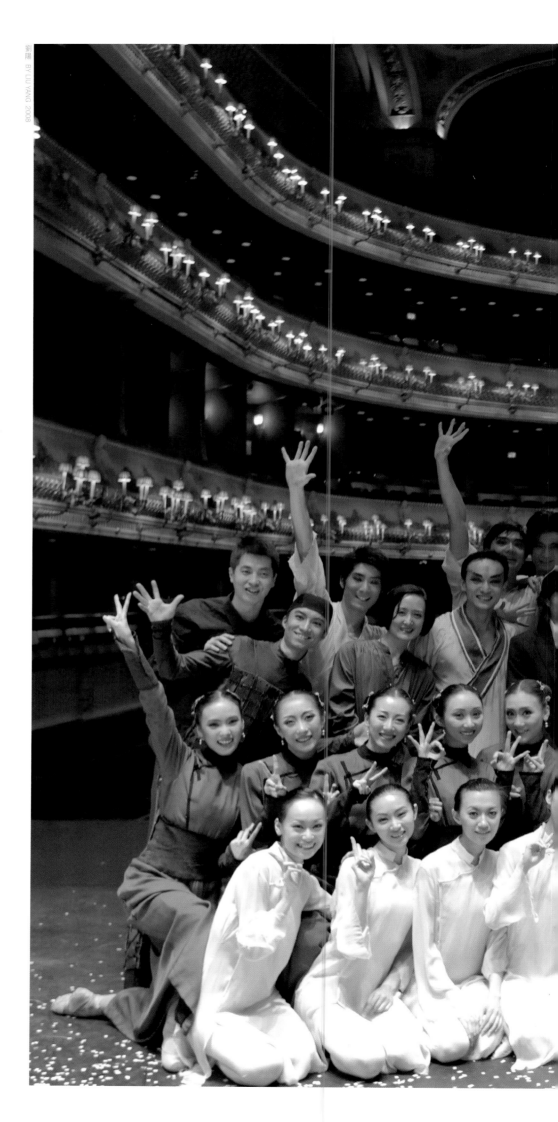

BY LIU YANG, 2008

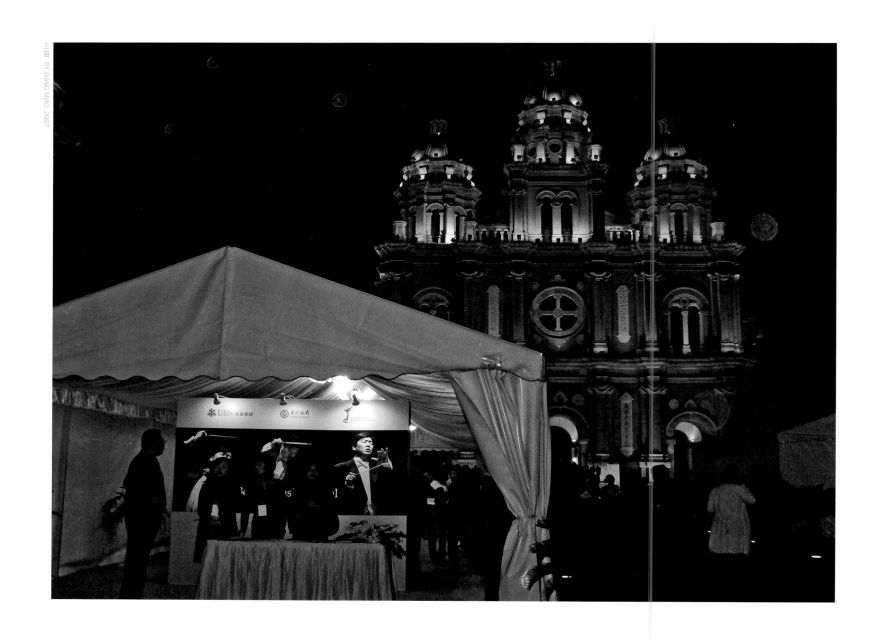

音樂與教皇
Classical Music

　　古典音樂與基督教都曾被視為異端，現在成為中國的時尚。為促進古典音樂在中國的普及，北京國際音樂節已舉辦了10屆，大大提高了人們的藝術品位。

　　Western classical music has re-emerged as a cultural phenomenon in China after decades of rejection. The number of venues holding classical music concerts has also mushroomed. The National Centre for the Performing Arts, which opened next to the Great Hall of the People in Beijing in 2007 has provided China with a world-class concert hall. The Beijing International Music Festival also recently celebrated its tenth year.

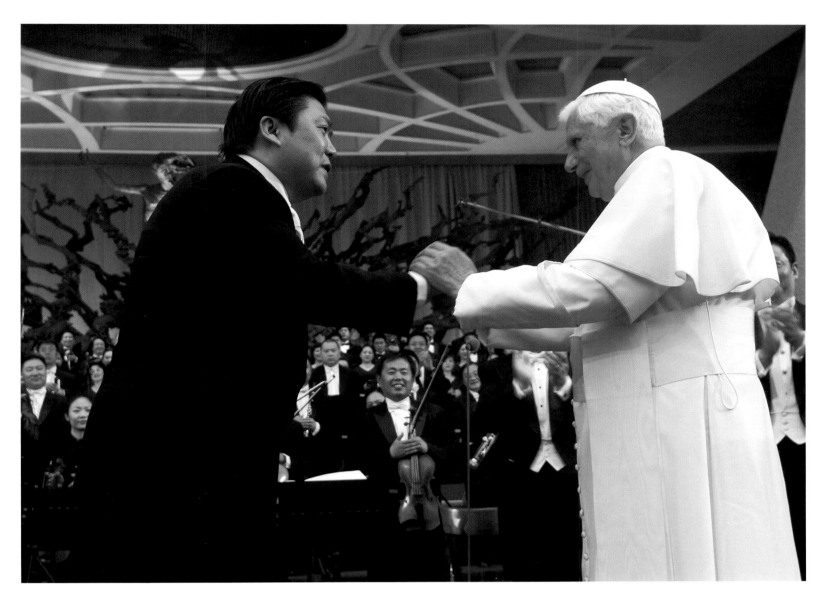

教堂音樂會

2007年在北京王府井教堂舉行的音樂會。

Concert-goers arrive for a church concert in Beijing's Wangfujing District in 2007.

破冰之旅

音樂成了溝通北京與梵蒂岡的橋樑。2008年5月7日，中國愛樂樂團在北京國際音樂節主席鄧榕和指揮余隆率領下，在梵蒂岡保羅六世音樂大廳為教皇本篤十六世演奏《安魂曲》。

Yu Long, President of the Beijing Music Festival Arts Foundation and Conductor of the China Philharmonic Orchestra, conducted Mozart's "Requiem" and the Chinese tune, "Jasmine" for Pope Benedict XVI at a landmark concert at the Vatican on May 7, 2008.

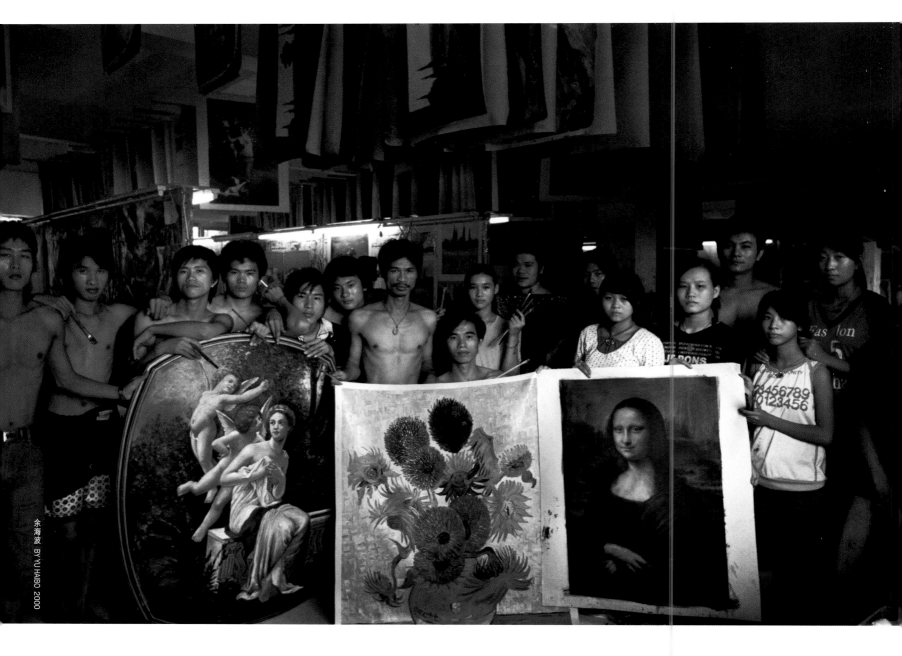

余海波 BY YU HAIBO 2000

創造價值

The Nouveau Riche of the East

　　從圖片上觀察文化創造的兩端是頗有意思的。一面，中國的鄉村用最低廉的勞動力批量創造着市場需要的文化產品，這些產品會隨着銷售鏈條的拉長而逐級升值。另一面，成熟的國際文化市場把前人和今人的創造抬升到令人瞠目結舌的價格。價值實現是或然的，但是創造兩端之間的這個升值空間是由時間和需求填補的。如果我們相信這個邏輯，那麼深圳大芬村乃至大芬村所代表的文化，就有可能在未來體現它未可限量的價值。

　　Global brands and luxury goods are being consumed in ever-greater quantities, due to China's rising wealth levels. Some luxury brand companies are doing very well by China. Take for instance the LVMH group, which produces Louis Vuitton apparel, along with Moët-Chandon wines and champagne and Hennessy cognacs. The company reported earnings growth in China of 25 percent in 2007, accounting for 16 percent of the firm's global business. Confectionaries are another major growth area, with an industry expanding into billions (in U.S. dollars). In China, 13 percent of the population is now estimated to have the financial power to purchase high-end luxury goods. During the 2008 financial crisis, London's Oxford Street traders were reported to have welcomed wealthy Chinese consumers while domestic recession-hit shoppers stayed at home.

複製名畫的工廠大芬村

2000年前後，深圳布吉鎮大芬村聚集了8,000名畫工，他們拿來西方傳統的油畫名作，在這「工廠」裡不斷地重複製作、臨摹，再被賣到幾乎中國和世界的所有地方。其中的畫廠老闆吳瑞球是大芬油畫村集藝源藝術公司董事長，擁有畫工600多名，每年有超過30萬幅的油畫遠銷世界各地。

Workers pose with their masterpieces at a painting factory in Shenzhen, where they copy works by old masters such as Van Gogh and Da Vinci. The factory, not far from the border of Hong Kong, employed more than 8,000 painters and churned out 300,000 paintings in 2000, most of them for export.

平谷農民的小提琴作坊

2008年12月，農民琴工在做大提琴。昔日靠種地為生的北京市平谷區東高村農民，如今依靠技術加工生產提琴致富。

A cello maker in Pinggu, on the outskirts of Beijing, in December 2008: one of the many peasants to learn a new skill for a processing trade.

蘇富比（Sotheby's）春季拍賣會

2007年中國當代藝術品的大宗交易吸引了國際拍賣行的注意。1994年，中國嘉德國際拍賣有限公司舉行了首次藝術品拍賣會，成交近200萬元人民幣。2005年，保利國際拍賣有限公司成立後陸續舉辦拍賣會，成交量也相當可觀。2007年，蘇富比在香港舉行亞洲當代藝術品拍賣會，成交額近 2 億美元。

Sotheby's Hong Kong auction house saw a record US$200 million in sales with a four-day series of auctions of Chinese art in October 2007. The sales, comprising more than 1,100 lots of art, watches and jewelry, had been expected to raise 129 million to 173 million U.S. dollars.

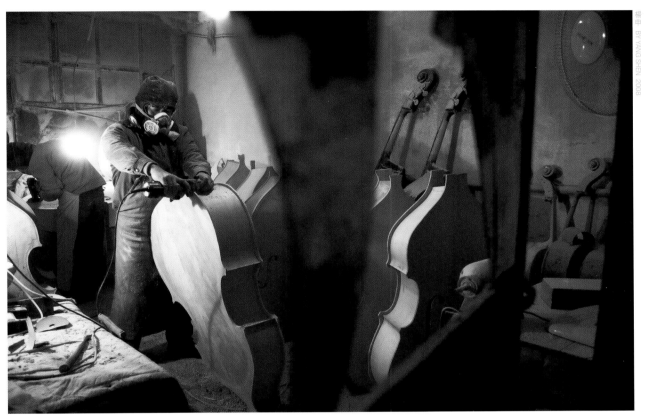

「名人」
The Age of Celebrity

　　一個社會的偶像是一個社會價值系統的標誌。如果把30年前的「名人」與30年後的「名人」名單做一個對比，你會發現最突出的變化是一群富翁的出現。而此前，作為一個社會角色，「富翁」是被排斥的。與所有社會一樣，文藝體育明星總是被關注的。也與所有現代社會一樣，新經濟中誕生的富翁們也被社會視為偶像。有趣的是，1980年代，「公務員」在偶像排名中是很靠前的，但在20世紀末，這個位置讓給了「科學家」。這或許說明，這個社會對教育和科學的重視程度也在提高。

　　With the end of personality cults in politics, China now has a thriving media scene with scores of adored celebrities. From current affairs and game show presenters to sports stars and movie actors, China's new media age boasts a growing rostrum of respected household names.

廖文靜 BY LIAO WENJING 2007

財富人生

2006年11月11日，上海浦東，《財富人生》舉辦5
週年慶典。中間是女主持人葉蓉，右邊是分眾的江南
春、阿里巴巴的馬雲，左邊是蒙牛的牛根生、通威的
劉漢元。《財富人生》2002年1月開播，不斷聚集中
國財經熱點和話題，先後對海內外200多位財經風雲人
物進行了專訪。

Business leaders gather to celebrate the fifth anniversary of the
popular TV chat show, *Caifu Rensheng* ("Fortune and Life"), in
Shanghai's Pudong District on November 11, 2006. More than
200 business "celebrities" from China and abroad had appeared
on the program, which focuses on Chinese economic issues. The
female (center) is host Yerong.

袁隆平 成龍 鞏俐出席華人盛典

2007年3月29日晚，「世界因你而美麗——2007影
響世界華人盛典」頒獎典禮，在北京大學百年紀念講
堂隆重舉行。在科學研究、公共事務、體育競技、文
化藝術等領域，榮獲「2007影響世界華人大獎」的
11位傑出華人最終揭曉。圖為「雜交水稻之父」袁隆
平（中）與國際影星成龍、鞏俐坐在一起，共同出席
盛典。

Yuan Longping, the Chinese agricultural scientist and educator
known for developing the first rice varieties in the 1970s, sits
between movie actress Gong Li and action film star Jackie Chan
at an award ceremony for Chinese who have been influential
abroad, in Beijing on March 29, 2007.

品牌
Luxury Brands – Are They for Real?

　　30年前，「品牌」對於國人還是一個陌生的概念。在有限的大件消費用品中，可供選擇的品牌很少，無非「永久」/「飛鴿」（自行車）/「蜜蜂」/「蝴蝶」/「飛人」（縫紉機）之類，國外品牌只在手錶裡，有「梅花」/「歐米茄」可選，價格也在「上海」的幾倍以上。在多數人都在揹帆布拎包的時候，LV的鮮為人知是必然的。對外交往的擴大使得人們具有更多選擇性的時候，LV這樣的非生活必需品反倒成了品牌競爭的先導，它們先是炫富的標誌，而後被發現是市場成功的一條捷徑，於是中國企業也使自己的產品加入品牌營造的行列裡。越來越多的企業家認識到，品牌的附加值裡是市場成熟度、管理成熟度的標誌，經過一番艱苦的競爭，有些中國品牌也開始躋身國際市場了。

Following China's accession to the WTO, many wealthy Chinese have fallen under the spell of famous brands and their connotations of wealth and status. Alongside this, a huge black market in fake brands has reached all corners of the country, with convincing but poorer quality imitations selling in the millions to both foreign tourists and domestic consumers alike. Buying a knock-off T-shirt at Beijing's Silk Market has become as popular a part of a tourist's itinerary as a visit to the Temple of Heaven. Multinational companies frequently complain of trademark violations and numerous crackdowns have been launched, but the problem persists.

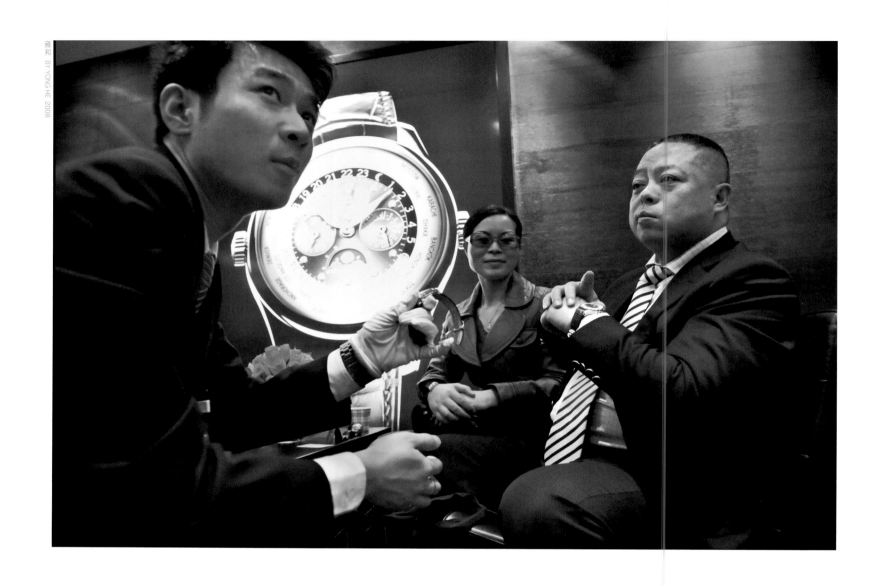

撮和 BY YONG HE 2008

致富
Getting Rich

　　一部國產電影中有一段膾炙人口的台詞，譏諷國內大款的消費行為，說他們「不求最好，只求最貴」。那些一擲萬金的人，把世界上最貴的汽車最貴的房子最貴的藝術品收進囊中，就像石油漲價以後的海灣國家的王子。琢磨這些人錢包鼓脹的途徑，可以窺見個人財富增長的秘密以及這個國家經濟結構的縫隙。有調查說，個人財富上億的人群中，多數是在股市及金融市場中掙錢；還有在諸如煤礦等資源性行業中得益；靠房地產和靠新技術致富的在人群中是少數，但也具有昭示的意義。有人弄了個「財富排行榜」，每年招來一堆鼓噪，它的數字其實可以存疑，不過是說明了中國確實有一些人是有錢了。

Following China's accession to the WTO and the opening of its markers, many wealthy Chinese have fallen under the spell of famous brands and their connotations of wealth and status.

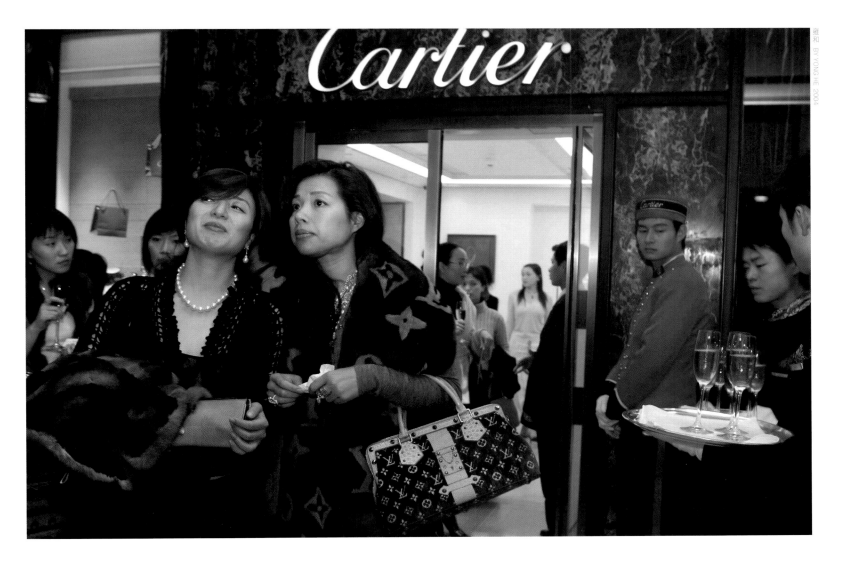

羅和 BY YONG HE 2004

富豪買名錶

2008年1月8日，上海某廣場地下珠寶廊，一個男人在挑選手錶。這裡賣的手錶從十幾萬元到幾百萬元不等。作為改革開放前沿的上海，是中國新生富豪的聚集地，上海也因此成為全球奢侈品業的必爭之地。

A man tries on a luxury watch in a Shanghai store in January 2008. Shanghai, a pioneer of China's economic reforms, tops the list of the country's wealthiest.

女富豪雲集

2004年12月18日，上海外灘18號，卡地亞旗艦店開幕酒會，受邀的女富豪雲集。過去的20年，中國經濟發展迅猛，個人財富爆炸式成長，一大批成功的私營企業出現，新的超富階層產生，貧富差距拉大。

Entry to the cocktail party for the opening of Cartier's first flagship store in Shanghai, on December 12, 2004, was by invitation only — and plenty of women turned out.

黃浦江遊艇上的西式婚禮

2005年，租用豪華遊艇，在上海黃浦江上舉辦西式婚禮的年輕人。

Newlyweds celebrating on a luxury yacht on the Huangpu River, Shanghai.

時髦女士商場體驗按摩椅

2005年，逛商場也不忘享受，愜意體驗高級按摩椅的時髦女顧客。

Massage chair salespeople find plenty of targets among the weary crowds in China's shopping malls.

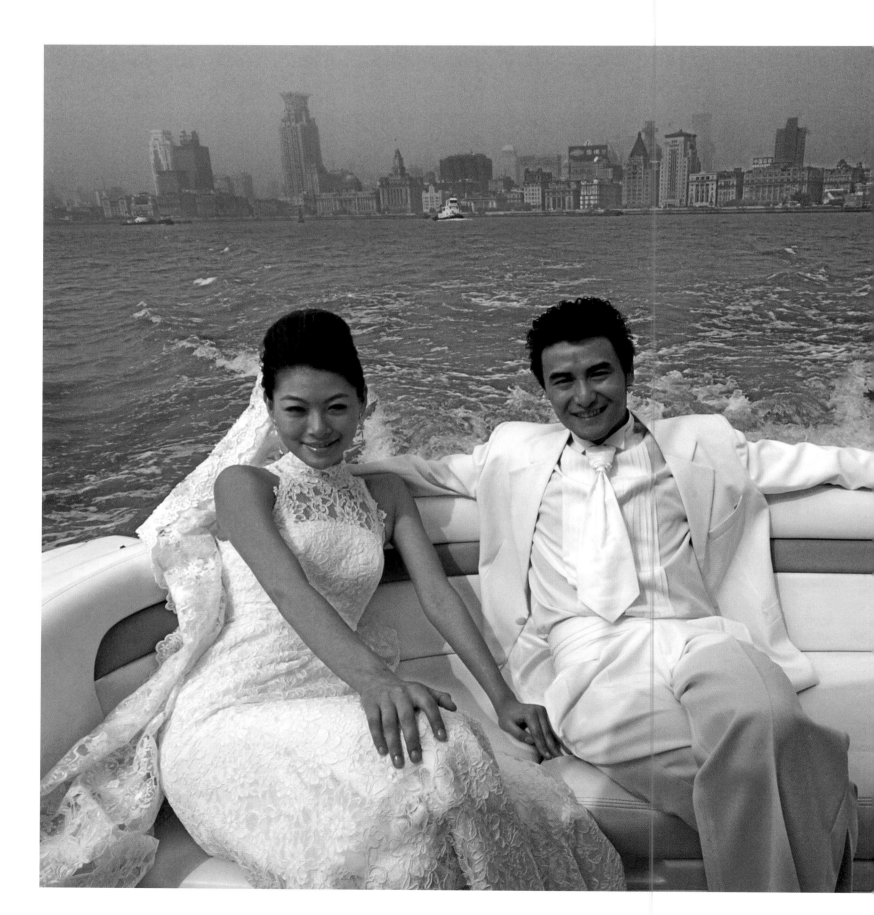

黃浦江遊艇上的西式婚禮

時髦女士商場體驗按摩椅

2005年，租用豪華遊艇，在上海黃浦江上舉辦西式婚禮的年輕人。

Newlyweds celebrating on a luxury yacht on the Huangpu River, Shanghai.

2005年，逛商場也不忘享受，愜意體驗高級按摩椅的時髦女顧客。

Massage chair salespeople find plenty of targets among the weary crowds in China's shopping malls.

大款們
Bags of Money

　　那撥先富階層被老百姓稱作「大款」。這個詞兒的中文語義很有意思，其與「貨款」、「貸款」這類表示實際財富的意思並無關係，反倒是與「款署」反映的地位與接待性活動中的風度有更多關聯。因此這個詞兒的精確翻譯應該是有身份（「款署」），有地位（「款待」）的有錢（「錢款」）人。其實先富起來的人並不一定有身份有地位，但他們中的許多人很願以各種方式炫耀或提升自己的地位。這就像1990年代以後「恭喜發財」漸入人們的社交口語一樣，說明追求財富是被社會支持和承認的。在語義學的意義上，「大款」這個詞也從略帶貶義到成為一個中性詞。

　　It's not just people who "got rich first" who enjoy all the perks of the good life. Luxuries and status-enhancing services and products have filtered to the mainstream, and now ordinary people can "look like a million yuan".

消費
Consumption

　　除了中國你絕看不到這樣的情景，消費需求製造了一種消費狂熱。為甚麼人們會置衛生、舒適等前提條件於不顧，把自己置身於這個環境裡？唯一的解釋是：熱鬧、新奇，以及由熱鬧新奇而來的刺激。城市生活水平提高刺激着人們的消費慾望，商家以種種手段鼓勵着這類慾望的提高。這裡也有一個有趣的課題：為甚麼中國人在保有世界上最高居民儲蓄率的同時，依然保有着他們對消費的需求？搞懂了這個問題，也就搞懂了微觀層面上中國經濟發展的秘訣。

As Chinese people have gained more disposable income over the past three decades, they have begun to spend more on food and recreation. This has spawned a big business in leisure. There is also plenty of evidence of a thriving music and arts scene, and vibrant counterculture among China's youth.

超級巨型火鍋

這個直徑達10米、能容納２噸底料的巨型電火鍋，
2006年2月17日在重慶市開鍋。吉尼斯中國總部官員
當場認定其為世界第一大火鍋，並頒發吉尼斯紀錄證
書。此鍋由不鏽鋼製成，平均1小時耗電3,700千瓦
時，可供68人同時進食。

The biggest-ever Chinese hot pot was recorded as a Guinness
world record in Chongqing on February 17, 2006. It could feed 68
people at once.

溫泉旅遊火暴

2007年1月2日，重慶，眾人在溫泉池裡享受魚療。
新年裡，很多地方的溫泉旅遊價格上浮，但並沒有影
響其火暴程度。據初步統計，重慶市30多處正規溫泉
酒店，每天迎接顧客總數均在萬人左右。愜意的過一
天，每人的花費僅在20~50元左右。

Holidaymakers settle down for a hot-spring soak on the eve of
Spring Festival 2007. About 10,000 people stayed at hot-spring
hotels in the city every day of the holiday.

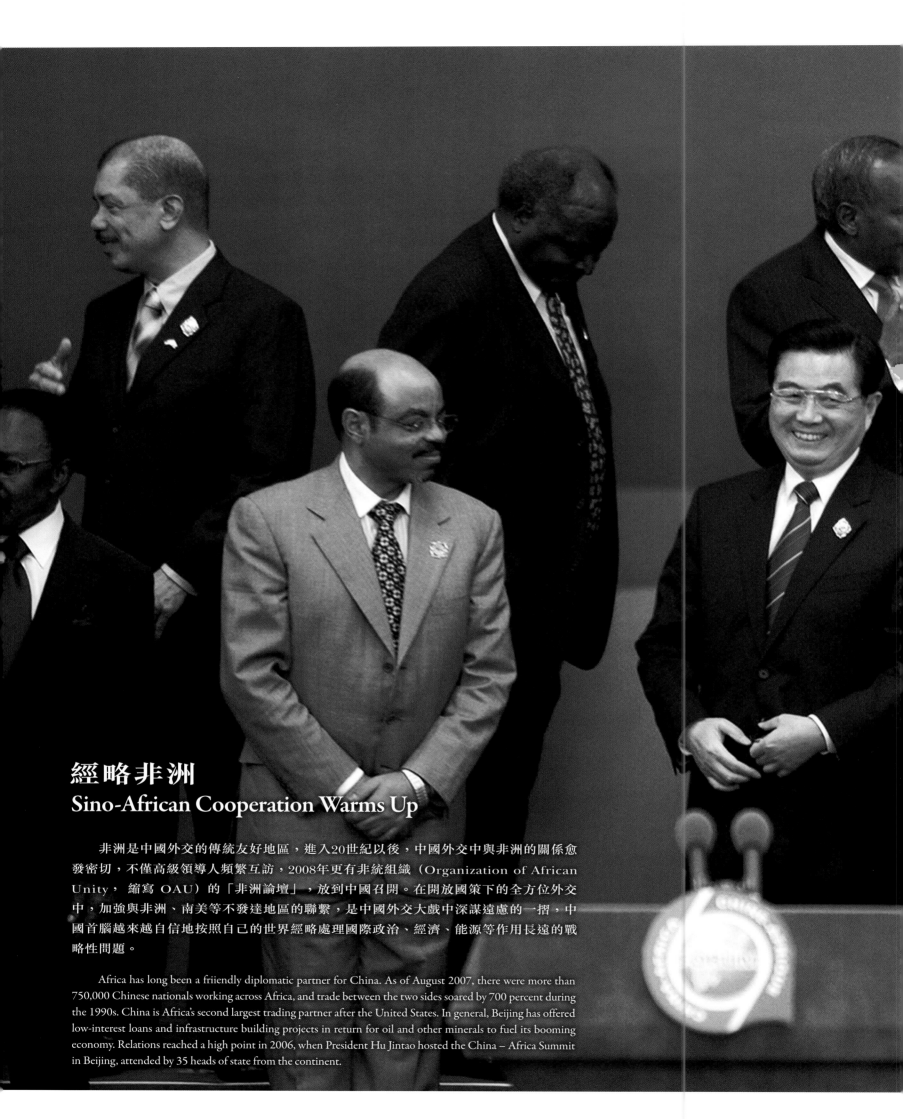

經略非洲
Sino-African Cooperation Warms Up

　　非洲是中國外交的傳統友好地區，進入20世紀以後，中國外交中與非洲的關係愈發密切，不僅高級領導人頻繁互訪，2008年更有非統組織（Organization of African Unity，縮寫 OAU）的「非洲論壇」，放到中國召開。在開放國策下的全方位外交中，加強與非洲、南美等不發達地區的聯繫，是中國外交大戲中深謀遠慮的一摺，中國首腦越來越自信地按照自己的世界經略處理國際政治、經濟、能源等作用長遠的戰略性問題。

Africa has long been a friiendly diplomatic partner for China. As of August 2007, there were more than 750,000 Chinese nationals working across Africa, and trade between the two sides soared by 700 percent during the 1990s. China is Africa's second largest trading partner after the United States. In general, Beijing has offered low-interest loans and infrastructure building projects in return for oil and other minerals to fuel its booming economy. Relations reached a high point in 2006, when President Hu Jintao hosted the China – Africa Summit in Beijing, attended by 35 heads of state from the continent.

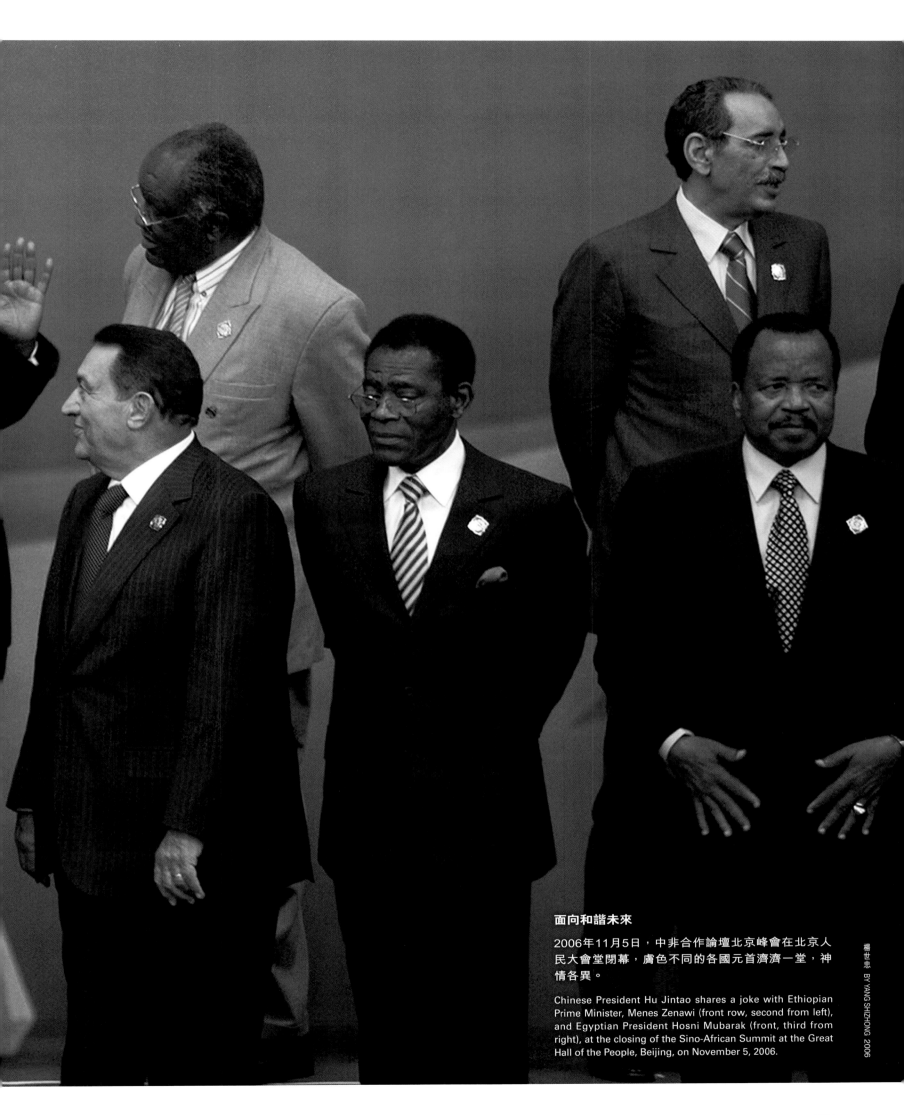

面向和諧未來

2006年11月5日，中非合作論壇北京峰會在北京人民大會堂閉幕，膚色不同的各國元首濟濟一堂，神情各異。

Chinese President Hu Jintao shares a joke with Ethiopian Prime Minister, Menes Zenawi (front row, second from left), and Egyptian President Hosni Mubarak (front, third from right), at the closing of the Sino-African Summit at the Great Hall of the People, Beijing, on November 5, 2006.

汽車產業
The Automobile Industry – On the Road to Global Domination

　　1990年代以後，汽車產業在中國經濟中佔有舉足輕重的地位。從1991～2007年，短短16年間，國內汽車年產量從不足100萬輛增至年產900萬輛；10年間城鎮居民百戶家庭汽車擁有量增加了30倍。不單是數字的增加，很少有像汽車產業這樣帶動着鋼鐵、原材料、能源等一系列支柱產業，而且給人民生活帶來巨大改變的。許多發達國家在經濟起飛和「巡航」的時候，汽車產業都起了重要作用。今天，中國汽車產業發展勢頭依然強勁，中國已是世界上汽車生產和銷售最活躍、市場最大的國家。

　　With the largest car market in the world, China produced 9.3 million automobiles in 2008, surpassing the United States to become the second biggest manufacturer after Japan. In Beijing around 1,700 new cars were hitting the roads every day in the first half of 2009. China has also attracted much attention for its development of electric vehicles. With chronic pollution blighting China's cities, the government is pushing hard to produce an emission-free car. Officials are aiming for 50 percent of cars to be electric-powered by 2030. Still, despite the rapid development, China has yet to break into the European or U.S. markets, where safety and emissions standards have been seen as an expensive obstacle. But Chinese automakers hope it is only a matter of time.

攝影大斌 BY WANG DABIN 2004

北京計程車飽和

2007年4月3日17:35，在北京市東城區的北京站東街上，一位騎著自行車的市民從大量的計程車旁經過。到2007年，北京計程車保有量已達67,300輛。

A lone cyclist sails past the mass of taxis parked outside Beijing Railway Station in April 2007, when the number of taxis in the capital hit 67,300.

二手車市場火暴

2004年的汽車市場交易清淡，許多消費者持幣觀望，等待價格下調。與此同時，二手車市場交易火暴。如大連二手車市場的交易量，就同比增長了百分之三十。圖為2004年8月22日大連後鹽二手車交易市場一角。

A second-hand car fair in Dalian, Liaoning Province, on August 22, 2004. Despite a rise in sales of 75 percent in 2003, new cars were still inaccessible to most Chinese. Automakers slashed prices in 2004, but sales growth plummeted to 15 percent, and the used car market boomed. Auto sales in the second-hand market in Dalian increased by 30 percent in 2004.

村民排隊買柴油

2006年3月21日，中國安徽省壽縣雙橋鎮加油站，無數村民排隊買柴油。受國際原油價格影響，國內油價持續上漲。連續幾天，壽縣雙橋、李台、正陽等地的農村加油站出現加油難現象，一些村民甚至凌晨就開始排隊購油。

Villagers, some got up at mid-night, line up for diesel at a gas station in the town of Shuangqiao, Anhui Province, on March 21, 2006. Demand outstripped supply after China's state-controlled oil prices rose on the back of soaring international crude prices.

廣東油荒

2005年8月16日，佛山。從桂城加油站對面的高樓望下去，排隊加油的隊伍頗為壯觀。進入7月以來，廣東特別是珠三角的廣州、深圳、佛山等地，相繼出現了不同程度的成品油供應緊張局面。

Motorists waiting for gasoline in Foshan, Guangzhou Province, on August 16, 2005. The Pearl River Delta area saw a shortfall in supply beginning in July of that year.

油荒
Oil Pressure

　　能源結構的變化大約可以算作30年來關乎國計民生的最重要的變化之一。30年前，中國的石油自給自足，30年後，中國的能源百分之五十要靠進口。於是，中國能源需求的增減，影響着國際石油價格的漲跌，而國際油價升降，也真切地影響中國人的生活。在更深層次，能源結構已經與國家經濟安全密切相關。為此，能源開採的國際合作、開闢能源進口的陸上通道、屏護中國油輪的海上通道等等，都已提到國家發展的議事日程上。在這個意義上，我們説「中國是一個負責任的大國」就是有實實在在的意義的。

One sure sign of China's rapid development appeared when the country joined the league of oil-importing nations in the 1990s, although it remains a crude oil producer. In 2006, the country imported 145 million tons of crude oil, accounting for 47 percent of its total oil consumption. With growing energy consumption have come political challenges. Many analysts say China's burgeoning demand for the black stuff has been a major factor in soaring oil prices in the latter half of the decade.

胡連會
Hu Meets Lien

　　20世紀中國歷史上的兩次國共合作，在每一次關乎民族發展和命運的時候推動了歷史進程；國共之間的恩怨血火也連綴了20世紀的70年歲月。其實，中國政壇上影響最大、最重要的這兩個政黨，他們的創始、意識形態根基、施政理念乃至在組織架構上都有許多類同之處。當然，更重要的是對一個國家、一個民族的認同。那麼，在全球化對地區經濟發展提出新的要求，大陸經濟發展日益欣欣向榮的時候，兩黨首腦的再一次握手也就是歷史的必然了。

　　On April 29, 2005, Taiwan's KMT Chairman Lien Chan traveled to Mainland China to meet President Hu Jintao in what was the highest exchange between officials from the two sides since Mao Zedong met Chiang Kai-shek in 1945. Hu and Lien, a staunch opponent of Taiwan's former pro-independence leader Chen Shuibian, signed a five-point declaration, which stated that Taiwan is a part of China and that the two parties should work together to "promote peace and development across the Taiwan Strait".

胡錦濤會連戰

2007年4月28日，中共中央總書記、國家主席胡錦濤在北京人民大會堂會見中國國民黨榮譽主席連戰等出席第三屆兩岸經貿文化論壇的嘉賓，並同全體與會代表一起合影。

Hu Jintao (front left), General Secretary of the Central Committee of the Communist Party of China, beside Lien Chan, Honorary Chairman of Taiwan's Nationalist Party or Kuomintang, and Lien's wife, Lien Fangyu (right). The two leaders came together at Beijing's Great Hall of the People for the Cross-Strait Economic and Trade Forum on April 28, 2007. About 300 Taiwan and 200 Mainland business people and representatives of the KMT and the Communist Party attended the event.

民工
Migrant Workers

　　經典理論是以大工業生產背景和生產的組織化作為產業工人特徵的。他們的「先進性」與他們的生產方式有關。中國的特色是：由於重工業生產的集約化、組織化，其工人的絕對數量其實是有限的。而輕工業中大量勞動密集型企業的存在，集中了數量龐大的工人群體，但這類企業生產中技術含量不大，對工人的文化要求不高，工人群體中的組織程度也不高。隨着建築業的發展，還有大量農民工向城市的建築行業集中，這是一個穩健和獲益的群體，除了政府曾注意他們的工資按時發放問題以外，沒有甚麼引人注意的群體事件發生。一些發達國家在經濟成長的過程中，都曾先後遭遇勞動者群體的經濟和政治壓力，在中國經濟發展中並沒有集中窺見這類現象。

　　China's migrant workers are among the heroes of the economic miracle. Turning their backs on a life of downtrodden peasantry, they have flocked to China's east coast cities in their millions to help build the skyscrapers that define the country's modern metropolises. By the end of 2008, there were more than 200 million migrant workers in China. In addition to construction, many work in manufacturing, particularly in Guangdong Province, and in catering.

上海越長越高

2006年12月4日，上海浦東陸家嘴，工人們正在建造中的環球金融中心樓頂工作。上海中心城區內現有4,000餘幢高層建築，其中約有1,900幢在20層以上。

A worker stands atop the International Finance Center building, under construction in Shanghai's Pudong district, on December 4, 2006. It joined 1,900 other buildings of more than 20 stories in the city.

央視新址民工午餐

2007年，坐落在北京國貿CBD商圈的中央電視台新樓，民工在午餐。

Migrant workers taking a meal break in front of the new China Central Television headquarters during construction in Beijing in 2007. Millions of peasant farmers from China's rural hinterland have been the mainstay of the city's urban labor force.

討薪

2008年1月3日下午，在鄭州街頭，30多名工人堵住欠他們12.2萬元血汗錢的濟源市一家房產公司老闆的豪華座駕——車牌號為豫U88888的價值百萬元的奧迪A8L轎車，討要工資。晚上，工人們圍住奧迪車打地鋪。

More than 30 migrant workers staging a sit-in around an Audi owned by the boss of a property development company in Zhengzhou, Henan Province, on January 3, 2008. The workers blockaded his car to demand unpaid wages.

自由軟體

2007年4月20日，微軟公司董事長比爾·蓋茨到訪北大，出席「創新盛會」並發表主題演講。就在蓋茨發表完演講後不久，開源軟體的積極分子王洋突然跑上主席台，手舉「自由軟體，開放源代碼」的標語，並喊出「反對暴利，反對壟斷，要求微軟開放源代碼」的口號。

Wang Yang, the chief China representative of the Linux Professional Institute, disrupts a ceremony attended by Microsoft tycoon Bill Gates (third from left) at Peking University on April 20, 2007. Wang held up a sign, reading, "Free software, open source," and shouted "Microsoft should open source." His minute-long protest drew censure, but also sparked a debate on software piracy, the cost of Microsoft products and the company's dominance in the Chinese market.

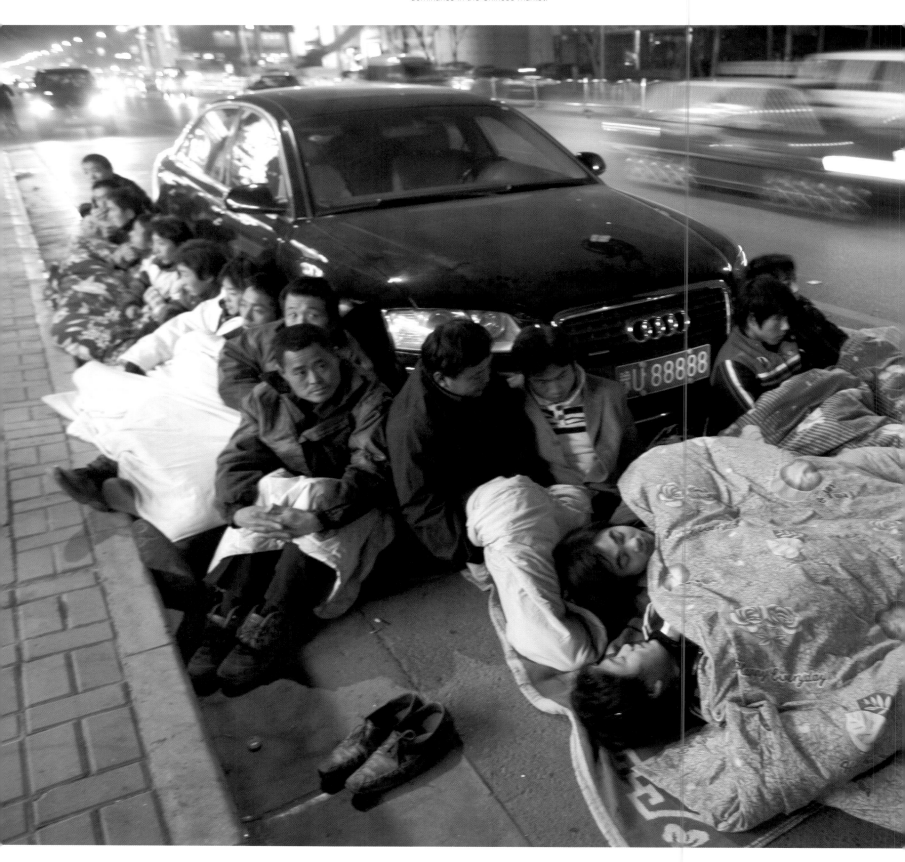

「反對暴利」
Fighting Exorbitant Profit

　　「暴利」的核定本是個技術性很強的事情，但是隨着貧富差距的擴大，卻愈成為政府、企業和平民們都關注的政治性問題。這裡的問題很複雜，正如照片裡所顯示的，既有可能的「為富不仁」的問題，也有可能的技術性和市場的壟斷問題，還有所謂的「仇富心理」問題。當然，利益分配是經濟成長中一個永恆的需要不斷解決的問題。

　　The growing gap between the rich and poor has created a series of complicated social and political problems such as disputes surrounding unpaid wages and unsafe work practices, to name but a few.

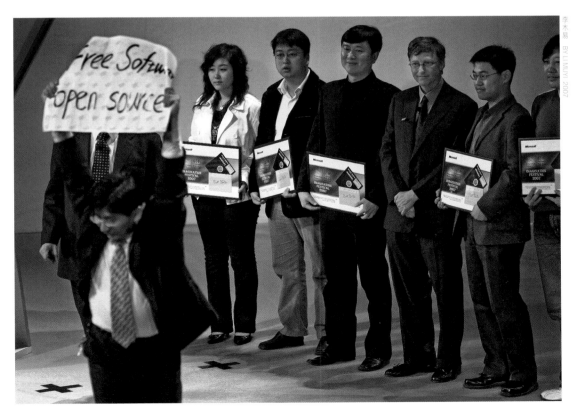

風雪中的春運

2008年1月27日，一名旅客頂着大雪在合肥火車站進站候車。當日，合肥再次降大到暴雪，致使公路、民航停運。許多準備回家過年的人顧不得人多擁擠、旅途勞累，冒着大雪湧入火車站，以求早日與家人團聚。

Ticket clenched in her teeth, a young woman hurries through the snow to catch a train back to her hometown for the Spring Festival in 2008, when most of south China suffered snow storms. The severe winter weather disrupted the travel plans of thousands of people on the most important holiday for Chinese families.

冰雪災害

Snow Disaster – A Nation Freezes

　　2008年年初，中國南方各省發生大面積冰雪災害。反常的氣象使大量旅客滯留在各大車站，給正值春運期間的全國交通運輸帶來沉重壓力。南方幾省的電力輸送系統在冰雪重壓下倒塌，又為正急需能源的社會生活雪上加霜。從另一個角度看大陸的社會結構，你會發現：幾十年的改革已經把中國構造成一個相互關聯、相互影響的龐大系統，北方的煤支撐着南方的電力生產，西邊的燃氣點燃着東部的爐灶。幾場連續的大雪，把這個剛剛建立不久的巨大系統的脆弱性暴露無遺，也是對這個系統應變能力的一次重大考驗。

　　The snowflakes began to fall on January 10, 2008, gathering momentum to become China's worst winter weather in half a century. The blizzards stranded more than 5.8 million people as they were heading home for the Lunar New Year, the country's most important holiday, also known as the Spring Festival. For many Chinese, who migrate from the countryside to cities to work in factories, the holiday is the only time during the year that they get to be with their families. So the disaster, which also left millions without electricity, was a particularly anxious time for the nation. The snow destroyed large areas of crops and cut off trucking lines in central, southern and east China. An emergency cabinet meeting described the situation as "grim". In a bid to show solidarity with those hit by the disaster, Premier Wen Jiabao traveled to the affected areas and met with travelers stuck at train stations.

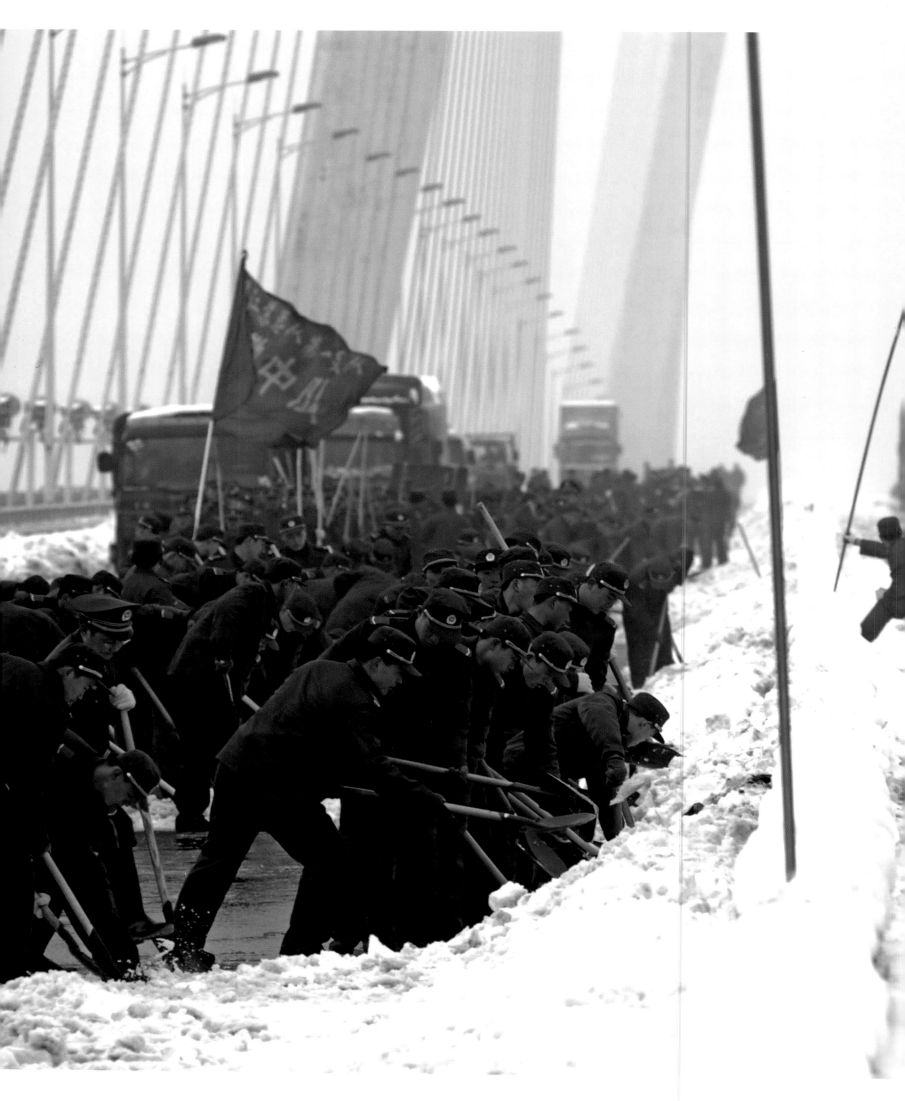

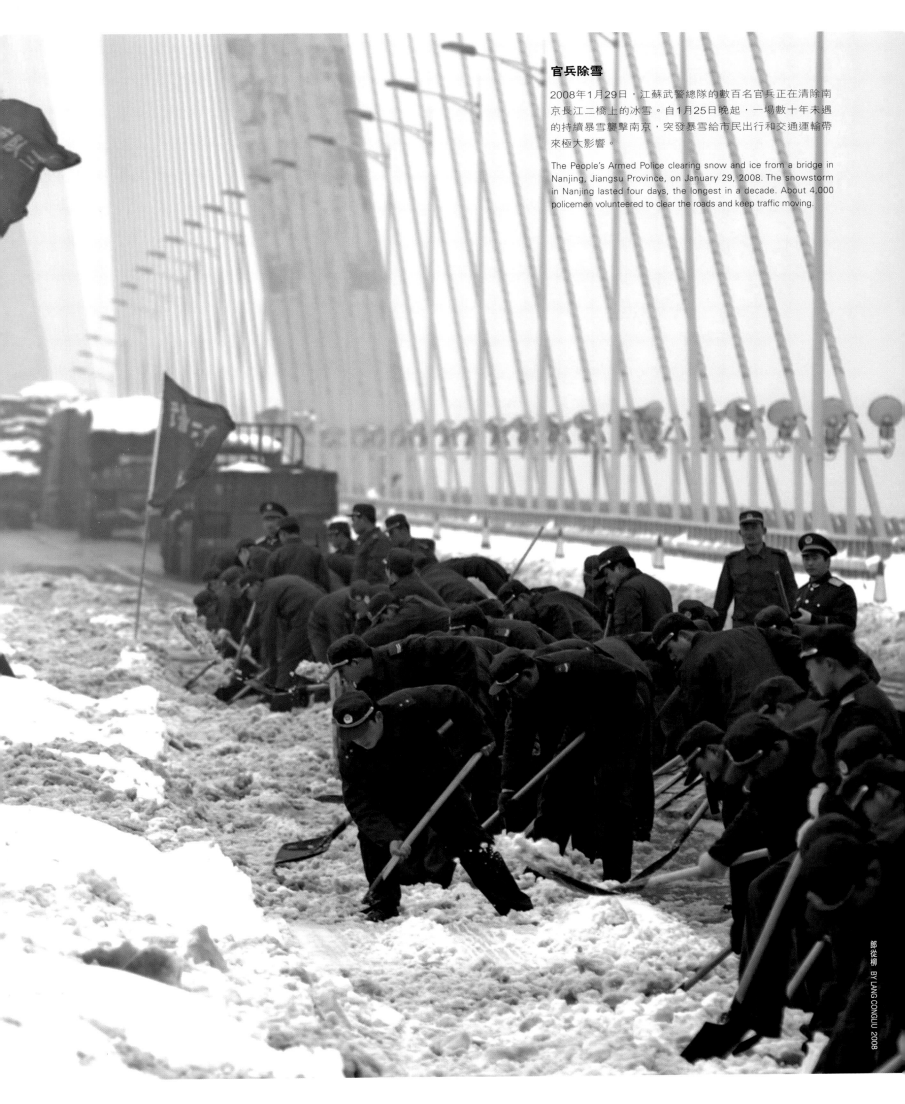

官兵除雪

2008年1月29日，江蘇武警總隊的數百名官兵正在清除南京長江二橋上的冰雪。自1月25日晚起，一場數十年未遇的持續暴雪襲擊南京，突發暴雪給市民出行和交通運輸帶來極大影響。

The People's Armed Police clearing snow and ice from a bridge in Nanjing, Jiangsu Province, on January 29, 2008. The snowstorm in Nanjing lasted four days, the longest in a decade. About 4,000 policemen volunteered to clear the roads and keep traffic moving.

郎從柳 BY LANG CONGLIU 2008

汶川地震
Sichuan Earthquake – The World Rallies

「應變」，有時候會成為觀察制度彈性大小、社會健康與否的契機。如果把30年打包為一個歷史的整體，那麼可以把兩場大地震作為30年前後社會應變能力的標誌。中國是一個多地震的國家，大災是對國家管理體制、綜合國力和國策的檢驗。所有人都看到——在汶川地震面前，全體國人萬眾一心，中國政府迅速有效地動員國力，國際救援與國內救援一起救死扶傷，災後重建和系統的社會救助有序展開。回顧1976年發生的唐山大地震，集中迅速動員國力的制度沒有變，不同的是綜合國力大大提升了；中國與世界的關係密不可分了；中國人民之間物質和非物質的聯繫強化了。

Global animosity directed at China following the Olympic Torch relay, quickly turned to sympathy and solidarity when scenes from the devastating Sichuan Earthquake were beamed around the world. The quake struck shortly before 2.30 pm on May 12, measuring 8.0 on the Richter scale, and was felt as far as Beijing, 1,500 km away. Nearly 70,000 people perished in the disaster and many more were injured. A further 18,000 people remain missing. The government was praised for its openness after it granted journalists from around the globe access to the disaster area. Premier Wen Jiabao attracted nationwide praise when he flew to the area 90 minutes after the quake struck to oversee rescue work. It also has set about building quakeproof schools and improving earthquake monitoring. Rescue efforts performed by the Chinese government were praised by the critical Western media. The Los Angeles Times described China's media coverage of the quake as "democratic". China's rapid response to the quake is being studied by emergency professionals the world over.

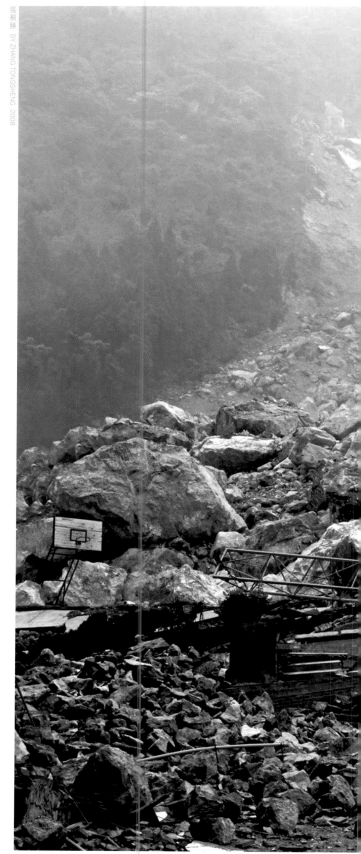

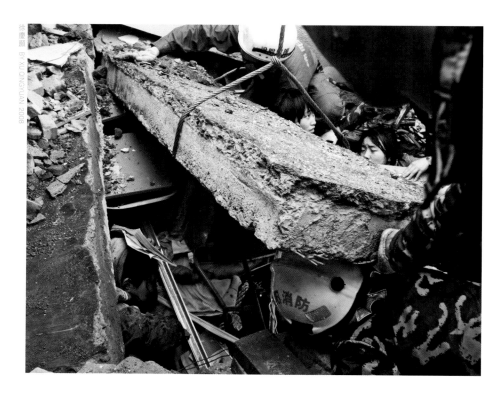

救援北川

2008年5月13日，四川省北川縣北川中學，消防救援人員從廢墟下搶救受傷學生。

Firemen struggle to lift masonry off children buried in Beichuan High School, Sichuan Province, on May 13, 2008. The earthquake of May 12 devastated the town, which was shaken by strong aftershocks for days afterwards.

大地震廢墟

2008年5月24日，四川省北川縣北川中學新區校園被地震造成的山體滑坡完全掩埋。

Beichuan High School disappeared completely — except for the flagpole — under a landslide on May 24, 2008.

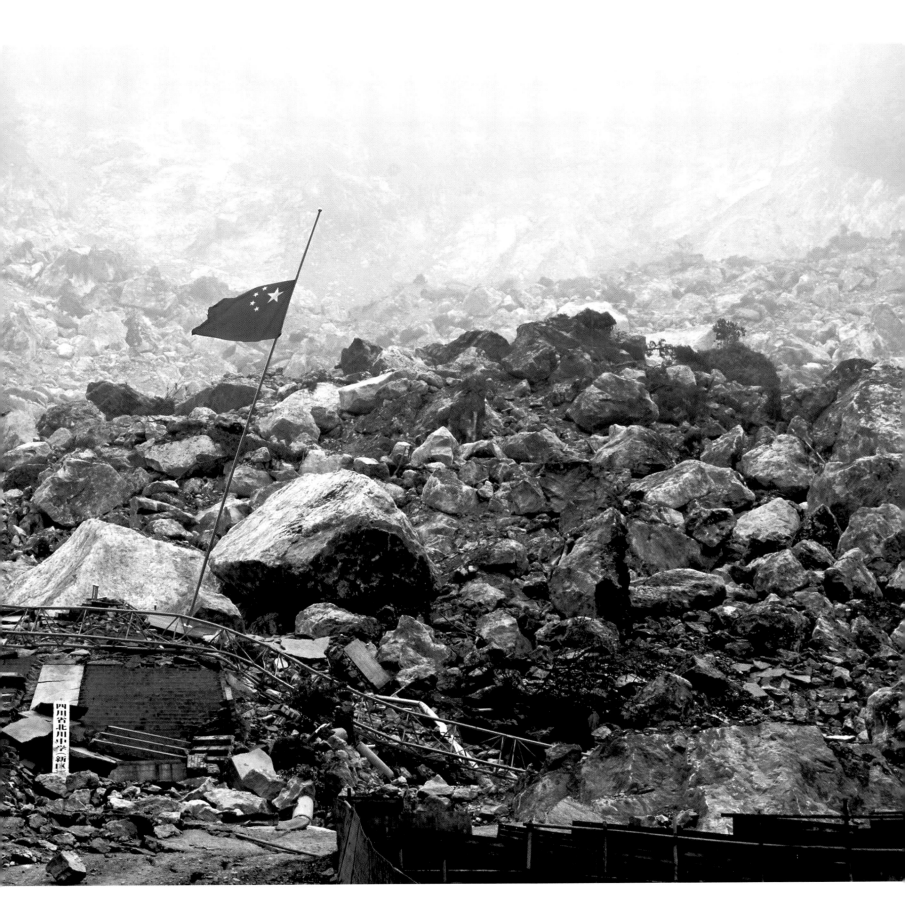

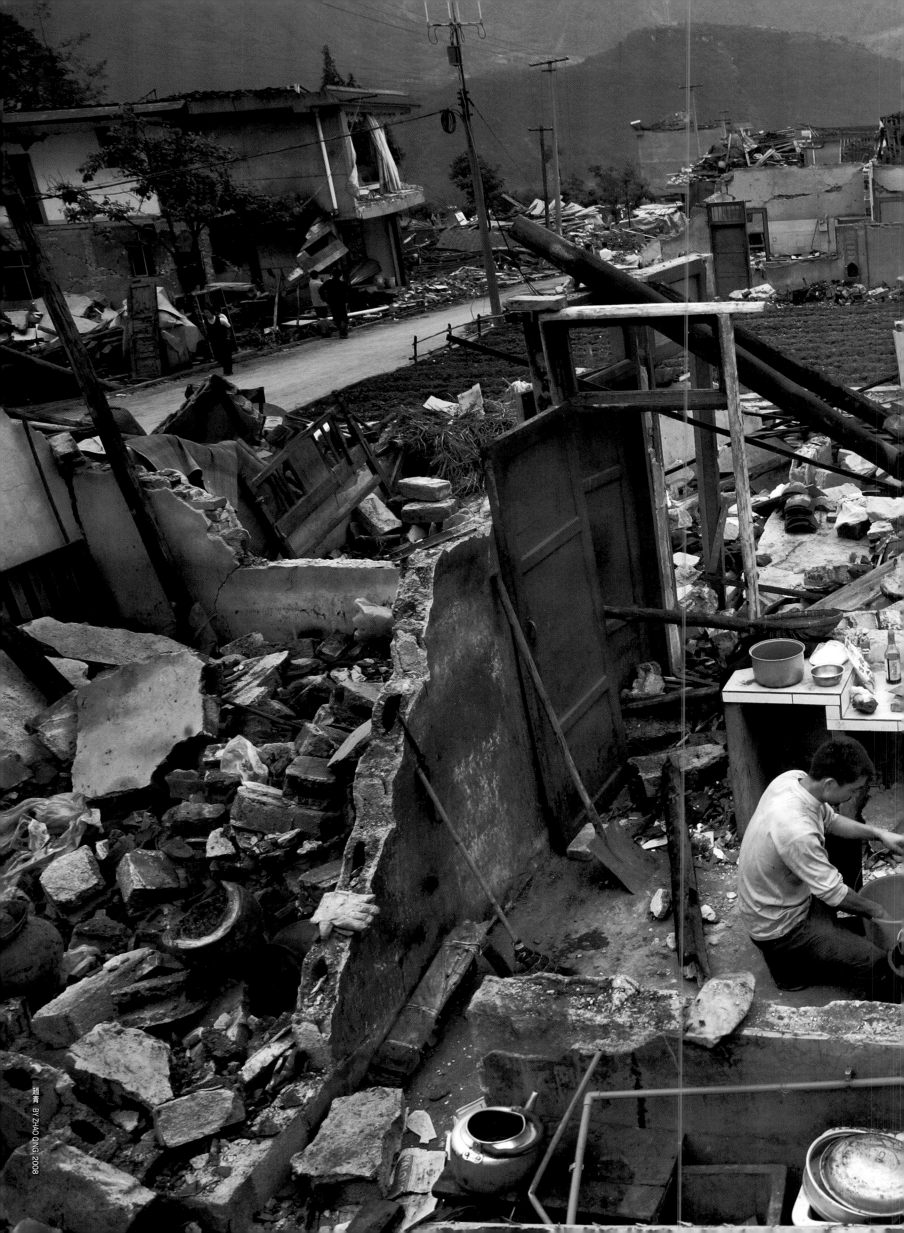

超青 BY ZHAO QING 2008

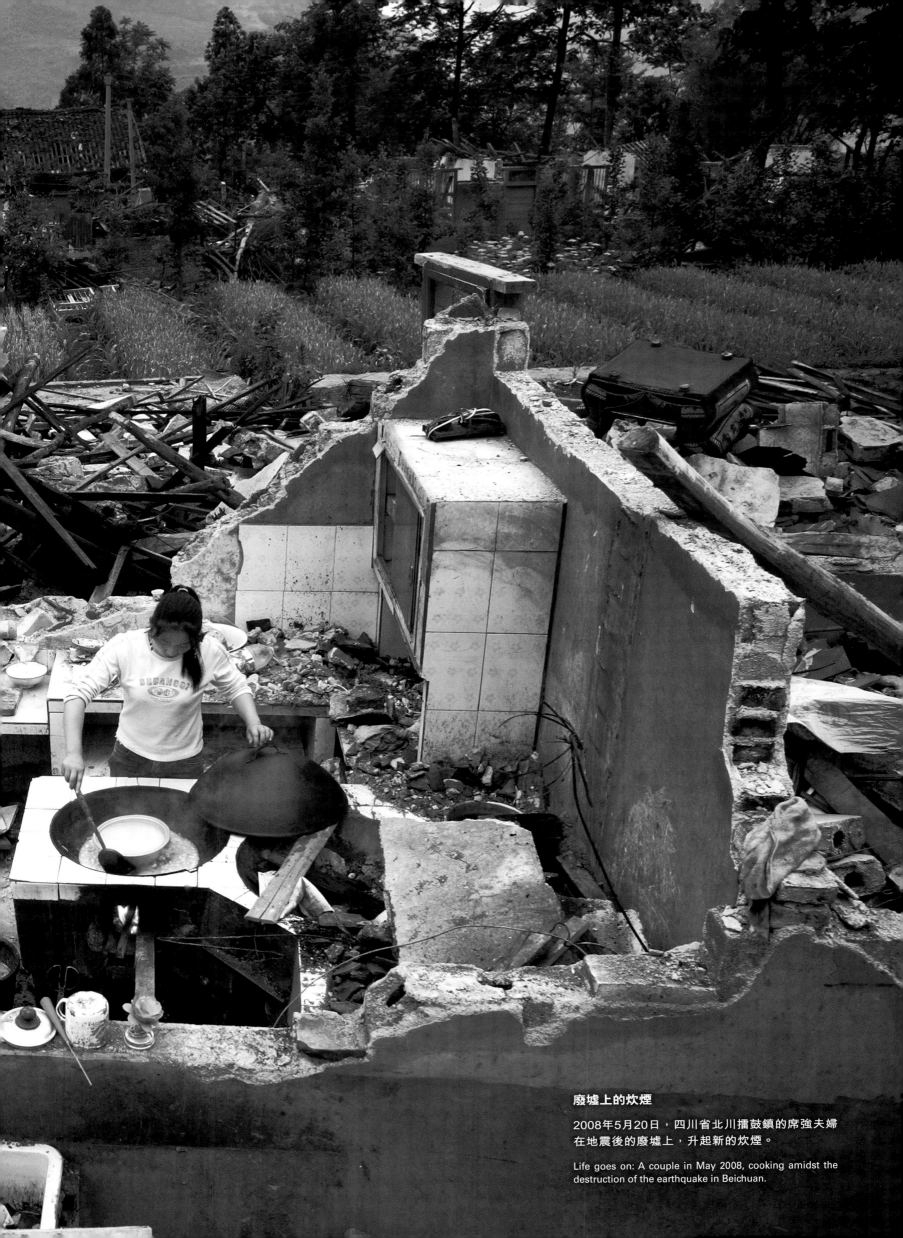

廢墟上的炊煙

2008年5月20日，四川省北川擂鼓鎮的席強夫婦
在地震後的廢墟上，升起新的炊煙。

Life goes on: A couple in May 2008, cooking amidst the
destruction of the earthquake in Beichuan.

奧運
Olympic Games – Showcasing Modern China

　　第29屆奧運會在北京召開，無疑是中國走向世界被世界承認的一個重要標誌。申奧成功的那一夜，各地市民自發走上街頭表示慶祝。奧運會的舉辦贏得了全中國人民的擁護和歡迎，對老百姓而言，這是民族自信心和自豪感的最好體現。奧運中，也有有趣的事。比如奧運會歷史上數量最多的那5個吉祥物，並沒有出現在開幕式和閉幕式上，除了那5個拗口的名字，它們的種屬（比如羚羊、老虎之類）也最終沒被人搞清。在通過奧運會努力展示中國的風貌之後，人們也意識到，中國融入世界是一個過程，重要的是你的實力，而且沒必要一下子把那麼多的功能承載在一件事情上。

If China is famous for anything in this decade, it's the 2008 Olympic Games. Beijing hosted what many have described as the most successful Games ever. Scores of sporting world records were broken in the tournament, which attracted more than 11,000 athletes to venues across the country. The successful conclusion of the event left the nation ecstatic.

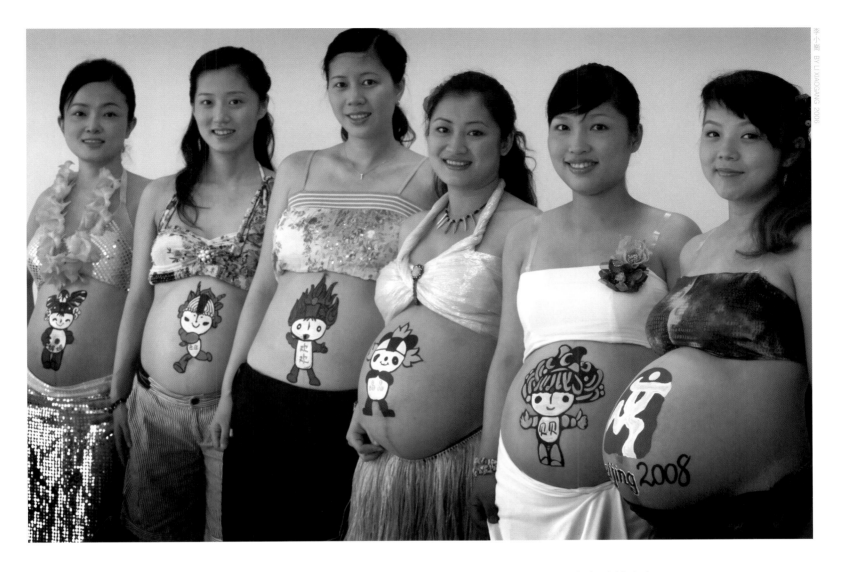

BY LI XIAOGANG 2006

萬名保安進北京

2007年，北京保安寺街。為確保2008年北京奧運會的勝利召開，來自吉林、山東的保安在經過嚴格的技能培訓和健康體檢之後，在北京執勤，希望能為北京奧運作點貢獻。

Five security guards hold rings to form the Olympic symbol on Bao'ansi Street, Beijing, in 2007. Security guards from all over China came to Beijing to help with the 2008 Olympic Games.

奧運媽媽彩繪大賽

首屆「海南省孕媽媽時尚形體彩繪」大賽於2006年8月22日在中國海南省海口市一所醫院落下帷幕，各個獎項各歸其主。這次比賽歷時20天，來自廣東、湖北、湖南、四川、重慶、上海、吉林、浙江、廣西等地的78位準媽媽，參加了時尚形體彩繪。

Expectant mothers in Hainan, sporting pictures of Olympic mascots, in a competition for the title of "Fashion Mom" in August 2006.

345

兩任國際奧委會主席

2008年8月11日,北京奧運會比賽
之餘,兩任國際奧委會主席薩馬蘭
奇和羅格相約來到國展2008奧林匹
克美術大會,看到自己1:1比例的
蠟像,兩任主席格外驚奇。

Former chairman of the International
Olympic Committee Juan Antonio
Samaranch and IOC Chairman Jacques
Rogge meet their life-size wax doubles
at the Beijing Olympic Fine Art 2008
exhibition on August 11, 2008.

347

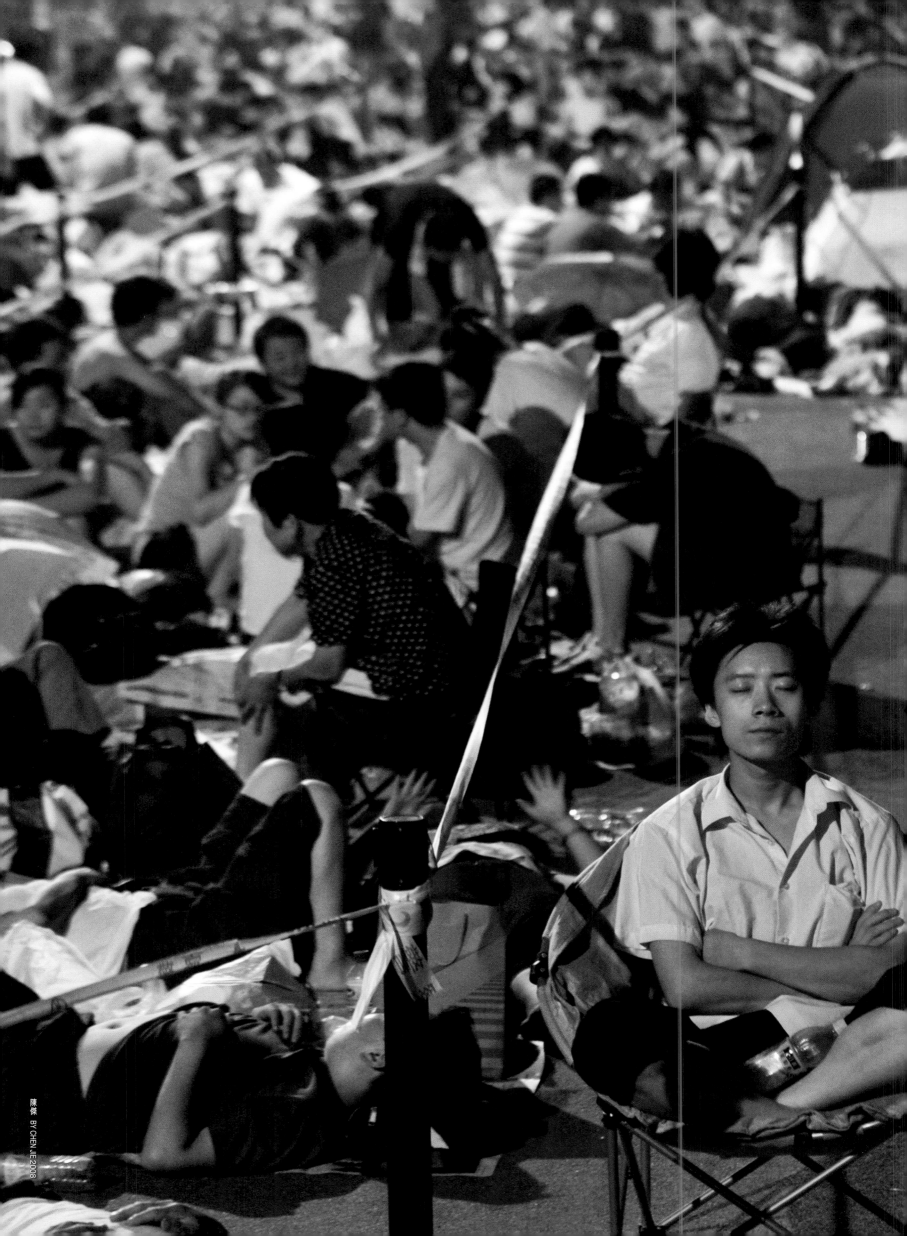

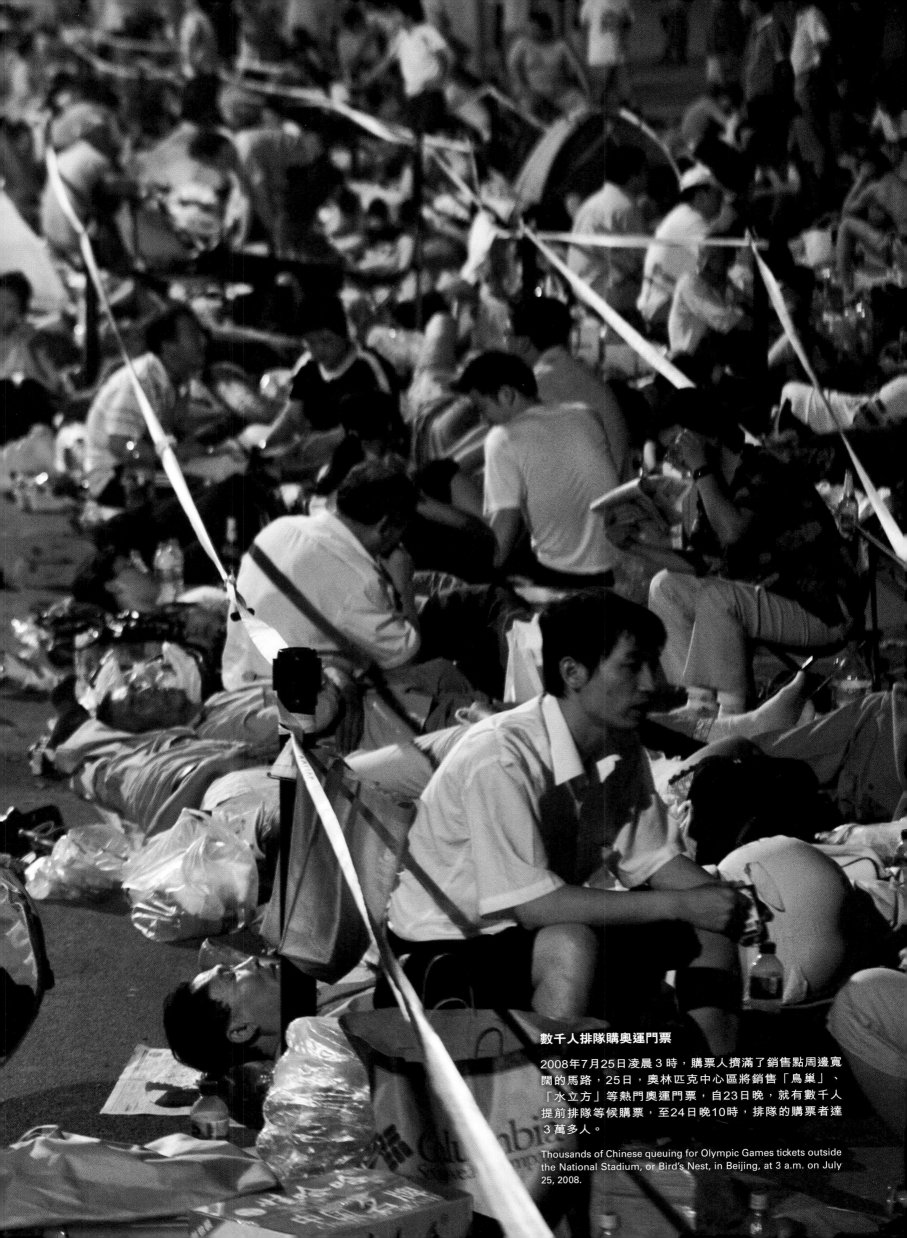

數千人排隊購奧運門票

2008年7月25日凌晨3時，購票人擠滿了銷售點周邊寬闊的馬路，25日，奧林匹克中心區將銷售「鳥巢」、「水立方」等熱門奧運門票，自23日晚，就有數千人提前排隊等候購票，至24日晚10時，排隊的購票者達3萬多人。

Thousands of Chinese queuing for Olympic Games tickets outside the National Stadium, or Bird's Nest, in Beijing, at 3 a.m. on July 25, 2008.

劉翔
Liu Xiang

　　被國人寄予厚望的田徑選手劉翔，在奧運會上出人意料地退賽了。在體育金牌的舉國體制下，這個偶然事件引發了人們的許多議論。或許，我們不應該讓某些個人承擔太多本不該承受的義務。對進步中的停止甚至倒退，應該有更多的寬容。在多年習慣於「一邊倒」的輿論和媒體氛圍之後，我們是不是應當創造和建立一種多元的思維方式？這類思考既是關乎劉翔的，也關乎一個民族的心智成熟。可以慶幸的是，這類冷靜的平和之論在這個時候已經漸為人們所接受。

　　The dramatic withdrawal of Liu Xiang from the Beijing Olympics 110-metrehurdles caused confusion and tears. In a nation that has put such a great emphasis on national pride, it is understandable that this incident draw so much criticism. Perhaps it is time for us to think in a pluralistic way and welcome different values. Afterall, the Chinese are learning to discuss matters in a calm and peaceful way.

劉翔因傷退賽

2008年8月18日11:50，在北京奧運會男子110米欄預賽中，因傷退賽的劉翔在 8 萬觀眾驚愕的目光下低頭走出「鳥巢」。

Olympic champion Liu Xiang walks off the track with a leg injury after failing to start in the 110 meters hurdles first-round heat at the Beijing 2008 Olympic Games on August 18, 2008.

閉幕式上，姚明為隊友拍照

2008年8月24日，北京奧運會閉幕式上，姚明為隊友們拍照留念。

Yao Ming snaps a photo of friends at the Beijing Olympics closing ceremony on August 24, 2008.

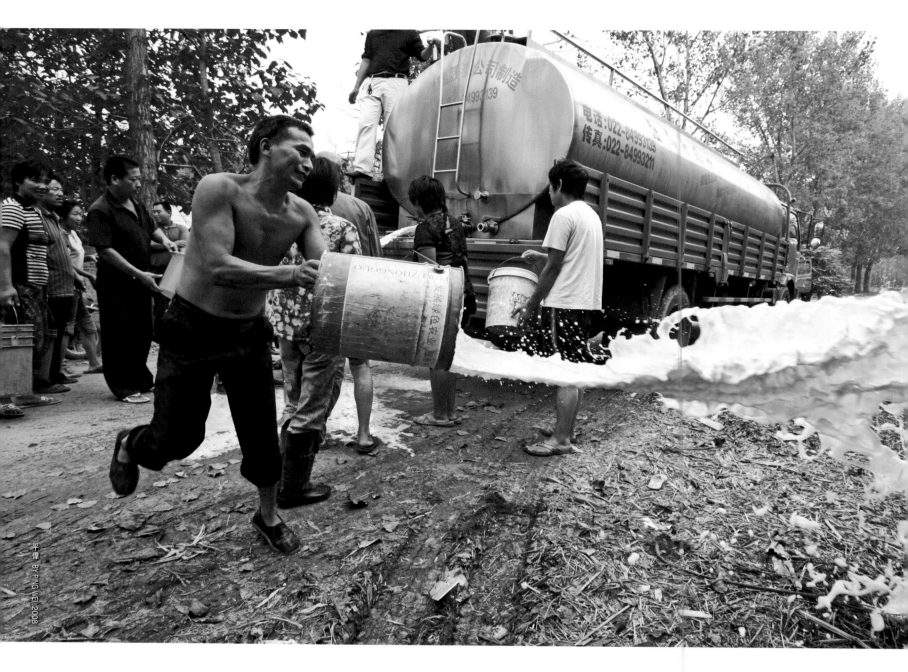

平偉 BY PING WEI 2008

奶農忍痛倒奶

2008年9月21日，河南省鄭州市中牟縣劉集鄉冉老莊村奶牛養殖基地，幾家養牛場奶農把被平頂山伊利分公司拒收的幾十噸牛奶倒在了場門前的路溝裡。自三鹿奶粉事件牽扯到更多乳品企業以來，一些乳品企業或停產或暫停收購鮮奶，奶農們只得忍痛倒奶。

On September 21, 2008, dairy farmers in Ranlaozhuang Village, Zhongmou County, Henan Province, threw away tons of milk refused by Pingdingshan Yili dairy company following the poisonous milk powder incident of Sanlu Dairy Corp. in Shijianzhuang, Hebei Province.

金融海嘯
2008 Financial Crisis – Weathering the Storm

2008年底，一場興起於華爾街的金融海嘯迅速席捲全球。儘管有學者認為中國有可能在這場危機中置身事外，但風浪襲來時對國內經濟依然影響深刻。30年改革開放，中國與國際經濟的聯繫密不可分、互為因果——中國以龐大的市場、活躍的經濟、強大的國力，在世界經濟的重大變動中，已有可能對世界施以積極影響。

The 2008 Financial Crisis had its roots in the United States and quickly spread globally, but devastated economies around the world. While China's export-led economy was hit hard, the country weathered the storm better than most, thanks to strong state control over key industries, and managed to post growth figures of around 8 percent. At the beginning of the crisis, Premier Wen Jiabao said: "The biggest contribution we can make to the world economy under the current circumstances is to maintain China's strong, stable and relatively fast growth, and avoid big fluctuations." As the crisis began to ease, it looked as if he was right.

廠房被封工友發愁

2008年10月23日，深圳港聲電子廠的陳錄俄（左）和一名工友坐在已經貼上封條的廠房前，為失去工作崗位發愁。

Two jobless workers sit despondently outside a closed factory in Shenzhen in 2008.

討債

2008年10月14日，一位催討債務的男子在江龍集團銷售辦公室睡覺。受全球金融海嘯影響，國內最大的印染企業江龍集團資金鏈斷裂，企業老闆出逃，大批債權人來到集團總部討債。

A man sleeps in the office of Zhejiang Jianglong Textile Printing and Dying Company, one of China's largest textile manufacturers until its credit line was cut and it went bankrupt in October 2008 with reported debts of 2 billion yuan.

朱丹陽 BY ZHU DANYANG 2008

傅擁軍 BY FU YONGJUN 2008

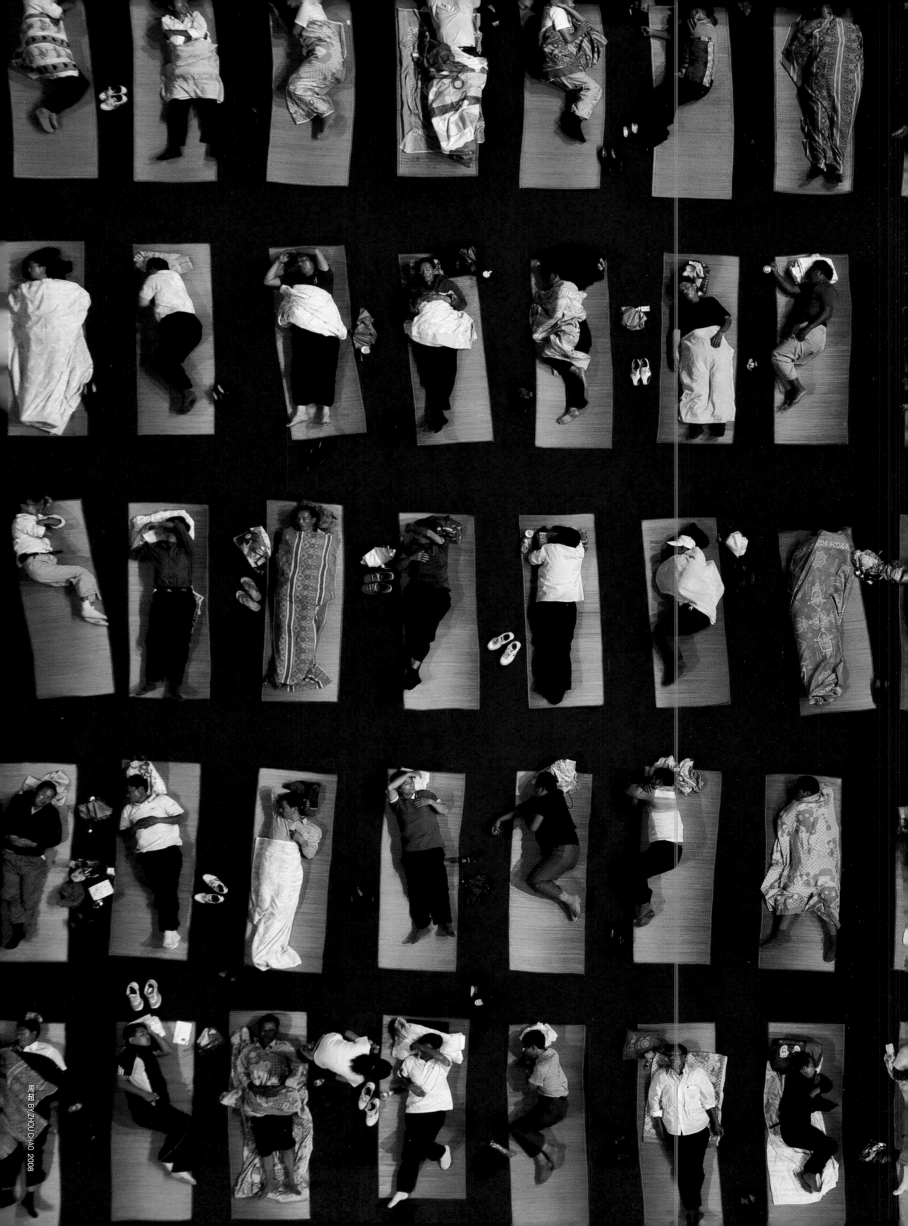

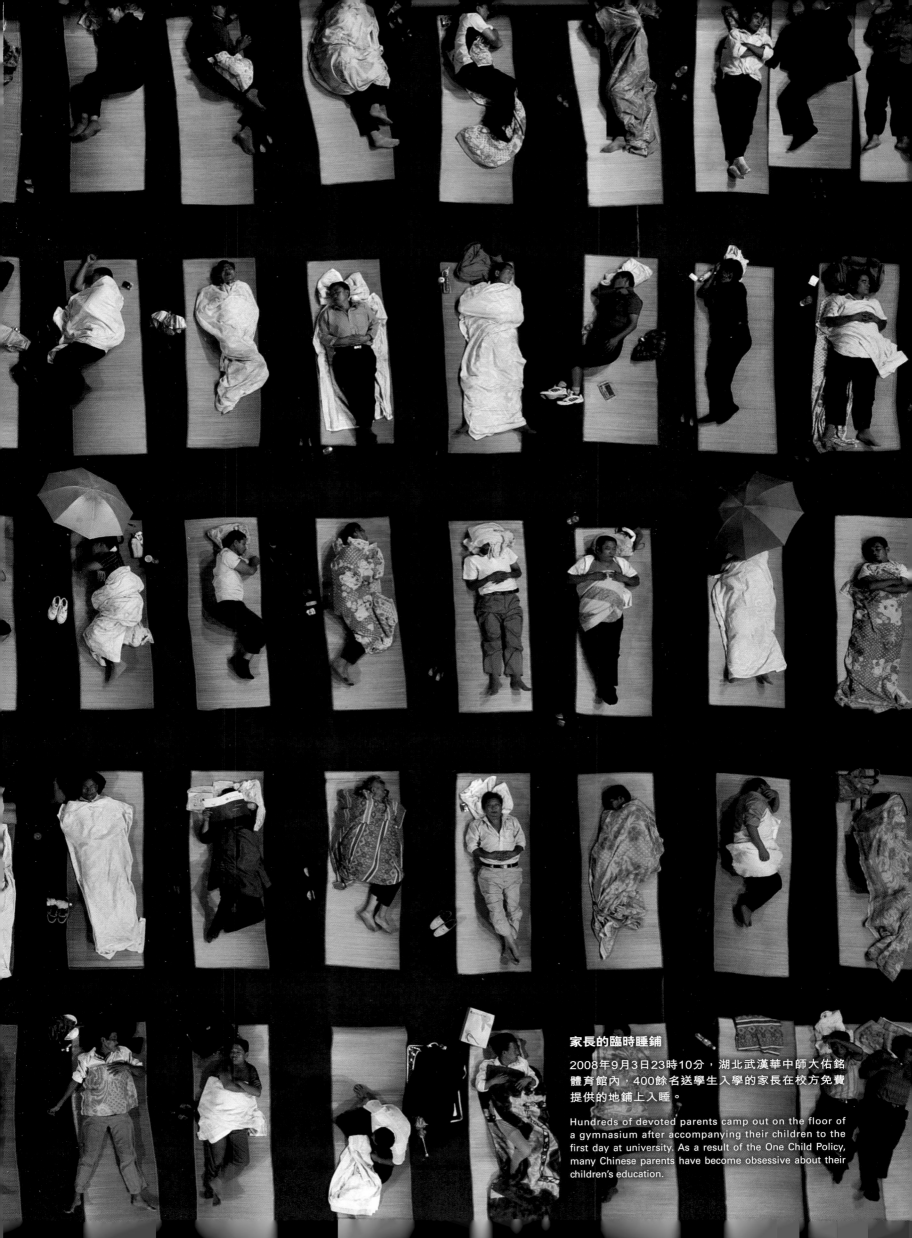

家長的臨時睡鋪

2008年9月3日23時10分，湖北武漢華中師大佑銘體育館內，400餘名送學生入學的家長在校方免費提供的地鋪上入睡。

Hundreds of devoted parents camp out on the floor of a gymnasium after accompanying their children to the first day at university. As a result of the One Child Policy, many Chinese parents have become obsessive about their children's education.

跋

　　三十年，相對於人類的歷史，僅僅是轉瞬即逝的一剎那；相對於中華民族的復興，也僅僅是前赴後繼的短暫片刻。然而，剛剛過去的三十年，對於中華人民共和國來說，則是一個極為重要的歷史階段，她使中國社會發生了翻天覆地的巨變；對於與共和國共同成長的一代人來講，則更是休戚相關、榮辱與共的關鍵時期，她奠定了我們人生旅途的基本走向。

　　《見證改革開放三十年》，是以圖片的形式記錄中國當代史上這場偉大的變革。為此，我們誠邀業內出道成名的大家，用手中的鏡頭把人們帶回歷史現場，再現了三十年間政治事件的跌宕起伏、經濟轉軌的艱難曲折、文化生活的急速變化，以及整個社會的巨大變遷。在一張張圖片的背後，所呈現的是改革者們尋找中華民族復興之路的艱辛探索，是億萬民眾擺脫貧困、追求富足的果敢行動。其間，既有氣勢恢宏的時代主旋律，也有一些難以忘懷的零星記憶，甚至還有一些不和諧的歷史噪音。誠然，這不是我們所期許的，但這就是歷史。歷史是應該被記住的，正因為此，歷史是不能被人們的善良願望所任意剪裁和編排的。

　　我們並非要刻意告訴人們甚麼，而只是想為歷史留下一部真實的記錄，為人們留下一個駐足思考的空間。如同三十年前一樣，今日中國又處在一個重要的關節點上。三十年間，我們經歷了從文革走向改革，從計劃走向市場；欣喜地看到中華民族終於回歸常識，回歸理性。然而，由於歷史的局限，在步入市場體制的過程中，我們也目睹了一些有悖改革初衷的醜陋現象，經歷了彷徨與困惑，由此悟到了我們與世界主流文明的巨大差距。因此，未來的三十年乃至更長一個時期，是決定中國復興的又一個極為重要的階段。三十年的輝煌，不應僅僅是歷史的回憶，如何打破中國三千年來周而復始的興衰歷史輪迴，仍是我們面臨的巨大挑戰。留下我們的觀察、見證與思索，不僅僅為自己、為當下，更是為了未來。

　　作為三十年的親歷者，我們見證、參與了這場偉大變革，經歷了太多的悲壯、挫折、奮鬥與探索，但與共和國一同走過從前，我們無愧無悔。致力於為中華民族的現代轉型貢獻一份心力，推動中華民族最終走向一個自由、平等、民主、法治的社會，是我們始終不渝的信念。

　　二十年前，中國證券市場研究設計聯合辦公室（聯辦）應中國資本市場的發展而生，成為推動改革開放的重要力量。2008年，在改革開放三十年之際，博源基金會為探討未來三十年中國的發展之路而設立，致力於為中華民族的現代轉向貢獻一份心力。

　　這本畫冊的出版，也表達了我們的一個心願：過去三十年，朋友們的幫助與支援，我們銘記在心；今後三十年，我們仍需要你們的友誼與信任。

秦　曉　博源基金會理事長　　　**王波明**　中國證券市場研究設計中心總幹事
何　迪　博源基金會總幹事

POSTSCRIPT

China's Thirty Years documents through photography a great transformation that has taken place in China in the past century.

As a generation that came to age with the People's Republic of China, we have witnessed and participated in this great transformation. Behind each image are reformers explorations for a way to China's revival as well as the yearning of millions for delivery from poverty. The glorious achievements of the past thirty years should not only be a historical remembrance, because we still must tackle the challenge of breaking out of a rise and fall cycle that has characterized Chinese history for three millennia. Accordingly, this record of observations, thoughts and possible answers is not just for ourselves or the here and now, but more importantly for the future.

Twenty years ago, the Stock Exchange Executive Council came into being with the emergence of China's capital markets. It has since become a major force in promoting China's reform and opening. In 2008, the Boyuan Foundation was set up to explore China's developmental path for the next thirty years, and to contribute to the deliberations on China's future direction.

The publication of this picture album is also an expression of our aspiration – that while we are grateful of the assistance and support of friends over the past thirty years, we continue to rely on your friendship and trust for the next thirty years.

Qin Xiao Chairman, Boyuan Foundation

He Di Director-General, Boyuan Foundation

Wang Boming
President, The Stock Exchange Executive Council

AFTERWORD 後記

三十年，時間很短，在歷史的長河中只是一個短短的瞬間。但這個三十年是中國改革開放的起始，是從封閉邁向開放的重要階段。

三十年，摸着石頭過河的前行，不僅僅是磕磕碰碰，也有許多激烈的撞擊。保守的頑固與改革的盲目，尤其是人們思想中的自我束縛和貪慾的滋生，加劇了開放過程中的矛盾和衝突。但在這個三十年，中國的發展確實快了。

三十年，我們記錄身邊發生的這些事，也是記錄了這個時代的曲折歷程。是工作，也是責任。

三十年，日子過得很快，這本畫冊所記錄的那些場面似乎就發生在昨天，會從紙上浮現，會從記憶中躍出，會使人們感覺到今天生活的來龍去脈。

Thirty years' time is very short. In the long river of history it is an exceptionally quick blink of an eye. But in these thirty years China gave birth to reform and opening. It was an important era of transition for a closed nation opening up to the world.

In thirty years China has crossed the river, groping the stones as she went. But there has been more than just a series of bumps; there have been intense impacts. Faced with stubborn conservatism and reformist ignorance, contradictions and disputes have intensified, particularly as a result of the collision between people's self-restraint and growing greed. Nevertheless, during these thirty years, China's rate of development has been tremendously swift.

For thirty years we have recorded these events as they happened around us. What we have done can also be regarded recording as a generation's tortuous course. For us, it has been a matter of both work and responsibility.

The scenes recorded in this album feel as if they happened only yesterday. But as the images appear on paper, memories of those days leap out, giving people a sense of context for today's life.

中國攝影師協會
China Photographers' Association